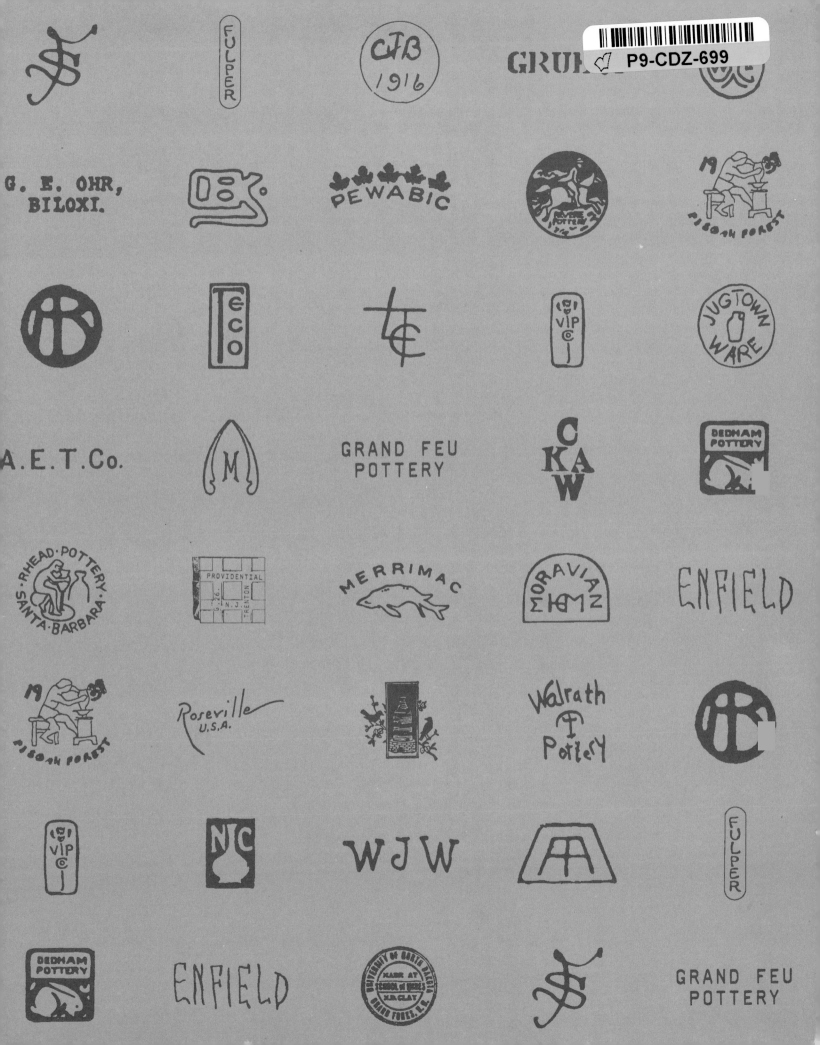

American
ART POTTERY

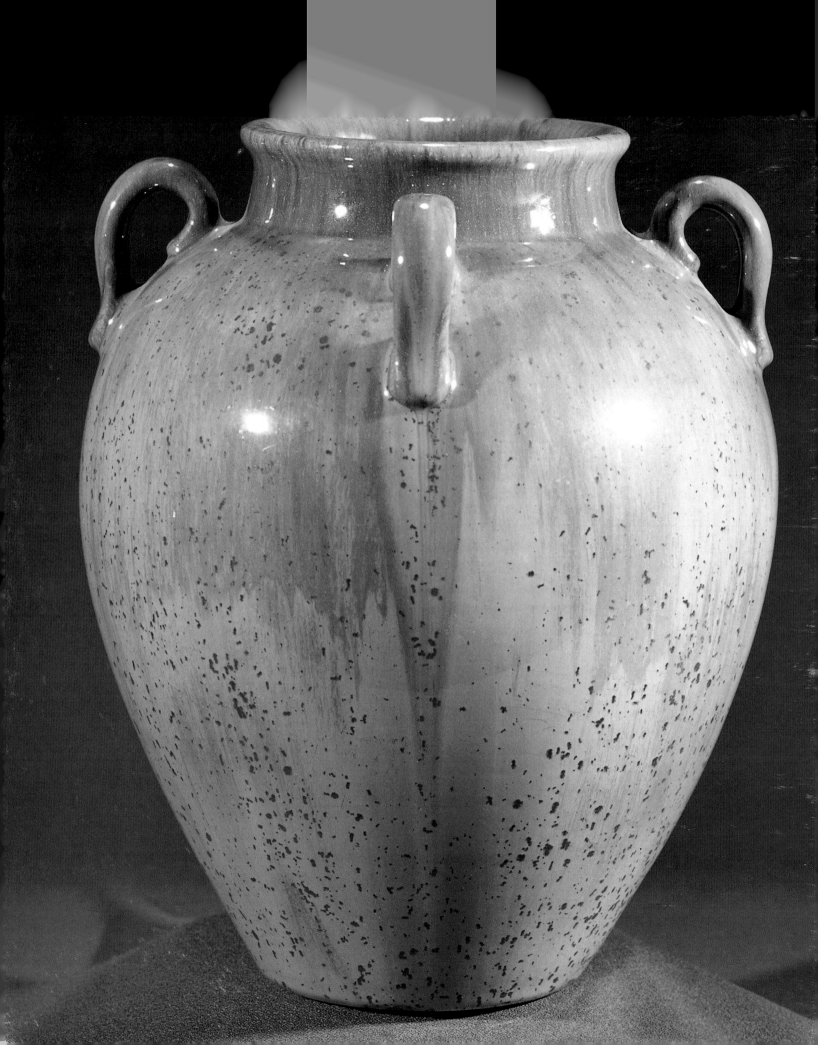

American
ART POTTERY

David Rago

KNICKERBOCKER
PRESS

Published by
Knickerbocker Press
276 Fifth Avenue
New York NY 10001

Produced by Saraband Inc., PO Box 0032, Rowayton,
Connecticut 06853

Library of Congress Cataloging in Publication Data available

ISBN 1-57715-014-7

Printed in China

EDITOR: Nicola J. Gillies
CONSULTING EDITOR: Robin Langley Sommer
ART DIRECTOR: Charles J. Ziga

Author's Acknowledgements

I would like to thank my parents, Mary and Domenic, for
igniting my interest in art pottery that strange and fateful
day when they brought home that awful Roseville Peony
tea set (in pink). It was all downhill from there. I would
also like to thank my wife, Suzanne Perrault, for diligently
sanding some of my many rough edges.

It is easy to underestimate the impact we have on others,
and I welcome this opportunity to thank a number of friends
who, in their own way, encouraged my interest in, and enthu-
siasm for, decorative ceramics. These include, but are not
necessarily limited to: Ms. Elaine Small Pichota, Dr. Eugene
Hecht, Robert Ellison, Dr. Martin Eidelberg, Rosalie Berberian,
Dr. Marvin Reingold, Dr. Bill Rubin, Robert Sears, Robert
and Betty Hut, Malvina Solomon, Bruce Johnson, Steven
Becker, Irene Stella, and Eric and Gail Silver.

Publisher's Acknowledgements

The publisher would like to thank Christopher Berlingo
and Wendy J. Ciaccia, graphic designers, for their assis-
tance in the preparation of this book. Grateful acknowl-
edgement is given for permission to reproduce the
photographs in this volume. Permission to reproduce the
photograph on page 105 was granted by Art Resource/
Cooper-Hewitt Collection. All other photographs are repro-
duced courtesy of David Rago Auctions, with special
acknowledgements noted in many individual cases. The
author has made every effort to ensure that all subjects are
correctly and fully credited; if any errors or omissions have
occurred, the publisher will be pleased to correct them in
future editions. Acknowledgements for the photographs in
the Decorative Tile chapter are as follows:

Collection of Raymond Groll: 238 (3rd); Vance A.
Koehler: 233 (r & b), 240 (c), 241 (t), 242 (b), 246 (bl);
Collection of Robert Mackey: 236, 238 (t), 245 (t); Collection
of Arthur and Diane Mann: 241 (b); Collection of Moravian
Pottery and Tile Works: 240 (c); Suzanne Perrault: 230,
231, 239, 241 (c & b), 244 (t); Perrault-Rago Gallery: 232,
233 (t), 234, 235, 237, 238 (2nd), 240 (b), 242 (t), 243,
245 (b), 246 (br); Private Collections: 238 (b), 240 (t), 242
(b), 244, 246 (t).

The author and editors also acknowledge the work of
authors of the works referred to during the preparation
of this book. Additional information on the American
Art Pottery movement can be found in Edwin AtLee
Barber's *The Pottery and Porcelain of the United States*
(1893), Paul Evans's *Art Pottery of the United States* (1987),
and Ralph and Terry Kovels' *American Art Pottery* (1993).
Comprehensive surveys of individual potters and studios
include *The Mad Potter of Biloxi: The Art and Life of
George E. Ohr* (1989), by Garth Clark, Robert A. Ellison,
and Eugene Hecht, and Robert Peck's *The Book of
Rookwood Pottery* (1968). Bruce Johnson's *Official Price
Guide to Arts and Crafts* (1992), which includes a chap-
ter on pricing art pottery by David Rago; Susan and Al
Bagade's *Warman's American Art Pottery and Porcelain*
(1994); and Ralph and Terry Kovels' *The Kovels' Collector's
Guide to American Art Pottery* (1974) are invaluable ref-
erences for evaluating pottery. More information about
decorative tiles can be found in Thomas Bruhn's *American
Decorative Tiles 1870–1930* (1979) and Vance Koehler's
American Decorative Tiles 1880–1950 (1994).

Contents

Introduction 6

1 Rookwood 8

2 Newcomb 32

3 Grueby Faience 48

4 William Walley 70

5 George Ohr 76

6 Tiffany 100

7 Teco 108

8 Van Briggle 122

9 Pewabic 134

10 Roseville 142

11 Marblehead 154

12 Frederick Rhead 162

13 Paul Revere 170

14 Fulper 180

15 The Best of the Rest 206

16 Decorative Tiles, *Suzanne Perrault* 230

Glossary 247
Who Was Who 248
Leading Studios 252
Index 255

Introduction

Below: Eccentric and brilliant, George Ohr believed himself to be "the greatest potter on earth."

S ome of the finest contemporary collections of American art pottery were formed during the mid- to late 1960s, and we can comfortably date the revival of interest in such ware to that time. Edwin Barber's *The Pottery and Porcelain of the United States* (1893) remains an essential text, but the first books on the subject published after the period ended appeared in the late 1960s.

These include Herbert Peck's *The Book of Rookwood Pottery* (1968), the Zanesville art pottery and tile books by Norris Schneider (1968), and *American Art Pottery* by Lucille Henzke (1970).

It was not until the landmark Princeton University exhibition catalogue text by Dr. Martin Eidelberg in 1972, the surveys by Paul Evans (*Encyclopedia of American Art Pottery*), and Ralph and Terry Kovels' *A Collector's Guide to American Art Pottery* that concise historical texts blending scholarship with photos of choice examples established collecting decorative ceramics as more than just a hobby.

Twenty-five years later, books on the subject abound. Numerous museum shows have fleshed out our knowledge of this field, and the books they've spawned are full of fresh information about the companies, the artists, and the techniques they used in creating this varied and complex artware. The period master, George Ohr, is the subject of no fewer than six monographs (and one television special). Five recent

books celebrate the history of Rookwood Pottery. On the Roseville Pottery, there are at least eight publications; on Fulper Pottery, two. And none of these takes into account the books that include them, and others, as part of the surveys they offer. It would have been difficult to believe, in 1970, the number of books, much less museum shows and general interest, that American decorative ceramics would ultimately command.

Yet, in spite of this deluge of information, almost none of it extends beyond the historical and technical. While this background material is invaluable to students of the period, it is largely devoid of the sort of editorial content that leads the interested to determine, for themselves, such questions as: How good is it?, What did the artist/pottery intend? What is it worth in relation to other pieces by the same maker?

Above: Maria Longworth Nichols founded Rookwood Pottery, the most successful studio in America, in 1880.

These are some of the questions this book addresses, focusing on the fourteen most important American companies/potters of the period. One might argue successfully that other companies should have been included in this work, but my intent was to select the companies and artists who were most influential in shaping the ceramic arts in twentieth-century America. The penultimate chapter describes briefly some of the other worthy producers. It is followed by a comprehensive survey of the art tile field contributed by specialist Suzanne Perrault.

The fourteen representative companies and studios are listed chronologically and form a cross-section of the geographical centers where art pottery was most vigorously pursued. These include the Northeast, the South, the Midwest, and the Southwest/West. It is easy to oversimplify such divisions, but, for the purposes of this work, they will prove more of a help than a hindrance.

If this book encourages you to be self-reliant in assessing and, ultimately, choosing the right pieces to add to your collection, then it will have earned its place on your bookshelf alongside the titles listed above.

—David Rago

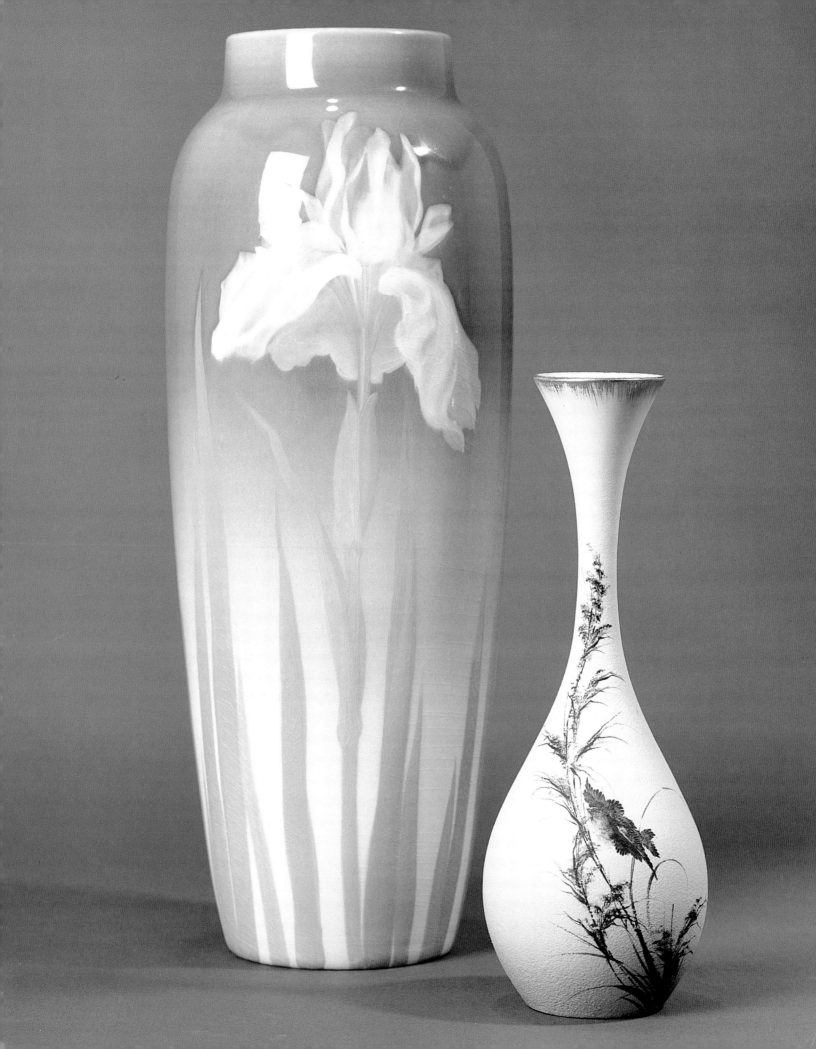

Rookwood

The story of the Rookwood Pottery—and the quality ceramics produced from 1880 until 1960—is in many ways the story of the art industry in America. From fairly simple and idealistic beginnings, Rookwood built an organization and maintained production standards that rivaled any in the world. Their humble interpretations of European copies of Oriental pottery in the 1880s were soon replaced by exceptional ware created by decorators, chemists, and designers from all parts of the globe. And the managerial and production changes instituted by the company in reaction to the two World Wars and the Great Depression reflected the industry-leading standards that were manifested in all other aspects of their organization.

There are as many types of Rookwood ware as there are styles of art in the last century; their 100-plus decorators displayed the training and influences critical to understanding what was happening in the art world at large. Some of these styles included Victorian, Aesthetic Movement, Art Nouveau, Arts and Crafts, Art Deco, and Art Moderne. The quality and innovation of the Rookwood production line, which existed for about fifty years, became an industry standard.

The earliest Rookwood work, from about 1880 until about 1895, consisted of imitative art that responded to the Oriental and European influences mentioned above. While company decorators and technicians forged an innovative style and developed some new techniques, perhaps the most famous of which was artist Laura Fry's blending of background color by atomizing pigment, this was the period during which Rookwood learned the skills that would make them a great pottery.

It doesn't take a scholar to recognize that all the attributes needed for greatness were either in place or in the process of getting there. For example, hiring the best artists was critical. Putting in place the same level of support staff in the form of technicians and designers was equally so. The failure rate at Rookwood was comparatively low,

Opposite: Two outstanding vases typical of Rookwood ware. The bisque vase on the right is from the early years and was decorated by Matthew Daly. The tall vase on the left with iris blossoms demonstrates Rookwood's Iris Glaze, in which pastel-colored slip was applied to the vase on a shaded background.

even though their standards were considerably higher than any of their major competitors'. Rookwood was one of only a few companies to "second" their work, often for small inconsistencies.

Work from this period began with coarsely rendered slip-relief designs of sea creatures, flowers, and birds painted against expressive "smear-glazed" backgrounds. Oriental and French influences were predominant at the time: Maria Longworth Nichols, the company's founder, was one of the many Americans whose interest was aroused by the French exhibit at the 1776 Centennial Exhibition in Philadelphia, Pennsylvania. A little later, they developed the Standard Glaze brown overcoat that was the perfect foil for a moody Victorian sentiment.

Rookwood moved swiftly beyond these relatively simple beginnings as they embraced the Art Nouveau and Arts and Crafts movements at the turn of the century. Their coterie of decorators increased fivefold, hundreds of new forms were introduced into their repertoire, and several new and important glazes such as Iris, Vellum, Sea Green, Aerial Blue, and assorted Mattes were added. Perhaps their decision to enter the 1900 Exposition in Paris spurred their progress at this time, or maybe they were just ripe for a challenge. Whatever the cause, there can be no denying the large-scale changes that swept the company in 1898.

Below: E.T. Hurley created this bulbous Vellum vase with fish decoration.

Describing a great glaze in words is far more challenging than simply showing one next to an ordinary finish. A superior glaze is thicker, less inclined to craze, and clearer than an ordinary finish. Further, it enhances the artwork it envelops by imparting a limpidness, a brilliance to it. It feels richer to the touch and is rendered evenly atop the surface of the pot. By 1900, Rookwood not only knew how to accomplish glazes better than those of any of their American rivals, but they did it consistently on many thousands of pots. Rookwood achieved greatness not only because their product was superior, but because they did a superior job of creating their superior ware with such remarkable consistency. One will occasionally find a well-glazed piece of Weller or Rozane or, more commonly, Lonhuda: the surprise one feels at having found such an example is indicative of their mixed quality stan-

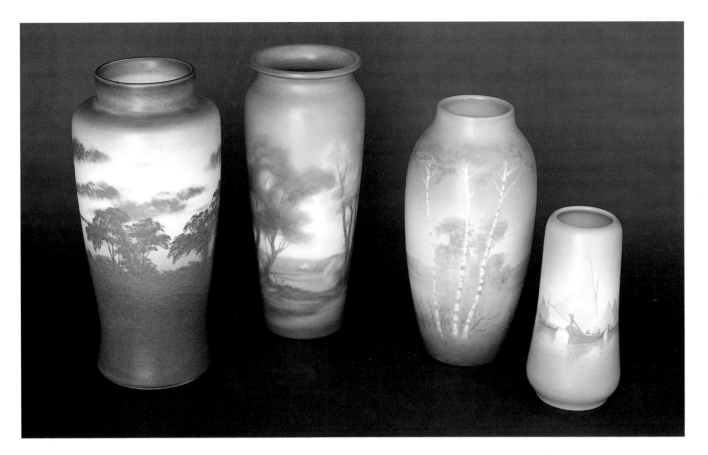

dards. With such a product as Rookwood's, we take for granted what is exceptional in their competitors.

Rookwood's Art Nouveau ware was typified by organically rendered flowers, and occasionally landscapes and seascapes, slip-painted on the clay body of the pot and covered with one of their famous glazes. The Iris glaze was simply a clear, high-gloss finish that afforded a photo-representational depiction of the study. Similar in feel, though focusing more on aquatic scenes and a slightly more stylized subject matter, was their Sea Green finish. This glaze, though as transparent as Iris, was a soft mint-green color which influenced all the color to the decoration below it; light green, not white, was the lightest color possible in this finish.

Another turn-of-the-century innovation was Rookwood's Vellum glaze, produced in direct response to the artwork of the French impressionists. A soft, diffusing finish, the Vellum glaze suggested artwork viewed though gauze and was in stark contrast to the crispness of the Iris glaze. Not surprisingly, one is as likely to find a vase decorated with a landscape scene as a floral.

The Aerial Blue glaze was an experiment that seems not to have succeeded. Denser than Iris or Sea Green, it almost exclusively enveloped vases depicting scenes viewed from above. The opacity of this glaze often obscured the work it covered, rendering such pieces unsaleable. There seems to be a disproportionate number of "X'd," or seconded, examples of Aerial Blue.

Above: Four Vellum vases with painted scenic decorations. Stanley Burt originated and developed Rookwood's line of Vellum ware, a cross between a transparent glaze and matte finish, beginning in 1904.

The final turn-of-the-century innovation was the Matte, or non-glossy, finish. Developed in response to the Arts and Crafts influence in America and fostered by such adherents as Gustav Stickley, such pieces were decorated with incised and/or modeled designs of stylized flowers in contrasting, soft matte finishes. Unlike the Art Nouveau-influenced glossy finishes, such glazes provided both color and surface and, not smudging to the touch, invited handling. Indeed, the soft, tactile quality of these glazes was among their most salient aspects.

As Rookwood aged gracefully, and as World War I necessitated a change in their production standards, the company grew a little smaller, but tighter and more mature. Their clay body changed in 1915 when they adapted a more porcellaneous base that expanded more consistently with the glazes they used. Crazing, or the gentle crackling of the glaze that occurs when the body and its glazing expand differently in the kiln, was often the bane of their earlier work. After 1915, with the introduction of this new clay body, crazing was reduced considerably.

It was at this time that their various porcelain lines became standard production. Jewel Porcelain is the most famous and popular of these, and you can easily spot a piece by the small bubbles that form in the glaze. Such pieces usually have richer, deeper colors because the porcellaneous body allowed for higher temperatures in the kiln.

Another reason why such pieces are consistently good is that, by this time, the company and their remaining artists were highly experienced. Gone were the days when scores of decorators produced hundreds of pieces weekly. Instead, a coterie of their most accomplished painters such as Sarah Sax, Kataro Shirayamadani, and Ed Diers finished piece after handsome piece.

Only after World War II, when the Rookwood Pottery—and factory-produced art pottery in general—seemed an anachronism, did production standards fall noticeably. By this time their diminishing band of artists were in their dotage, and their innovative work was a thing of the past. Designs were often repeated, and old ideas were dredged up at the expense of creating new ones. The company trudged on until 1960 but, for all intents and purposes, Rookwood was finished by the time of World War II.

One remaining aspect of Rookwood's work is their Production Ware, or work which is simply glazed and not artist-decorated or

signed. Rookwood introduced this ware around 1905, and the earliest pieces are their best, with sharp organic designs under rich, flowing matte glazes. As with the rest of their output, the later Production Ware gradually diminished in quality and design, and the last pieces often showed muted, stylized designs under lifeless, high-gloss finishes.

One shouldn't judge Rookwood by these vestiges of their greatness. No single company achieved so much for so long as Rookwood. While the company may not have fostered the individuality of a George Ohr, it established and maintained a standard of quality that did much to elevate the worldwide opinion of American decorative ceramics.

There are as many prices as there are types of Rookwood. Generally speaking, if perfect and finished by hand, a typical 8-inch floral vase in Standard is worth $450; Iris, $1,000; Sea Green, $2,500; Vellum, $750; Aerial Blue, $3,500; Jewel Porcelain, $2,000; Painted Matte, $3,500; and Matte, $800. Damage hurts the value of Rookwood more than that of any other American pottery. A chip will reduce the value by at least 50 percent.

Opposite: Fred Rothenbusch painted this ovoid Vellum vase with roses. The pastel colors used on this piece are typical of Rookwood's ware after 1894, when new glaze techniques, including the Iris Line, were introduced and dark background colors were replaced with soft pastels.

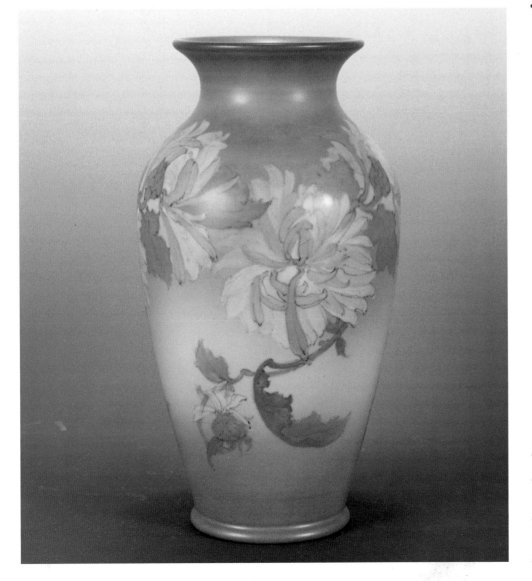

Left: A fine, crisply painted Vellum vase decorated by Fred Rothenbusch, a prolific artist at Rookwood.

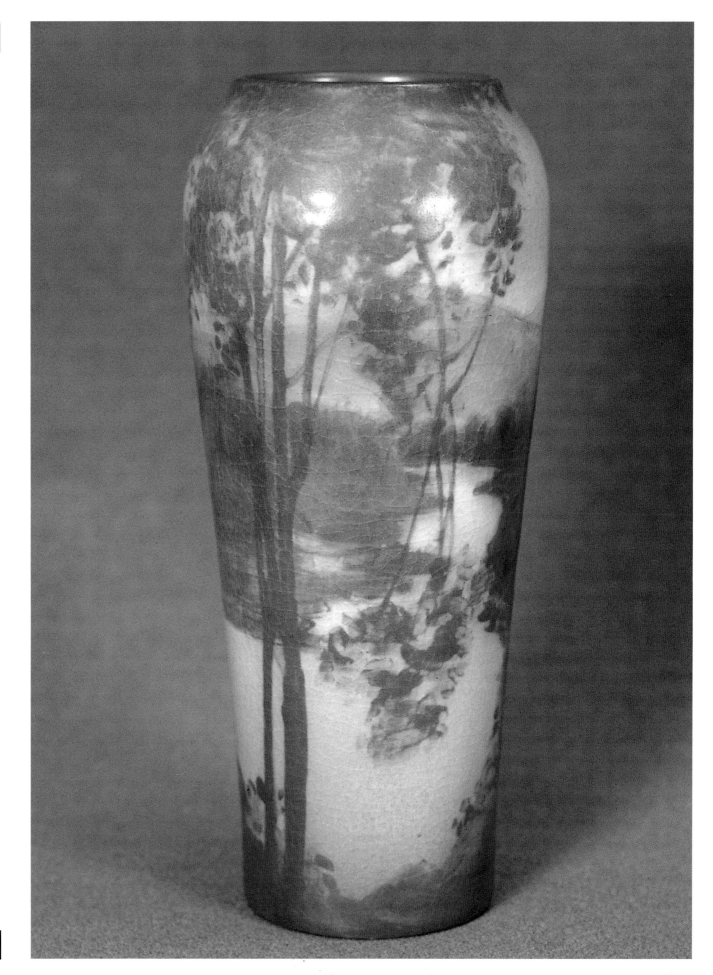

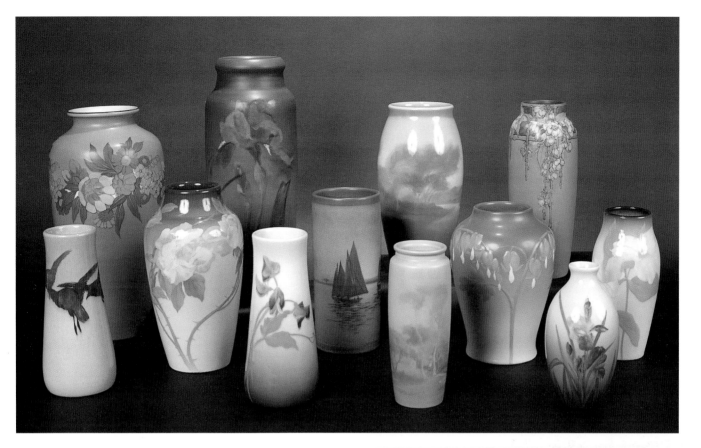

Assorted Vases *Above*
An assortment of vases produced at
Rookwood around the turn of the
century. More than 120 artists and
decorators worked at the pottery during
its 87 years of operation.

Vellum Vases *Opposite and right*
Two Vellum vases with landscape
decoration. The vase on the opposite
page is an exceptional example of Vellum
ware. Fred Rothenbusch created the tall,
corseted Vellum vase on the right.

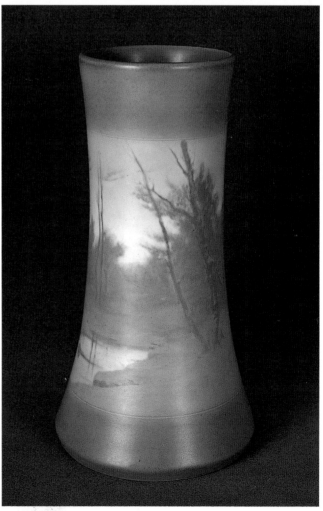

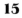

Production Vase *Opposite*
Tall and bulbous, this two-handled matte vase is an example of Rookwood's Production Ware, for which decoration was embossed in the molds rather than hand-carved or modeled.

Painted Matte Vase With Poppies *Right*
An unusual piece of Rookwood pottery on which red poppies are painted and glazed simultaneously.

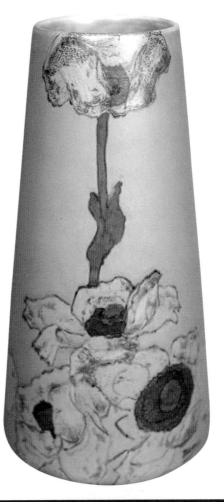

Loving Cup *Below*
Kataro Shirayamadani painted this three-handled Vellum loving cup with fish.

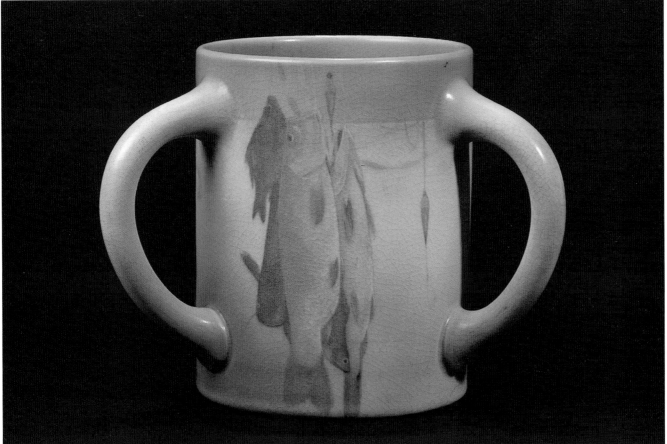

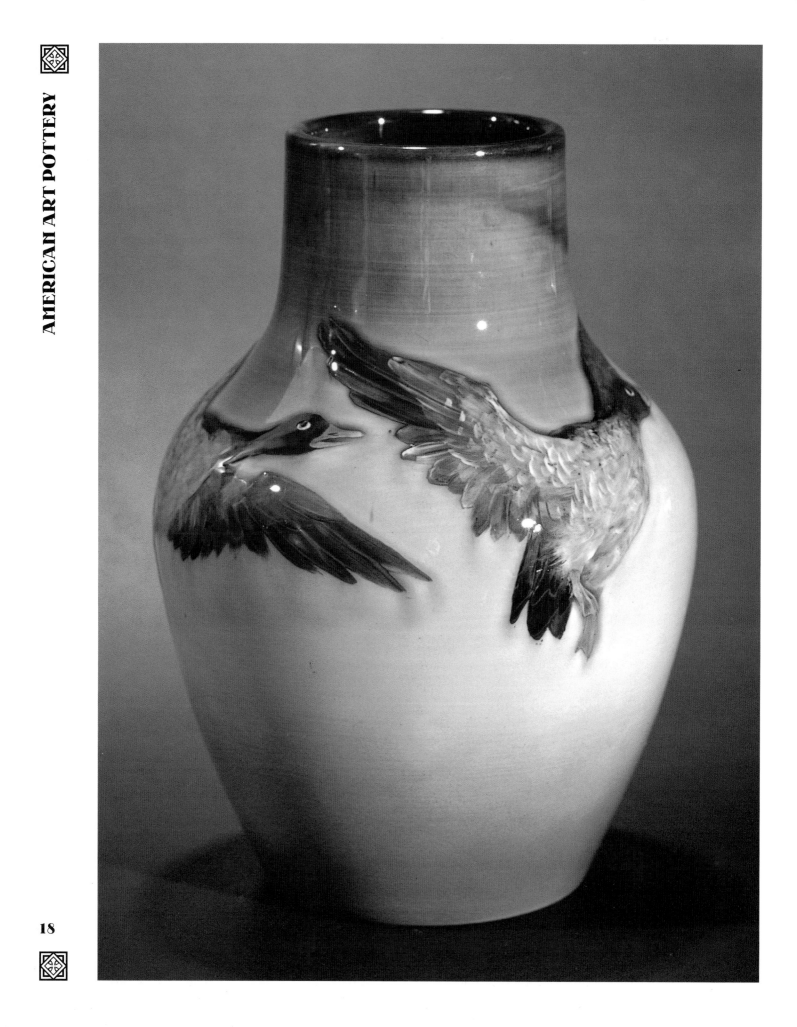

Inspiration From Nature *Opposite and below*
Two bulbous vases, Sea Green and Iris, respectively, decorated with paintings of geese and ducks. Sea Green ware, one of the Art Nouveau-influenced lines, was introduced at Rookwood in 1894. Their interpretation of natural motifs had a significant influence on other American potteries.

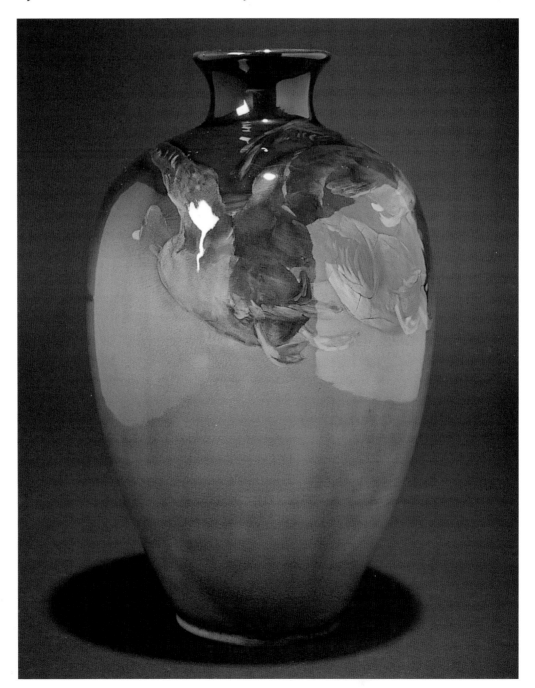

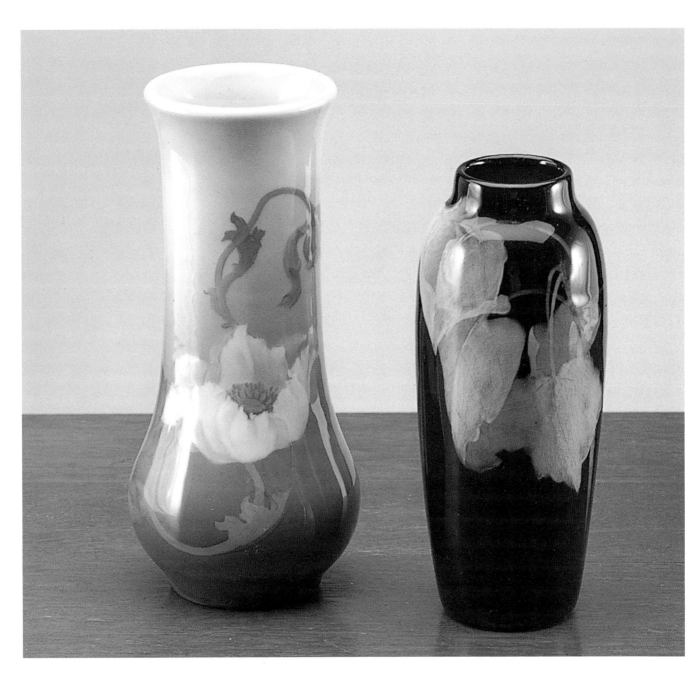

Iris Ware *Above and opposite*
*Four Iris floral vases. The right-hand
vase above demonstrates Black Iris
glazing; those on the opposite page
reflect their artists' individual talents.
Sarah Sax created the corseted Black Iris
and Fred Rothenbusch decorated the
smaller vase with poppies.*

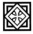

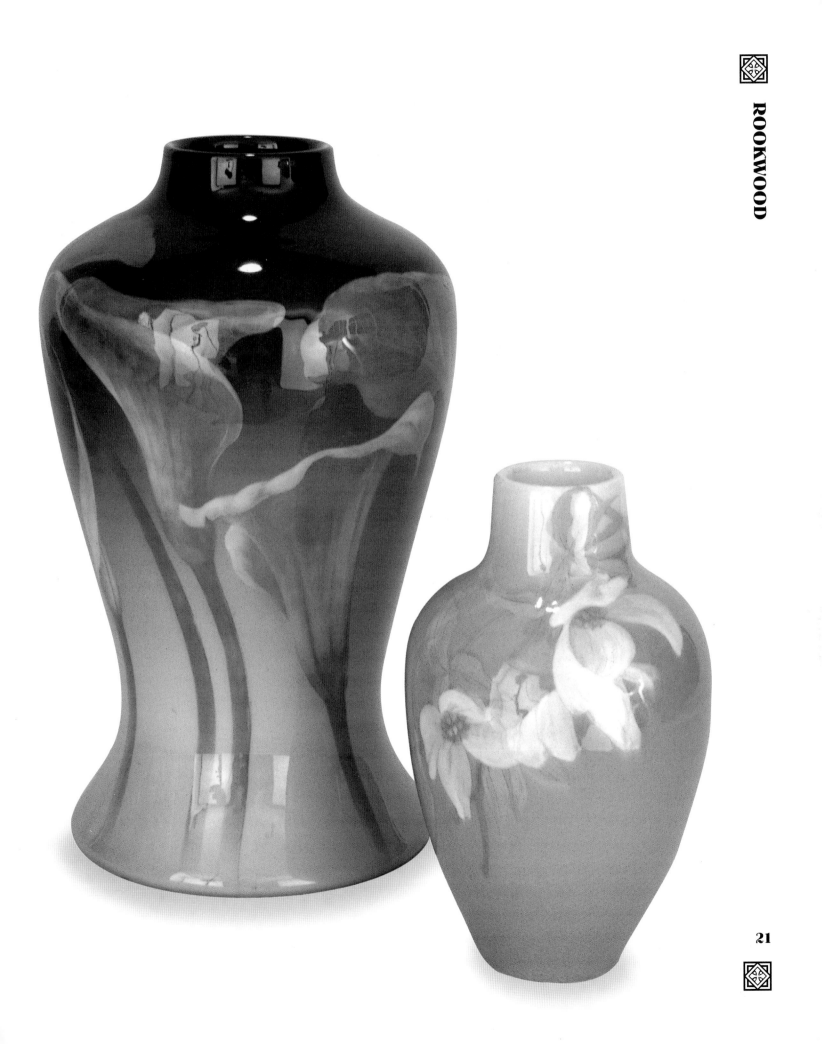

Contrasting Finishes *Right*
Three pieces of Rookwood ware. The vase on the left is finished with the Standard Glaze. The center vase is decorated with both incised and relief designs, painted to emphasize the peacock motif. The small piece on the right is glazed in a brilliant purple, a contrast to the familiar pastel colors of Rookwood ware.

Jewel Porcelain *Opposite and left*
Two examples of Jewel Porcelain ware, which was introduced at Rookwood at 1920. The tall Jewel Porcelain vase at left was designed by L. Eppley. Sarah Sax created the exceptional Jewel Porcelain vase opposite and decorated it with enameled poppies and green matte glazing.

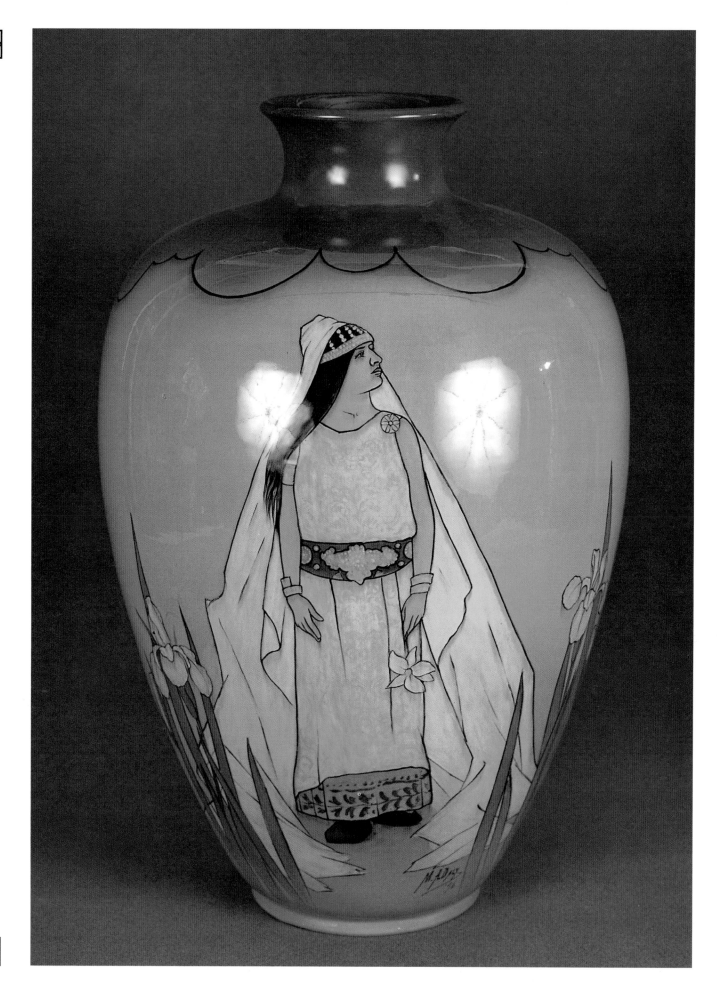

Portrait Vases *Opposite and below*
Two Standard Glaze portraiture vases.
The large bulbous vase on the opposite
page is decorated with a stylized pre-
Raphaelite figure. Artus Van Briggle
created the vase on the right with its
Arabian motif. Van Briggle worked
at Rookwood from 1886 until 1900,
when he left to establish his own
pottery company.

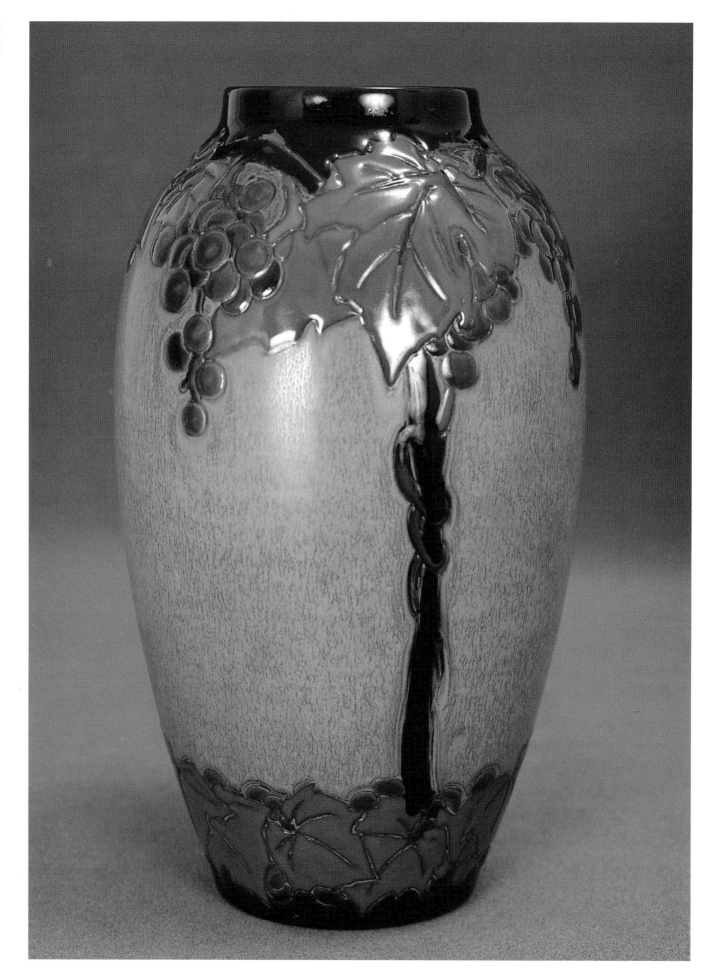

Incised and Painted Vase *Below*
An incised matte vase with floral decoration by C.S. Todd.

**Jewel Porcelain
With Grapes**

Opposite and above
Sarah Sax was the artist who created this handsome Jewel Porcelain vase with grapes (detail above). Many middle-class American women, for whom employment as ceramists was regarded as acceptable, found a market for their creativity in the nation's art potteries.

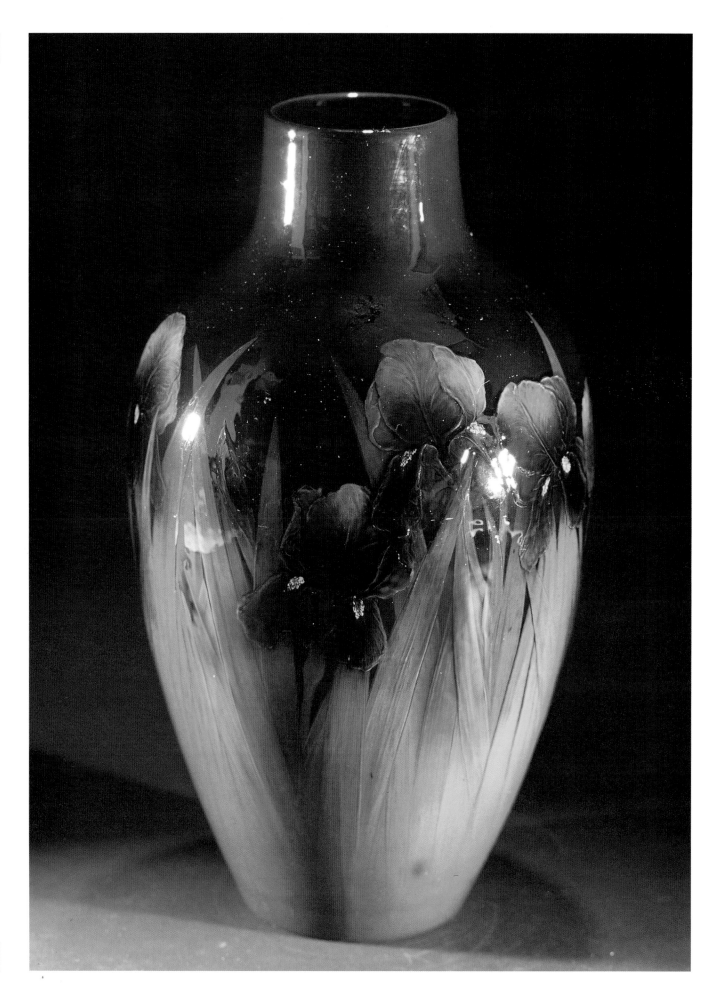

Standard Glaze Vase *Opposite*
Kataro Shirayamadani created this exceptional piece of Rookwood's Standard Ware decorated with iris blossoms. Standard Ware was introduced at Rookwood in 1883, but the glazing for this line was not perfected until Laura Fry developed improvements to the technique in 1889. The gentle tooling of the decoration on this vase is a rare technique in Standard Glaze that adds depth and imparts a tactile quality.

Decorated Temple Jar *Below*
This Jewel Porcelain temple jar was decorated with leaves and berries by E.T. Hurley.

Jewel Porcelain Ware *Below*
E.T. Hurley designed the Jewel Porcelain ovoid vase with birds (left), while Arthur Conant was responsible for the Jewel Porcelain floor vase with a rooster (right). Conant's vase reflects the strong Japanese influence that permeated Rookwood. Kataro Shirayamadani, who worked at the pottery from 1887 until 1948, was a major influence on decorative ware.

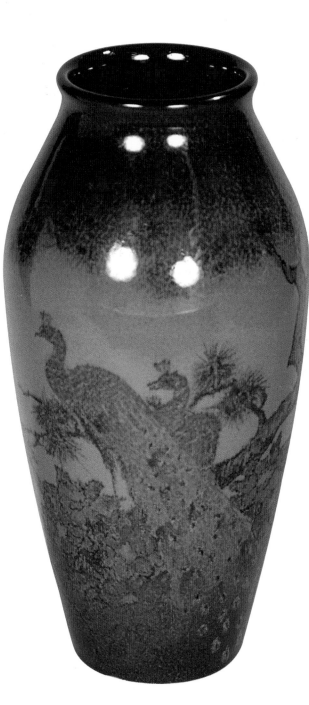

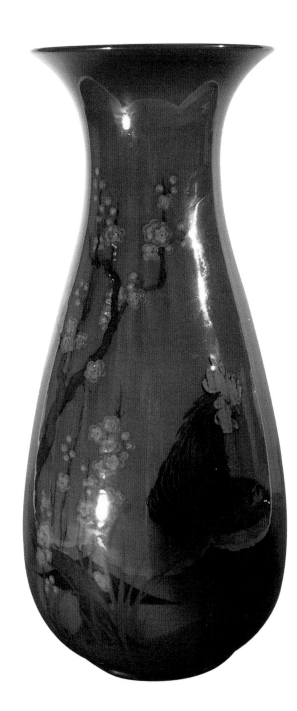

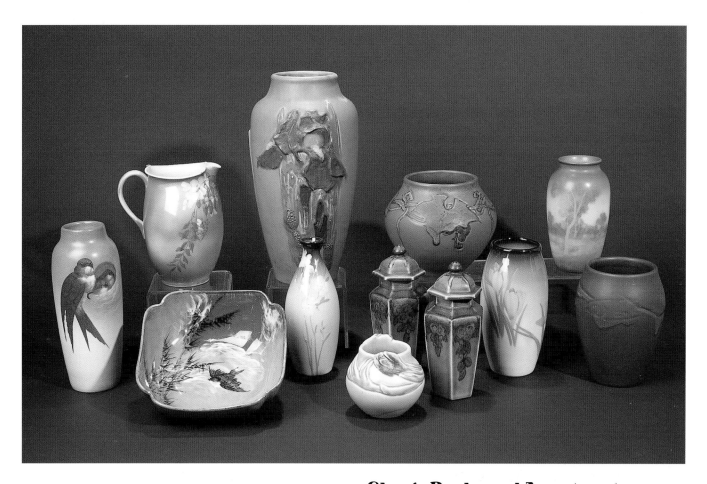

Classic Rookwood Assortment *Above*
A selection of Rookwood ware spanning eighty-seven years of operation. Maria Longworth Nichols founded the pottery in an old schoolhouse in 1880; 1882 marked its first full year of production. In 1893 ceramic historian Edwin Atlee Barber described Rookwood as "the first in this country to demonstrate the fact that a purely American art product...can command the appreciation of the American public."

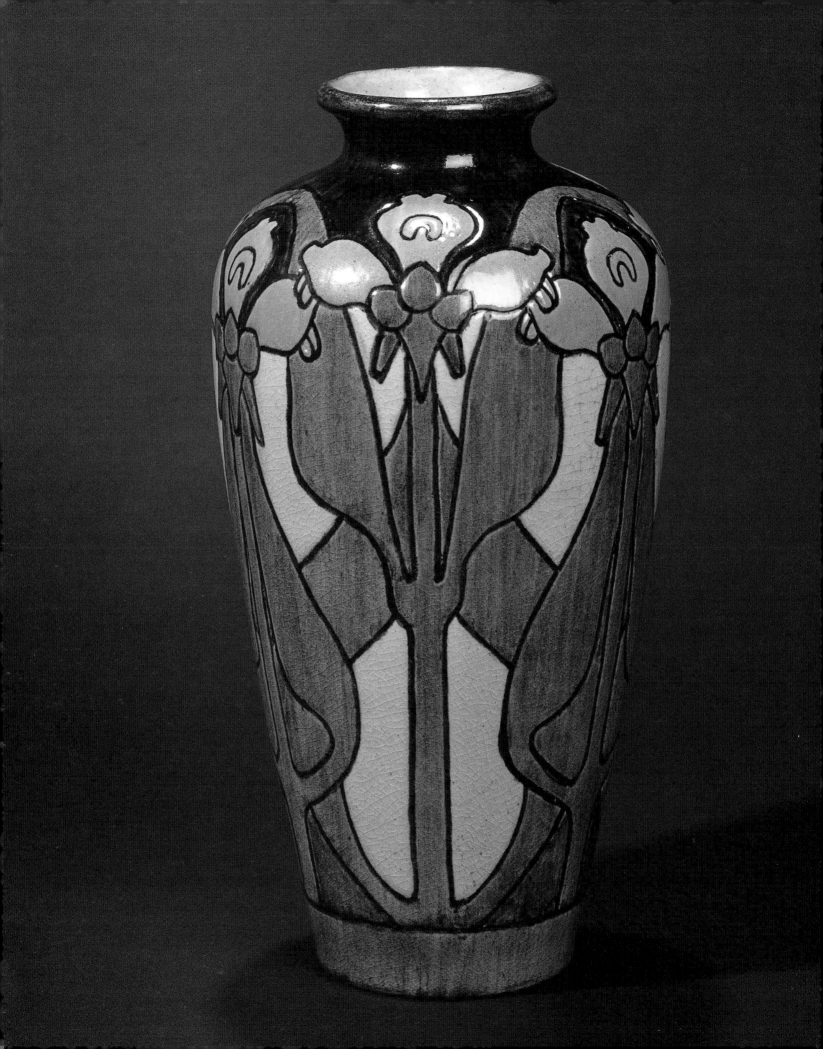

Newcomb College

T he history of Newcomb College Pottery is as interesting as the artware the company produced. Newcomb College is appreciated for the soft, feminine-looking, regionally influenced ware that won the company worldwide acclaim. The story of their background reveals their achievements as symbolic of the Old South's move into the twentieth century.

The Sophie Newcomb Memorial College, founded in 1886, was an adjunct of Tulane University in New Orleans, Louisiana. The institution was founded expressly to instruct young Southern women in the decorative arts. The production of art pottery on a for-profit basis began only in 1895 under the supervision of two art professors, William and Ellsworth Woodward.

While each Arts and Crafts center in America took from the movement different influences—attributes that spanned the realms of art, philosophy, religion, and society—the artists in turn redefined what these influences meant. The Deep South, ravaged by the Civil War, lacked venues whereby women could escape the Victorian parlor and enter the workforce. Although pottery design may seem a far cry from today's interpretation of "work," this "acceptable" occupation for women was a radical and transformative concept in the South of a century ago.

Arts and Crafts Movement adherents believed that individually designed, handmade objects—things that captured and contained the creative spirit of the artisan/creator—were essential to the personal environment. This was a lofty ideal and a total departure from the prevailing standards of furnishing with soulless, mass-produced, assembly-line goods that robbed the creator of creatorship and resulted only in mediocrity.

It would not be an exaggeration to say that the experiment at Newcomb College helped pave the way for the women's rights and liberation movements. This opening of opportunity for women was widened by World War I and still more so by World War II, when "Rosie the Riveter" took up factory work only fifty years after the

Opposite: An exceptional example of an early Newcomb vase with yellow fleur-de-lis. Early pieces are always finished with a clear, high glaze.

Overleaf:
This unusual tapering vase of the early period is decorated with yellow lilies on a white ground.

Newcomb experiment. It would be wrong to overstate this as a precursor of the economic and social changes that women would experience, but equally wrong to deny its relevance.

Newcomb's earliest work was comparatively naive: simple designs painted on easily thrown forms and covered with glossy, clear finishes. From about 1900 to 1905, the artists began to model their surfaces, stylize their designs, and introduce bolder colors such as yellow (and, rarely, violet) into their work. During this period, each piece was unique, heavily influenced by local sources of inspiration in the form of plants and, occasionally, animals. In many respects, the years between 1903 and 1909 generated the work regarded as the zenith of Newcomb's decorative ware. Then two talented potters, Paul Cox and Frederick Walrath, contributed their expertise to create a new "transitional" ware, which modified the glossy finishes into a soft, waxy semigloss.

This transitional phase of production, which lasted for about four years (c. 1909–13), was forward-moving in adapting less stylized designs and adding new colors and techniques, including reticulating and a more intense modeling. The company produced a ware that was more consistent in design quality and glazing, but only at the expense of creating fewer individual masterpieces.

The last phase of Newcomb's work focused on the modeled matte-glazed ware for which they are best known. This period, from the early 1920s into the late 1930s, is exemplified by decoration carved in relief, in muted matte tones of green, blue, pink, and, occasionally, yellow, almost exclusively on medium-blue grounds. Typical decorative treatments are local flowers and romantic bayou scenes of oak trees and Spanish moss.

The brief final period at Newcomb was undistinguished. It signaled the demise of the pottery's role as a noteworthy producer and the diminishing interest in art pottery in general. Production ceased in 1939.

Pricing for the three basic kinds of Newcomb College pottery is very different. The early high-glazed pieces are the most valuable and the least affected by damage. An 8-inch glossy vase with an all-over floral decoration in blues and greens, in perfect condition, is worth about $3,500. The same vase with yellow flowers would be worth about $5,000. A small base chip will reduce the price by about 10 percent, and a crack might diminish the value by about 35 percent.

An 8-inch matte floral vase, made about 15 years later, is worth about $1,500. An 8-inch matte scenic would bring about $2,250. Either of these would lose about 50 percent of its value due to a crack or a small but visible chip.

Below: The rare bulbous vase below is decorated with stylized, surface-painted swordfish.

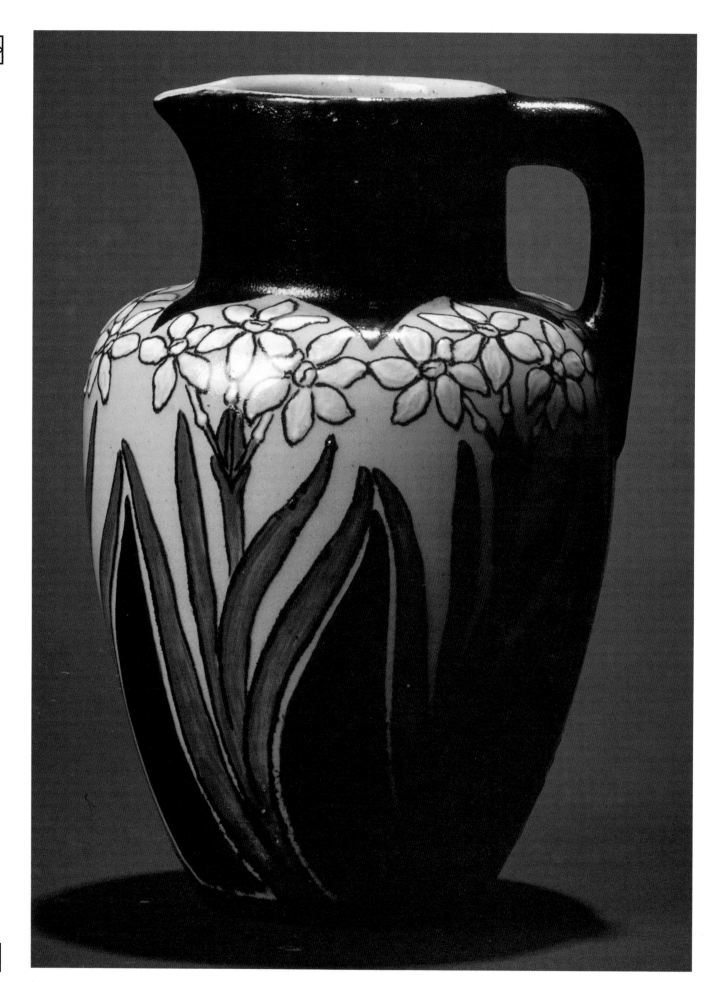

Rare Pitcher and Vase *Opposite and below Two extremely rare examples from the early years at Newcomb: the pitcher on the opposite page is decorated with white narcissus on a yellow ground, framed with black. Flat, conventionalized designs and simple shapes, like those of the alligators on the vase below, character- ized Newcomb's distinctive ware.*

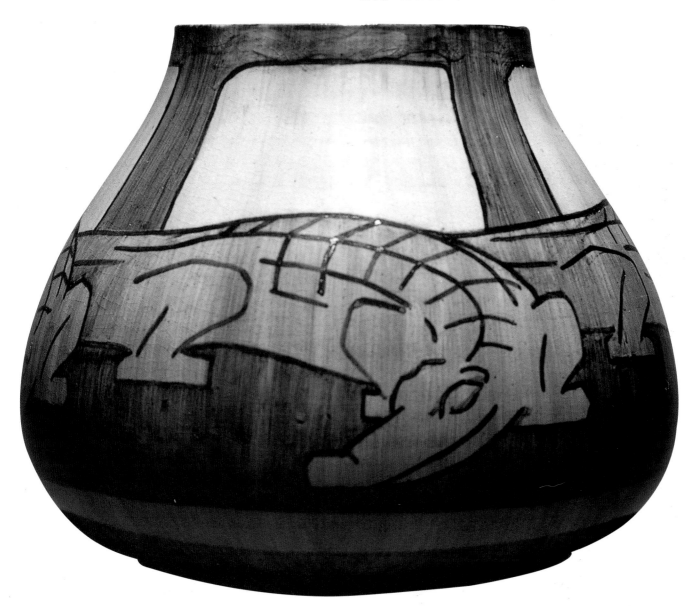

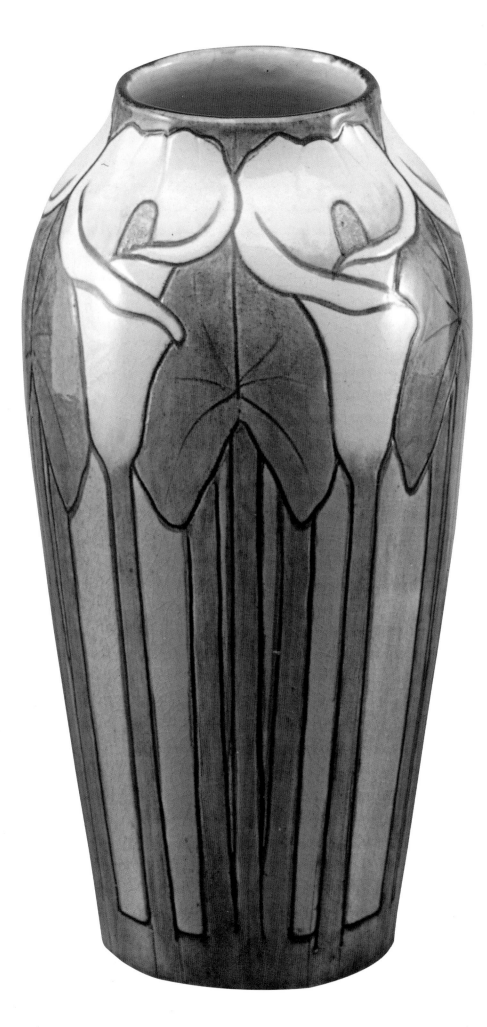

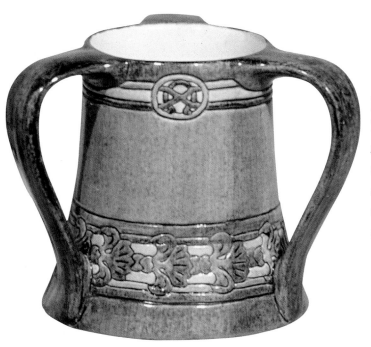

High-glazed Ware *Left and below*
Two early high-glazed pots in shades of blue with incised decoration. The decorative bands emphasize the corseted shape of the vase below and the cylindrical form of the tyg (three-handled cup) at left.

Stylized Decoration *Opposite*
The vase on the facing page with tapering rim and incised calla lilies is an outstanding early-period piece.

High-glazed Vase *Right*
A high-glazed piece with incised decoration from the early period. No two pieces of Newcomb pottery are the same; all were hand-thrown and individually decorated by the ten to fifteen women students of Tulane University who worked at the pottery each year.

Incised with Jonquils *Left*
This early bulbous vase is decorated with incised yellow jonquils and finished with a high gloss. Southern flora and fauna were typical of Newcomb's stylized designs, which were deeply incised onto the wet clay.

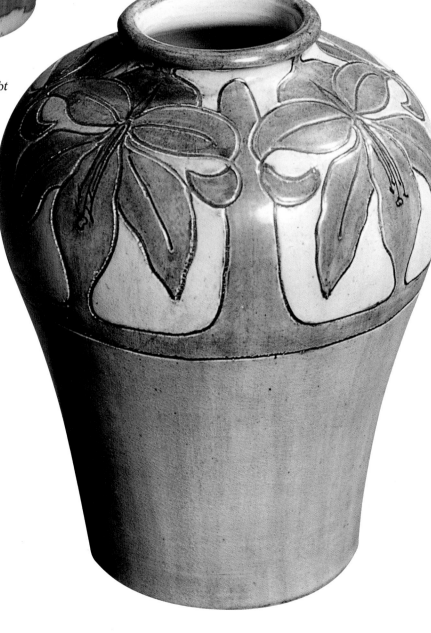

Painted Landscape *Left*
A very early example of a bulbous vase surface-painted with highly stylized and unnaturalistic landscape. Sadie Irvine, Henrietta Bailey, and Anna Francis Simpson, all former students of the college, were the main designers.

Painted with Tiger Lilies *Right*
An early bulbous vase painted with tiger lilies and matte finished. Newcomb received the bronze medal for its pottery at the Paris International Exposition of 1900.

Incised Decoration with Matte Glazing

Below

The bulbous vase on the left is decorated with an incised scenic view; the tall vase on the right has an incised bayou scene. Both demonstrate matte glazing. After the designs were incised onto the clay, the pots were fired and underglaze oxides applied. Finally, the pieces were finished with glazes ranging from matte to semigloss.

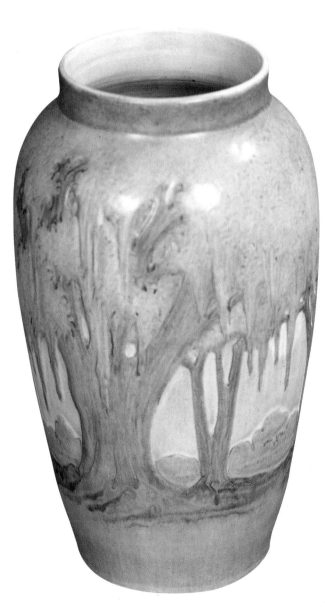
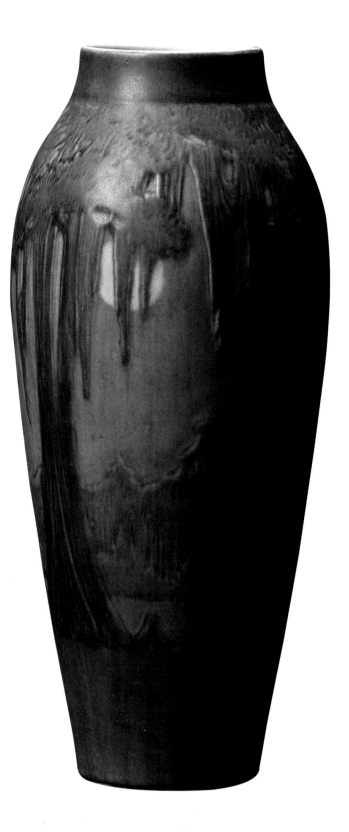

Four-handled Vase *Right*
Squat and bulbous, this green-blue pot has carved handles and a matte finish.

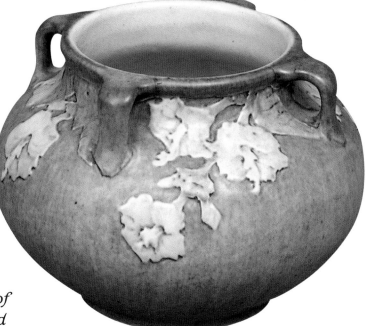

A Selection of Newcomb Ware *Below*
A rare purple vase with scenic decoration and matte glazing (left); an unusual transitional piece with white narcissus (center); and a rare example of an early bulbous vase with lid decorated with cyclamen and a glossy finish.

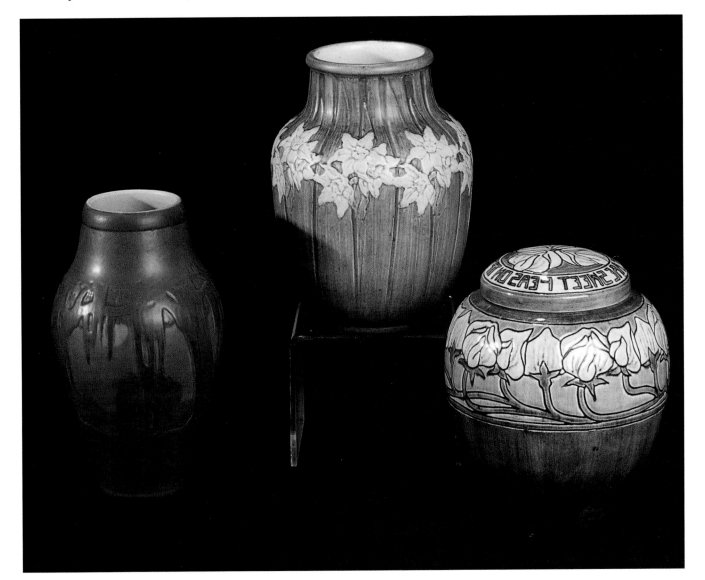

Early Newcomb Ware *Below and Opposite*
Two early Newcomb vases: the bulbous vase below is decorated with incised wisteria in shades of deep, rich blue. A stylized landscape scene circles the early vase (opposite). The width of this piece is emphasized by the bands of color.

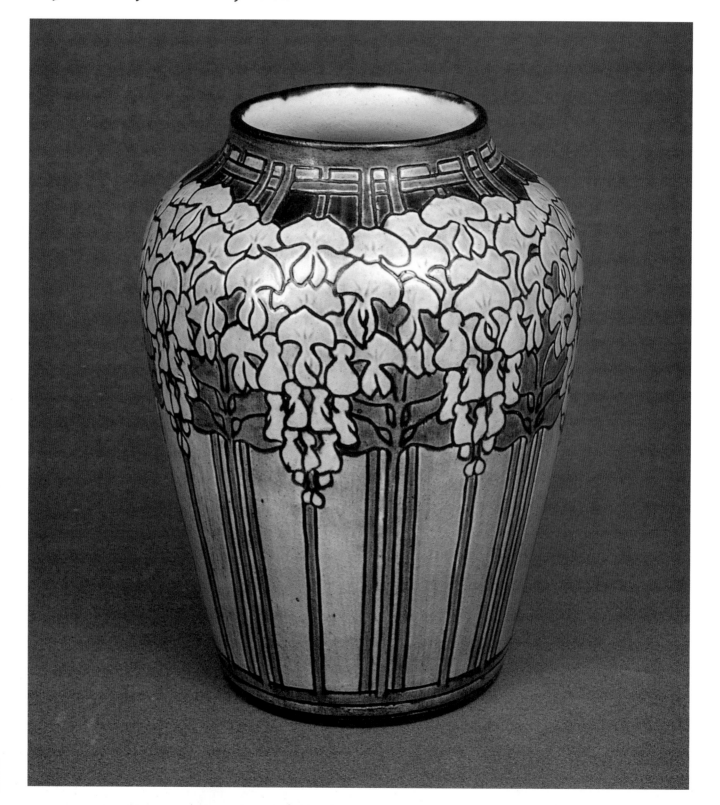

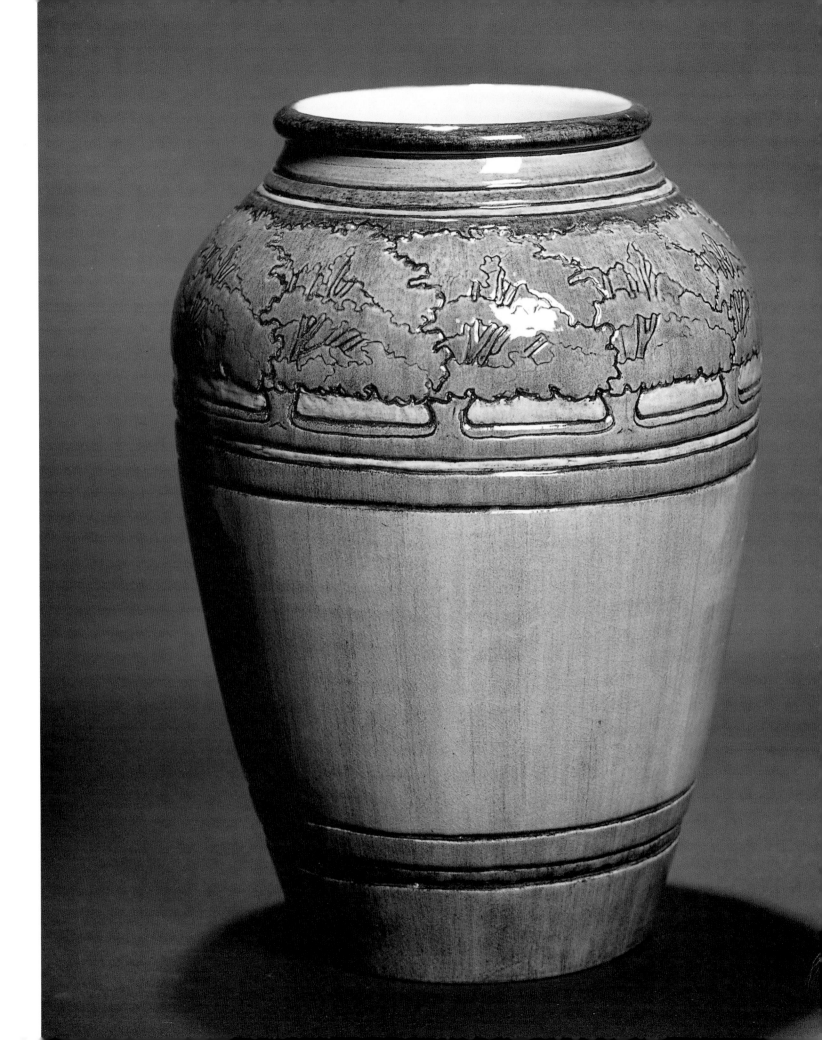

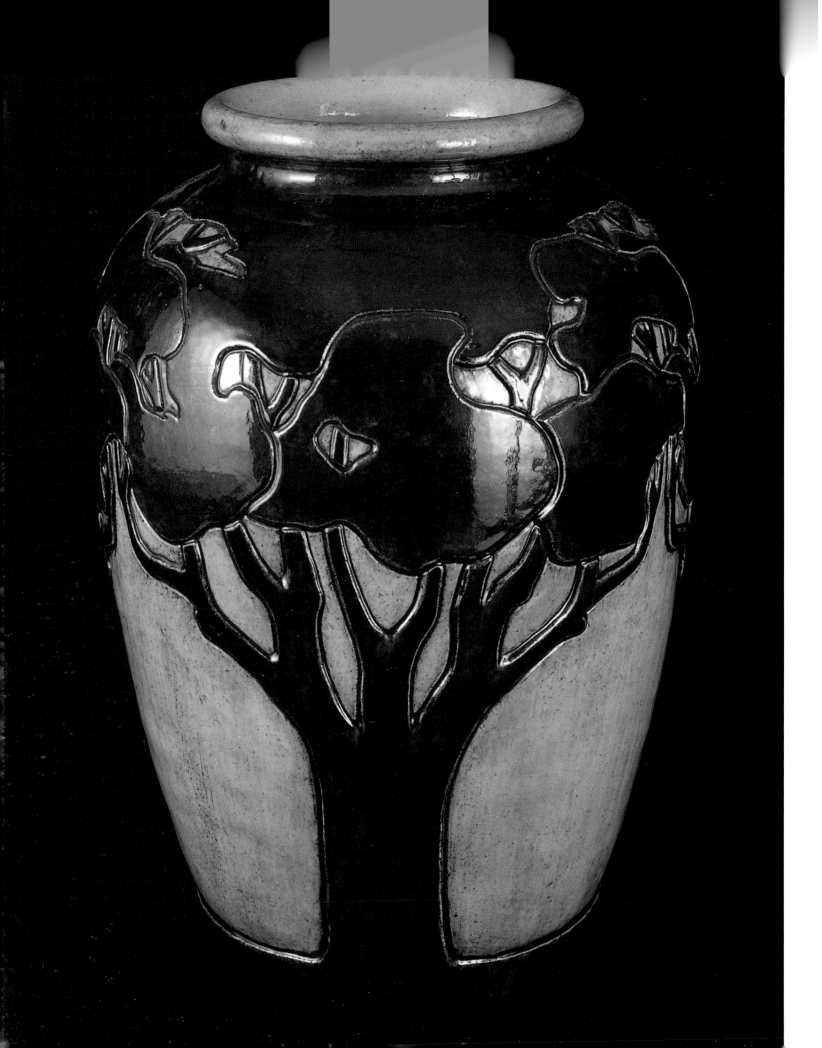

Painted, Incised, and Excised Decoration *Opposite, right, and below*
The early, bulbous vase on the opposite page is decorated with an excised oak tree. The one on the right has incised thistles, and the three high-glazed pieces below demonstrate painted, incised, and excised decoration.

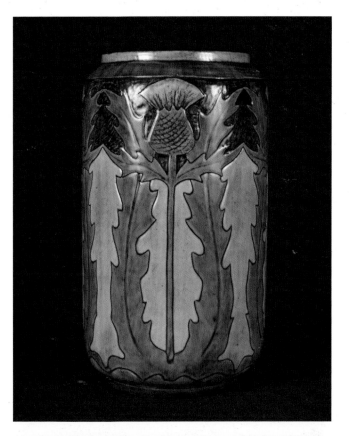

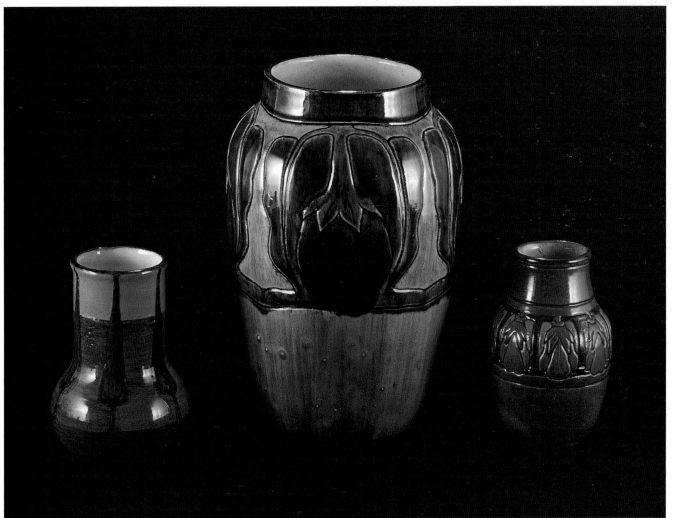

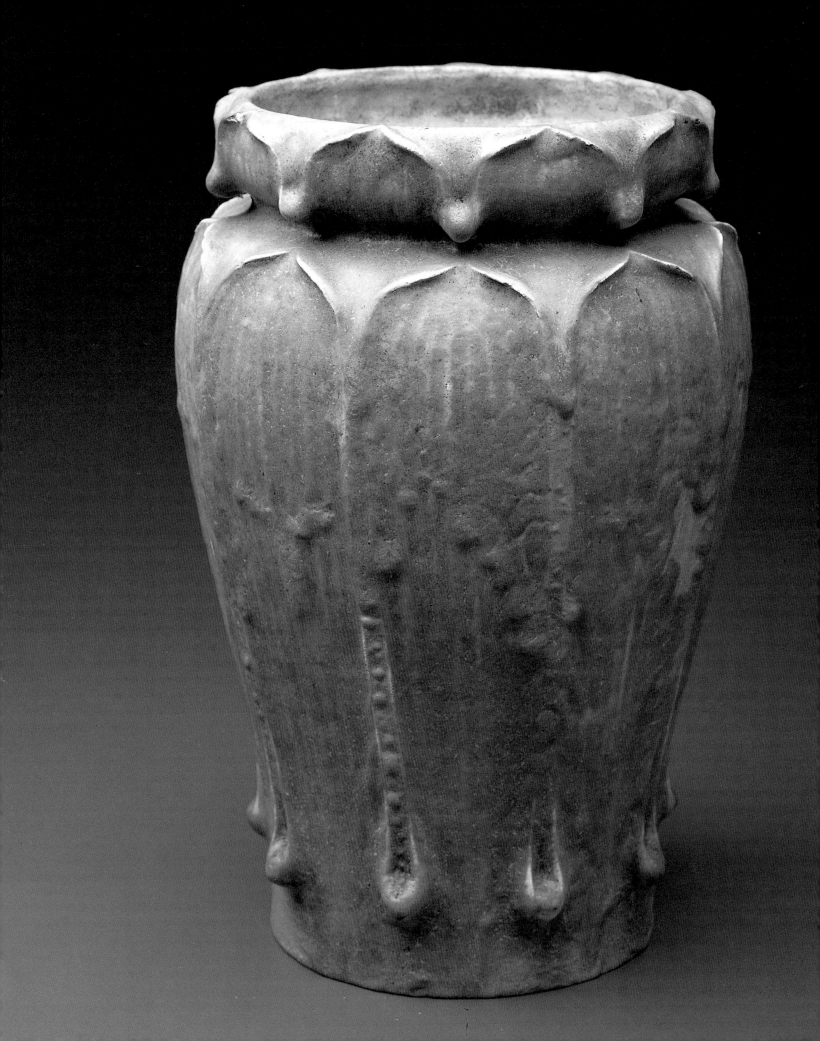

Grueby 🖋️

It is possible that, in terms of the art they explored and the impact they had on American decorative ceramics, Grueby Pottery of Boston, Massachusetts, was the most important producer in the country. They made pottery for a relatively short period of time, from 1894 until about 1909 (at which time they changed their production to art tile only), and, unlike Rookwood and Roseville, produced only one type of ware. Nevertheless, Grueby was in many ways the textbook example of how America was influenced by Europe, developed its own style, and became a world leader in quality and technique.

We know there was correspondence between William Grueby and the French ceramic master Auguste Delaherche, whose work predated Grueby's by a decade. A simple comparison of the forms, designs, and decorative techniques shows the similarities. However, Grueby sought to develop "organic naturalism" in his craft and, after a brief flirtation with glossy finishes in collaboration with Eugene Atwood in Boston, worked in the textured, vegetal matte finishes that established his fame and encouraged a hundred imitators.

It has been said that a piece of Grueby looks more harvested than potted. And in assessing a great piece of his work, it is only a mild exaggeration to say that you almost want to water it because it looks so alive. Grueby may be remembered as a technician for his glaze formulae and the studio-factory he established, but, at least to this eye, he brought a sensitivity and a direction to American decorative art that was a critical part of its development.

In the most basic ways, Grueby's work explains the craft of potting, reminding us that the ceramic art is earth speaking of earth. Those of you who have potted understand the process whereby you raise wet, pliable clay from a ball on a spinning wheel and, with trained hands, shape it into a vessel. It is a most allegorical craft, because the potter, like the clay, must be centered or it will fly off the wheel (and who among us hasn't been guilty of that?).

As the hollowed vessel spins, a gentle touch on the outer wall will immediately shrink the piece and, on the inner wall, will expand it.

Opposite: A fine example of a Kendrick gourd vase with Ochre enameling [Collection Ray Frangiamore]. Most Grueby decorators were women from Boston's School of the Museum of Fine Arts, the Massachusetts Normal Art School, and Cowles Art School.

Above: White flowers adorn the corseted neck of this bulbous vase. William Henry Grueby's opaque, lustreless enamel, introduced in 1897, was one of the most important achievements of the American art pottery movement.

Truly, the potter and the vessel are linked, so that one becomes an expression of the other. It is no wonder that, since Biblical times, the art of potting has been likened to God's crafting of our souls (see the chapter on the Reverend George Ohr for more on this one).

Similarly, just as the energy of the pot moves upward as it is raised from the wheel, so, too, does that of the floral decoration that adorns such work as Grueby's. The solid bottom of the pot gives way to the side walls, which open at the lip in a flourish, and the decoration, beginning as leaves or a stem at the base, rises to an open flower blossom or bud near the rim. The decorative process always echoes the forming of the pot and mimics nature in recreating it.

Less obvious, except to students of the craft, are the decorative techniques Grueby employed. Many of Grueby's contemporaries, such as Rookwood and Roseville, used the surface of the pot as a canvas on which to paint. Although they did this well, nevertheless, they reinforced the notion that the pot was subordinate to the artist's work. This was further complicated by the fact that such ceramic ware was almost always molded, or slip cast, rather than hand-turned. In short, hand-painted, or slip-relief, decoration sat on the surface of the pot and, under relatively clear glazes, nearly always attempted a photo-representational depiction of the subject, whether that was a nasturtium blossom or a native American chief.

Grueby, on the other hand, sculpted stylized decoration into and above the surface of the pot and covered it with dense, matte finishes to blur the line between craft and life. While hand-painted ceramic establishes a clear delineation between surface and decoration, hand-modeled ware blends the two so that it becomes difficult, if not impossible, to determine where one stops and the other starts. More, while you will always be able to distinguish a daffodil from an iris on a Grueby vessel, you will never confuse either of them with the precise clarity of the same blossoms on a Rookwood vase. Grueby seemed more interested in capturing the natural essence of the flower, and the vessel it adorned, than he was in snapping a photograph.

Further, Grueby's shape selection was not nearly as varied as Rookwood's, but his shapes were consistently natural and unforced, or easily thrown. While Rookwood and the Ohio Valley potters often

employed forms from the Victorian parlor of classical antiquity, Grueby's shapes were of the backyard garden, with gourds and butternut squash. There is rarely a sharp, in-body edge to be found on any of Grueby's work.

And, finally, Grueby's award-winning glazes were the acme of his achievement. Nearly one hundred companies in America alone, encouraged by Grueby's success, copied him: long-term study of all of these imitators will show that, while some come close, there is only one best, as seen in the plates that follow.

When properly fired, Grueby's glazes, particularly his dark green, achieve a deep, rich, matte crystalline effect that is most successful in approximating the skin of a cucumber. While many of those other potteries flirted with the look, Grueby alone captured the feel. It should be noted here that Grueby pottery was glazed in other natural matte colors such as ochre, brown, and lighter shades of green, as well as the not-so-natural shades of blue and mauve.

While all of these elements together would seem to guarantee a superior product, there is one last, less easily defined, quality that supersedes all Grueby's other achievements. I like to compare this aspect to the same design sense that established Arts and Crafts furniture maker Gustav Stickley's early work as the standout in a field full of accomplished imitators: proportion.

It is relatively easy to create a great object if it is full of decorative elements, because they tend to take on a life of their own. For example, if a Victorian chair with carved lions' heads and claw feet is exquisitely rendered, the viewer might overlook the clumsy form of the piece, or even the fact that it's uncomfortable to sit on. Similarly, on a piece of hand-painted pottery, if the artistry is exceptional, the art of potting will often be ignored.

If, on the other hand, there are no "lions' paws" or decorative native American chiefs, and you are forced to look at the object from the ground up, there is no place to hide inferior workmanship. Close inspection of a Gustav Stickley chair and a Grueby pot will illustrate this point, because the primary elements of construction are the primary

Below: An extremely rare vase showing three colors on a blue background [Private Collection, New York].

51

elements of decoration. The former employed quartersawn oak and natural ammoniated finishes in creating spare, well-proportioned forms. And the latter used rich, low-fired local clays with dense natural glazes over easily thrown shapes. There is little wonder that the two exhibited together at contemporary exhibitions. In fact, Stickley showed pieces of Grueby pottery with his furniture in his sales catalogues and sometimes set Grueby tile into stands for plants and chafing dishes.

Essentially there were two types of pottery crafted in turn-of-the-century America, with Grueby and Rookwood as the respective trailblazers. Most critics focus on their products, but they would be just as well served by considering the philosophy behind and the influences on their work.

The early, glossy work produced by Grueby and Atwood when the company was formed needs little discussion. Suffice it to say that the shapes and glazes employed have little to do with Grueby's best work except to serve as a point of departure: a short examination of this ware says all that is needed about the brevity of Grueby's partnership with Atwood. Nor will we cover Grueby's exceptional tile output which is discussed in the chapter by Suzanne Perrault. The following is a brief summary of the pots Grueby produced and the myriad flower forms and glazes that covered them.

Perhaps 15 to 20 percent of Grueby hollowware is undecorated, at least in the sense that it is only glazed, or with simple tooled ribbing, rather than hand-modeled or carved and then glazed. About 40 percent of their production was decorated with tooled and applied leaves of various forms: the majority were spade-shaped. Another 20 to 25 percent were also adorned with tooled and applied buds or flower forms to which color was added. These were usually simple buds glazed yellow, although Grueby sometimes stepped over the line into the extravagant. The remainder of their output comprises pieces that were completely unglazed, or had unglazed sections, tooled handles, and so forth.

The vast majority of Grueby's work, perhaps 90 percent, was matte green. While many would argue that this glaze was their "best" and most successful, no collection has seemed complete without a sampling of their other enamels. Whatever a collector's particular bent, all of Grueby's glazes were of the highest order.

Opposite: This bulbous vase with flaring rim is a rare example of Grueby's experimental drip glaze [Courtesy Treadway Gallery]. The popularity of Grueby glazes inspired imitation among competitors, which kept the pottery active in trying out new techniques.

Below: This bowl with flaring rim has a matte finish. Grueby glazes could be so thick that the marks were obscured, making it difficult to distinguish an original from an imposter.

Right: A detail of Grueby's hand-modeled work in which applied ropes of clay were modeled into the ware before firing.

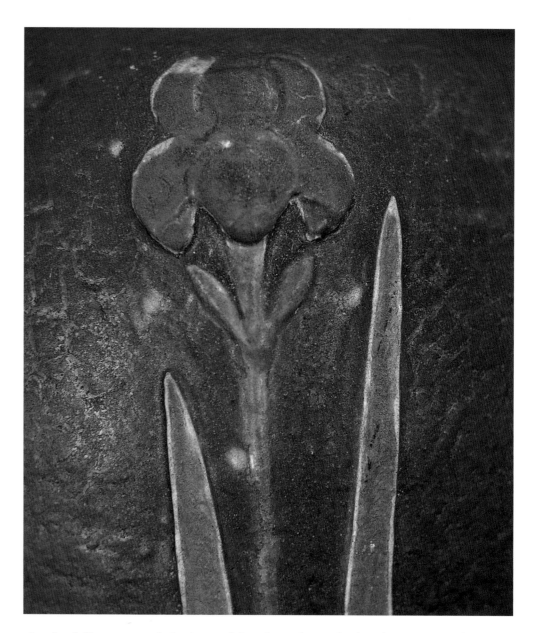

And while most of their multi-colored work displays second, third, and occasionally fourth colors on green grounds, a small percentage are decorated with other colors on non-green grounds. In the case of the latter, yellow seems the most common base color.

The size of Grueby's ware can be categorized similarly. About 75 percent of their production was 8 inches or less in height, and less than 5 percent was higher than 12 to 13 inches. Perhaps less than 1 percent of all that Grueby produced was more than 18 inches high. Also, most Grueby is taller than it is wide, which explains the relative scarcity of bowls (particularly decorated ones) and severely squat bulbous forms.

Condition is less of an issue with Grueby than it is with other pottery, probably because collectors of Arts and Crafts pottery are less concerned with this factor. Hand-thrown, hand-decorated pieces are, by their nature, one of a kind: either you take it as it is or you won't ever get it. Also, Grueby is fairly low-fired ware, and the body is not

as strong as with Rookwood or even Newcomb College pottery. Considering the nature of Grueby's hand-modeled decoration, with thin, sharp edge work, flaking is the norm and not the exception.

It is safe to say that larger pieces of Grueby with multi-color decoration of full flower blossoms, in near-perfect condition, are the most valuable. However, you will seldom have the chance to buy such a piece, so it is a good idea to acquaint yourself with more available ware. An 8-inch matte-green Grueby vase with tooled leaves and buds, in perfect condition save flaking at leaf edges, is currently worth between 1,500 and 2,000 dollars. An undecorated 5-inch vase in matte green, also in perfect condition, is worth about 500 dollars. A 12-inch vase with full blossoms instead of simple buds would sell for more than 10,000 dollars. The same 12-inch vase, with a thumbnail-sized chip in the rim, would decline in value to about 7,500 dollars.

Remember that you are dealing with unique ware, and even the "same" form and design will be considerably different if put side-by-side with a similar example. There are also great disparities in glazing, based on placement in kiln, the type of enamel chosen, the interaction of that particular clay batch with that particular glaze mixture, and so forth.

Above: An example of a squat, bulbous vase with unusual blue matte glaze. The fecund quality of the body is set off by the narrow, pinched rim.

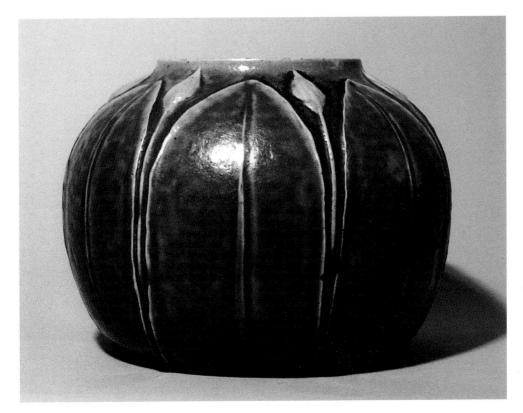

Left: This unusual bulbous bowl of the early period has green and yellow finish [Private Collection, New York].

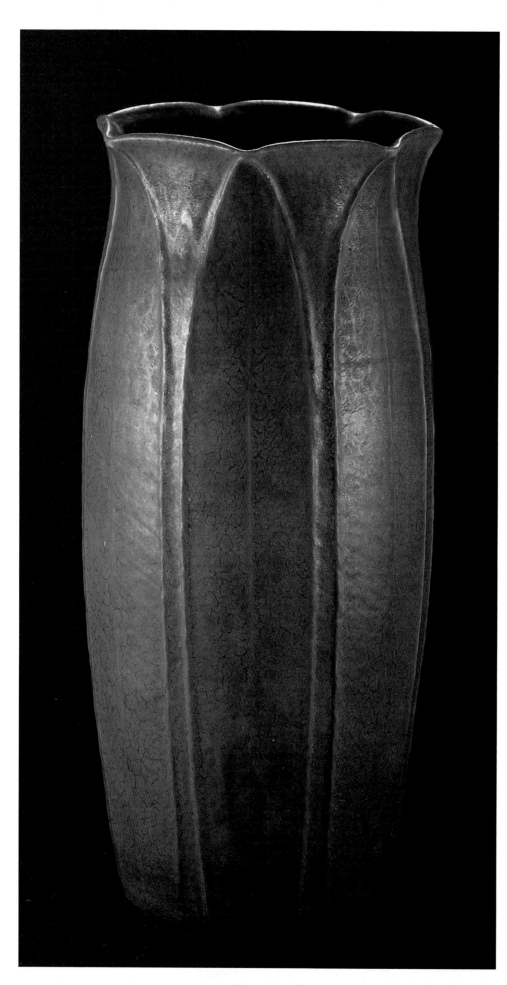

Rare and Classical

Opposite
This classical vase is a rare example of an early piece with modeled figure, tapering neck, two handles, and the characteristic Cucumber Green enamel [Private Collection, New York].

Umbrella Stand

Left
This tall umbrella stand with brown matte enamel may have enhanced an Arts and Crafts interior.

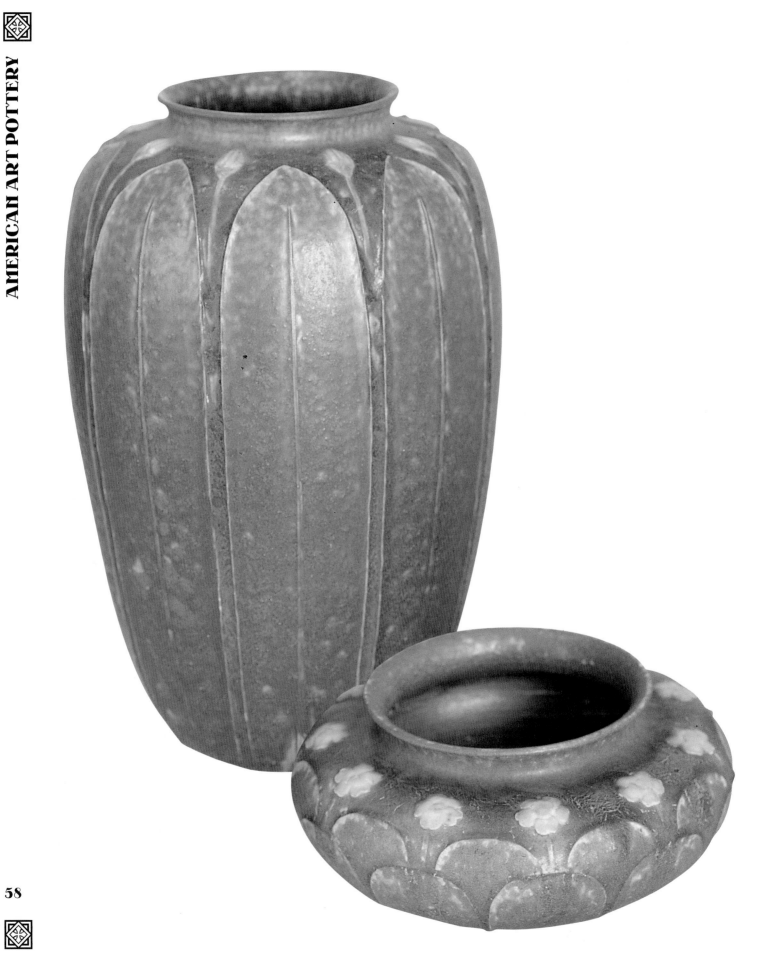

Women Decorators *Opposite*

Ruth Erickson decorated the eleven-inch-tall vase at left with modeled leaves and applied yellow flowers. The broad bowl with flaring rim was decorated by Annie Lingley with applied yellow flowers and leaves. Of the twelve monograms that marked Grueby ware, eleven belonged to women [Courtesy JMW Gallery, Boston].

Lamp Base *Below*

A squat two-color lamp base of the kind that Gustav Stickley would have shown in his furniture catalogue to complement his products [Collection of Bill Curry].

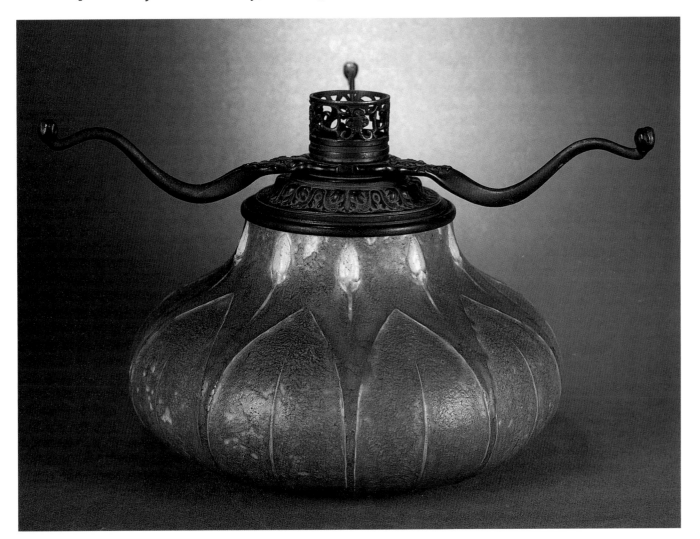

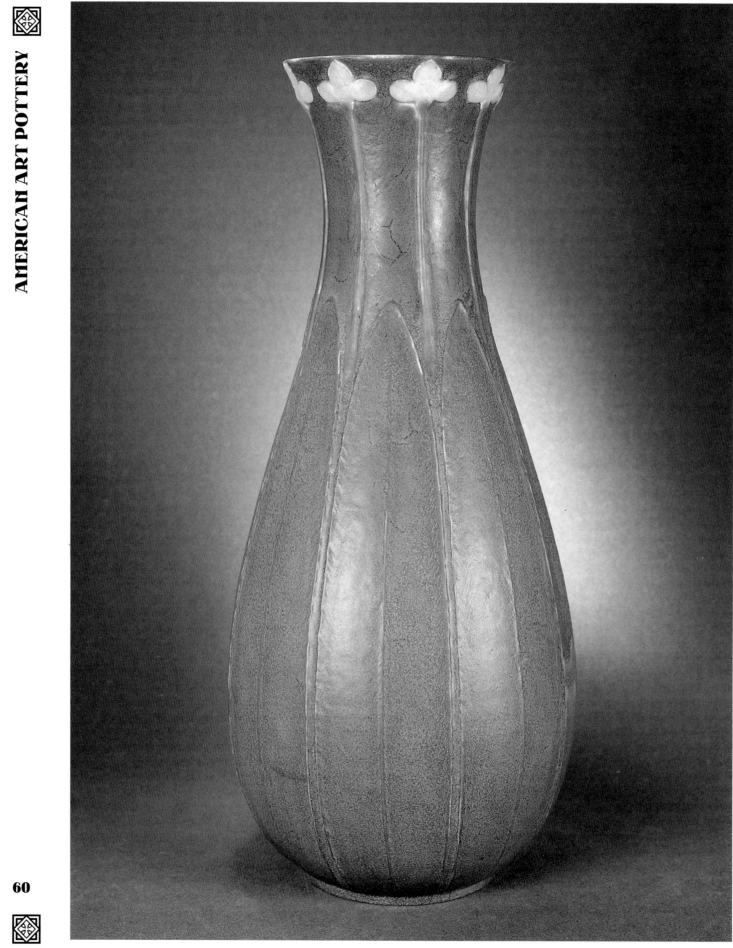

Floor Vase *Opposite*
An impressive floor vase with yellow
trefoils standing out against the
Cucumber Green matte finish
[Collection of Bill Curry].

Alligator Matte Enamel *Below*
The height of this vase is emphasized
by the long, narrow neck; the rough
texture of the Alligator Matte enamel
is apparent.

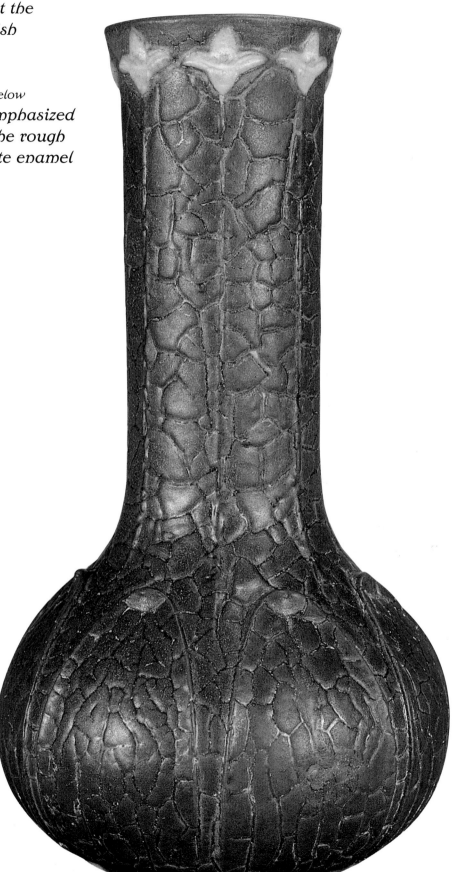

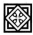

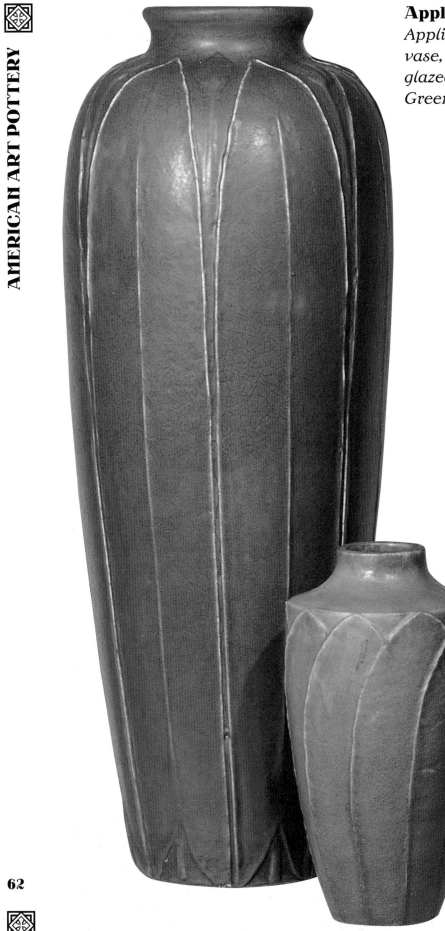

Applied and Incised Decoration *Left Applied leaves decorate the right-hand vase, incised leaves the left. Both are glazed with the characteristic Cucumber Green finish.*

Applied and Painted Decoration *Below*
This unusual tall vase has a tapering neck and is decorated with overlapping, applied leaves and yellow flowers.

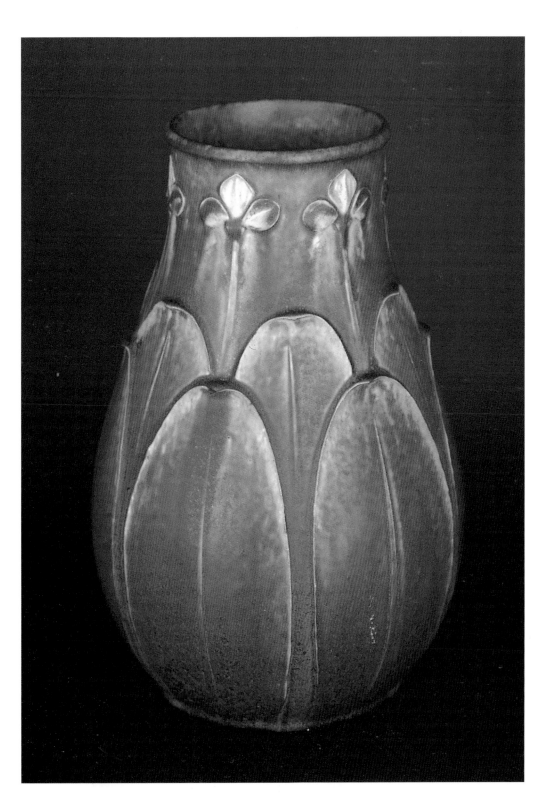

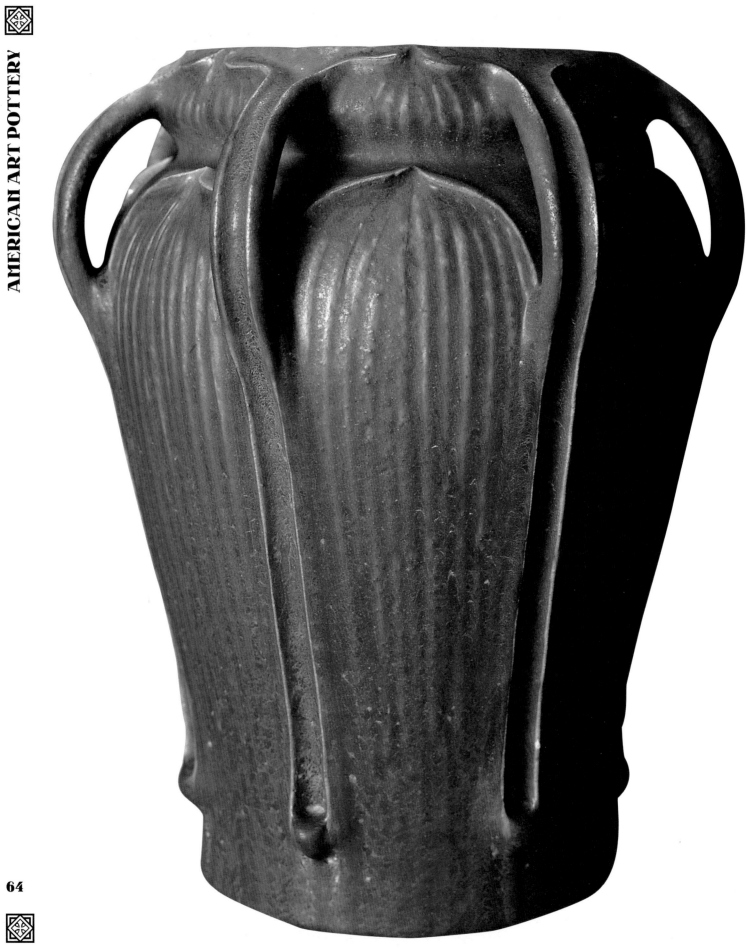

Seven-handled Kendrick Vase *Opposite*
An exceptional seven-handled Kendrick vase with Cucumber Green matte finish applied by the women who worked at Grueby as decorators.

Gourd Vase *Below*
A Kendrick vase with brown matte finish. George P. Kendrick designed most of the vessels at Grueby in the years before 1902.

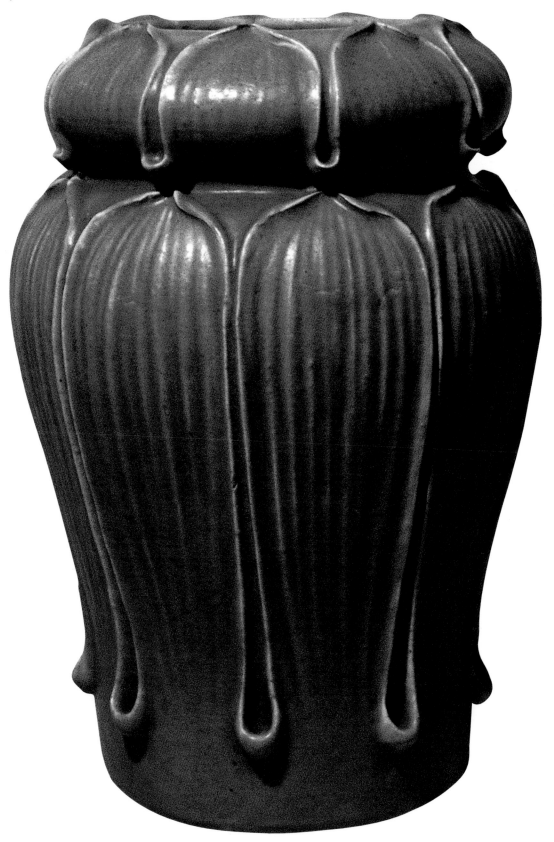

Ochre Kendrick Vase *Below*
This seven-handled Kendrick vase with Ochre matte enamel is perfectly proportioned. After 1902 Addison B. Le Boutillier would design most of Grueby's pottery.

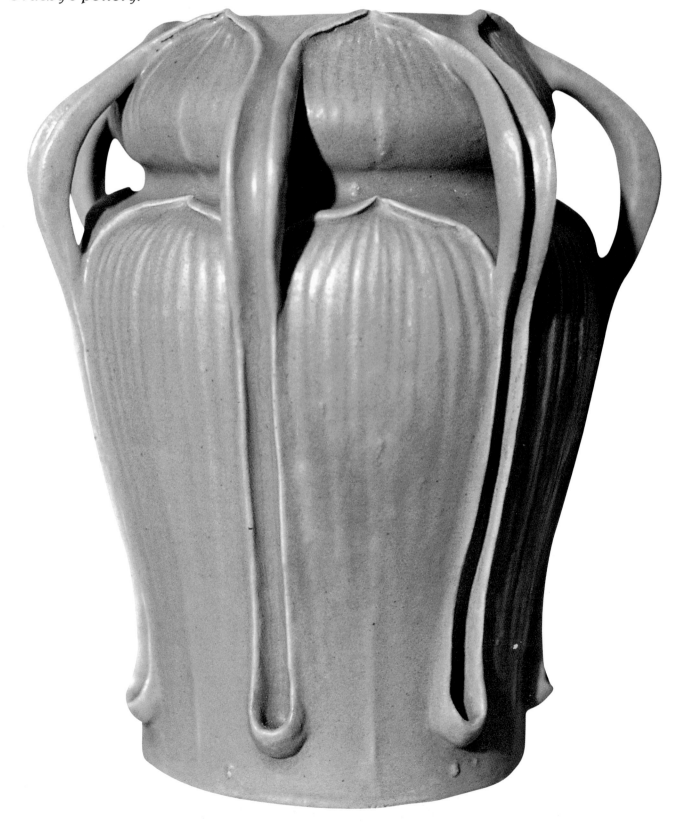

Organic Gourd Vase *Below*
This Cucumber Green gourd vase was designed by Kendrick and produced at the turn of the century. It is typical of Grueby's intensely organic ware.

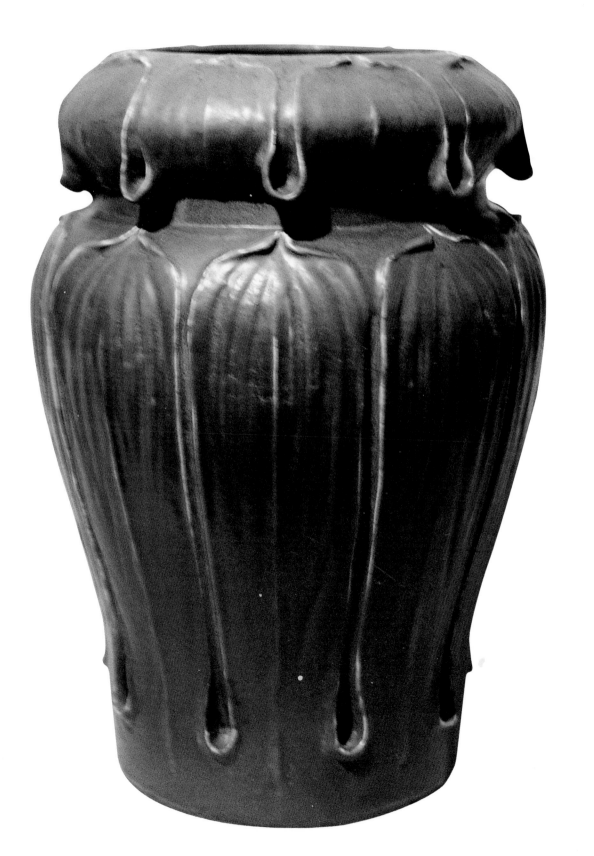

Flambé Finish *Opposite and below*
The bulbous vase on the opposite page is a rare example from the early period with four-color flambé finish. Two colors were used to finish the smooth bulbous vase below.

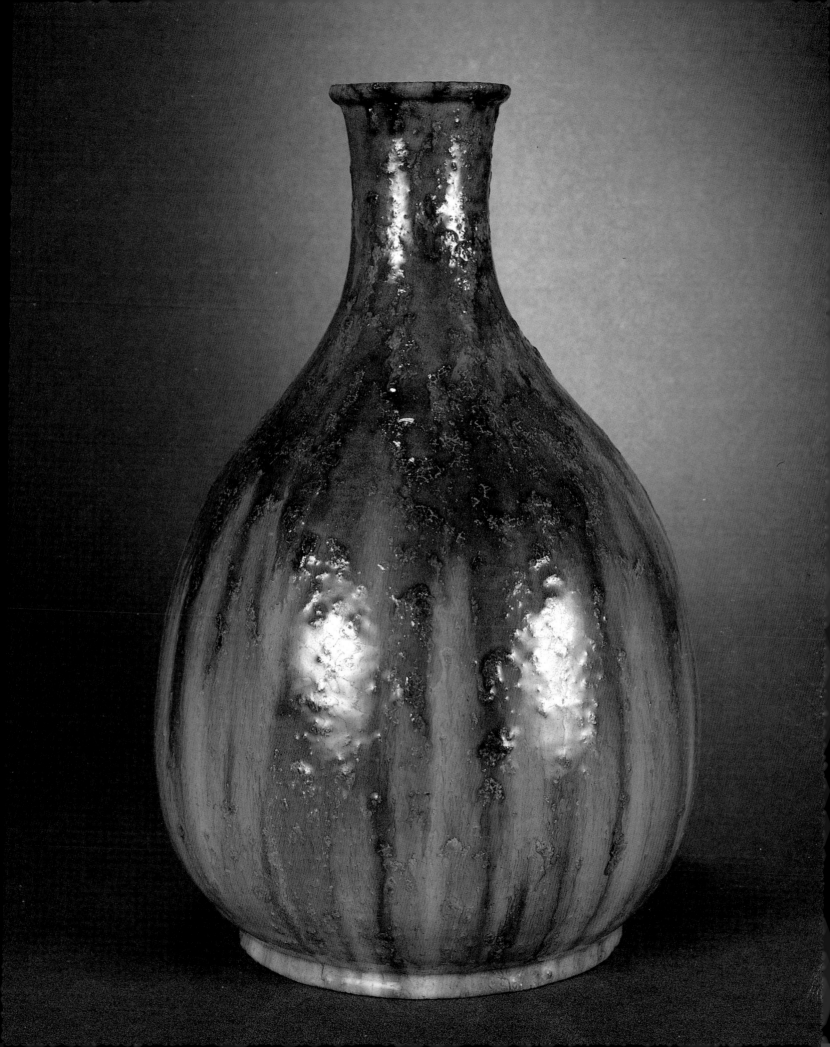

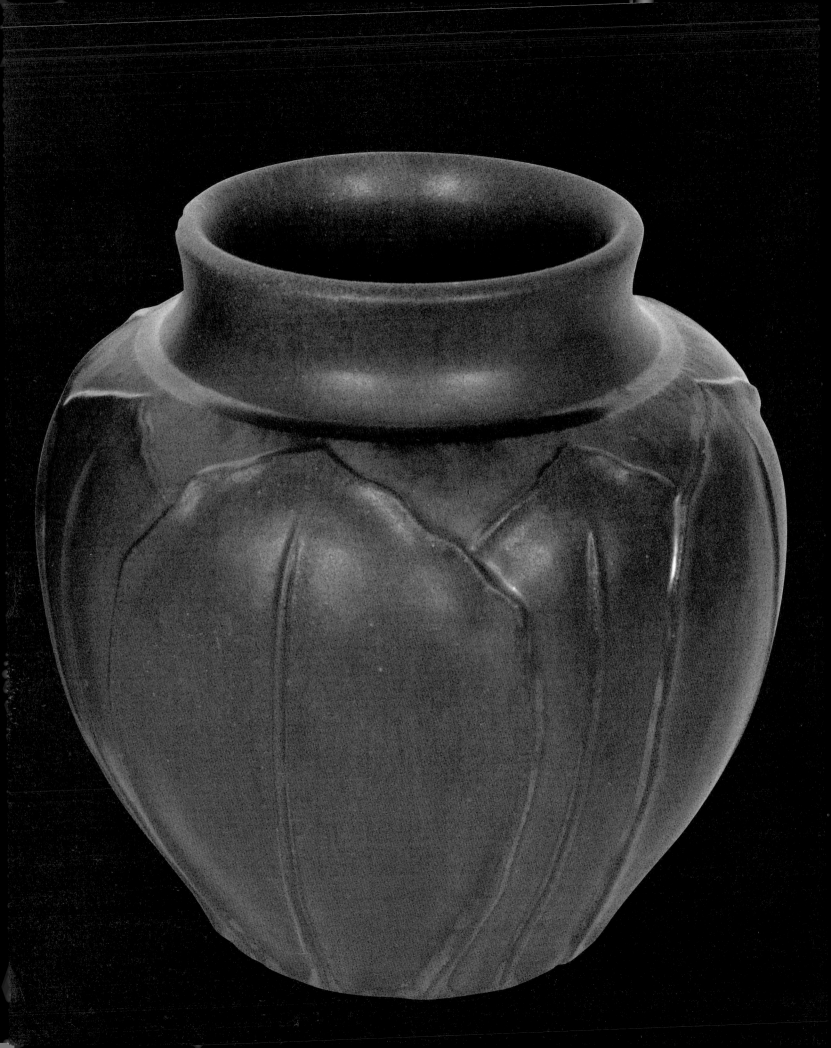

William Walley 🖋

Working in West Sterling, Massachusetts, from 1898 to 1919, William Walley was an accomplished artist with a specific vision. While he created few masterpieces and blazed few new trails, he maintained an integrity and espoused a philosophy that merits more than passing credit. Although Walley lacked the potting and self-promotional skills possessed by George Ohr, these two men had several things in common.

Had Walley potted a century earlier, he would have been one of those local craftsmen who made his living turning utilitarian ware for townsfolk and the tourist trade. But as America became more cosmopolitan, and as new design trends and techniques spread even to smaller communities, he couldn't help but influence and be influenced by them.

Walley was very much of the New England Arts and Crafts school of potting, working with unforced forms and decorating them with hand-tooled, naturally influenced designs, covered mainly with organic matte glazes. Although Grueby's influence is undeniable, Walley's work was distinctly different in achieving an almost naive sophistication. Perhaps he is most important for having represented both what pottery was, and where it was going.

Walley proclaimed that "there is more artistic merit in a brick, formed and fired by one man, than in the best piece of modeled pottery ever made." He was in business for two decades, but he remained a local personality rather than a widely acclaimed potter who won national exhibitions. He seemed content with simply making fine art pottery and, were it not for the quality of his ware, he might have died an obscure figure.

Typical of the contemporary sentiment that working with clay had a therapeutic capacity, as seen in Arthur Baggs's work at Marblehead and Frederick Rhead's at Arequipa, Walley taught the basics of potting to patients at the nearby Wooster State Hospital. These pieces, marked with the die-stamped letters WSH, make up in historical significance what they lack in quality. Otherwise, he worked from a

Opposite: This vase with flaring rim is typical of Walley's ware in that it is decorated with applied leaves and glazed with an organic shade.

Below: Two colors were used to glaze this short vase with flaring rim. Walley's ware was most often glazed in shades of green, red, and brown.

small studio and, using a local red clay, turned pots that he covered in glazes of his own concoction. Walley used a broad range of finishes, although a variety of green mattes and semi-glosses were his favorites. Some of his other glazes include brown and mahogany mattes, a light blue semi-gloss, and a glossy brown.

Most of Walley's decorated pots were adorned with tooled and applied stylized leaves; he also incised designs and modeled the surface of his pots. One of his best-known creations, the devils mug, occasionally appears with gemstone eyes. More often, he produced simple thrown forms covered with a single glaze.

About 60 to 70 percent of Walley's work was simply glazed, and perhaps 10 to 15 percent was heavily decorated. Damage affects the value of his work much in the way it does Grueby's, probably a result of its handmade scarcity and because it attracts the same kind of collector. Most of his work, some 75 percent, is under 7 inches tall; perhaps less than 5 percent is more than 12 inches in height. A 6-inch glazed vessel is worth about 350 dollars. A vase of similar size with tooled leaves will bring about 1,000 dollars, although exceptional pieces have brought several times that amount.

Decorating Techniques *Left and below:*
The detail (left) of the vase on the facing
page shows Walley's proficiency with
applied decoration. Two colors were
used to finish the bulbous vase with
rolled rim below.

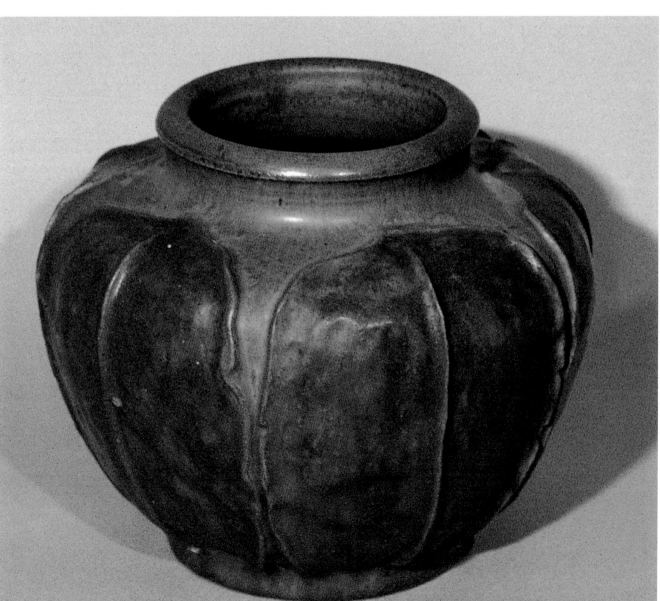

Essays in Glazing *Right and below*
An unusual blue-green glaze finishes the vase at right. Toward the end of his career, Walley experimented more and more with the chromatic effects of his glazes. The piece below is more characteristic of his ware—the rarity of which makes Walley pottery highly sought after.

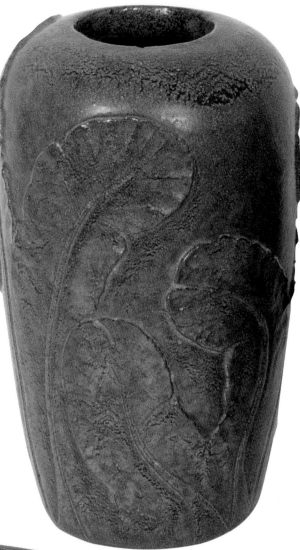

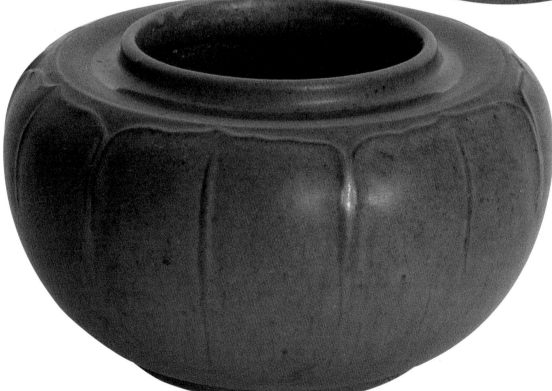

Verdigris *Below and right*
The squat bowl below (detail at right) is characteristic of Walley's ware, which has a sculptural quality. He threw and finished all of his own pottery in the stated belief that "[he was] just a potter trying to make art pottery the way it should be made."

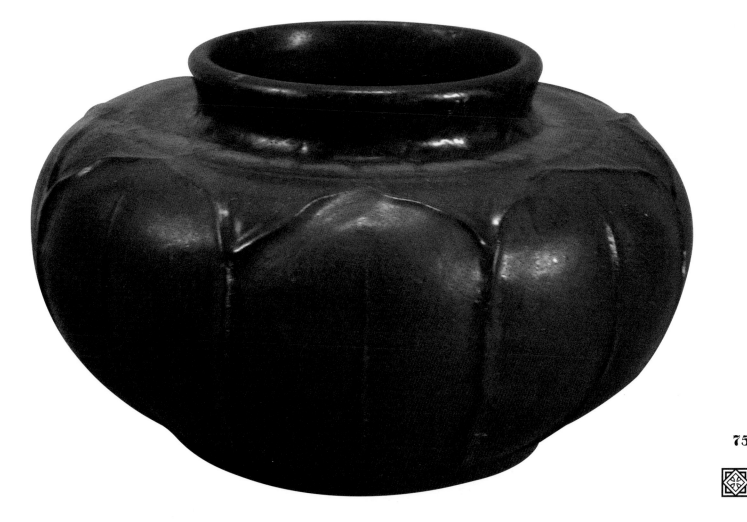

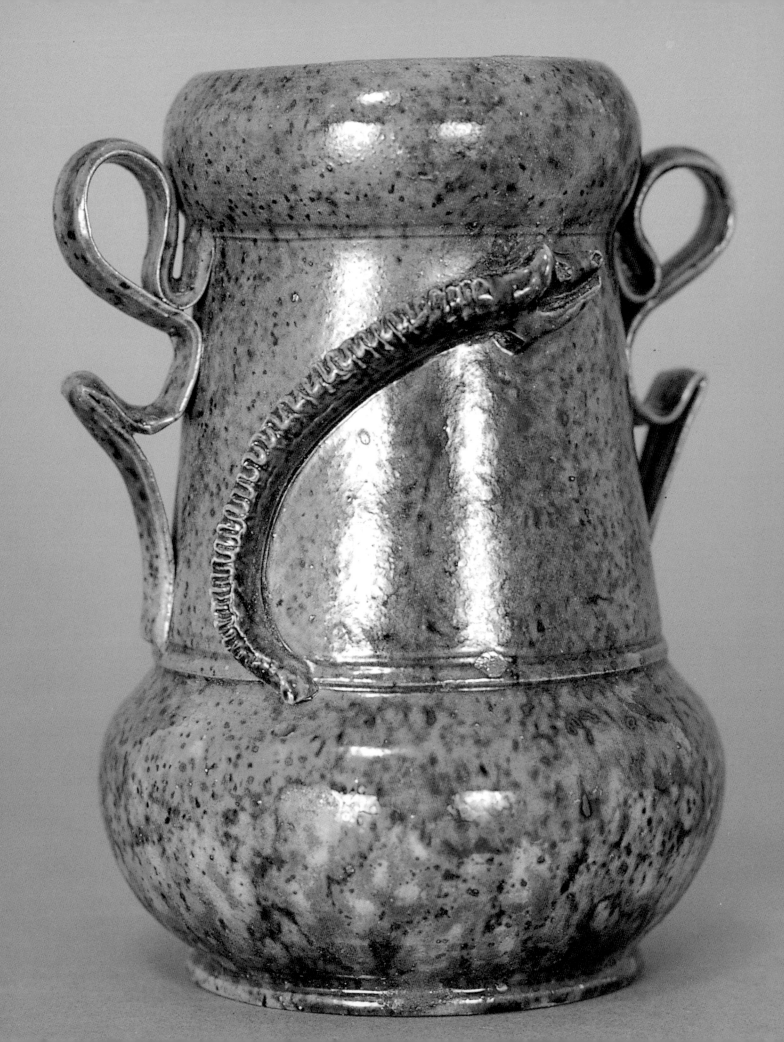

George Ohr

George Ohr was arguably the most important potter this country has ever produced, although some would place Adelaide Robineau, of Syracuse, New York, in this position. Nevertheless, it is impossible to understate the towering presence of so much ego and talent.

Potting in Biloxi, Mississippi, from 1885 to 1907, Ohr pursued an odd and sublime personal expression in spite of financial hardship and public scorn. His production totaled about 10,000 pieces and it had the dubious distinction of remaining almost entirely intact: the fact that it was hard to sell was complicated by Ohr's choosiness about potential purchasers of his "mud babies." He wouldn't sell them to just anyone.

Thus, the motherlode of Ohr pottery was stored in the attic of the Ohr Brothers Motorcycle and Auto Repair Shop until 1972, when Jim Carpenter, a New Jersey barber and antique dealer, bought the collection from two of Ohr's surviving sons. Depending upon which part of the country you live in, Carpenter either brought it home in a carpetbag or was the savior of the Ohr legacy. In any event, there is no denying the importance of having moved this extraordinary collection to within two hours of New York City, the capital of the art world.

As word of this hoard circulated, and as more books, articles, and museum shows spread the gospel of Ohr (more on that later), the New York art intelligentsia raised interest in the master's work to higher and higher levels. Soon, some of the most important names in modern art, including Jasper Johns and Andy Warhol, along with some influential New York dealers and collectors, gave Ohr the respect that he had worked so hard to establish by adding his pots to their collections. Johns also paid him the compliment of incorporating images of Ohr pots into his work.

This is a good place to mention that Ohr was in many ways his own worst enemy. The extremism that characterized his emotional and aesthetic make-up put him constantly at odds with the law, government, and the art critics of the day. While his studied aloofness may have served as an effective defense against a dubious public, it

Opposite: Applied snake decoration on a two-handled bulbous vase.

77

Above: An early example of a bowl with traditional glazing. Ohr used only local clays, which he dug from the banks of the Tchouticabouffe and Pascagoula Rivers.

also helped to maintain his alienation from buyers. His 10,000 pieces did not remain unsold without good reason, and his attitude was very much a part of the self-fulfilling prophecy that left him penniless and misunderstood.

A major retrospective of Ohr's work was held in 1991 at the Contemporary Craft Museum in Manhattan, coinciding with the release of the definitive text on the artist's work, *The Mad Potter of Biloxi*. While the exhibition was smaller than it could have been, the 100 pieces displayed afforded a breathtaking overview of the man's genius. Ohr's excellence as a technician had never been doubted, but here, for all to see, was a creative giant fueled by a playful inquisitiveness.

A moderately educated man, Ohr traveled for years to study the work of other American potters before building his own kiln and setting up shop. While he was schooled in a traditional style, some of his early work clearly displayed his unorthodox proclivities. His earlier efforts are very traditional in feel, with the tobacco-spit brown and glossy yellow glazes typical of the day. By the early 1890s, he would sometimes throw in a twist or the sort of manipulation that would become his trademark, although this was more the exception than the norm.

Ohr occasionally plied his craft at other potteries, the most famous of which was Newcomb College at Tulane University in New Orleans. At the behest of his good friend and fellow potter Joseph Myers, Ohr threw pots for the young college women to decorate. With his waist-long mustache and Popeye biceps, he may have cut a rather masculine figure in spite of his smallish height. Unfortunately, at least for Newcomb College, he was deemed unsuited to working with women of a Victorian sensibility. Although it has never been proven, it is not unimaginable that one of his bawdier creations, a ceramic bank in the form of a woman's genitalia, served as his undoing.

Tragedy struck in October 1894, when Ohr's entire inventory was destroyed by the flames that engulfed much of Biloxi and all of his property. Without money, inventory, or a building, Ohr rebuilt his pottery from scratch. As it rose from the ashes, so, too, did his creative spirit. As though traditional restraints had been consumed along with his pottery, he emerged a more daring and expressive artist.

There is little doubt that a freer hand guided his artistry after that fateful fire: an outpouring of creative energy is readily apparent to students of the medium. The walls of his pots became thinner, his manip-

ulative techniques became more daring, and his use of color was wilder and less predictable. More importantly, his reliance on the typical vessel form raced toward abstraction, and his sense of whimsy and irreverence heightened. Who else would throw a teapot and then fuse the lid to the top so it was unsuitable for use? His half-coffee, half-teapots, one of which is in the Smithsonian Institution in Washington, D.C., are each unique in form and context, and largely unfunctional.

Ohr believed that his art was to get out of the way and let God manifest through him, a spiritual view that informed his work. Ceramic art has often served as a vehicle of religious expression, as seen in references to humankind as "earthen vessels"—moist clay on God's wheel, responding to His touch and direction. Those who have had the privilege of learning to throw may well have experienced the Zen of losing oneself in the process. As Ohr described it, one "gets out of the way" of the craft more than he actively participates in it. This statement was akin to others that Ohr made throughout his years as a potter. Another was: "God made no two people alike and I'll make no two pots alike," which remained a guiding principle. In fact, whenever Ohr exhibited at expositions and fairs around the country, he posted signs proclaiming "No two alike." A review of his work in available books and collections will show this to be true of all but the most commercial of his enterprises—fair tokens and trinkets made to help pay the bills. These were usually molded and aimed for the quotidian market. And, true to form, he sold a small collection of "fun tokens": two-sided ceramic coins with suggestive sentiments in place of heads or tails.

Below: An assortment of brightly colored vases, all of which have been subjected to Ohr's signature violent manipulation. The pots were usually signed, and "Biloxi" was often incised or impressed onto the base.

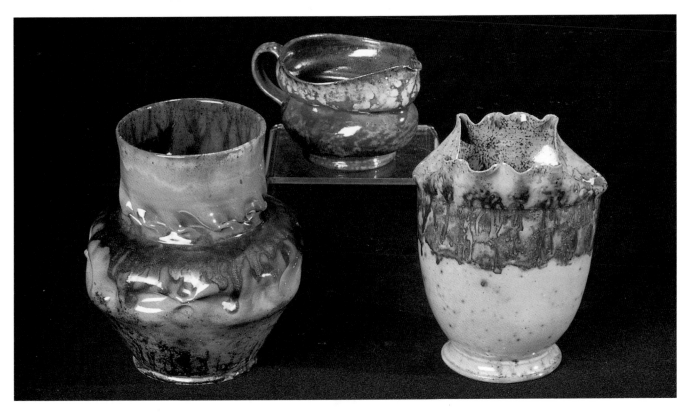

Opposite: An ovoid vase with blistered pink glaze and pinched rim. The coarse, bumpy texture of the body is apparent [Collection of L.A. County Museum].

Finally, Ohr's observation that "God put no color in souls and I'll put no color on my vases" was the prelude to his last and most mature period. From about 1900 until the end of his potting career in 1907, he eschewed glazing, allowing the ceramic body of the pot to stand as the finished product. In addition to the "coloring" achieved by the various minerals in the clay, the proximity of the pot to the kiln's heat source altered its appearance by bringing darker metallic oxides to the surface. Ohr would also "scroddle," or mix together clays of various colors, providing a swirled effect. Those familiar with how Arts and Crafts furniture producer Gustav Stickley used the natural grain patterns of quarter-sawn oak as "decoration" on his furniture will understand the sensitivity and honesty of Ohr's choice.

The lack of applied color served to heighten the intensity of his later forms: this last period is that of his most abstract and provocative artistry. In viewing several thousand of these pieces, it seems at times that Ohr totally abandoned the vase and bowl forms, with pieces defined as such only because they were more tall than wide, or vice-versa.

In the end, the farther out he went, the more bizarre he must have seemed to a society looking for pots to put flowers in. But, in so doing, he anticipated the work of generations of potters to come, blazing a trail of artistic achievement straight into obscurity. At least until that New Jersey barber came along...

Below: A wide bisque bowl with highly manipulated rim, left unglazed.

Pricing Ohr requires a doctoral degree in suspended judgment. I have seen small pieces sell for deep into five figures and tall vases (12"+) sell for $2,000–3,000. I suggest you get auction catalogues and check prices to get a clearer indication of value.

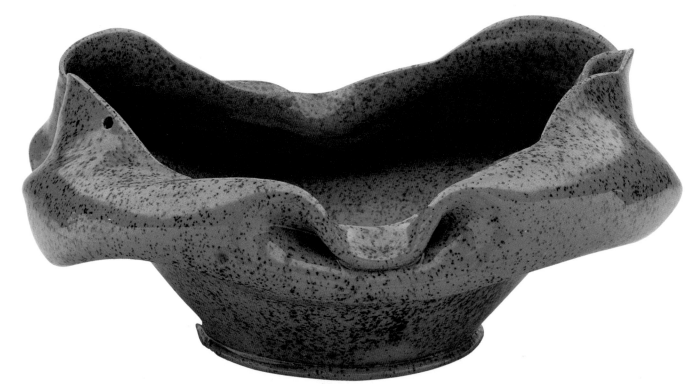

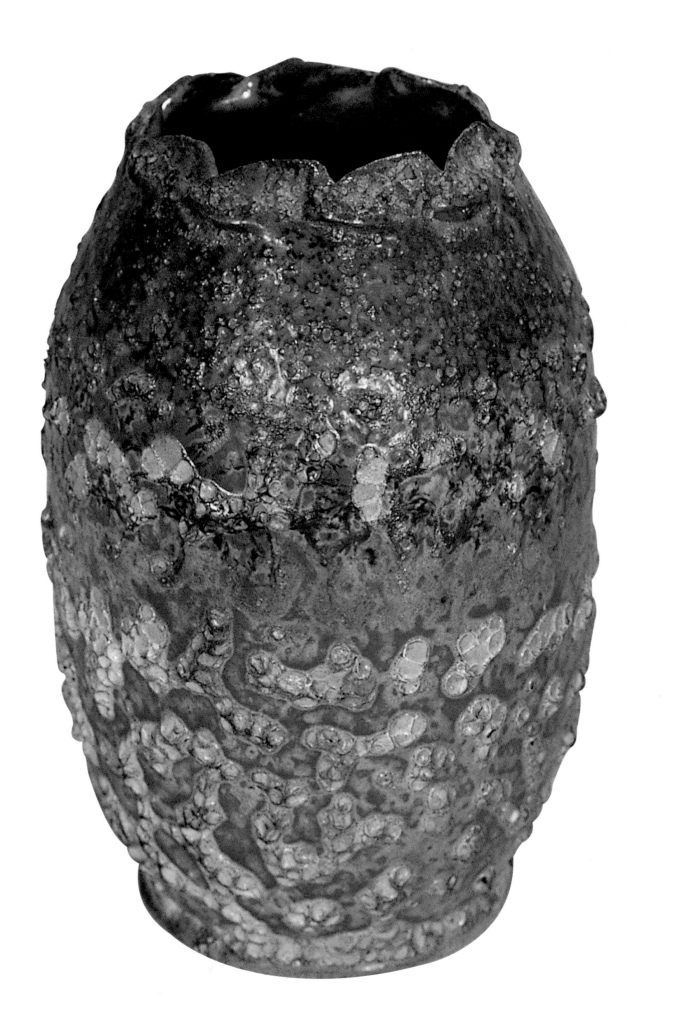

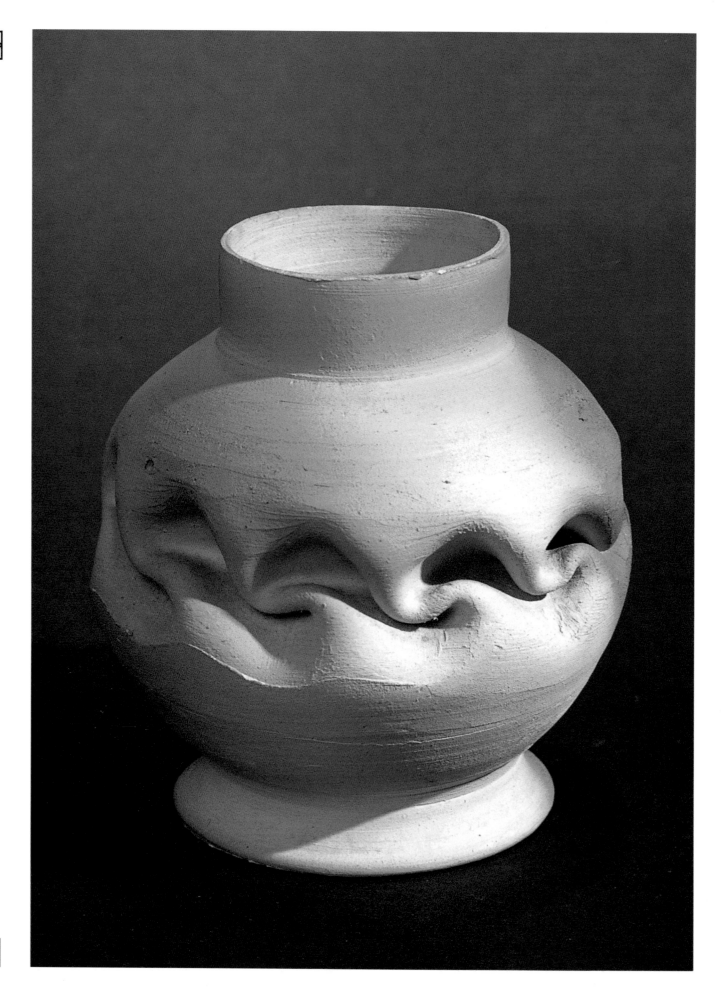

Bisque Ware *Opposite, below, and right*
The bulbous bisque vase on the opposite page has a twisted center. The free-form bisque bowls below demonstrate the varied colors of Ohr's clay. The extravagantly manipulated bisque bowl on the right was never intended to be functional. Ohr's creation of dysfunctional objects earned him the nickname "the Mad Potter of Biloxi."

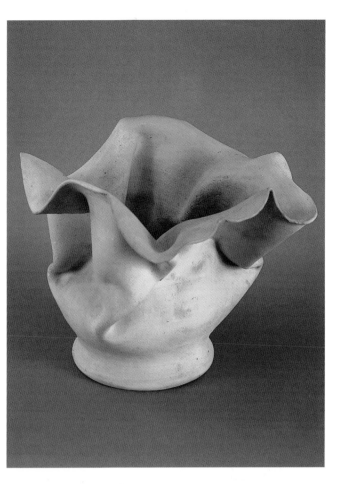

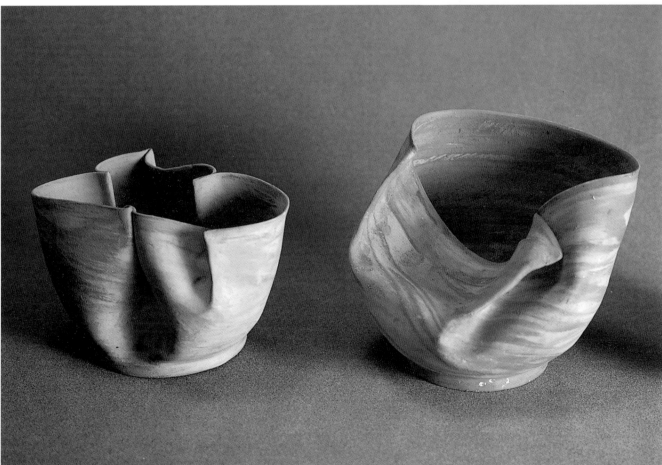

Serpentine Teapot *Below*

The bulbous teapot below has red and yellow glazing and a serpentine spout. Ohr's glazes appear to have been inspired by the natural world: their organic qualities are reminiscent of the speckling on rocks, leaves, or marine life.

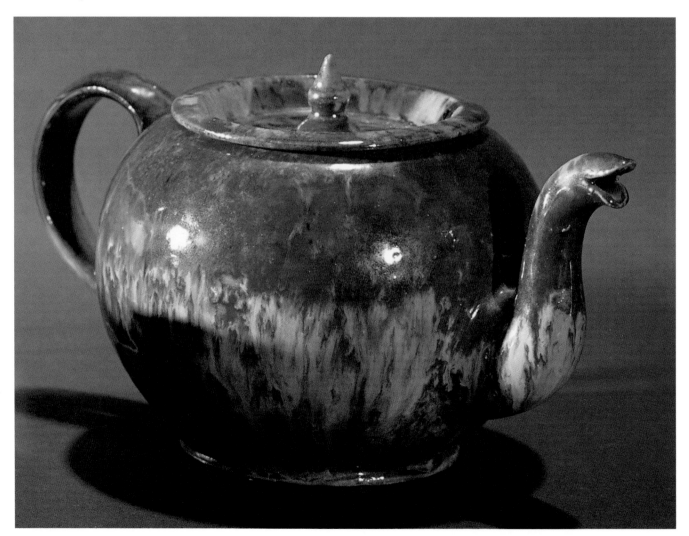

Polychrome Flambé Teapot *Below*
The serpentine teapot below has a polychrome flambé finish. The midsection of this piece is corseted.

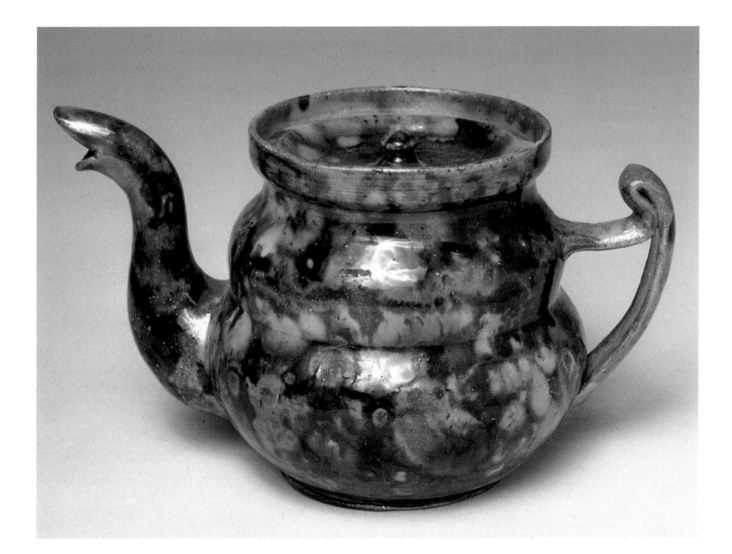

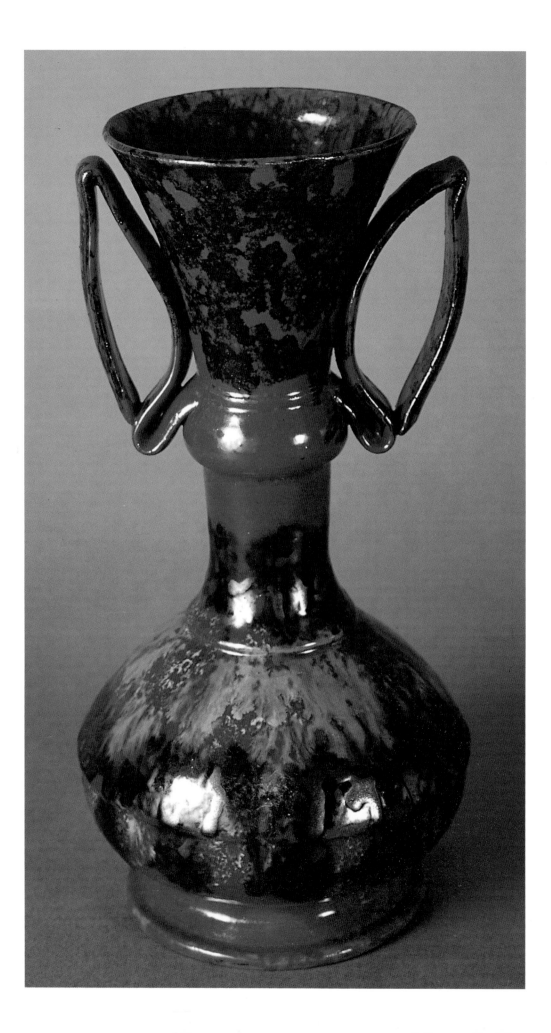

Enameled Red Glazing

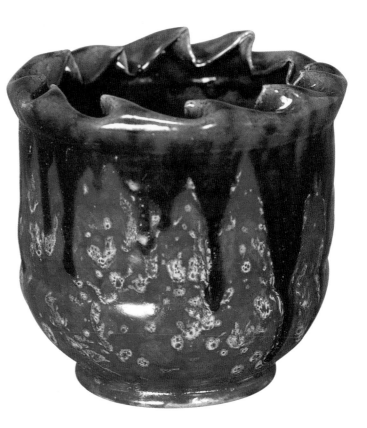

Opposite, right, and below

The unusual double gourd with "bat-wing" handles on the opposite page is brilliantly glazed in shades of red, yellow, green, and black [Private Collection, New York]. The vase below illustrates Ohr's severe manipulation of the clay, which has been described as "torturing." It is decorated to resemble a ladybug. Speckled with yellow over the enameled red glazing, the piece at right has a crimped rim that directs the viewer's eye around the body of the work.

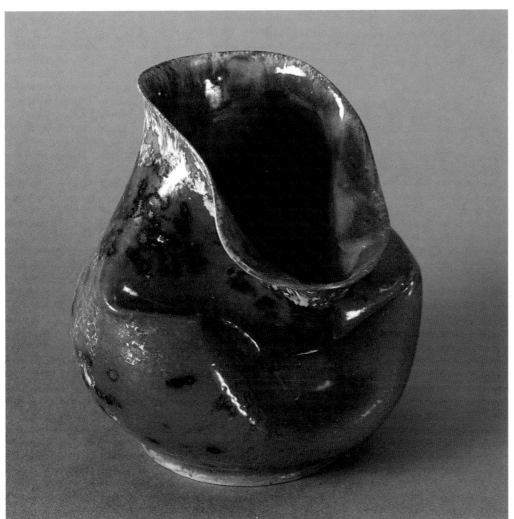

Easter Egg Vase *Left*
A tall, corseted "Easter Egg" vase aptly named for its speckled decoration [Private Collection, New Jersey]. The walls of many of Ohr's pots were eggshell thin—quite an accomplishment considering that he used unrefined clay.

Frog-Skin Glazing *Opposite*
Frog-skin glaze was used to finish this highly manipulated, organic vase. The ware that Ohr produced was subjected to varying degrees of twisting, denting, folding, pinching, and squeezing.

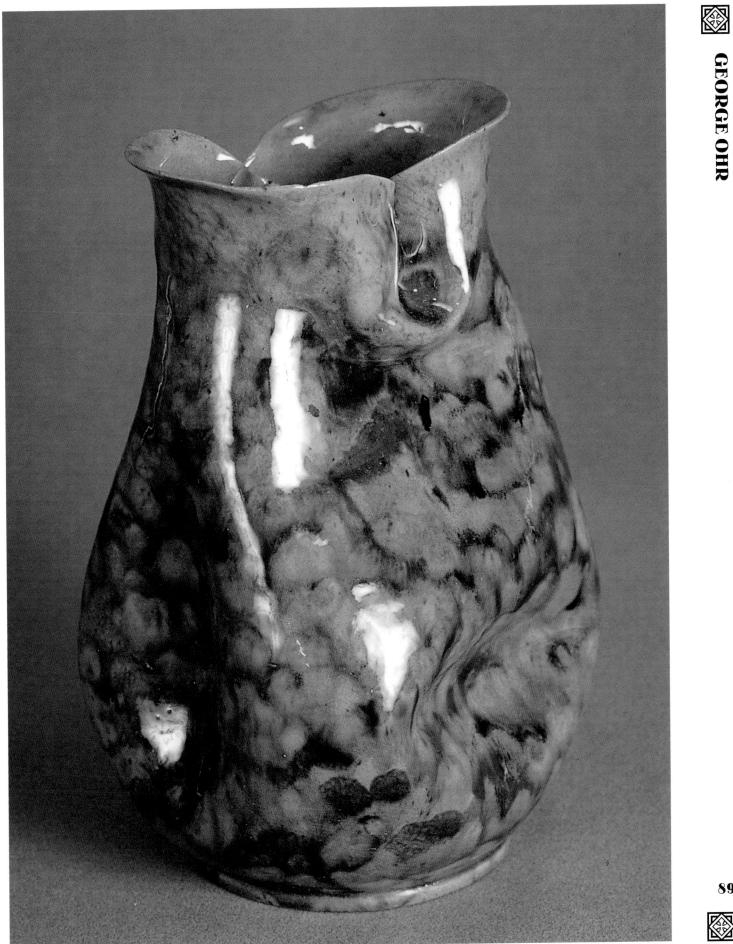

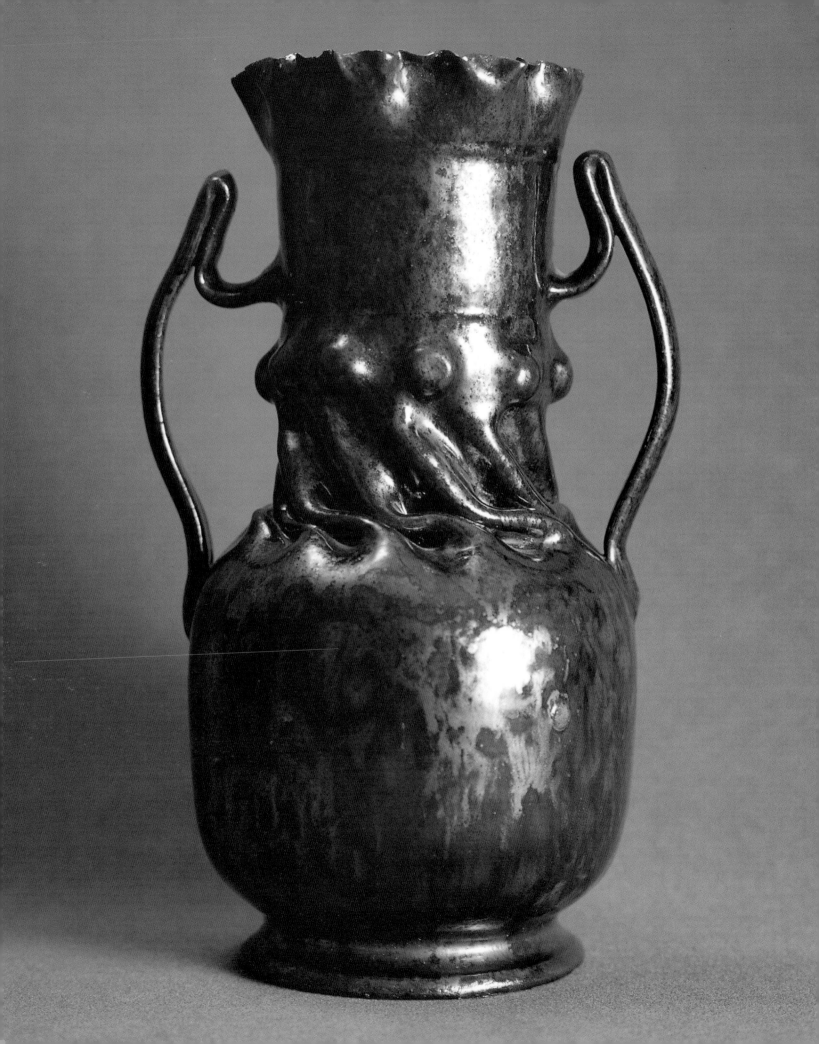

Manipulated Vases *Opposite and below*
The exceptional tall vase on the opposite page has a twisted center, pinched rim, and two manipulated handles under a metallic flambé [Private Collection]. The vase below is an excellent example of Ohr's "Petticoat" ware—vases in which the body of the piece is ruffled into separate sections to resemble a woman's undergarment [Private Collection].

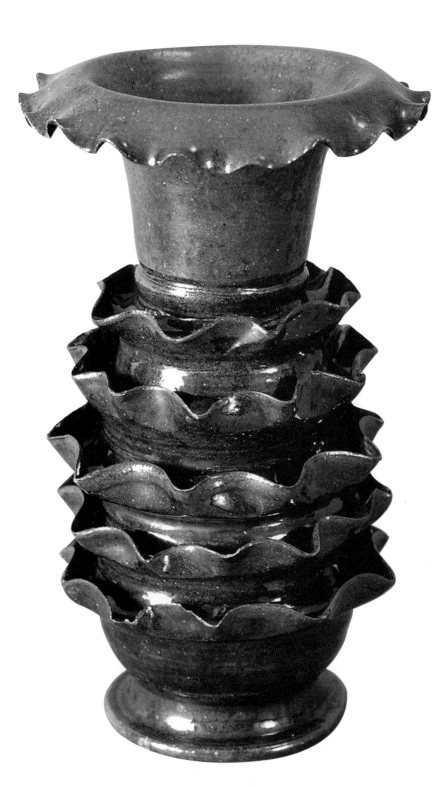

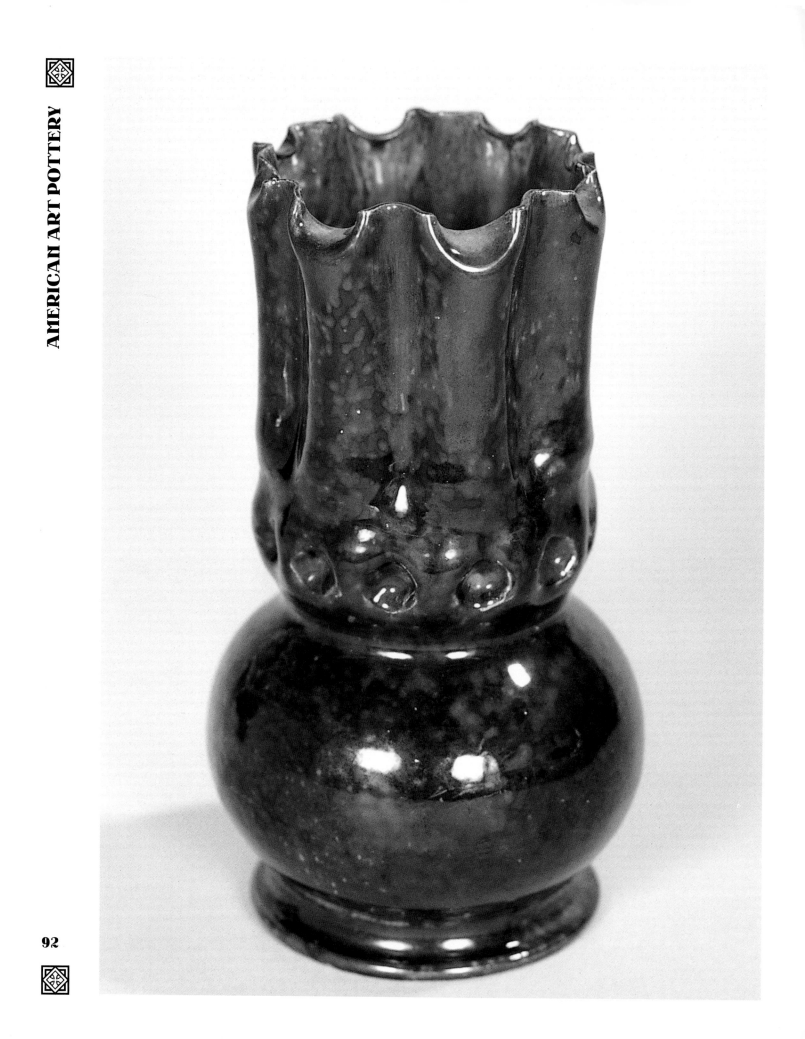

Degrees of Manipulation

Opposite and below

A long, fluted neck with ruffled rim graces the otherwise bulbous body of the tall vase on the opposite page. It is glazed in rich shades of blue and shows minimal manipulation. The double gourd vase (below, left) with enameled glazing demonstrates Ohr's ability to create standard ware with little or no manipulation. The flat-shouldered flaming vase (below, right) has a deep in-body twist and enameled glazing.

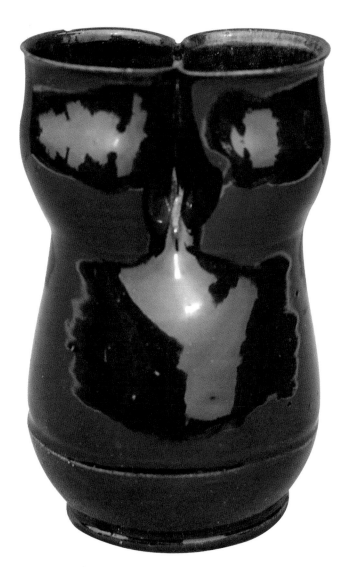

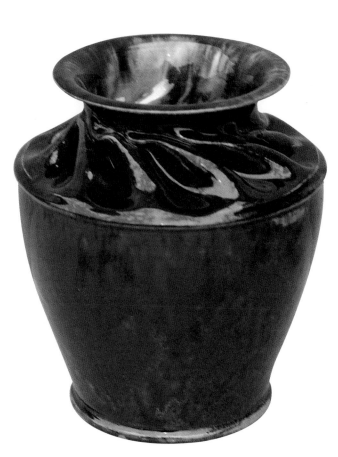

93

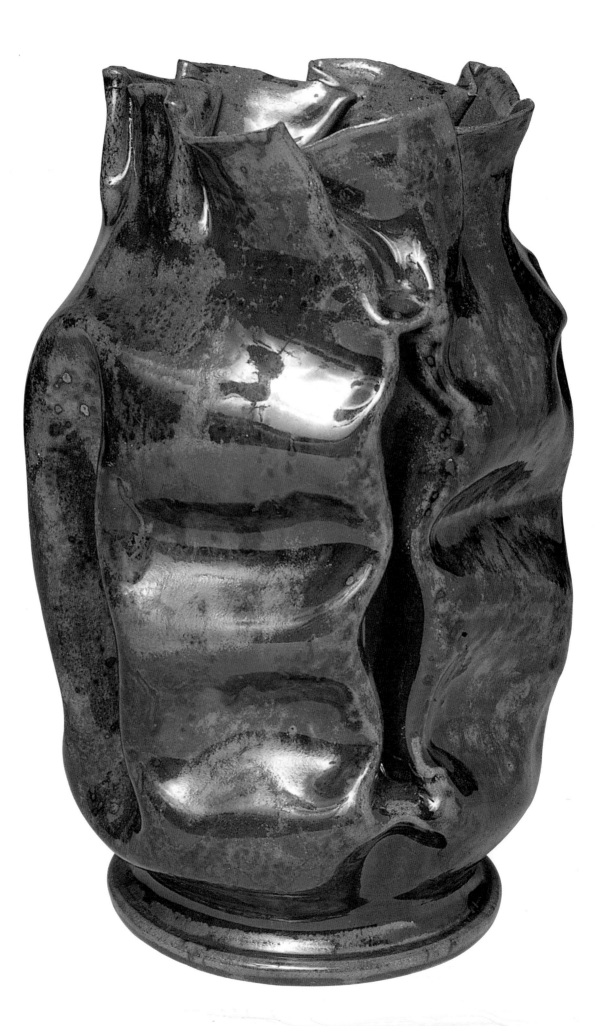

Sculptured Vase *Opposite*
An exceptional example of a four-sided sculptured vase with four-color flambé glazing [Private Collection, New York]. The production of such masterpieces supports Ohr's claim that he was "the greatest potter on the earth."

Enameled Ware *Below*
Large and rounded, the vase below has a ruffled rim, twisted center, and enameled glazing.

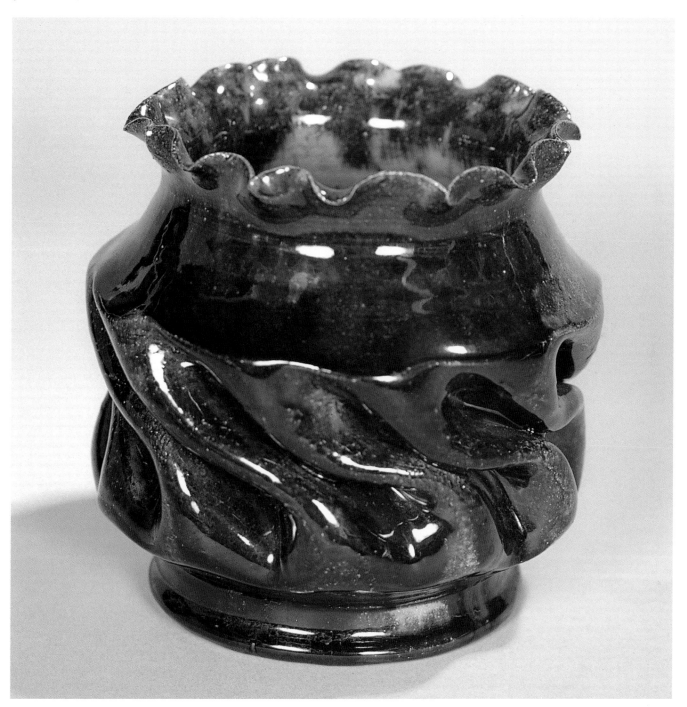

Brilliant Glazing *Opposite and below*
*The tall, flat vase on the opposite page
has double-manipulated handles. The
variety of vibrant colors was achieved by
Ohr's application of a polychrome finish.
Tall and corseted, the vase below has a
flaring rim and brilliant blue-green
glazing [Private Collection]. Ohr's pottery
was a one-man operation: he designed
and threw all of his own pots.*

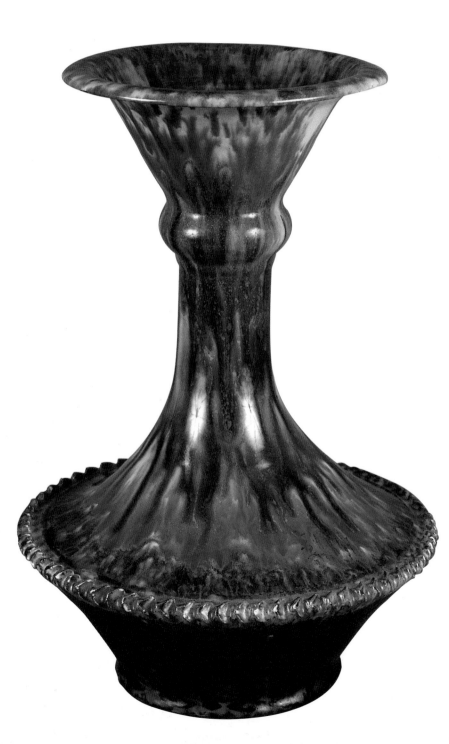

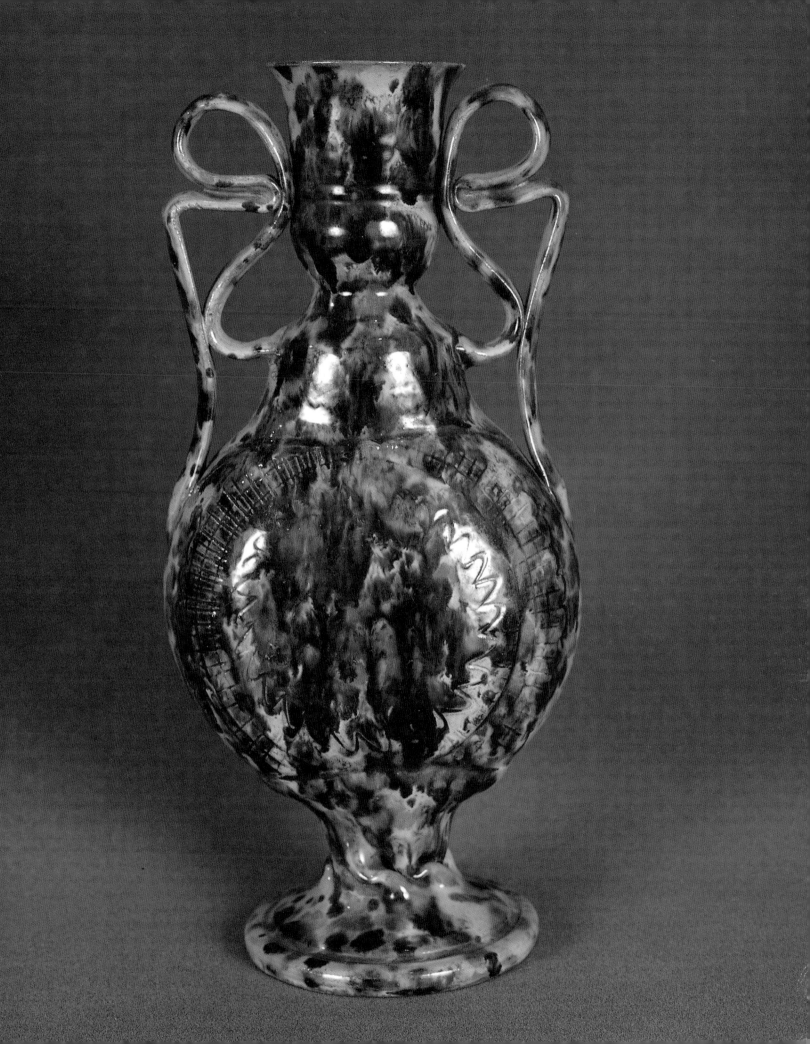

Assortment of Ohr's Ware *Below*
These vases illustrate Ohr's diverse handling of form, shape, and glazing. All of his pieces were made on a wheel of his own construction in the workshop he called "pot-OHR-ree." Ohr said of his work, "It is as easy to pass judgment on my productions from four pieces as it would be to take four lines of Shakespeare and guess the rest."

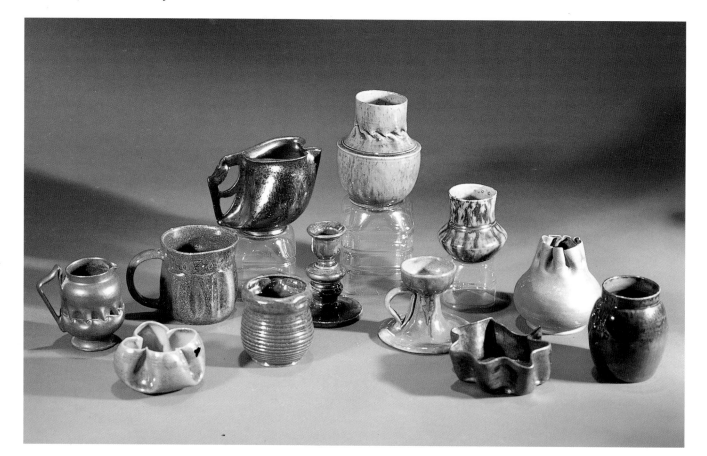

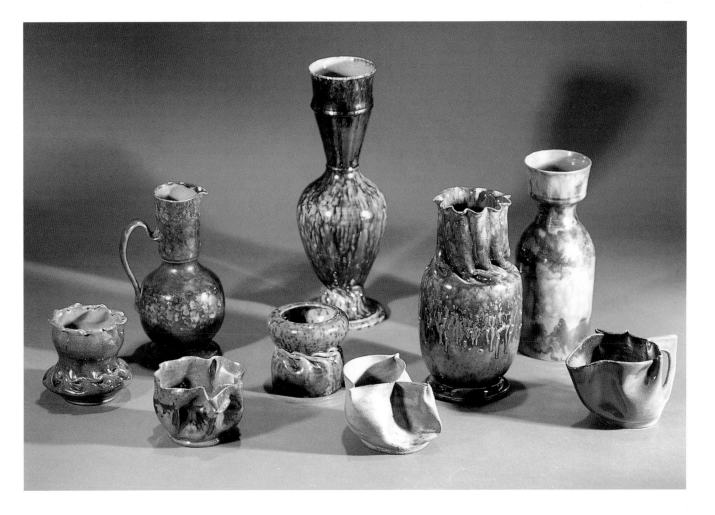

Assortment *Above*
This grouping of Ohr's ware demonstrates his strength and versatility, characteristics affirmed at the St. Louis Exposition of 1904, where Ohr received a medal for his pottery.

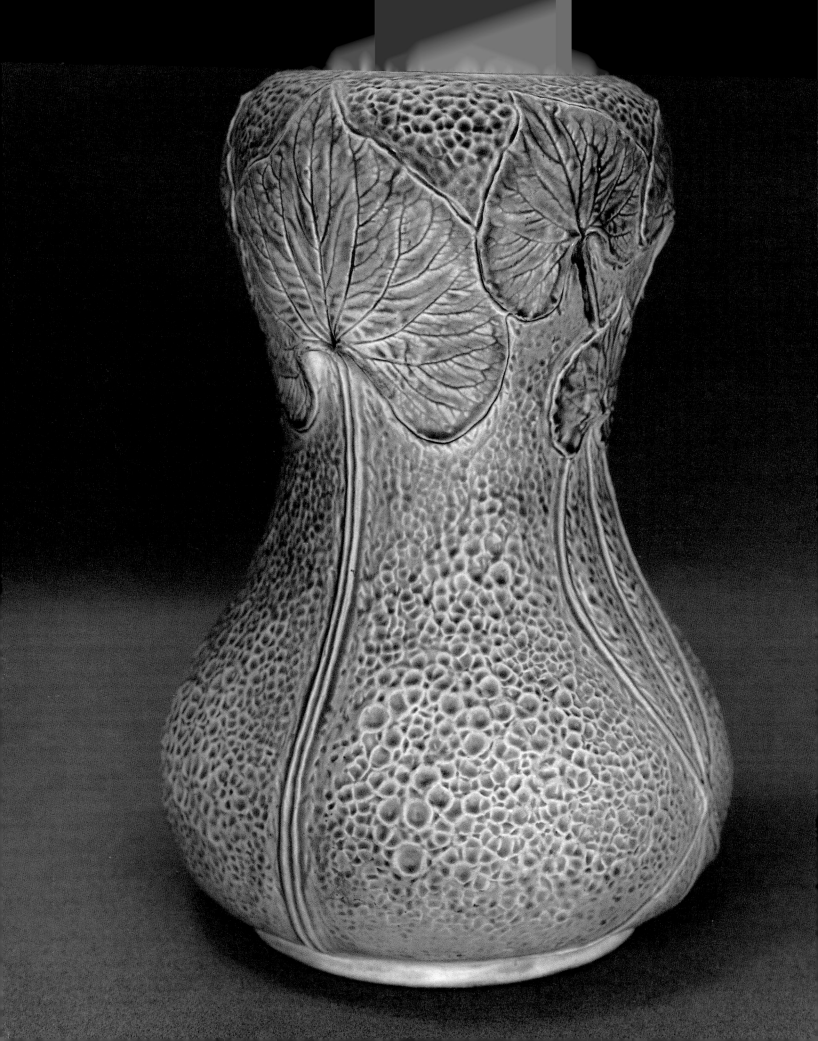

Tiffany

Louis Comfort Tiffany will always be remembered for his exquisite leaded-glass lamps, which helped establish him as the leading exponent of Art Nouveau design in America. An excellent artist, promoter, and businessman, Tiffany is less known for his work in other media, including bronze, enamel, and the art pottery he produced at his Corona, New York, kiln from 1898 until about 1911.

The 1,000-or-so ceramic pieces that have survived Tiffany are evidence that pottery production was more than a whim. Nevertheless, these remaining pots also make it clear that they were not his primary interest. Most Tiffany pottery is underwhelming. Pieces were frequently left undecorated, except for the respectable glazes that covered them. Other pieces are well designed but were left entirely unglazed, with the bisque surface of the clay as a finish. There is not much great Tiffany pottery about.

However, a successful piece of Tiffany pottery is a work of sophistication, elegance, and subtlety. His best work is organic and flowing, gently glazed in soft greens and yellows. Though very much in the manner of the French masters who influenced Tiffany, such as Auguste Delaherche and Ernest Chaplet, his work in clay proved that American artists and potters were sensitive to this European aesthetic and could offer their own interpretation of it.

Most of Tiffany's best pottery is molded, with embossed organic designs of fern fronds, leaves, birds, mushrooms, and other natural motifs. These were finished in transparent glazes of light green or yellow, with traces of gun metal. One marvelous example, which is currently in the collection of the Cooper-Hewitt Museum in New York City, is a seven-handled fern basket in green and yellow, with the fronds joining above at the center like an inverted octopus.

Simply, the more organic and outrageous, the better. Reticulations, whiplash flower petals and leaves, layered embossed work, and rich, soft glazes are features of Tiffany's better work—the most organic and expressive pieces being the best. Although his larger pieces are gen-

Opposite: This green corseted vase has incised leaves and organic, shellac glazing. Natural motifs included water plants, poppies, ferns, and birds.

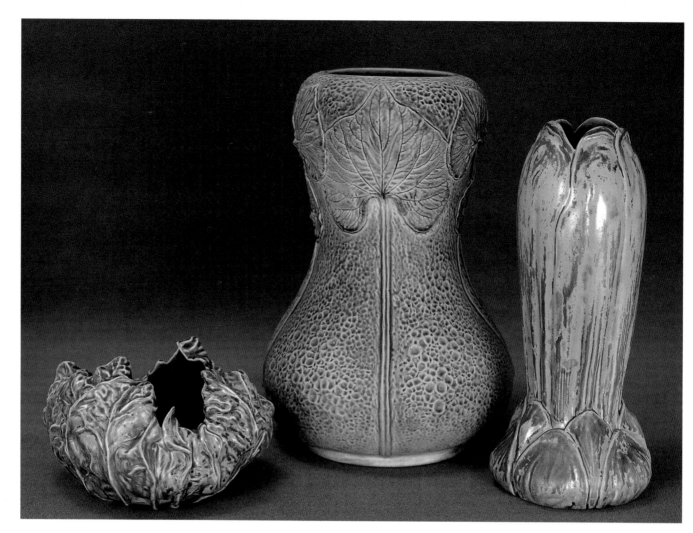

Above: Three pieces of organic Tiffany ware. Although each piece was individually crafted by different artists, Tiffany pottery was always attributed collectively to the studio.

Opposite: No embossed decoration was used on this tall bulbous vase with Green Flambé finish.

erally higher quality, some of the best pieces to surface have been six to seven inches tall. There is another marvelous piece in the Cooper-Hewitt collection which is covered with a bronze coat and embedded with four Tiffany-glass scarab cabochons. It is about five inches tall.

Perhaps 60 percent of Tiffany's pottery was left with unglazed exteriors, although the interiors always bear a gloss coat, usually light green. About another 25 percent are pieces with simple thrown or cast forms that were glazed with interesting flambé finishes. The remaining 15 percent have embossed designs covered in the light, glossy finishes described above.

Damage does not lessen the value of a Tiffany vase as much as it does the work of most potteries. While it is a molded, and thus repeatable, product, fine examples are sufficiently rare that much will be overlooked. A more common piece with damage will be worth little and is difficult to sell. An eight-inch Tiffany vase with embossed organic decoration and a fine glaze will sell for about 3,000 dollars, where a more expressive piece might bring 5,000 dollars. The same form without glaze is worth about 1,500 dollars. A simple, undecorated piece with an interesting glaze is worth about 750 dollars.

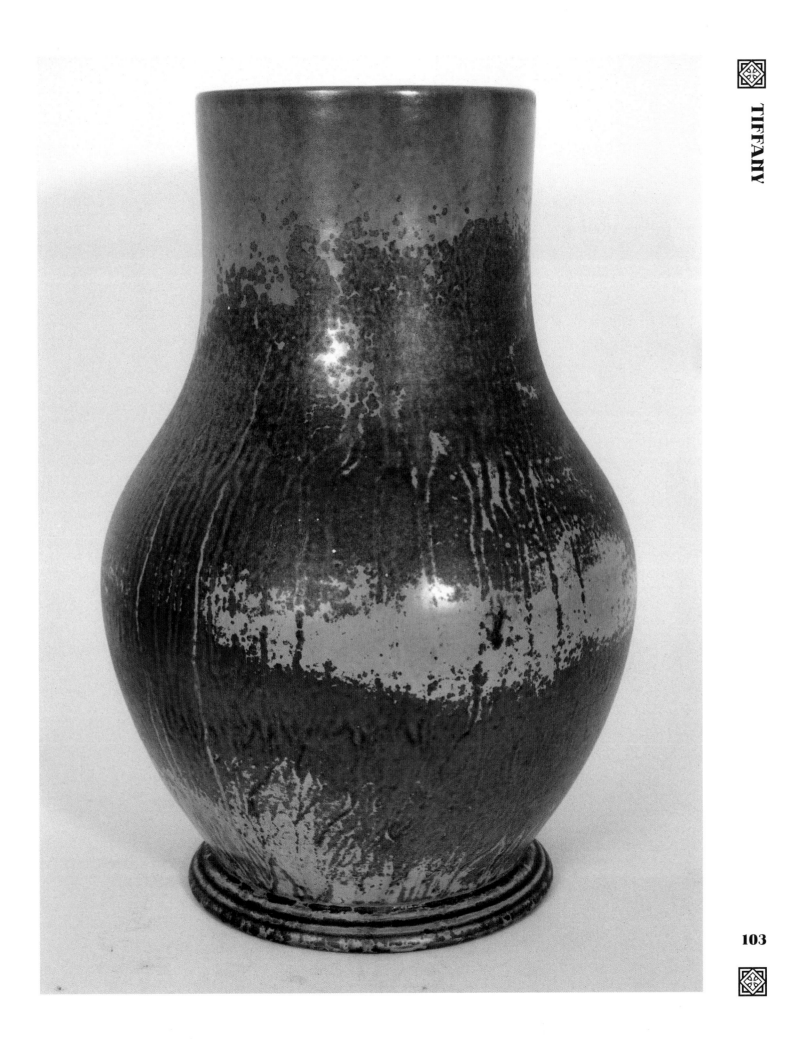

Organic Ware *Opposite, left, and below*
A seven-handled fern basket (opposite) in green and yellow with embossed decoration. Tiffany pieces were usually modeled with excised or incised relief and then glazed by hand [Collection of Cooper-Hewitt National Design Museum, Smithsonian Inst./Art Resource, N.Y.]. Organic forms were often the inspiration for Tiffany's designs, as illustrated in the cabbagelike bowl pictured below. The dramatically ruffled rim (detail at left) demonstrates that this bowl was never meant to be used.

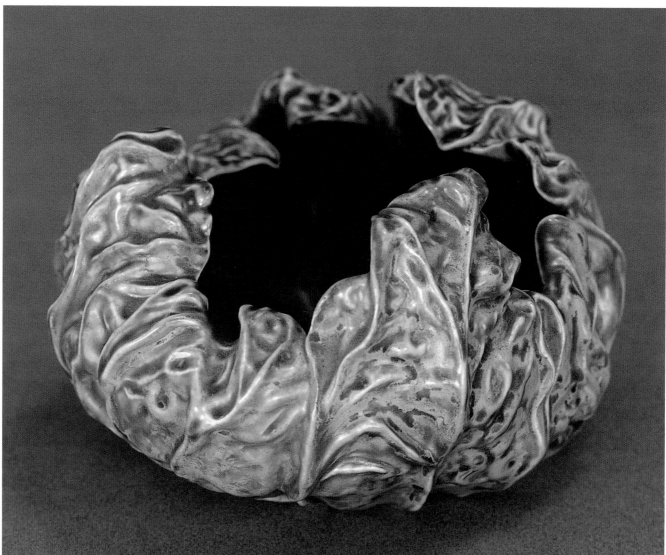

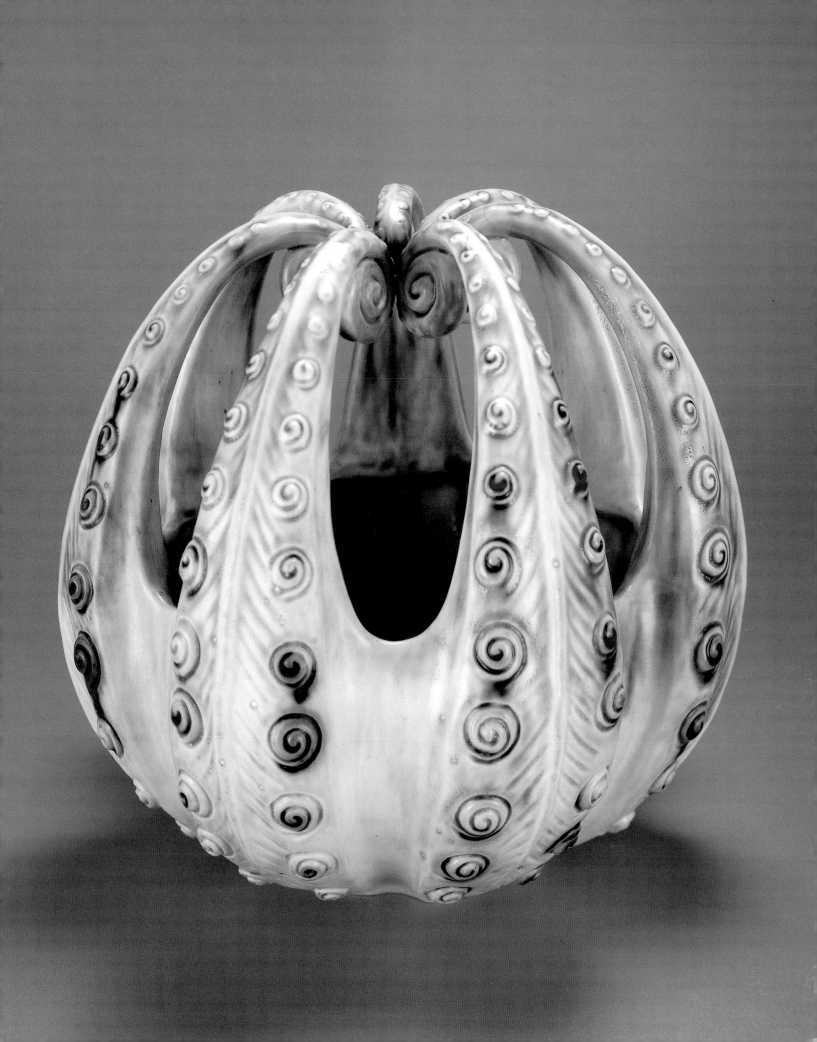

Molded Decoration *Below*

An unusual example of an organic vase with a white porcelain finish and molded decoration. Although experiments with pottery began at Tiffany in 1898, the ware was not displayed until the St. Louis Exposition of 1904.

An exceptional vase with green organic finish and molded decoration, below, [The Schecter Collection]. All of Tiffany's pottery was marked: most with "L.C.T." cipher incised; some with "L.C. Tiffany," "Favrile Pottery," or "Bronze Pottery" etched into the base.

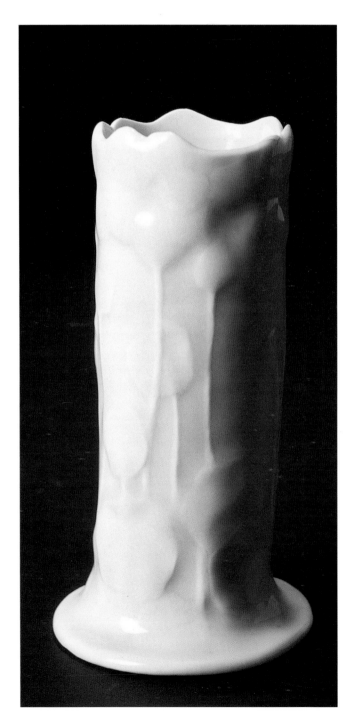

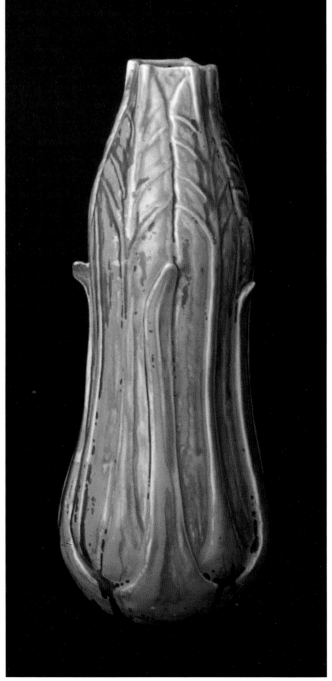

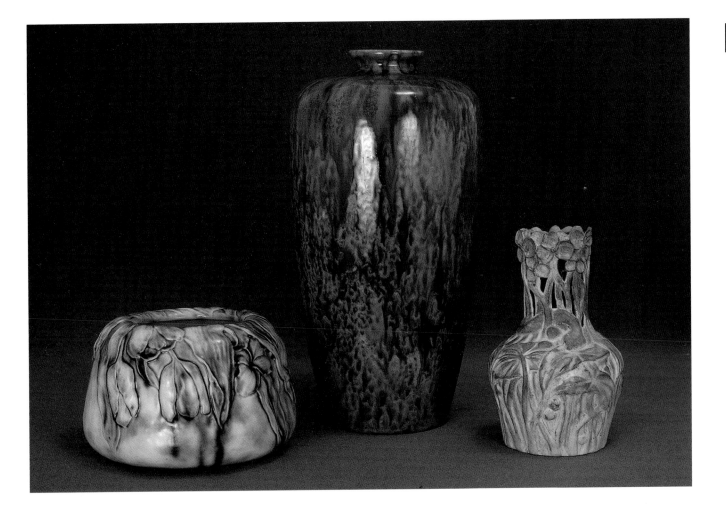

A Selection of Tiffany Ware

Above and right

The three pieces above show the variety of techniques used at the studio. Squat and bulbous, the piece at left has organic, shellac glazing and was part of Tiffany's Favrile Old Ivory line, offered to the public in 1904. The center piece demonstrates the studio's proficiency with glazes, and the bisque vase at right is decorated with molded flowers. Finished with green-and-yellow shellac, the vase at right is decorated with molded fern fronds and was made around 1905.

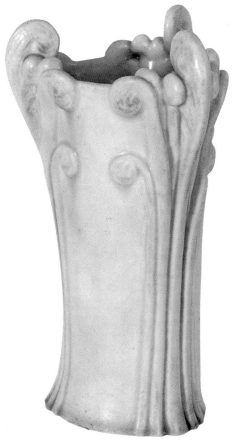

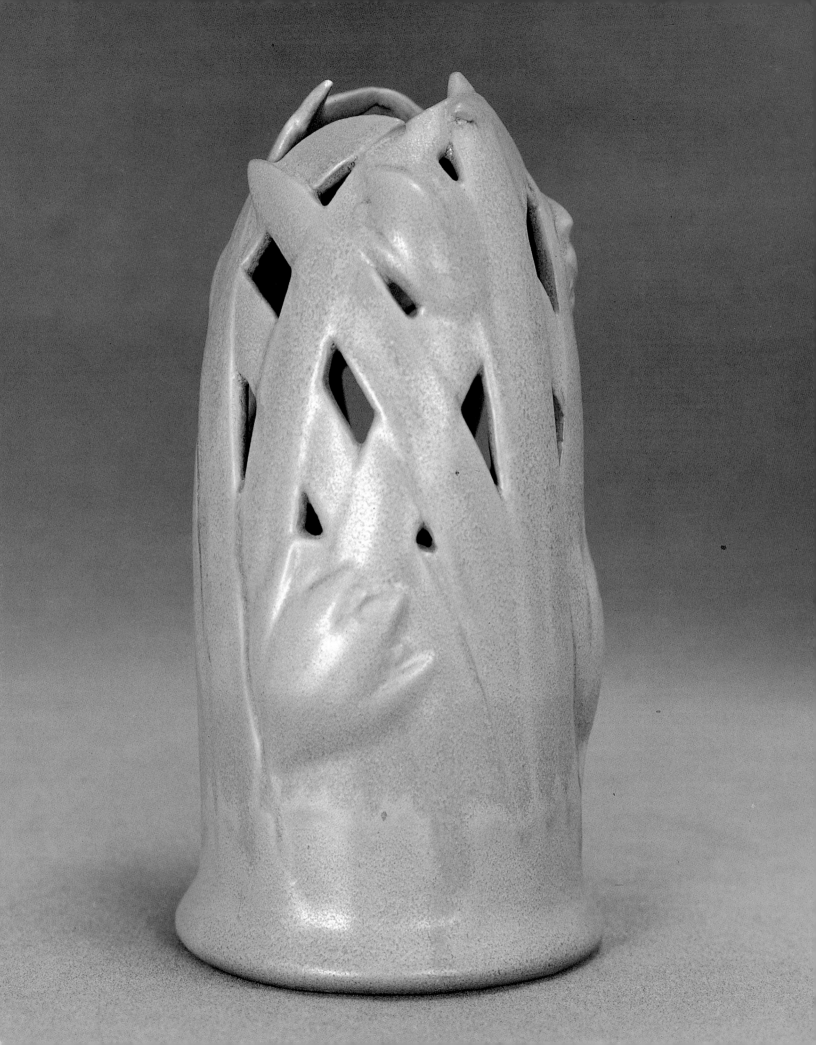

Teco

Teco (an acronym for the Terra-Cotta and Ceramic Company of Terra Cotta, Illinois) is considered the "pottery of the Prairie School," and not without good reason. The style, the approach to ceramics, the artists employed were all in concordance with this regional branch of the Arts and Crafts Movement. Perhaps nowhere else in America did the European roots of Arts and Crafts and the forward-moving, mechanized pace of the United States combine to forge such a modern and sophisticated aesthetic.

The Prairie School, of which Frank Lloyd Wright, influenced by his mentor Louis Sullivan, was the leading exponent, was informed by the long, low lines of the vast American prairie, in the middle of which is Chicago—the seat of this design movement. Just as the visual style and philosophical meaning of the English Arts and Crafts Movement had changed when it reached the Eastern seaboard, so the American movement was reinterpreted as it moved westward into other centers of national life.

While Gustav Stickley preferred the bungalow and the hearth as domestic features for the new nuclear family, the Prairie aesthetic favored long, horizontal buildings in harmony with their surroundings. Neither Gustav Stickley nor Frank Lloyd Wright shared the European artisan's disdain for the machine. The Prairie School embraced it as an essential tool in building the ideal human environment, while East coast adherents merely accepted it as a means of taking the drudgery out of their work.

While these differences might appear subtle, their influence on design was anything but. A comparison of any Gustav Stickley home with a Frank Lloyd Wright dwelling demonstrates this clearly. Nevertheless, both interpretations had more commonalities than dissimilarities. While each designer chose his own interpretation of the Arts and Crafts Movement, both expressed variations upon the same ideas. Which leads us back to Teco. The chapter on Grueby explains why their ceramics were so compatible with Stickley's interiors: they shared a warmth and an aesthetic that originated in similar inter-

Opposite: An exceptional organic piece, this bullet-shaped vase is reticulated, with the matte green glaze that dominated Teco's ware until 1912.

pretations of Arts and Crafts philosophy. This shared aesthetic is mirrored in the relationship between Teco and the Prairie School.

Purists sometimes disparage Teco because the ware was seldom hand-cast—rather, mainly mass-produced. Teco was a large factory and its craftsmen churned out countless pieces in more than 10,000 different shapes. Their glazes were "neither fish nor fowl," exhibiting neither the soft, organic mattes of the Arts and Crafts producers on both coasts, nor the glossy finishes of the Ohio school. As one might suspect from the production of so many different shapes, Teco was primarily a commercial venture, interested in being all things to all markets, rather than a serious, artistic concern wherein potters would strive to define their niche and work ceaselessly to achieve it.

In spite of these factors, Teco created a sleek, stylish, machine-age interpretation of Arts and Crafts design that apparently accomplished the impossible: the company offered great design and great quality, produced such ware consistently, and stayed in business. In the process, Teco attracted some of the most important creative minds in American design history—including Wright and Sullivan—and adorned some of the nation's most beautiful and noteworthy interiors.

Teco ware is typified by soft, medium-green matte finishes that are seldom complicated by layered nuance or secondary glazing. Perhaps 20 percent of the work has "charcoaling" (copper crystal blackening), in the form of a metallic, black secondary finish. At least 90 percent of Teco's pottery is predominantly green, although successful finishes were produced in light and dark blue, brown, yellow, pink, and maroon. Limited quantities of a mahogany-to-amber aventurine, or sparkling finish, were also produced, mainly of excellent quality, but this is not perceived as vintage Teco and remains of little interest to all but the most broad-minded of collectors. While the matte glazes unique to Teco are of consistently good quality, the company's reputation rests on the varied and innovative forms of the pottery. The breadth of their production, and the talent of their designers, is most apparent from this point of view.

Teco ware can be divided into three broad categories: rectilinear, organic, and architectural faience. The rectilinear, or geometric, forms are the most famous and collectible. They are immediately identifiable by the angular handles and buttresses that adorn the pieces. Occasionally undulating rims and curving bodies appear, but the best examples have a more severe line. Some of these forms are further strengthened by the addition of recessed and reticulated handles, or buttresses extending above the top or below the bottom rims, forming fins.

Teco's organic work is usually less interesting but, ironically, includes many of their most dynamic and compelling forms. Swirling handles, curving reticulations, and whiplash buttresses—occasionally accented

by embossed floral designs and leaf-shaped handles—combine to create a distinctive and exuberant ceramic. While many such individual pieces are among Teco's finest, these forms were far less consistent in design quality compared to their geometric ware.

It should be added that Teco produced smallish, nondescript clunkers in both rectilinear and organic forms—pieces with the glazing and the feel of their best work, but little of the drama. However, this factor was as true of most major producers as it was of Teco. Their business-oriented approach made such work an acceptable necessity.

The third aspect of their production was their architectural faience, usually large, heavy tiles or garden pots for use in interior and exterior settings. These were mainly of high quality for this type of ware, but not to the same standard as their regular production. The tiles often show embossed designs, and the garden ware shows more than occasional Classical influence.

Damage is less excusable on Teco ware than on that of Grueby or Ohr, perhaps because Teco is essentially a molded ceramic, and the possibility of finding the same form with little or no damage diminishes the value. Yet, considering the angularity of their geometric ware, the exposed arms of some of their organic pottery, and the scarcity of such pieces without damage, such resistance will probably ebb. Investing in pieces of great design with minor damage, at a price that takes the latter into consideration, should be a forward-thinking move.

Most of the Teco ware in circulation is green, under 8 inches, with little or no organic or architectural detailing. These pieces sell regularly for 400 to 500 dollars and, while they have held their value well, they will probably never rocket upward in price. Smaller rectilinear pieces with architectural flourishes, such as buttresses and reticulated handles, will start at 600 to 700 dollars and may be worth thousands. A fine 8-inch piece with a rare form will easily sell for 1,500 to 2,000 dollars. Some larger pieces have changed hands at tens of thousands of dollars. The organic pieces are usually larger. Taller vases with spiraling handles and curving forms begin in the five-figure range. Smaller and more common forms, usually sell for 2,000 to 3,000 dollars.

Below: A buttressed centerpiece bowl that demonstrates the influence of the Prairie School, inspired by architect Frank Lloyd Wright and including Walter Burley Griffin.

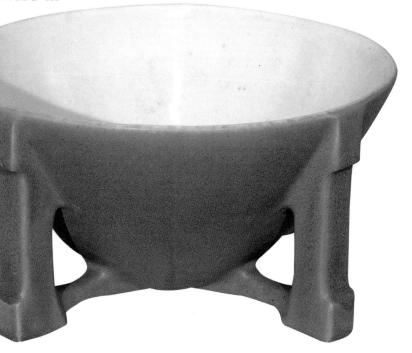

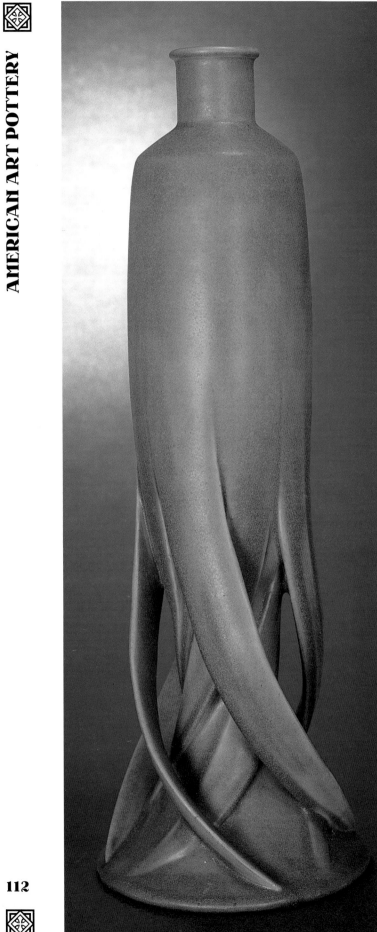

Tall Organic Ware *Opposite and left*
The tall vase at left with swirling arms is a rare and exceptional example of Teco's ware. The unusual piece opposite has buttressed arms. Most Teco ware was sculpted in clay, cast in molds, and sprayed with glaze. These simple and refined shapes illustrate the pottery's objective: "to produce an art ware that would harmonize with all its surroundings,...adding to the beauty of the flower or leaf placed in the vase, at the same time enhanced by the beauty of the vase itself."

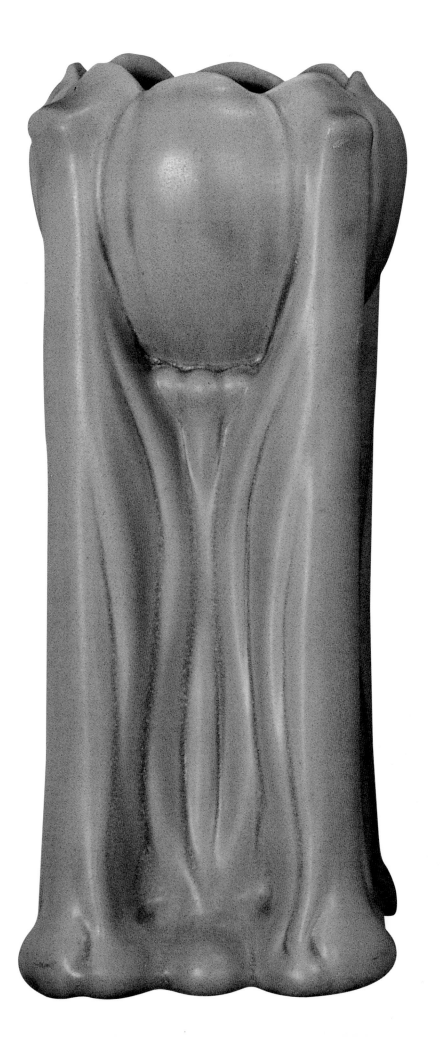

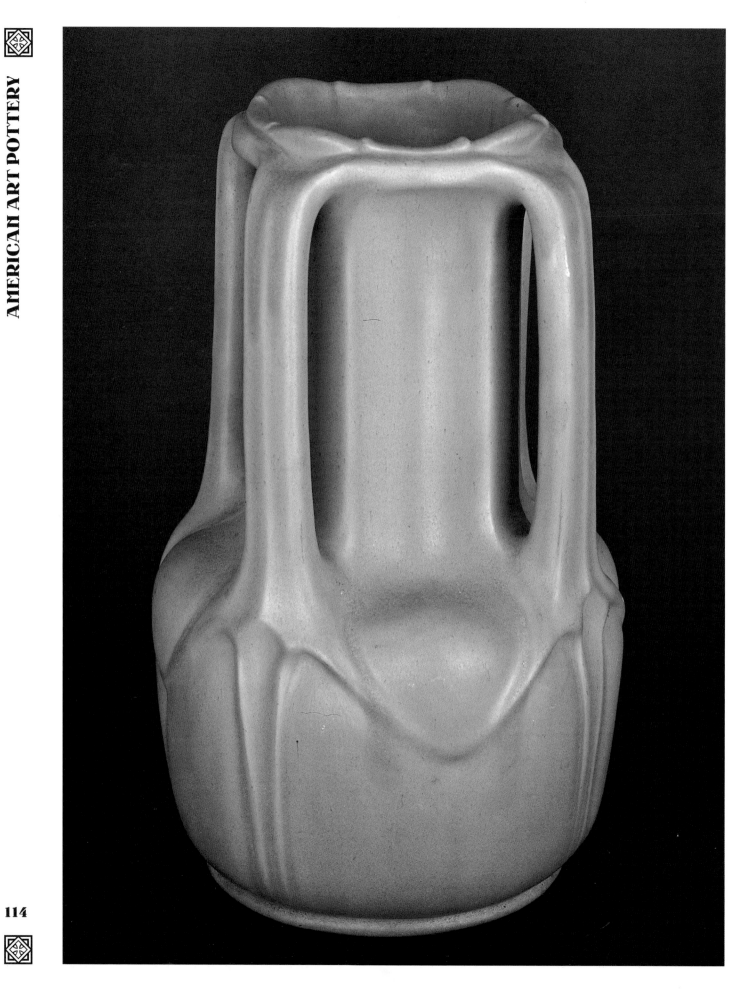

Four-handled Vase *Opposite*
This four-handled vase has a bulbous base and narrow neck. The matte green glaze—known as Teco Green, the pottery's hallmark—emphasizes the organic qualities of the piece [Pearlman Collection, New York].

Arrowroot and Tulip Bowl *Below*
Arrowroot leaves and embossed tulips decorate this bulbous vase with flaring rim.

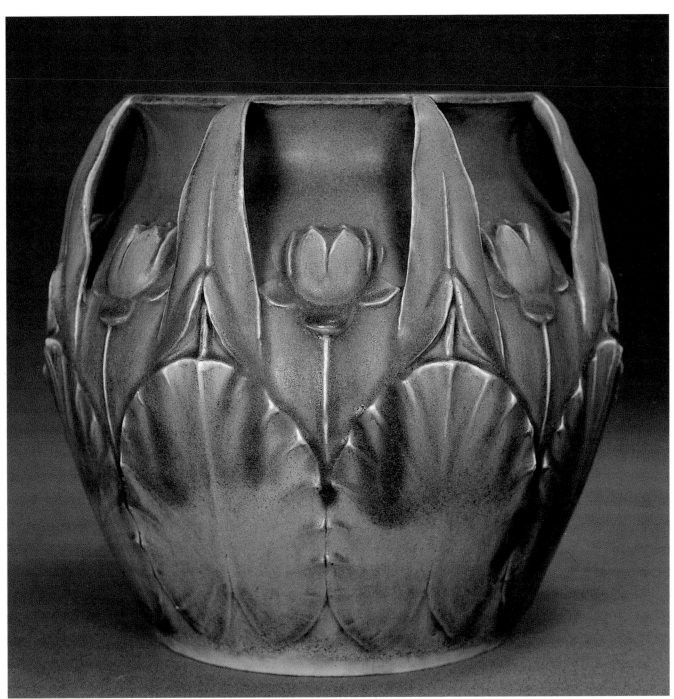

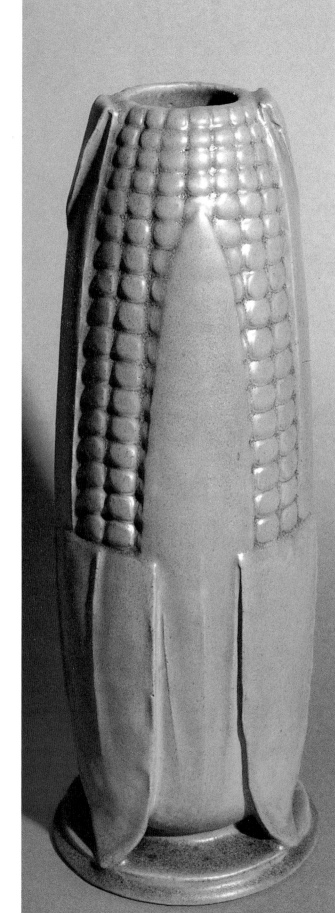

An Assortment of Teco Ware

Opposite, left, and below

The umbrella stand on the opposite page has embossed floral decoration and is an unusual example of Teco ware. Left, an extremely rare example of Teco's reticulated Corncob vase, and a bulbous vase with pretzel handles (below).

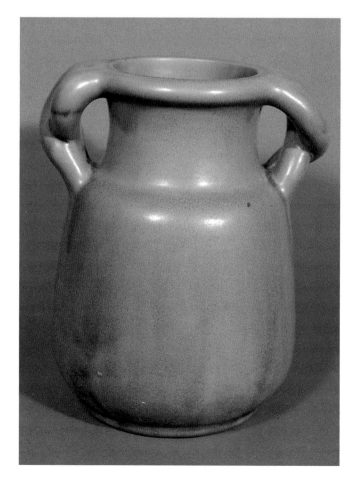

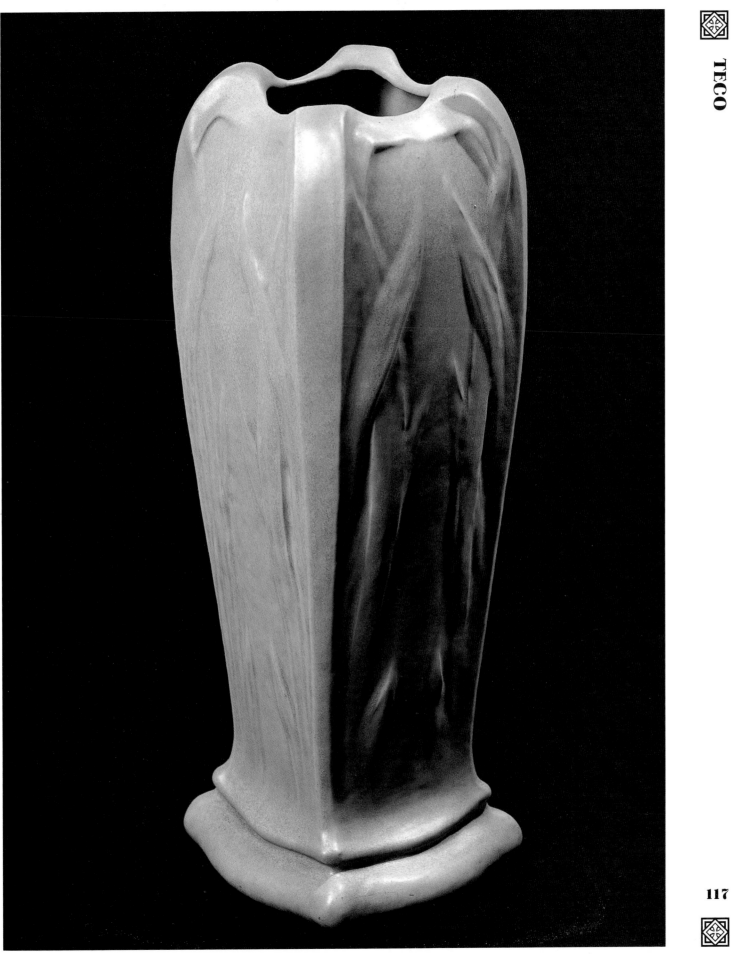

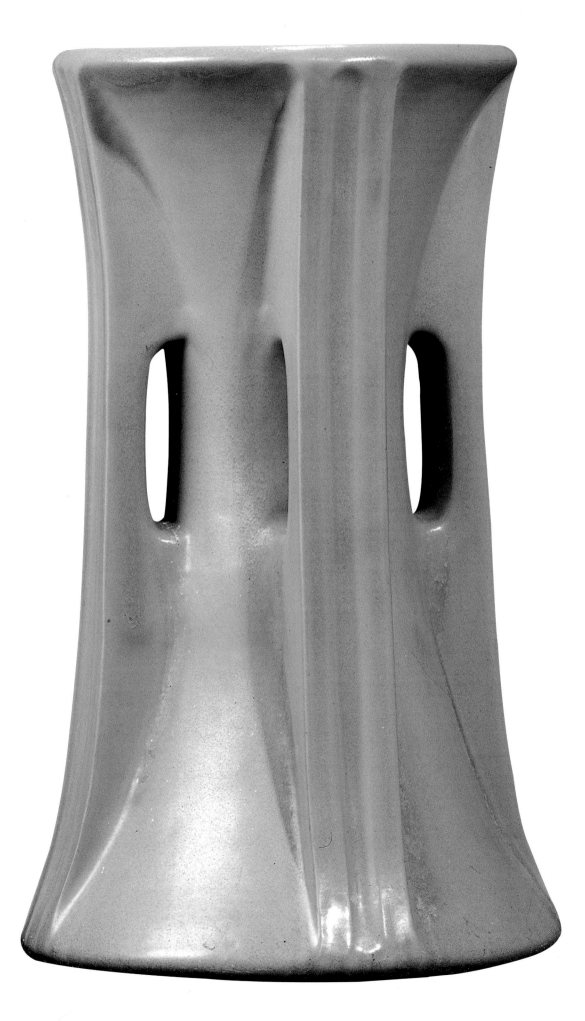

Architectonic Ware *Opposite and below*

The exceptional corseted vase on the opposite page is a fine example of Teco's architectonic ware for interior decorating. Nearly 1,200 designs were produced at Teco, most of them identified by pattern numbers. Cylindrical examples of Teco's architectonic ware: with buttresses (below, left), and with reticulations (below, right).

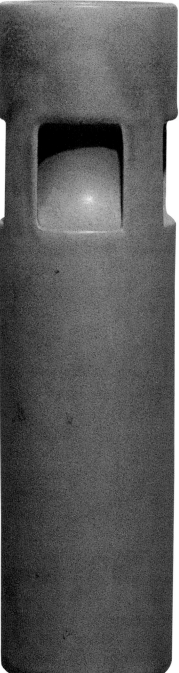

Floor Vase *Below*

A classically shaped floor vase with flaring rim. Most Teco ware is marked with an impressed, long-stemmed "T."

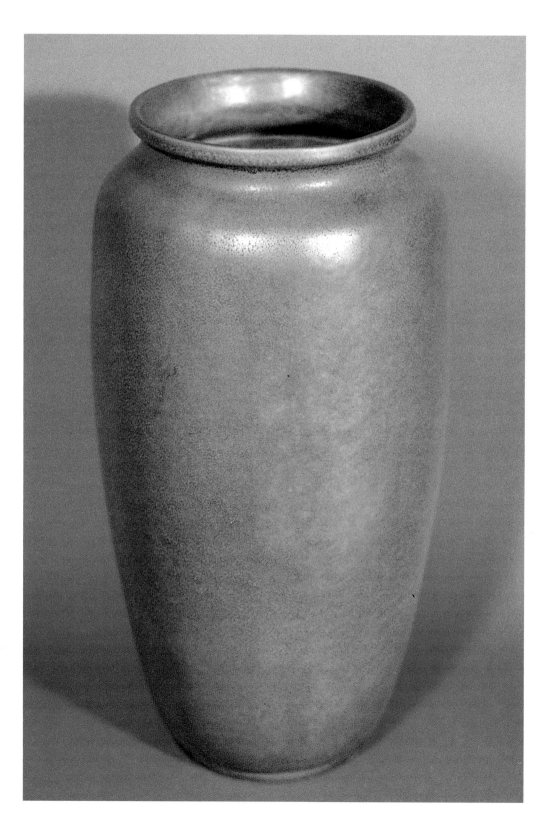

Aventurine Glaze *Right*
Similar in shape to the floor vase on the opposite page, this classical piece is a rare example of Teco's glossy Aventurine glaze.

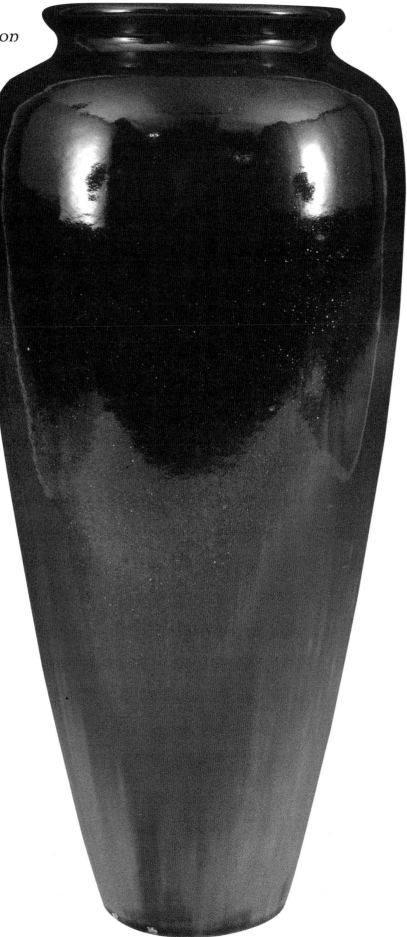

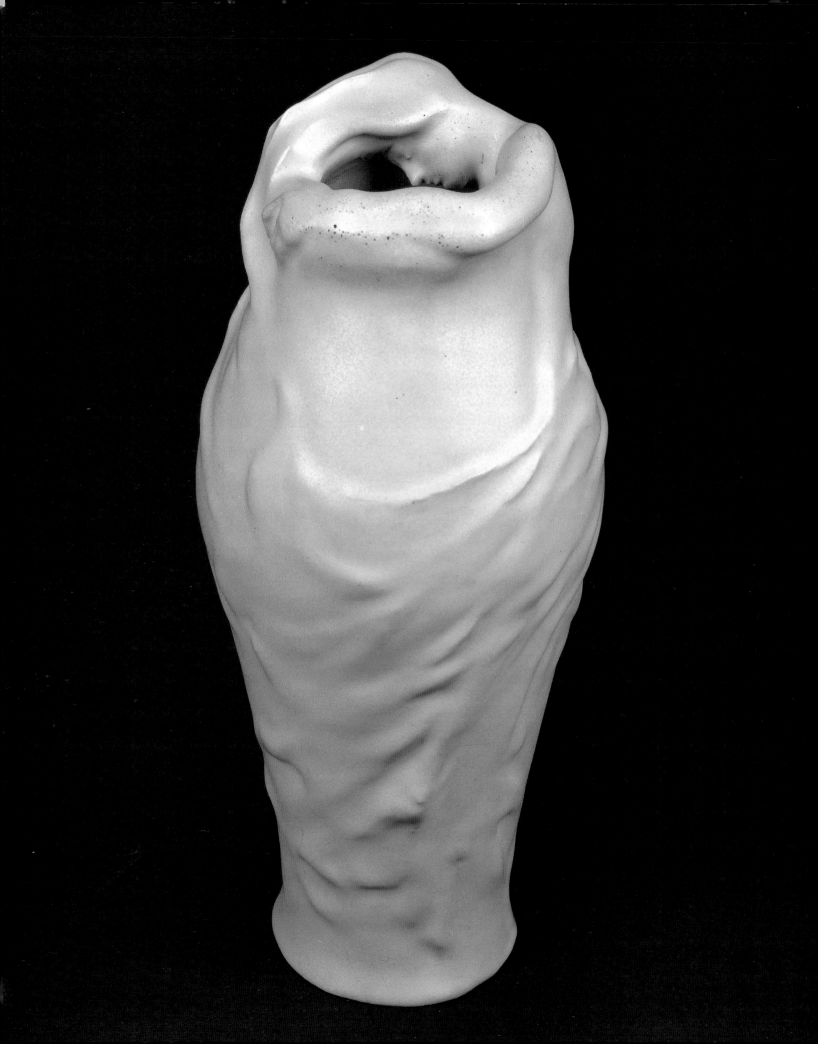

Van Briggle

It has been said that artists are the antennae of society and that to really "get" a work of art, you must have some understanding of the artist and the social context within which it was created. Maybe. At the very least, the more you know about Artus and Anne Van Briggle and their pottery in Colorado Springs, Colorado, the more you'll enjoy the lyrical, sensuous ware they made there for a very brief time.

Artus and Anne were both decorators at the Rookwood Pottery in Cincinnati, Ohio. They were among the coterie of Rookwood's elite who were sent to Paris to study "the new art" with the masters of the day. Artus developed his sculpting skills under no other then Rodin himself and, when he returned to the States after his tour, he was a changed man, personally and artistically.

Originally, Van Briggle, who claimed direct descent from the Flemish Renaissance family of artists the Brueghels, was an exceptional slip decorator, working both in bisque painted ware and Rookwood's famous Standard Glaze. A standout among standouts at Rookwood, his brush stroking was of the highest order. Ironically, the technique he learned in Paris was modeling, or sculpting, clay, and he abandoned brush painting upon his return in favor of his newly developed talent.

It was both these new skills and his failing health that precipitated Van Briggle's move to Colorado Springs. He was suffering from consumption, or tuberculosis, and believed that the climate and altitude would help him. Artus and Anne left Rookwood and began work at their new pottery on North Nevada Avenue in Colorado Springs in the fall of 1900. The pottery officially opened in 1901.

Creativity can be at its height during an artist's last days, and the quality of Van Briggle's work before his death lends credence to this notion. The observant student can identify a murky, sensuous symbolism in many of his last pieces. The young, recently married couple created their ware in the full knowledge that his life was ebbing, and the poignancy of their situation found expression in their work.

123

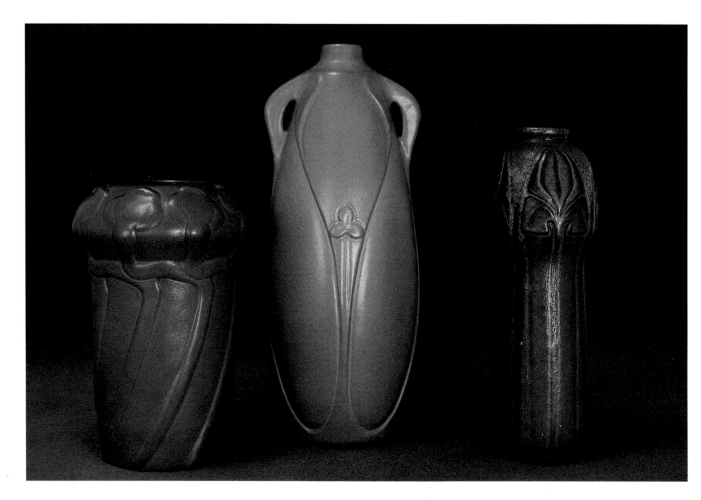

Above: An assortment of early Van Briggle ware.

Opposite: A fine example with a feathered matte green flambé.

Had they not left behind their masterpieces, the "Lorelei" and "Despondency," this might seem merely a romantic idea. The former depicts a lithe and beautiful woman, diaphanously shrouded, wrapped around a vase; the other, a full figure of a man in repose, his forehead in his hand and his body limp.

Not all their pieces were so elegiac: flowers provided the inspiration for most of their work. While Van Briggle's forms benefited from his proficiency in sculpting, the true mettle of his work was galvanized by his silky, "dead matte" glazes. Van Briggle was certainly influenced by the vegetal matte glazes of the Grueby Pottery, but he perfected a particularly dry and intense matte finish of his own and used this to coat his sculptural vases. The unique glazes were also employed on plain blanks, but these seldom approach the value of the molded, modeled ware.

Artus died in 1904, and Anne continued the pottery until she was bought out in 1912. The business is still in operation and continues to produce pottery that shows the Van Briggle influence—if not the quality and subtlety (or value!). The company has the rare distinction of being one of the only producers from the period never to go out of business.

Thanks to Artus and Anne's decision to date their ware (a feature they had in common with Rookwood), their work is easily evaluated

despite the subsequent history of the company. The pieces from the early period, prior to Van Briggle's death, are those most likely to be crisply modeled, nicely glazed, and well designed. Perhaps no pieces from 1900 survive, and only a few 1901 examples have surfaced in the last twenty-five years. From 1902, the first full year of production, enough pieces remain to indicate that the pottery was fully functioning at that time. Pieces dating from 1903, while uncommon, are the most abundant of his late ware. The year 1904, cut short by his death, seems to have generated about as many pieces as were made in 1902.

As one might expect, this early work is the most valuable and collectible. "The older the better" is a good rule of thumb and, while a desirable piece should have embossed decoration of some kind, any genuine early ware is a valuable piece of history. A word of caution: most pieces apparently dating from 1900 are not genuinely that early, but were made in 1906. The second "0" is usually a "6" partially glazed over. A dental X-ray authenticates the year simply and cheaply.

The next period of Van Briggle pottery covers 1905 through 1907. Again, the earlier the better in terms of value. This is considered the "middle period" of their early work. Anne, recovered to some extent from her husband's death, maintained a tight hold over the pottery and monitored the quality of production personally. While introducing new forms—many of which were not up to Artus's genius—the shape selection remained as imaginative and broad as that of any in the country.

The last "early" period, that from 1907 to 1912, was a time when better glazes were the norm, but new forms were erratic and production standards uneven. It is apparent that Anne was losing interest and, while maintaining quality, she didn't break new ground. When she was bought out by businessmen in 1912, the company changed direction as well as ownership.

Some respectable pieces of pottery were made by the Van Briggle company through the 1910s, but the new forms were clumsy at best, the glazes were flatter and less interesting, and the clarity of the molding declined. Overall, standards were lower, and Van Briggle became primarily a commercial ware.

The final period of Van Briggle's collectible production was the 1930s. Pieces made during this time will not be con-

Following pages: This tapering vase with embossed flowers has a feathered glaze (left). A 1902 version of a Lorelei with brown matte (right).

fused with superior artware. But production standards were still fairly strong until 1932, when the company did well simply to survive the Great Depression. All later work is considered "new" and is neither particularly valuable nor collectible.

In addition to the markings stamped or incised into the bottom of Van Briggle ware, the color and quality of glazing offer an indication of the period. Most collectors are familiar with the dense purple and blue "Persian Rose," and the equally turgid blue-green "Turquoise Ming," both of which are later standards and only poor adaptations of Van Briggle's earlier glory. With the rare exception of (equally insipid) white and pink matte surfaces, Persian and Turquoise were the only common glazes after the Depression.

By comparison, the early years saw a varied array of earth tones. Ochre, several greens, maroon, several blues, purple, and others—used alone or convincingly in tandem—were as much an expression of Van Briggle's creativity as were the pots these glazes covered. While the denseness and opacity of the earliest glazes gave way to more variegated, feathered surfaces from 1905-12, the overall quality was still exceptional. It was only after Anne's departure that the sluggish and repetitive finishes for which they're now more widely known became standard fare.

Van Briggle pottery is very robust, and damage is less common than with almost any other maker: as a generalization, Van Briggle is either in perfect condition or smashed altogether—and that is only a mild exaggeration. While its molded nature does allow for the same form being available from the later period, the earlier the piece and the better the form and glaze, the rarer it is—and the less the damage matters. Exquisite pieces of Van Briggle with more than minor damage have sold for thousands of dollars, although this happens less often than collectors might wish.

An 8-inch vase with embossed flowers and a good, single matte finish, dated 1900, might be worth 10,000 dollars. The same vase from 1901 would probably bring 7,500 dollars. From 1902, $3,000; 1903, $2,250; 1904, $1,750; 1905, $1,200; 1906, $1,100; 1907, $1,000; 1907-12, $800; 1913, $350; 1914-17, $300; 1918-25, $275; 1925-32, $225; post-1932, $100.

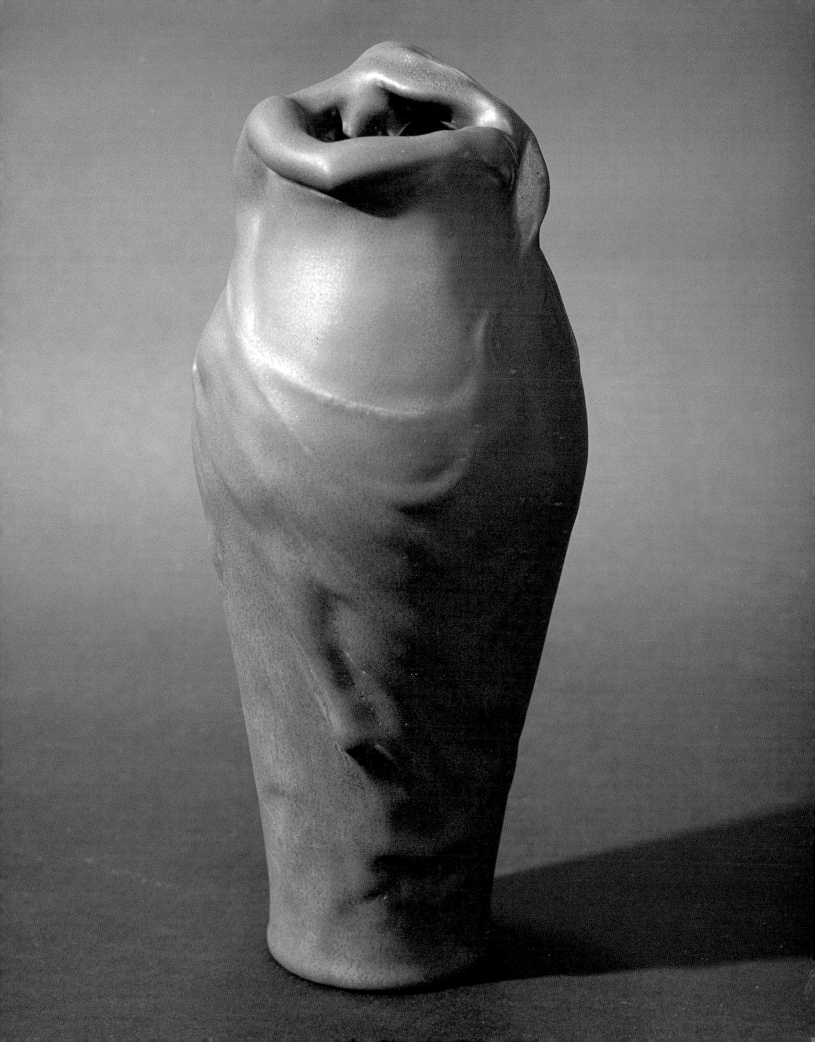

1903 Vases *Below*
This pair of two-color vases was produced in 1903. Both have embossed flowers along the top. Artus and Anne Van Briggle worked at their pottery together and used a double "A" (for Artus and Anne), enclosed in a square, to mark their ware.

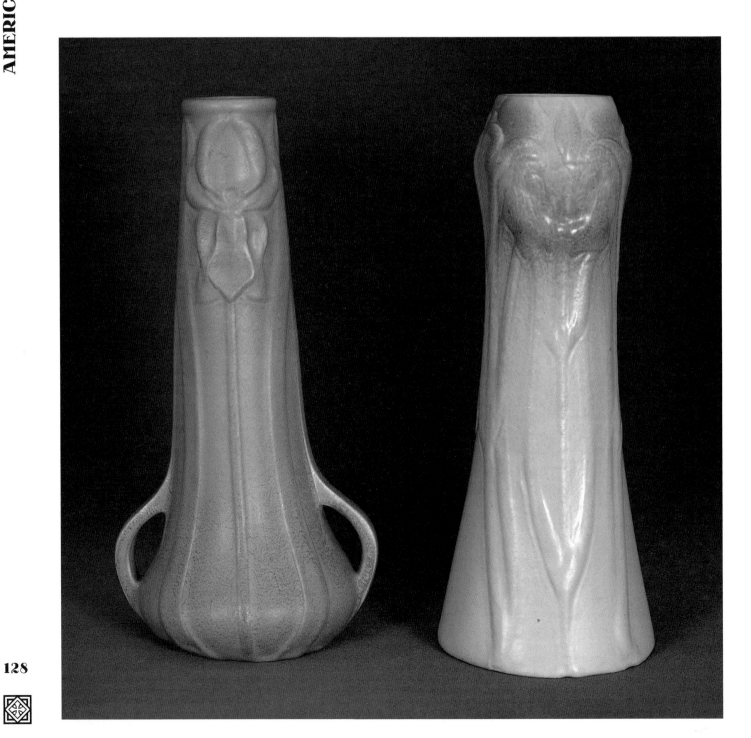

Vase with Morning Glory *Below*
*Embossed morning glory blooms
decorate this two-color ovoid vase from
1903. The tall, sensuous shape of the
piece provides a backdrop for the
sinuous curve of the flower. The pottery
that Artus Van Briggle created before he
died in 1904 is emotional and romantic
in nature.*

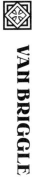

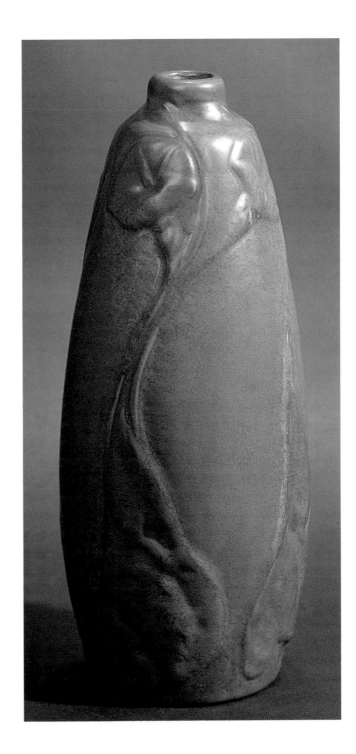

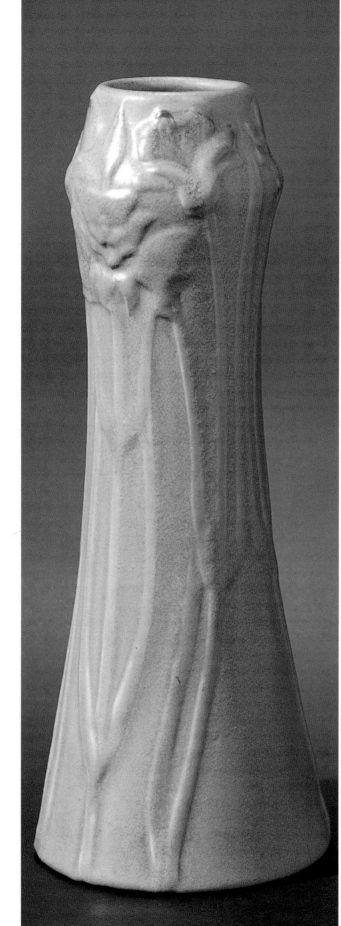

1903 Vase with Poppies *Left*
Crisply modeled, this 1903 vase is decorated with embossed poppies and a two-color glaze of green and yellow. The glazes were applied to the pieces with an atomizer that was run by compressed air.

1904 Vase with Leaves *Opposite*
This 1904 vase is decorated with embossed leaves and a red matte glaze. The bulbous mid-section of this small piece gradually tapers to a narrow mouth. Before 1908 most of the ware produced at the pottery was small.

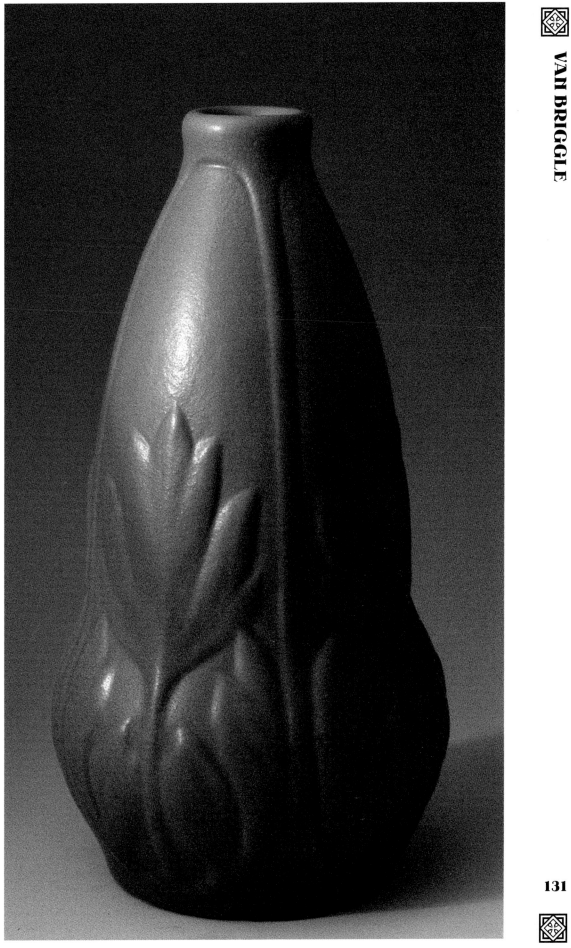

Pebbled Matte Finish *Below*
This 1906 bulbous bowl with pebbled matte finish is decorated with shades of blue and green. Embossed leaves wrap around the rim, creating a feeling of movement.

Climbing for Honey *Opposite*
Two applied bears climb playfully to the mouth of this cylindrical vase, shaped to resemble a beehive. This piece was produced in 1906, two years after Anne Van Briggle became president of the pottery and reorganized it as Van Briggle Company.

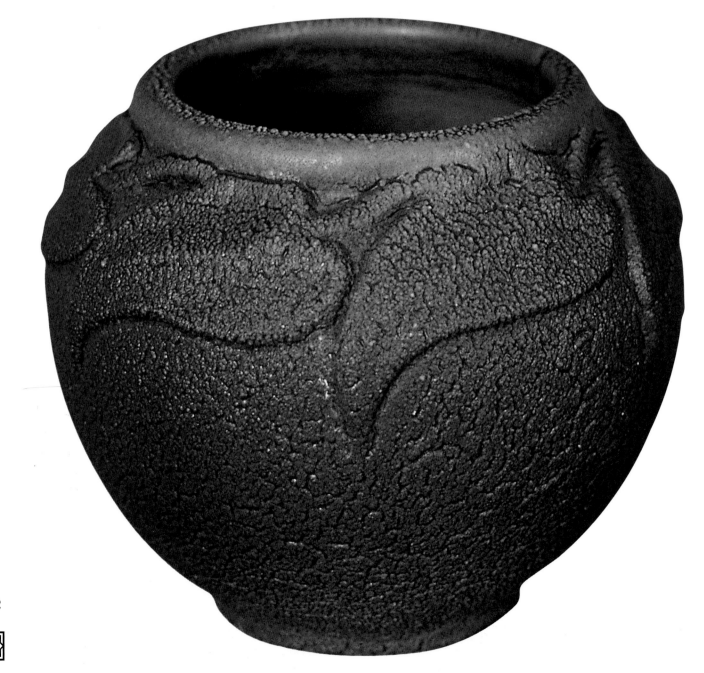

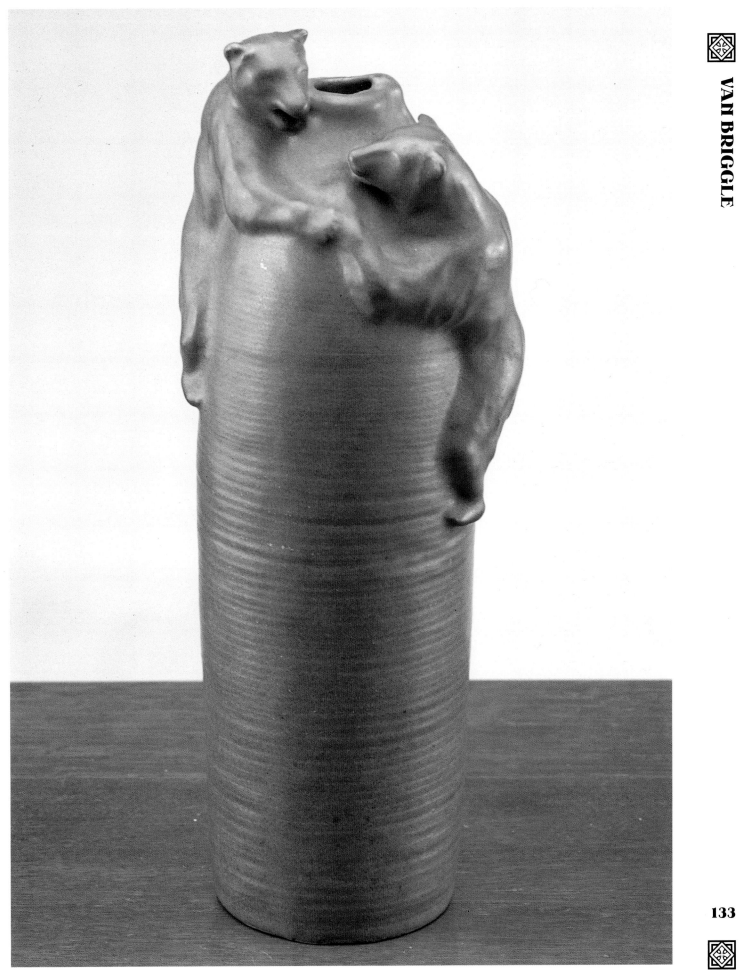

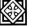

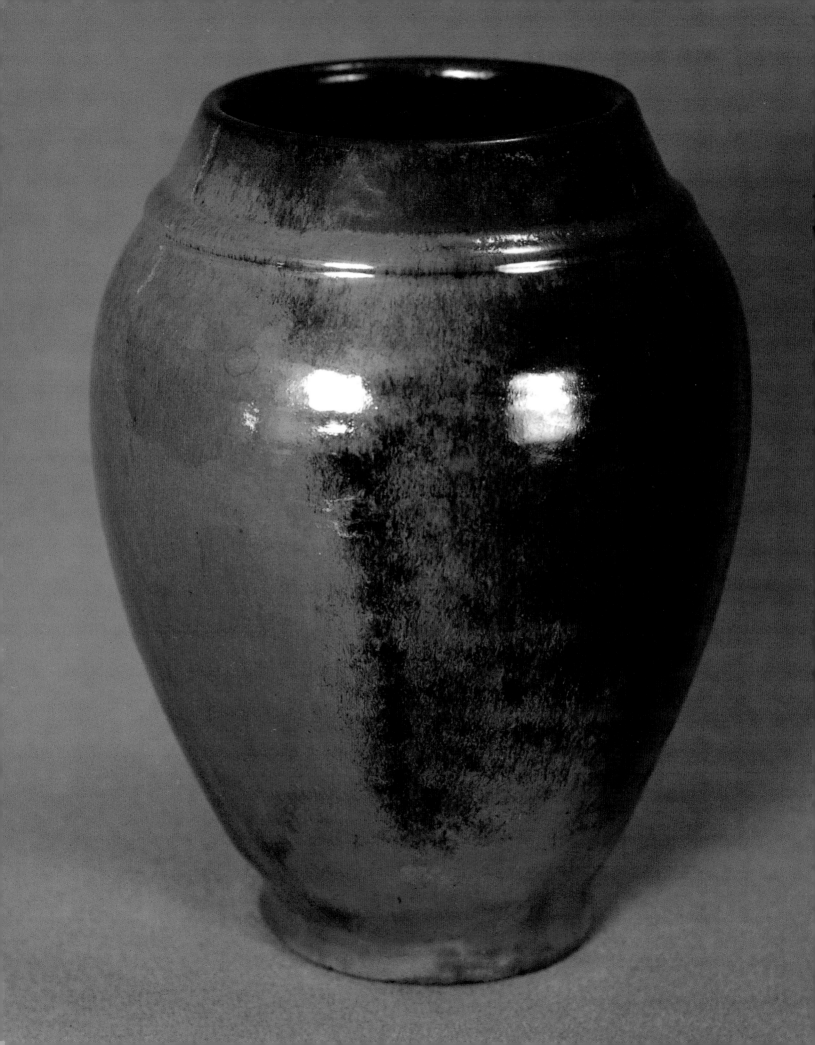

Pewabic

T he Pewabic Pottery, which began operation in Detroit, Michigan, in 1903, and remains in business today, produced two distinctly different types of ware, the first in response to the popularity of matte green glazes, and the second, on a course of their own, featuring scintillating, iridescent lustres and flambés. This was yet another pottery headed by a woman, and Ms. Mary Chase Perry directed the company well. Excepting the work of some students who tried their unsteady hands, Pewabic managed to produce a fine and consistent product for decades after the art pottery period had arguably ended. In fact, some of their most flamboyant and exciting work was made in the 1940s.

Pewabic's earliest work usually employed thick, matte glazes in green, ochre, dark blue, and light blue, over textured hand-thrown blanks. These finishes, like just about everyone else's, were distinctly their own, with fine matte crystalline veining and a peculiar dense dryness. They were seldom used in conjunction with other glazes.

Pots were crudely and heavily thrown, though the quality of construction was still superior to hand-built work. When decorated, Pewabic's pieces were usually carved deeply with naturalistic designs favoring leaves and seed pods. The majority of their matte work, however, consists of simply glazed vessels; you would do well to find a modeled example of any kind. Such work is nearly always marked with their early maple-leaf designation, though it is often obscured by the rich glazing.

This description of such important and germinal work flatters Pewabic's ware far less than it deserves. While these early pieces are often crude and ungainly when compared to the finer work of Grueby, they hold the spirit and promise of Ms. Perry's powerful vision at its earliest stages.

Perry's work soon changed to the exploration of nacreous flambé glazes on simple, hand-thrown forms. Even though her matte glazed work earned considerable respect, it was still derivative artware. Her iridescent pottery established her as one of the best and most

Opposite: This handmade bulbous vase is finished with an iridescent glaze that ranges in color from bright shades of green and blue to dark hues of brown and black.

135

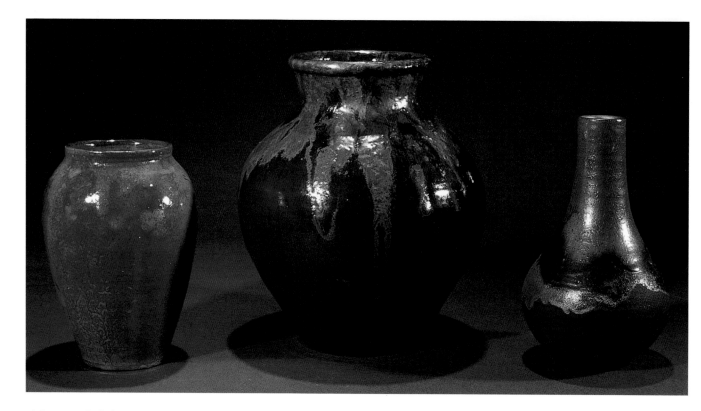

Above: Iridescent glazes were used to finish the three pieces above.

prolific producers and teachers in America. While the shape selection of this later work was remarkably similar to earlier efforts, the thick, organic matte glazes seem never to have been used again, and hand-modeling of any kind was scarce. Instead, primary and secondary glazed were mixed, or "intermodulated," to achieve often stunning effects.

To be sure, Pewabic produced their share of predictable and unimpressive vases and bowls. Yet, this sort of uninspired production was familiar to every potter's studio, even George Ohr's. When assessing the work of any of the period masters, you must sift through the ordinary and determine their genius by evaluating the pieces they considered their best artware.

Pewabic's signature work employs distinctive forms, often bottle-shaped bases with long necks, covered with deep gray, silvery blue, metallic green, and golden lustres. A combination of these fine finishes will further improve a piece's stature. Rarely, iridescent glazes are dripped over stark matte finishes for a striking effect. Rarer still, matte glazes are enhanced with a spider-webbed texture. Occasionally, mirrored lustres cover these iridescent surfaces for a limpid and striking finish.

Pewabic is unusual in that the quality of their work was not drastically affected by size. Larger pieces will often show modestly successful glazes, while numerous miniatures have extraordinary finishes. Nevertheless, a large pot with a great glaze is rare, desirable, and collectible. However, larger examples of carved, matte work remain the most valuable.

An 8-inch iridescent vase with a very good glaze, in perfect condition, is worth about $750. The same pot with a great, 2-color drip flambé might sell for as much as $2,000. An 8-inch carved matte green vase of modest character will sell for about $2,500. A 12-inch example with great modeling and texture would easily sell for $5,000.

Because Pewabic is a "one-of-a-kind" pottery, the price of their work is not severely diminished by minor damage. A small rim chip will reduce the value of a good piece by about 25 percent, and it will still be quite saleable. Because some Einsteins liked using their bottle forms for lamp bases, many of these have neat holes drilled through the center of the bottom. This kind of flaw will have less impact on value and saleability.

Below: Two early pieces of Pewabic pottery, one with relief decoration, the other incised, both with matte finishes.

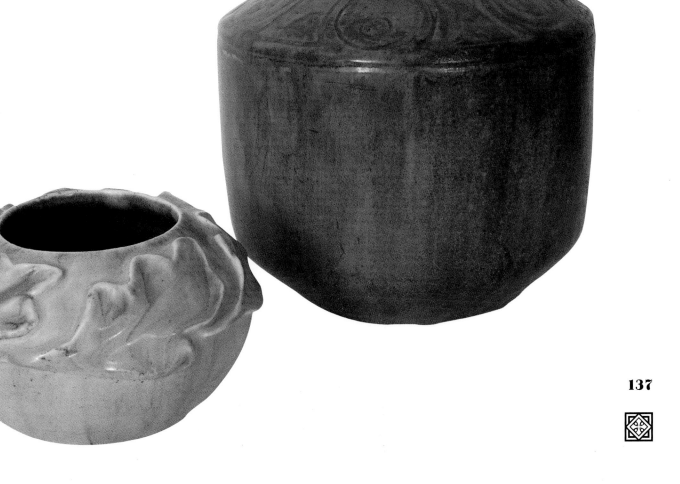

Rare and Unusual *Left and below*
The unusual bottle-shaped vase at left is finished with an iridescent glaze over a matte underglaze, while the vase below has a matte finish and deeply carved decoration. Mary Chase Perry was responsible for developing both forms and glazes for the ware; it is the latter for which Pewabic is famous.

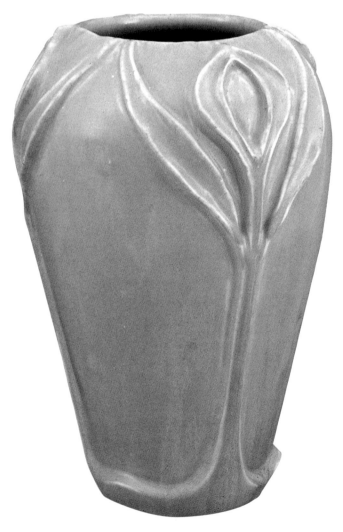

Iridescent and Matte Glazes *Below*
The fine, tall vase at right has a flaring rim and is finished with Pewabic's iridescent flambé. The exceptional two-color vase on the left is decorated with carved leaves of unusual depth. The body of the vase has a matte finish, while the leaves bear a contrasting matte glaze.

Assortment of Iridescent Ware

Below and opposite

This selection of Pewabic's ware demonstrates the variety of iridescent glazes that were used at the studio. These finishes were often so thick that the impressed backstamp used to mark the vessels was obscured.

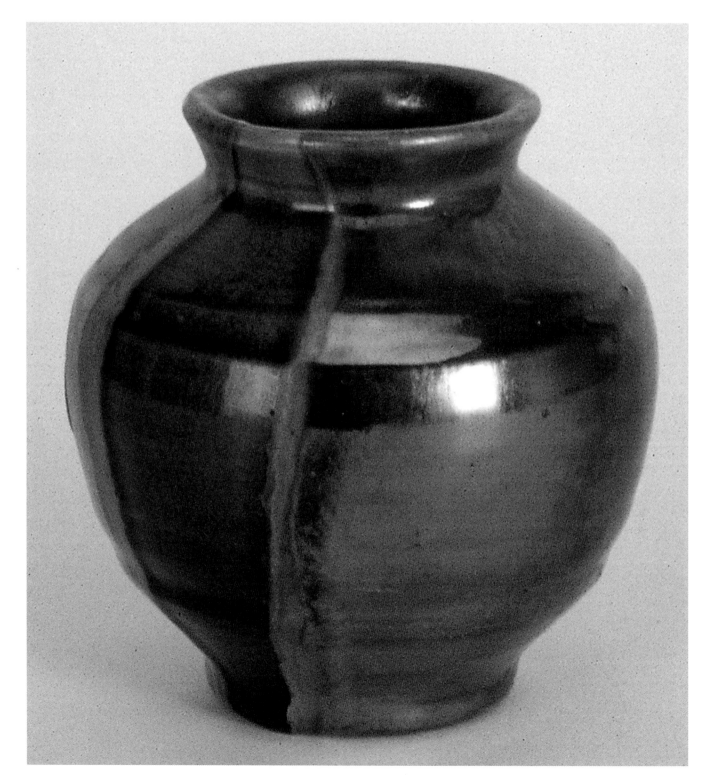

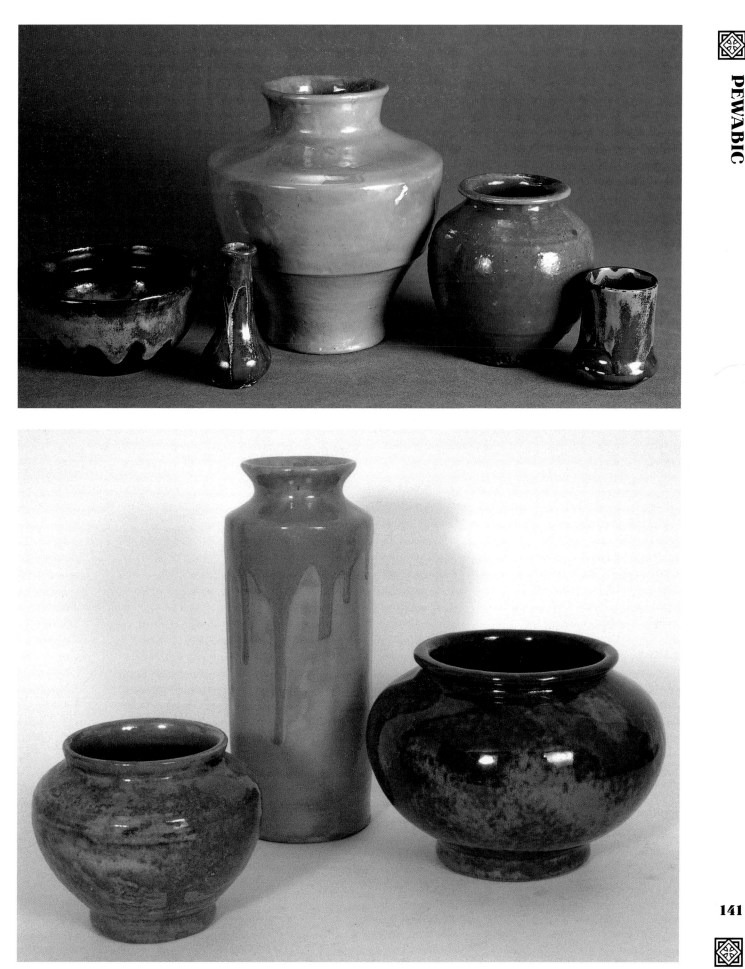

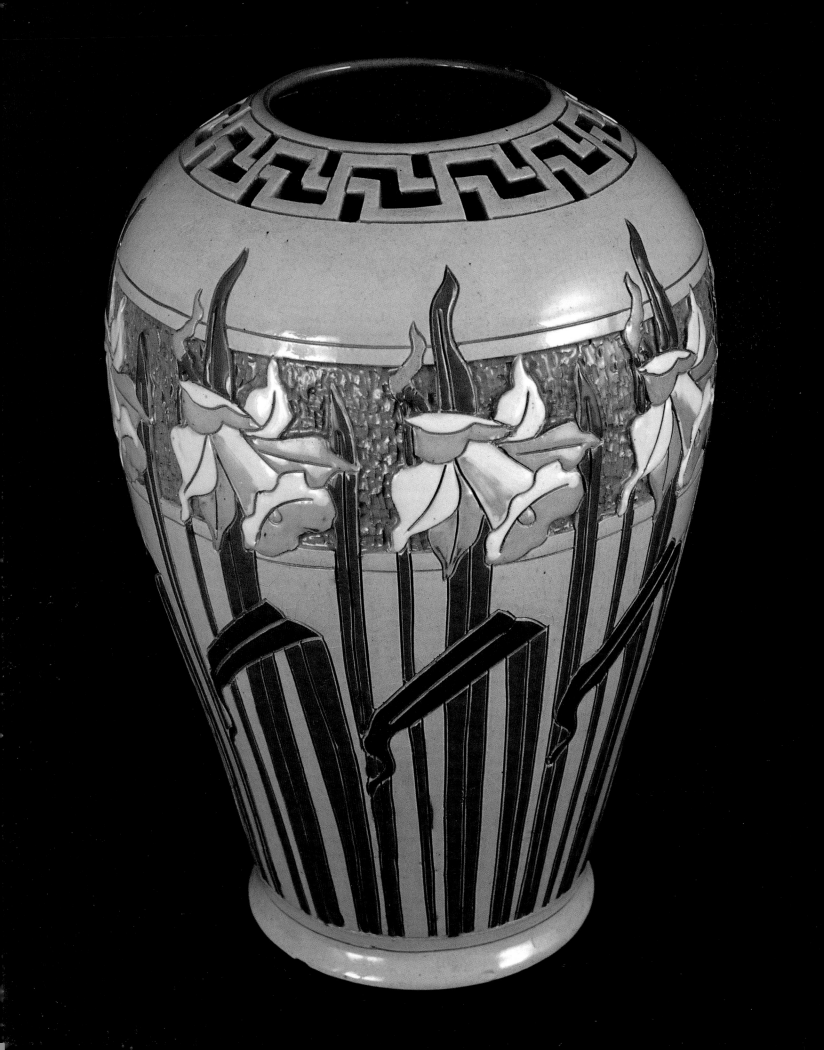

Roseville 🦋

One of the most famous and enduring ceramic producers in America was Roseville Pottery Company of Zanesville, Ohio, producing high-quality artware from 1900 until about 1908 (production continued until 1954). This company mirrored the flow and ebb of the ceramic industry in America: a careful examination of their history will yield much information to students of the craft.

Beginning as a producer of simple utilitarian pottery such as umbrella stands and cuspidors, Roseville was one of many companies to respond to the growing market for decorative ware. Zanesville was a town full of competing potteries, and this tension was critical in forming a complex and varied product: the range of Roseville's ceramic ran the gamut from world-class design to mass-produced commercial pottery.

The cross-pollination between Roseville and other local giants such as Weller and J.B. Owens, where ideas were stolen freely and department heads and artists were lured from one factory to another, resulted often in similar lines with similar names (as in Roseville's Fudji and Weller's Fudzi) and, less often, in superior pots with sophisticated decorative techniques (Roseville's Della Robbia and Weller's Sicardo). The unevenness of quality and design of the Zanesville potteries, and their dependence on less expensive copies of lines popularized by companies like Cincinnati's Rookwood Pottery, had relegated them to second-level status.

Nevertheless, when one considers the unique artware produced at Roseville during their early period, it is clear that they were serious purveyors of the craft. Masters like Frederick Rhead and Gazo (Fudji) Fujiyama taught new techniques to a large and enthusiastic staff. Their work there established firmly Roseville's capacity to produce superior artware. It is the groundbreaking work of such artists as these that brought them the most credibility.

The market for expensive, labor-intensive artware dwindled slowly around 1908 and, like many competing factories, Roseville changed

Opposite: This large and bulbous vase is an exceptional example of Roseville's Della Robbia line. In 1906 seventy-two different versions of Della Robbia ware were introduced by the line's creator, Frederick Hürten Rhead.

143

Right: An assortment of Roseville's production ware. While other potteries struggled to create an interesting line of production ware, Roseville produced one that was both imaginative and aesthetically pleasing.

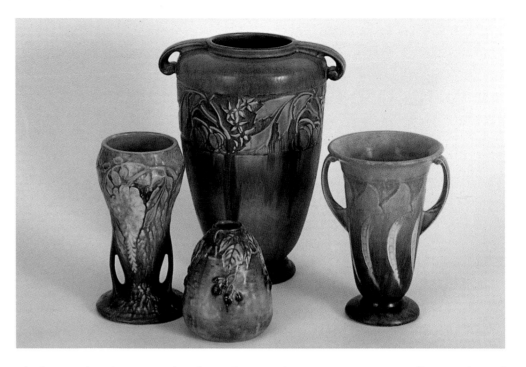

their production standards in favor of more commercially produced ware. Hand painting gave way to transfer decoration, and modeled design became molded decoration. It was, in fact, Roseville's ability to adapt that became their most enviable attribute: throughout their history, they produced the best quality and design of any of their immediate competitors.

During their early period, for example, having hired the already famous Frederick Rhead (who is represented in this book with a chapter of his own), the company introduced in 1906 a line of 72 versions of his Della Robbia ware, named for the Renaissance master. This work is typified by excised, or cut back, stylized designs of flowers and, occasionally, people. This was a time-consuming technique wherein the original surface of the pot was left alone, and the design's surrounding areas cut away, sometimes ⅛ inch deep, to produce an intricate and stylized decorative motif. The original surface was further decorated with incised shading and detailing, and finished off with polychrome enameling.

Several years later, a second Della Robbia line replaced the first. Here, the excising was less intricate, only two colors were used, and enameling was no longer present. The shape selection was a fraction of the first line's—perhaps one-third as many variations. Judging by the relative scarcity even of this second line, production was equally short-lived. As with all of Roseville's local competitors, the production of artist-decorated ware had ceased by World War I. However, adversity seems to have been Roseville's strong suit. The uninteresting production ware that was the bane of most American pottery companies achieved its highest level of aesthetic and commercial success there. Roseville, it seems, was just beginning to hit their stride.

While the company's early attempts at commercial ware were far from their best, they indicated Roseville's commitment to continuing the tradition of good, marketable pottery. By the 1920s, after introducing a series of new lines including Sunflower and Jonquil, it was clear that they were willing to integrate international design trends, distill them into a pleasing variety of shapes and sizes, and maintain a consistent level of quality. While the handwork on these pieces was restricted to painting color over embossed, molded designs, the effects achieved were bold and proved to be popular with the buying public. For example, when the influence of Art Deco moved west from France, Roseville introduced its Futura line: numerous vases, bowls, jardinières, pedestals, and candlesticks reflected this brash, angular aesthetic. This was, and is, their most popular commercial line, examples of which are proudly displayed on the shelves of schoolteachers and movie stars alike.

The production of art pottery was threatened again in 1929, by the Depression. While the few remaining art potteries were either shut down (as with Cleveland's Cowan Pottery) or forced to make serious compromises (as in the case of New Jersey's Fulper Pottery), Roseville revamped their production line to reflect a softer, more commercially viable standard. Though not as intense and striking as Futura and Sunflower, such creations as Cosmos, Dawn, Poppy, and Pinecone proved to be handsome additions to their résumé.

Still another production change was necessitated by World War II, resulting in a weaker, prettier commercial ware. Despite the need to

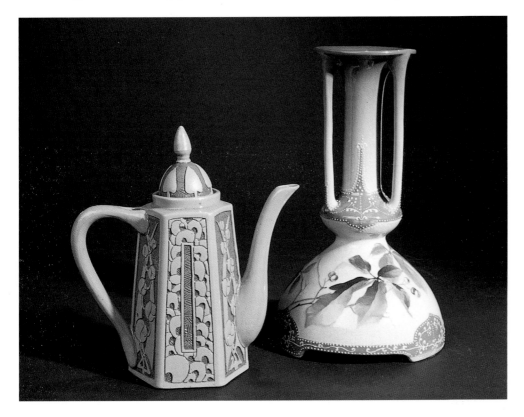

Left: A Della Robbia teapot and an unusual three-handled and three-footed Rozane Royale light vase. The vase is a rare example because of the added squeezebag decoration.

forego the highest standard, these later designs were the best such pottery made in America, even if they lacked much of the elegance and consistency of earlier work. The last design change occurred in the 1950s, when a rather banal, if streamlined, work signaled the company's last days. They closed operations in 1954.

It is difficult to evaluate Roseville's pottery, because they made so many levels of work over so long a period. For example, their best Della Robbia pieces from the early art period will range in value from $1,000 to $30,000, depending upon size, design, and condition (the technique demanded a softer clay, one less able to resist damage). The second Della Robbia line will sell for $1,000 to about $4,000.

Early commercial ware, such as Carnelian I and Imperial I, are relatively uninteresting creations and generally sell in the low $100s. However, Carnelian II and Imperial II are pots of a different color, and it is not uncommon for larger, better pieces to bring between $1,000 and $2,000. Their most popular 1920s line, Sunflower, is a perennial favorite and ranges in price from $400 to $1,500.

Lines from the 1930s, such as Pinecone and Poppy, will generally sell for $150 to $1,000. Innovations of the 1940s, like Clematis and Snowberry, are in the low hundreds. Their last work, such as Raymore and Mock Orange, are similarly priced.

Minor damage is usually acceptable, if not expected, on such lines as Della Robbia, although less tolerated on other art lines like Woodland and Fudji. The opposite is the case with their later production ware: its collectors have established themselves as the finickiest buyers in the market. This too, however, has shown change, as prices have risen dramatically and the availability of larger pieces in better lines has dwindled.

Opposite: This example of Della Robbia ware is decorated with water lilies and pierced with decorative reticulations along the rim. Rhead, the creator of this line, worked at Roseville from 1904 until 1908, when his brother, Harry, replaced him as art director.

Right and above: An assortment of four Della Robbia pieces. The top view of the second vase from the right, shown above, demonstrates the intricate sgraffito and enameling process used to decorate the first version of Della Robbia ware.

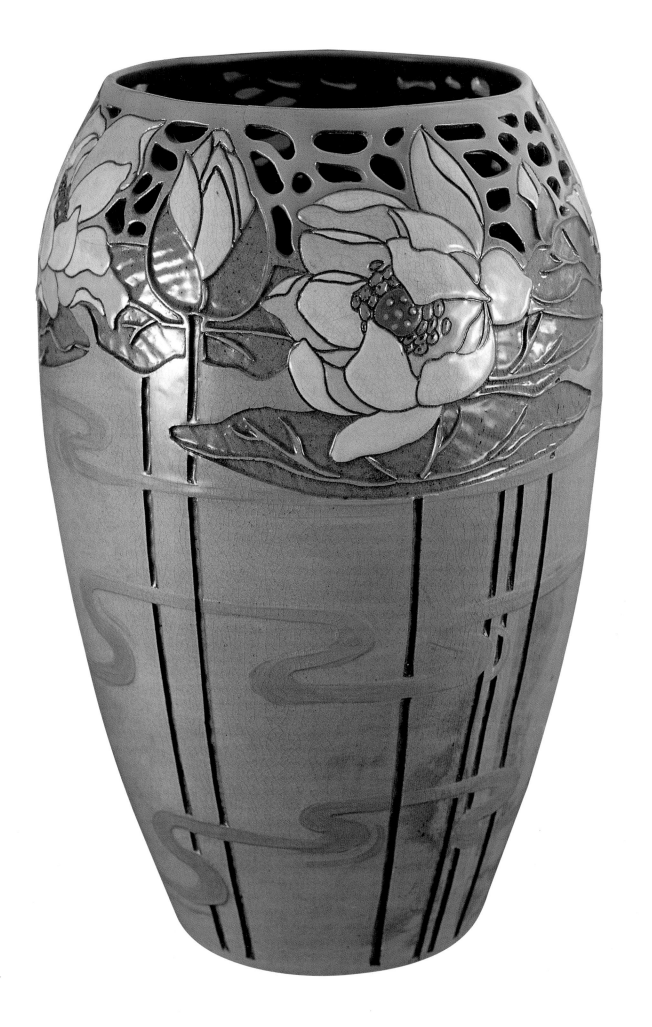

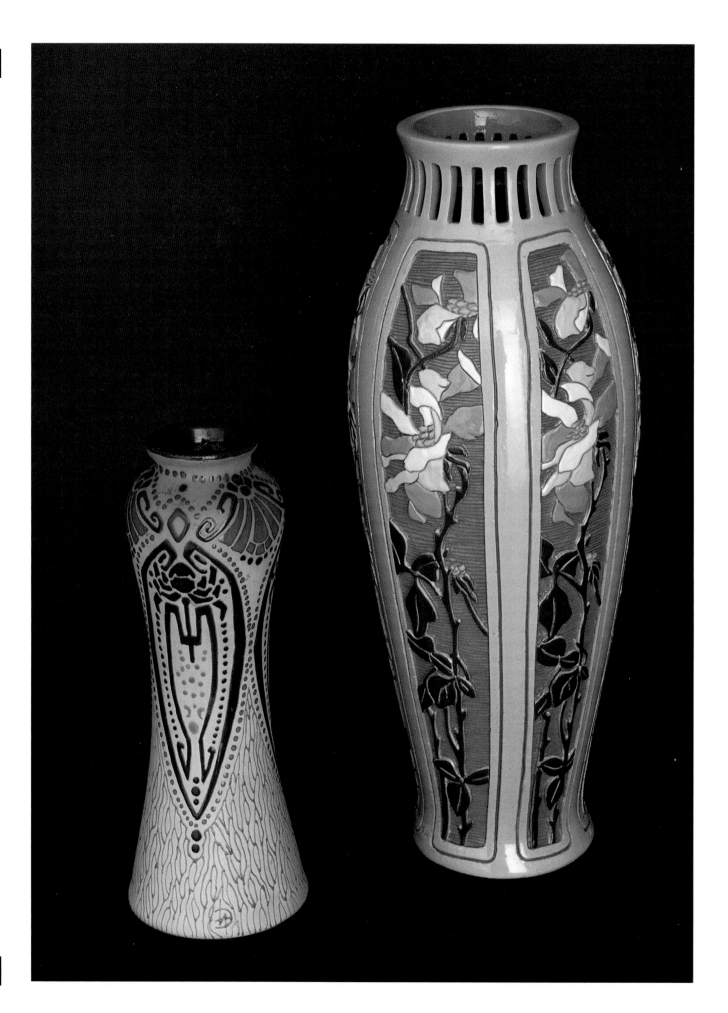

Fujiyama and Della Robbia Ware

Opposite

The vase at left is an example of a corseted Fujiyama with enameled glazing. The line was named for its creator, Gazo (Fudji) Fujiyama, a Japanese artist at Roseville. The tall, reticulated Della Robbia vase at right is decorated with poppies.

Della Robbia and Fujiyama Ware *Below*

The two pieces of Della Robbia ware at left demonstrate a few of the many different decorative styles that were used to finish Roseville's pottery. During the four years that he worked at Roseville, Frederick Rhead also created the company's Aztec and Olympic lines. The vase on the right is a rare example of Fujiyama, because of both the coloration and the artist's signature.

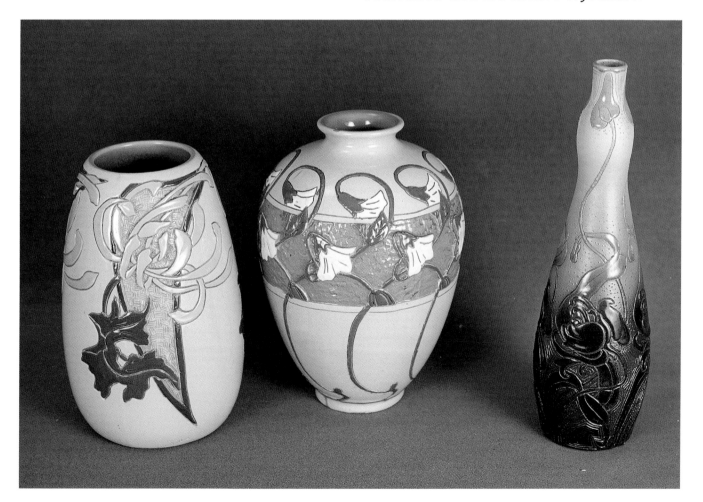

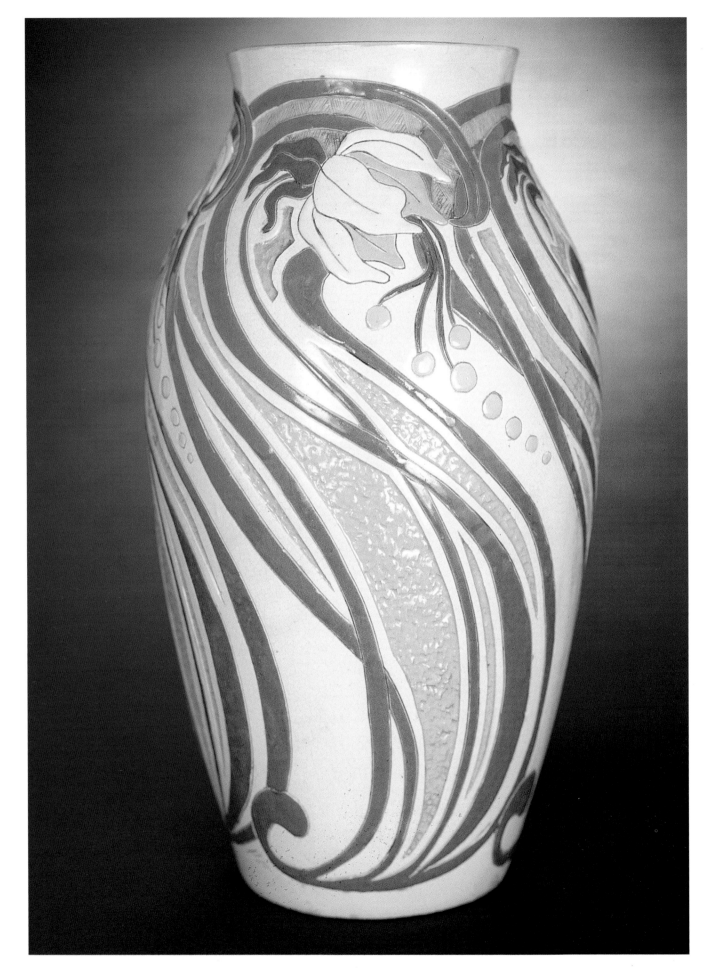

Della Robbia Ware *Opposite, right, and below*
The tall, bulbous Della Robbia vase on the opposite page is decorated with swirling leaves and flowers, creating a feeling of movement. The high standards of design engendered by the spirit of competition among the Zanesville potteries are apparent in this piece. The tall vase at right is decorated with the figure of a cavalier, while the tapering vase below bears stylized trees. Both demonstrate the sgraffito process and enameled glazing.

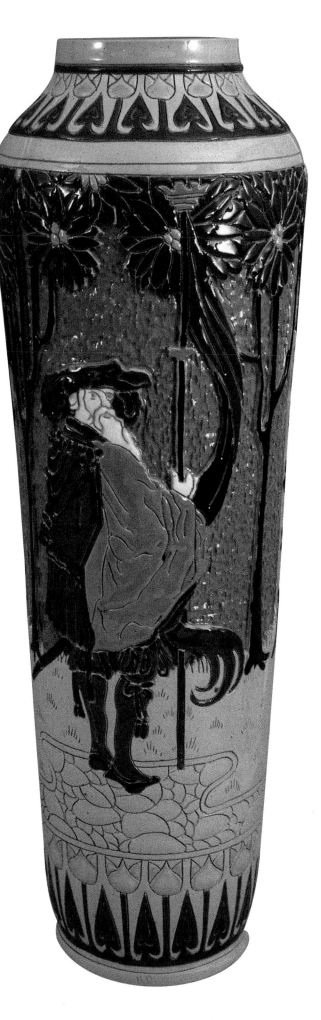

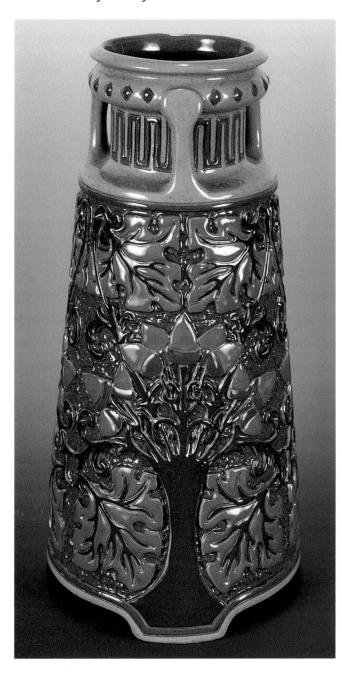

Roseville Production Ware *Below*
*These four pieces are typical of
Roseville's production ware, a more
commercial line that was usually molded
and decorated merely by having an artist
brush color over the raised designs.*

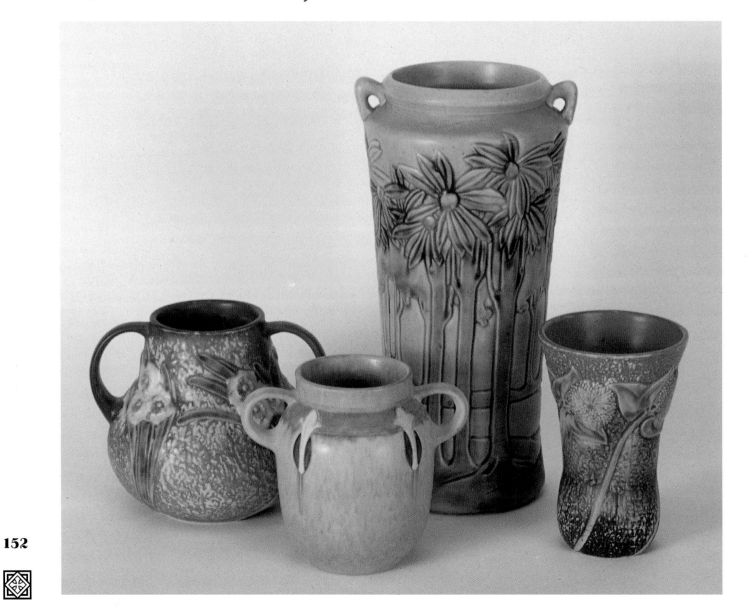

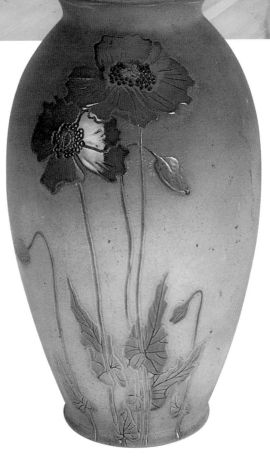

A Selection of Roseville Ware

Above and right

The impressive grouping above demonstrates the versatility that was primarily responsible for Roseville's longevity. The bulbous vase with flaring rim at right is from the Rozane Woodland line. Incised decoration surrounds the glazed design of the flowers.

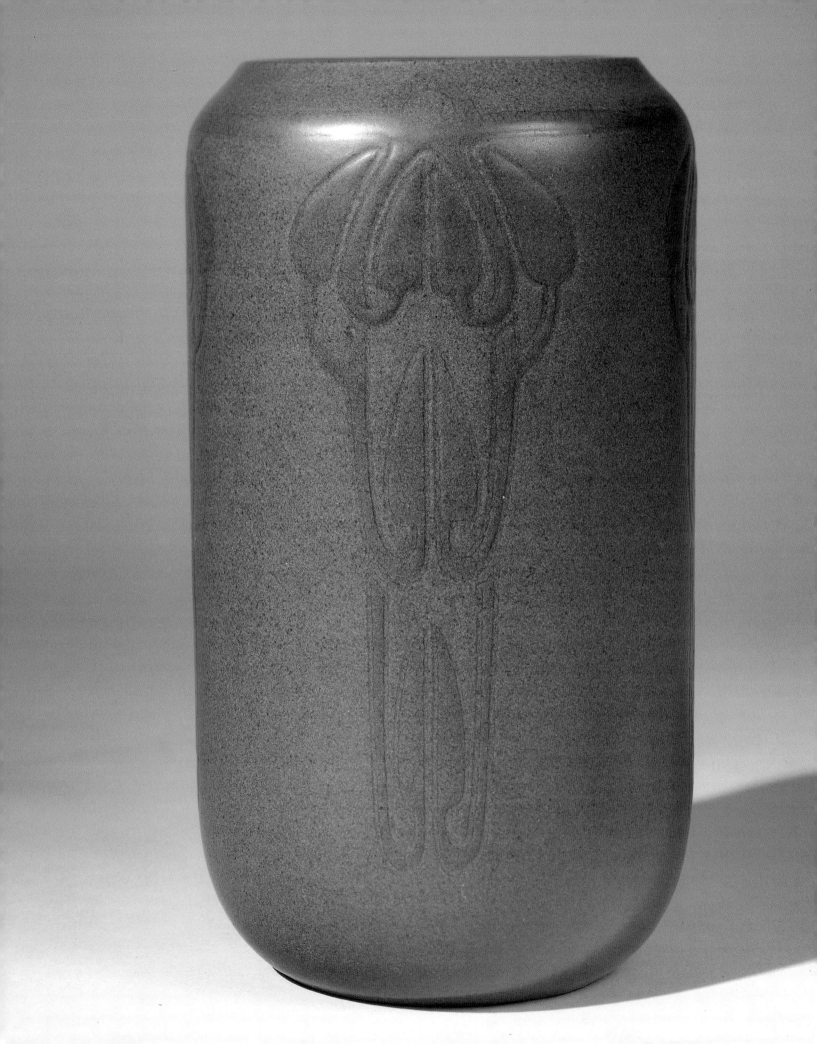

Marblehead

The Marblehead Pottery of Marblehead, Massachusetts, was one of the rare small-studio operations that produced a subtle ware of consistently fine quality, all the while carving out their own special piece of the art pottery market. Originally conceived in 1904 to teach ceramics to sanitarium patients at Devereux Mansion as convalescent therapy, it slowly grew into one of the great small potteries of the twentieth century.

Arthur Baggs, who studied under the master Charles Fergus Binns at Alfred University in New York State, was the director of pottery operations at Marblehead from about 1905 until the pottery closed in 1936. He championed a rather austere decorative style which employed bold, geometric designs, often hand-incised and surface painted, into backgrounds of marginally contrasting color. The earliest work often bears simple "nautical" designs, such as stylized waves and harpoons, on matte pebbled grounds.

While these wares are among the least appreciated that the company produced, they remain the most unique and inspired in a very naive way. Although Frederick Rhead's formative work at Jervis, and the clumsy stylization of the early Newcomb decorators, seldom attract the same interest as their high-styled, mature production, they remain important in how they define the earliest and purest vision of the founders. The quirky and starkly Arts and Crafts work from Marblehead's early years offers a similar glimpse.

It was probably a combination of a maturing style and the preferences of the market for a less austere ware that precipitated gradual stylistic changes. Where earlier pieces were seldom decorated in more than two colors, by 1910 the company had shifted to a prettier, more decorative output. The addition of more colors, sometimes five or six, to decoration and the adaptation of curvilinear, floriform designs was sure to have been more commercially viable.

There was a brief window of time when these lighter designs were still rendered by discerning hands, where the stark severity of the European school merged effectively with a more elegant, organic

Opposite: This two-color cylindrical vase demonstrates incised and surface-painted decoration [Herschell and Asher Gallery, New York City].

style. In many ways, this marks the acme of Marblehead's achievement. This transitional work is distinguished by tightly drawn and gently incised motifs in colors sharply contrasting to lighter grounds, offering excellent clarity. Nevertheless, the vast majority of the pottery Marblehead produced was finely thrown and covered with the hard, pebbled matte finishes that were their trademark.

As the company continued into the 1920s, there was a gradual decline in the designs Marblehead employed, and the craftsmanship used to render them. Incising and gentle modeling gave way to work that was entirely surface-painted. Designs were more often repeated, and merely stenciled on the sides of pots. The motifs employed shifted from the Arts and Crafts standards on which the pottery had cut its teeth, becoming even more decorative and mainstream. Memorable in its extravagance is a large ovoid vase with a surface-painted cockatoo in polychrome, mistaken for a masterpiece because of its size, but more accurately remembered as a minor work trapped in the body of a museum piece.

No chapter on Marblehead would be complete without mentioning the superior "commercial" ware that dominated their production. In fact, few American potteries lavished such attention on their everyday ware as did Marblehead. Most of their work, perhaps 95 percent, falls into this category. Such pieces, usually small, are hand-thrown and covered with the same excellent glazes, which served as the only decoration.

Most Marblehead is small—under 5 inches—except for their earlier decorated work, which is often 8 inches or larger. They used a host of matte finishes, the most common colors being dark blue, dark and light green, pink, yellow, brown, gray, and orange. The only molded pieces the

Below: A pair of early hand-thrown candlesticks with stark geometric decoration.

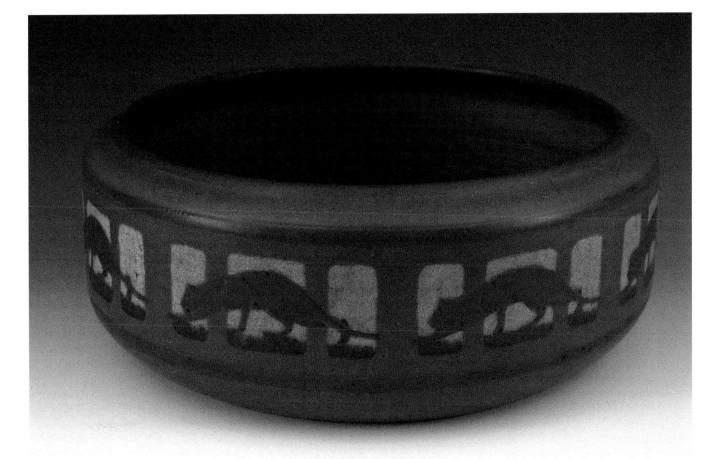

company produced were figural perfume jars, bookends, and tiles. A series of molded pitchers with embossed boats was part of their later production line.

Marblehead produced a hard and durable ware, so damage is less frequent than with most potteries. Yet, in spite of its unique, hand-thrown nature, and the rarity of their best decorated pieces, damaged ware seems very underpriced at the time of this writing. Once again, buying very good to great Marblehead with minor damage seems prescient.

A 4-inch decorated, 2-color, and incised geometric vase would be worth about $1,200. An early version, 7 inches tall, with a striking, Arts and Crafts design, would be worth about $3,500. A later, uninspired piece with stylized leaves surface-painted in 2 colors might bring $800. Damage on any of these will reduce the price by 40 to 50 percent.

Above: Entitled the "Stalking Panthers" bowl, this sturdy piece shows the conventionalized design and durability that characterize Marblehead ware.

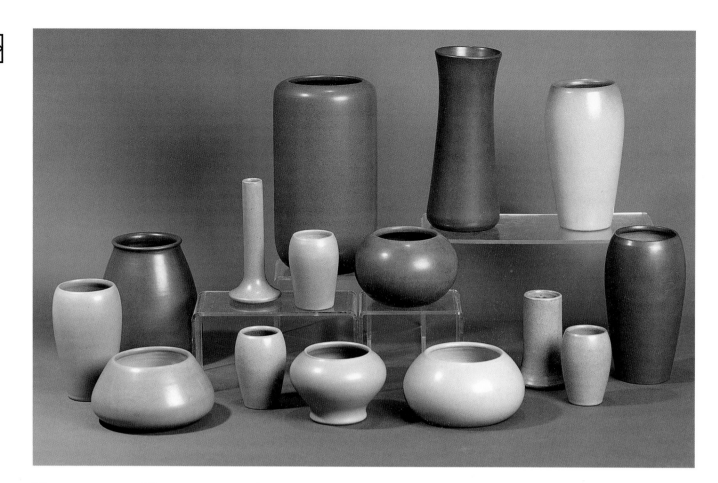

Undecorated Marblehead Ware *Above*
This selection demonstrates the studio's
impressive matte glazes and the variety
of simple shapes it offered. Most
Marblehead ware is marked with a ship
and "MP" cipher.

Two-color Finish *Opposite*
This bulbous vase, with a two-color matte
glaze and tapering neck, is typical of the
pottery's early geometric ware. Patients
at the sanitarium worked at decorating
the pottery and were paid for their time.

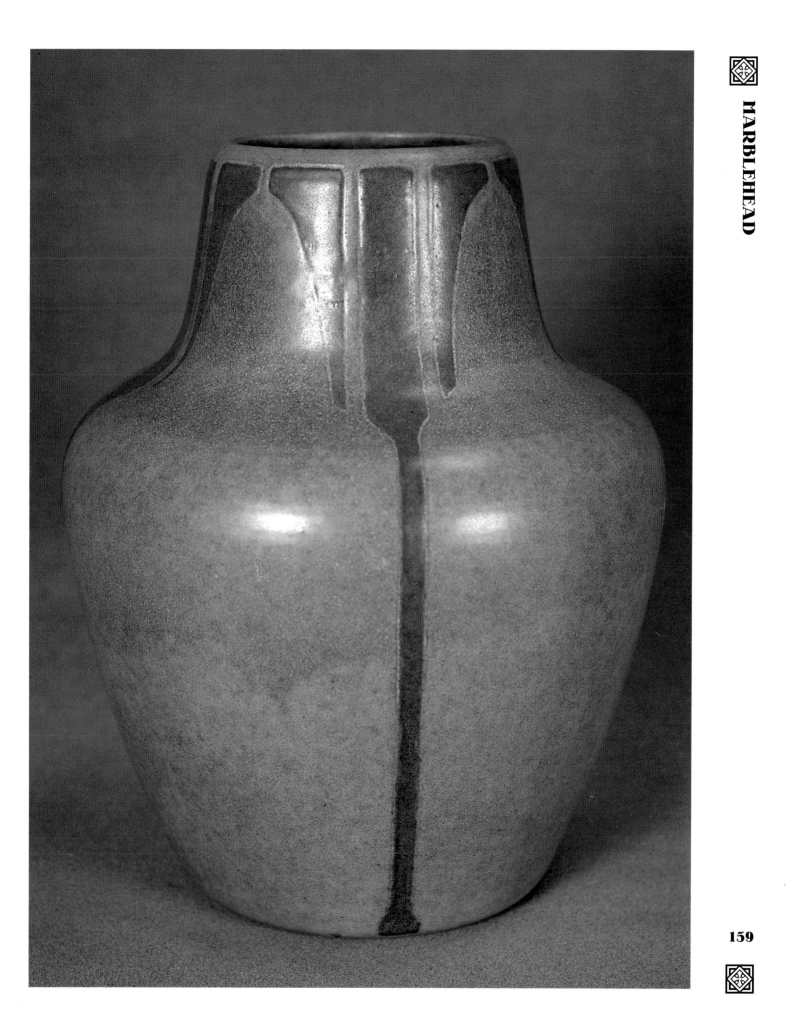

Floral Motif *Below*
Both of these squat vases were finished with three different matte colors and decorated with repeating flowers that wrap around the rim.

Abstract Decoration *Opposite*
This cylindrical vase is decorated with a repeating abstract design that was painted and incised directly onto the piece. Decoration was sparse at Marblehead: it favored simple, flat designs over naturalistic representations.

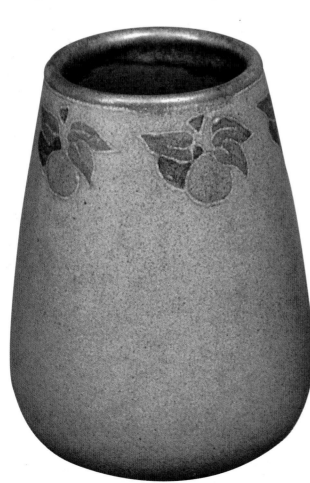
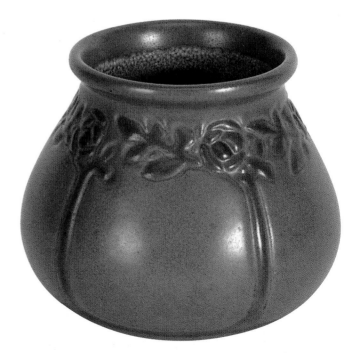

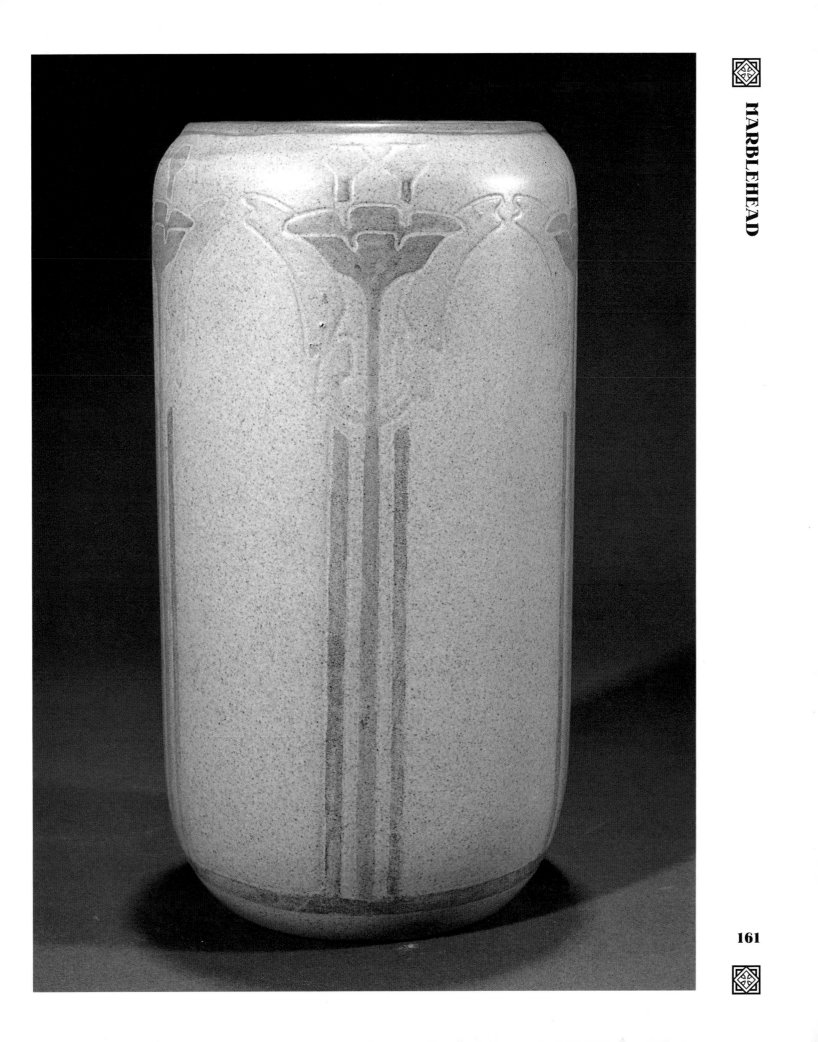

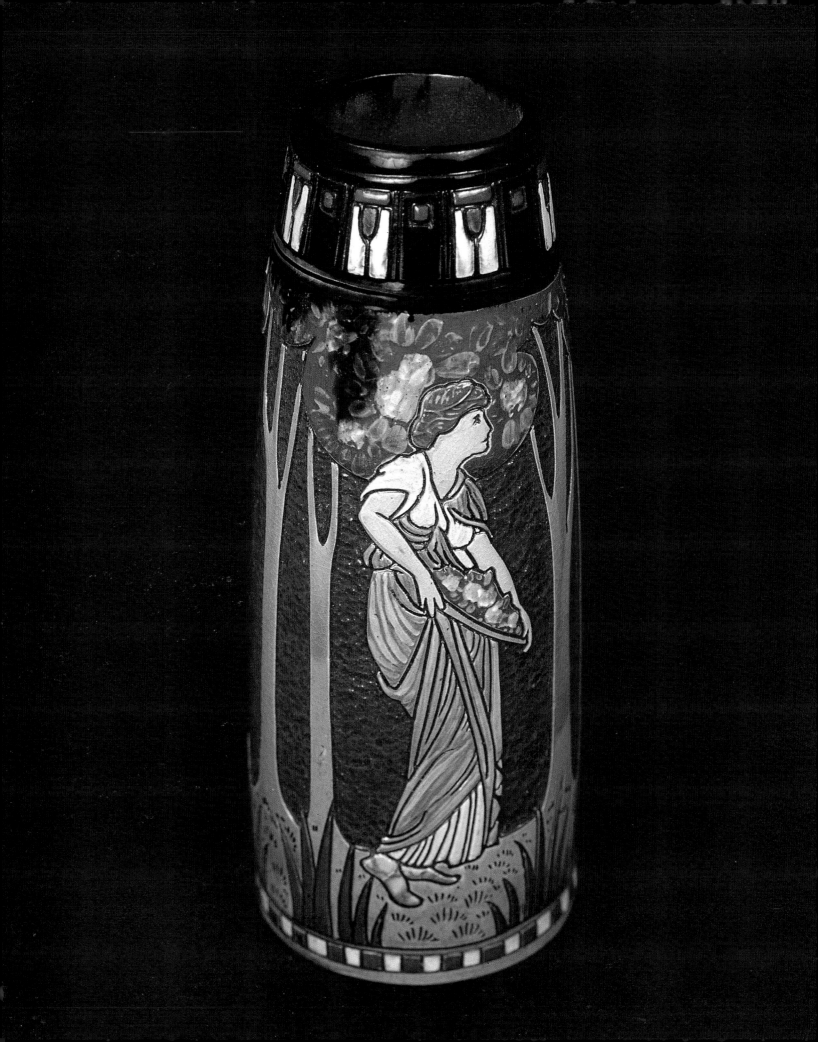

Frederick Rhead

Frederick Rhead was an English-born ceramist who became one of America's premier art potters: to review his career is to trace the growth and direction of the decorative ceramics industry in America. During the forty years that Rhead potted and decorated in this country, he significantly influenced or managed ten companies, including small studios, large factories, well-intentioned experiments, and even a sanitarium.

Emigrating from England in 1902, Rhead started as a decorator for Avon Pottery Works in Wheeling, West Virginia. Bringing with him the slip-trail, or "squeezebag," technique he had learned as art director of England's Wardle Pottery in 1899, he soon defined Avon's best and most interesting work. Most examples show black, stylized trees on shaded dark grounds. Better pieces have a sharp white or yellow beaded edge outlining and detailing stylized floral and landscape designs. Occasionally, a light incised modeling, or sgraffito, decoration of the background adds to the quality. As one might suspect, his work at this time was strongly reminiscent of his accomplishments at Wardle.

Rhead next worked for Weller Pottery in 1904 and, in Zanesville, Ohio, he enjoyed levels of artistic freedom that he had not known before. Zanesville boasted a burgeoning ceramics industry: its rich Ohio Valley clay deposits and access to several major rivers for product distribution made the community a regional powerhouse. The competition created by no fewer than five major potteries in so small an area fueled a creative bonanza for Zanesville, and for the American ceramics industry in general, as top artists from around the world were hired to ply their craft for art and commerce.

Rhead created several lines for Weller, the most famous of which was Jap Birdimal, a squeezebag ware usually depicting Geisha and stylized Oriental landscapes. Rarer, though not necessarily better, are flatly rendered designs of just about anything—some collectors seem to like a line that shows repeating bunnies. While Rhead's designs and techniques for Weller reflected his earlier efforts, a subtle change in both is first noted during this period.

Opposite:
Stylized trees surround the classical figure on the vase on the opposite page, which bears Rhead's signature. He created it during his employment at Jervis.

163

Below: Rhead decorated this one-handled mug with a rooster in flat squeezebag while he was working at Weller (1904). It exemplifies the style that is known today as Rhead Faience.

Rhead's greatest commercial success was achieved at Weller's crosstown rival, Roseville Pottery Company, where he worked from 1904 until 1908. As one of the company's cadre of famous designers, Rhead introduced in 1906 his Della Robbia ware—a line of seventy-two forms with excised, enameled, and/or incised decoration. Motifs included flowers, animals, birds, and the human form, and stylistic influences included Classical, Art Nouveau, Oriental, and English Arts and Crafts elements.

Rhead left Roseville Pottery in 1908 to assist his friend William Jervis in establishing Jervis Pottery in Oyster Bay, Long Island; the two had worked together at Avon Pottery five years earlier. Rhead left the huge factories of Zanesville behind to work in fairly modest environs. In reviewing about fifty pieces produced by this firm, one can surmise that production was small and facilities crude. The shape selection was very limited, the red clay used was rather coarse, and the design elements were often repeated. Nevertheless, Rhead's work here was dramatically simpler and more understated than in Zanesville. Even though he occasionally borrowed designs and forms directly from his earlier Della Robbia line, the end result was more serious and austere; his exaggerated use of color and surface manipulation were less expressive but, somehow, more intense. During this period, Rhead still excised and incised designs, but his use of enameling was limited. It is interesting to note how a maturing Rhead brought ideas and forms from one company to the next and, while maintaining a visual link with his earlier decorative elements, changed from one incarnation to another.

Rhead's brief stay with Jervis was followed by his association with a short-lived experiment in University City, Missouri, at University City Pottery (1909–11). Edward G. Lewis, an enthusiastic businessman with questionable ethics, lured some of the best potters and ceramic designers in the world to his firm to form an impressive staff. Notables included the Frenchmen Emile Diffloth and Sèvres artist Taxile Doat, American master Adelaide Robineau, and Rhead's talented wife, Agnes Rhead. This cross-pollination of talent and ideas was the central theme of early twentieth-century American art, and University City, although ill conceived as a business, was a melting pot for ceramic genius.

At UC, Rhead's work gave clear indication that his flamboyant decorative style was giving way to a more restrained expression. Three examples of University City pottery bearing

Rhead's hand-incised signature were seen to be heavily decorated, but atypically rectilinear and conventionalized. Excising, a style at which he excelled, gave way to incising. Bright multi-color enameling became patchworks of softer matte hues. And the designs themselves became harder to "read," as though the natural motifs that influenced him became mere starting points for abstraction.

University City closed, and the Rheads moved on to the small Fairfax, California, studio called Arequipa, where they taught ceramics to patients at the sanitarium there. Rhead's work at Arequipa, usually dated 1911 and 1912, displays his trademark squeezebag style, but in a new and delicate hand, depicting spare, stylized versions of leaves and flowers. While much of the pottery produced at Arequipa is simple ware made by people under Rhead's supervision, the work of the Rheads has a quiet power in design and use of color.

Rhead moved on to found Rhead Pottery of Santa Barbara, California, which was another short-lived venture. Judging by the quality of Rhead's work, the studio there was much more sophisticated than at Arequipa. His squeezebag work in Santa Barbara was mostly flat and broad, often enhanced by enameling. Some incised and modeled pieces exist, although these are very rare.

The quality of work from this period, piece for piece, is among Rhead's best. The clays and glazes used, the designs he chose, and the overall impact of the finished product were consistently fine. It appears as though Santa Barbara provided Rhead with the right atmosphere at the right time.

His last pottery ventures, after 1917, were of a commercial nature, with American Encaustic Tiling Company and Homer Laughlin Pottery Company, both in Ohio. One can surmise that having pursued designing, decorating, and management of decorators, he wished now to manage larger operations as a different expression of his art. Again, this was typical of the American ceramic industry at a time when World War I caused companies either to close or to become commercial producers.

Below: Two squat bowls with squeezebag, or slip trail, produced by Rhead at Arequipa Pottery. He worked there from 1911 until 1913, when he left to open his own pottery in Santa Barbara, California. His most mature work was produced there.

Prices for Rhead's work vary from company to company, although any piece bearing his signature, or the appearance of his hand, brings a premium price. For example, a Weller Jap Birdimal vase with a Geisha might sell for $1,000, but if Rhead's signature is found on the side of the pot, the price will double. Della Robbia ware, apparently made under his supervision and never by his own hand (no known example bears his signature), sells for $1,000 for smaller, modest examples, to upwards of $30,000 for the few masterpieces still to be found. His work for Jervis seldom bears his name, although a heavily decorated vase signed and dated by Rhead recently brought $16,500. Occasionally, Rhead-signed pieces from University City surface: their starting price is in the $10,000 range. Rhead-signed examples from Arequipa may not exist, but pieces from the "Rhead Period" there (1911–12) regularly bring from $2,000 to $8,000. And fine examples of his Santa Barbara pottery, though rarely, if ever, individually signed, will range from $3,000 to $10,000. Do remember that many lesser pots were made by each company, because each employed less-skilled labor. Such ware is valued in the hundreds, not in the thousands.

As with any other pottery crafted and signed by a master, damage is less of an issue than it is with production ware. Because of the scarcity of pieces hand-decorated and signed by Rhead, a small chip might reduce price by only 10 or 20 percent.

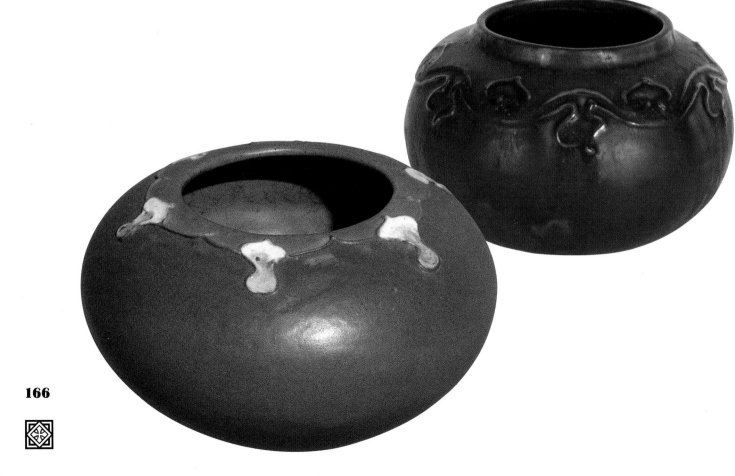

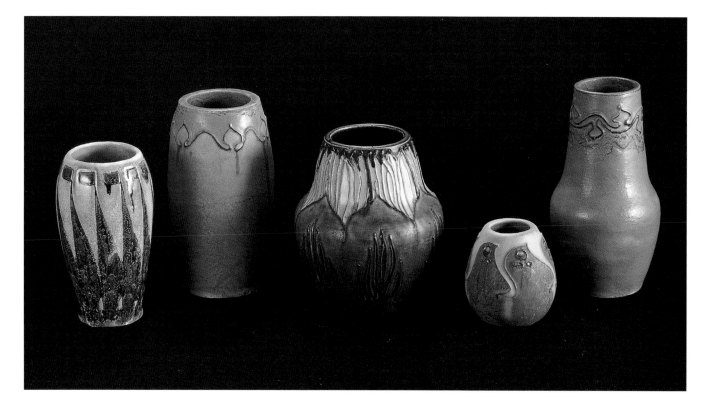

Rhead Ware from Arequipa *Above*
*These five vases demonstrate Rhead's
work at Arequipa Pottery. All were
decorated using the squeezebag
technique, which involved applying
decoration to the body of the pottery by
squeezing liquid slip through a narrow
opening in a bag, much like the process
used to decorate a cake.*

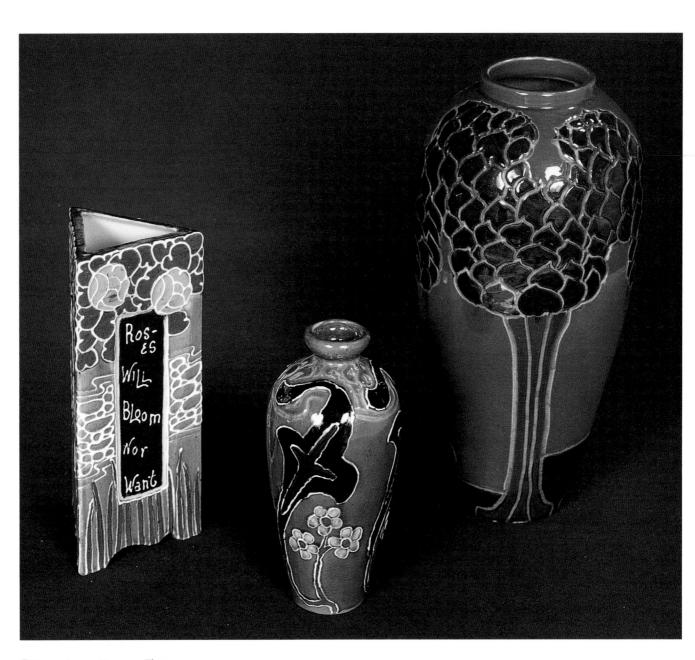

Rhead at Avon Faience *Above and opposite*
These four pieces were produced during Rhead's years at Avon Faience and were decorated using the squeezebag technique. Rhead had brought this decorative process from England to the United States in 1902, thereby revolutionizing the decoration of art pottery, beginning with his tenure at Avon (1902–3). Notice the gentle incising of the background on the piece on the opposite page.

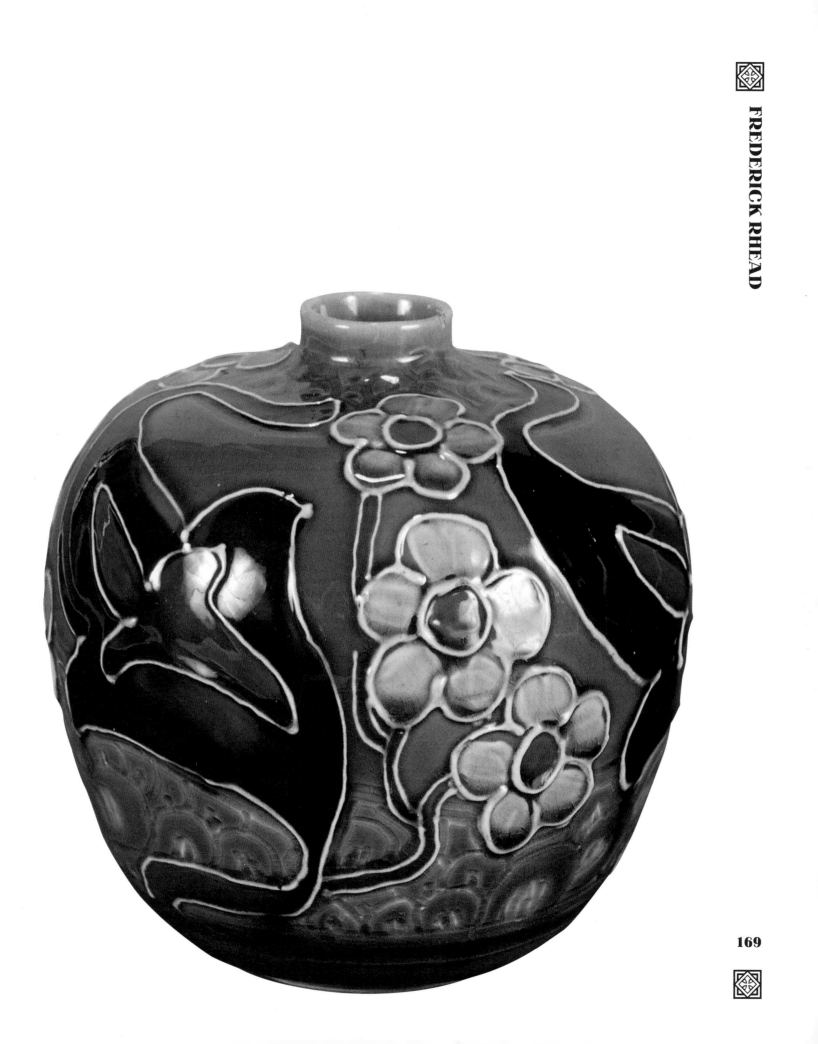

Paul Revere

The purpose of this book is not only to describe the pottery created by the major American factories and studios, but to give some insight into how these companies came to be and, accordingly, what these vessels show about where they were made and the artists who created them. Each of these companies has its story, and the fourteen producers selected for this book were chosen for the quality of their artware and their social and historic contribution to the realm of art pottery. The story of the Saturday Evening Girls Club of Boston, Massachusetts, for example, says as much about the philosophical and spiritual aspirations of the Arts and Crafts movement as it does about the work these ideals engendered.

SEG was started in 1904 by Edith Guerrier and Edith Brown as a social project intended to keep Italian and Jewish immigrant girls off the streets of Boston on Saturday evenings. The idea of improving society by teaching hands-on art is a theme we see repeated in the potteries at Newcomb College, Marblehead, and Arequipa. In addition, Boston was one—perhaps the major—American center for the Arts and Crafts movement, and other important potteries, such as Grueby and Marblehead, were located nearby. The seeds of the SEG Pottery fell on fertile soil.

Many people think of the Arts and Crafts movement in artistic terms: less known is the period's idealistic approach to transforming society from the inside out. The concept of hearth and home as the meeting place of the soul really did deal with good, honest family values. Decorative ceramics, woodworking, stenciling, and embroidering were all avenues whereby the layman could become part of the creative process, and the joy derived from making such objects superseded the beauty (or lack thereof) of the product itself. This approach was in stark contrast to the "soulless" mass-produced products of the Victorian period, against which the Arts and Crafts movement rebelled.

While it is uncertain what impact SEG/Paul Revere Pottery had on the women employed there, the quality and individuality of their art-

Opposite: This pitcher with painted tulips is an exceptional, and probably unique, example of early SEG/Paul Revere ware.

171

ware is undeniable. Although stylistically worlds apart from that of the women at Newcomb College, as seen in chapter 2, SEG/Paul Revere also shows pre-eminent examples of a "woman's hand." The designs chosen, the soft glazing, and the delicate surface treatment are common to the artware of both companies. It is primarily the regional and cultural influences on the two women's potteries that make them so different visually.

Most of the shapes produced at SEG/Paul Revere Pottery were utilitarian forms such as plates, bowls, creamers, and salt dips. Vases, or hollowware, were far less common; tall decorated vases are the rarest. The most prevalent decorative motifs are stylized animals, flowers, and landscapes. Animals include chicks, hens, and pigs, while flowers feature stylized lotus blossoms, with the occasional tulip or wild carrot. Landscapes are the least varied, usually restricted to banded designs of puffy trees and rolling hills.

What does vary in SEG pottery—and can offer you an immediate assessment of vintage and quality—is the *cuerda seca* technique on the vessel's surface and the type of glazing used. As with almost any other period producer, their earliest pieces are most appealing because of their naive and slightly raw quality. Their brief middle period is arguably their best: techniques and glazing became more sophisticated, not yet watered down by commercial concerns and the waning interest of a changing America. And their later work, after about 1918, offers only a glimpse of their best production, with a reprise of their early designs and less labor-intensive decorative techniques.

Below: The rim of this broad shallow bowl is decorated with a repeating nasturtium motif.

The earliest pieces are subtly modeled, with soft, porous glazes that have a very dry, almost coarse, quality. Pieces from this "Bowl Shop" period (1905–09) are characterized by neatly tooled designs of barnyard animals and the aforementioned stylized landscapes. What they lack in sophistication is more than compensated for by their purity of design and emotion. They speak of a simple and hopeful time, and, as such, are among the most satisfying pieces produced in America.

SEG's middle-period ware, from about 1909 until 1917, is typified by glazing that is crisp and even but has more of a gloss than the earlier finishes. Apparently, they were able to achieve better control over the effects of firing on these glazes, because they seldom ran, maintaining a crisp and bright appearance. Decorated ware from this period was also slightly more adventurous, and the combination of exceptional material and more mature designs resulted in the production of much of their best work, most of which, based on firsthand observation, was completed before 1916.

Their later work became consistently less interesting, as designs were either reworked motifs and/or brasher offerings abstracted by broad glazing, with little wax-resist delineation to highlight details and keep the glazes in place. While one might occasionally see a great piece made after 1920, these were almost exclusively the work of instructor Edith Brown—probably presentation or exhibition pieces. There was also a preponderance of mass-produced, "glaze-only" pieces made during this period.

Below: Plates and pitchers were mainstays of Paul Revere's utilitarian ware. These examples feature cuerda seca *decoration.*

Above: This three-piece tea set is rare both because of the early glazing and design and because it is a complete set, including teapot, creamer, and sugar bowl.

Damage to SEG pottery is slightly more tolerable than it is with most ware, probably because of its hand-made and -decorated nature and because the biscuit used was fairly soft. Further, because so much of their work was utilitarian, it was frequently damaged during normal use. Flaking to the edges of luncheon plates, for example, will have little impact on pricing, perhaps 10 to 15 percent. Saleability is more of a factor, but, with rarer designs such as camels, witches, or windmills, it seldom matters. On common designs and forms, chips and tight cracks might reduce value up to 40 percent. However, a great vase, fully decorated with incised designs, will still realize 90 percent of its full value in spite of a small chip or short, tight line.

Most decorated SEG sells for $300 to $400, including small bowls, luncheon plates, and trivets. The same forms from the earlier period, with *cuerda seca* and bolder designs, will edge into the $1,000 range. A small, 4-inch decorated scenic vase from the later period is worth about $1,000. A larger, 8-inch scenic vase from the early period might sell for more than $5,000. And should anyone be so fortunate as to find SEG's "chrysanthemum" vase, of which only two are known, they are probably in possession of a pot worth between $25,000 and $35,000. And no, that small chip won't make much of a difference.

Enameled Decoration *Below*

This middle-period pitcher was decorated with an enameled landscape. Although many different decorators were employed at the pottery during its thirty-six years of operation, consistency of design makes Paul Revere ware immediately recognizable.

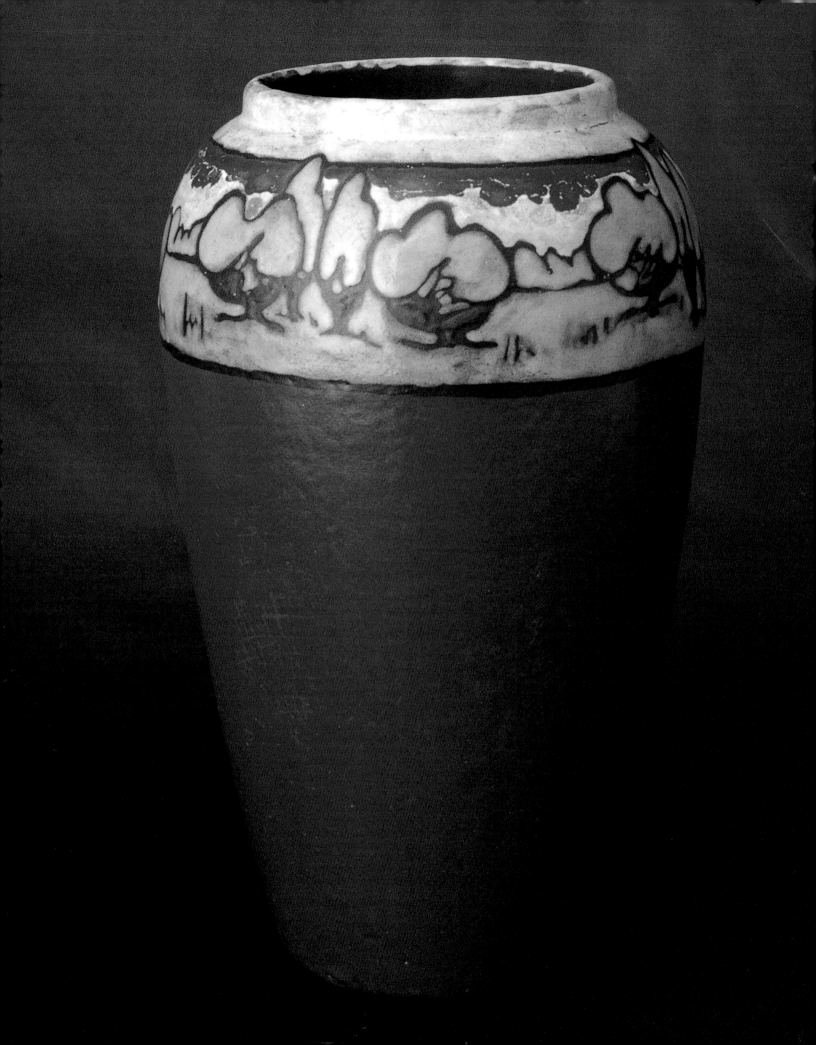

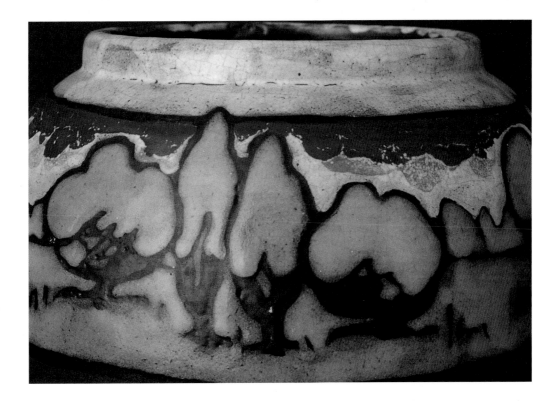

Painted Decoration

Opposite, above, and below

The vase on the opposite page (detail above) and the bowls below demonstrate the technique by which painted decoration was applied to Paul Revere ware. A design was outlined on the surface in a thick line of wax and manganese glaze. The wax burned away during the firing process, leaving a black outline that created a flat, non-naturalistic representation.

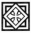

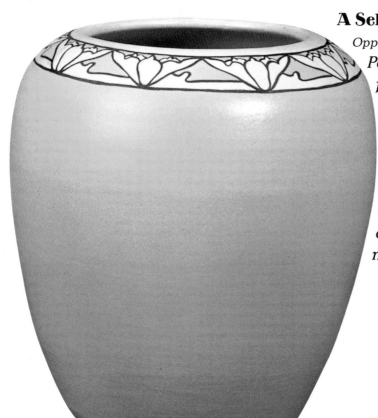

A Selection of SEG Ware

Opposite, left, and below

Paul Revere Pottery was founded to provide employment for members of the Saturday Evening Girls Club, an organization for poor immigrant girls. Monochrome backgrounds with hand-painted, stylized decoration, as demonstrated in these three examples, characterize SEG ware, most of which was molded.

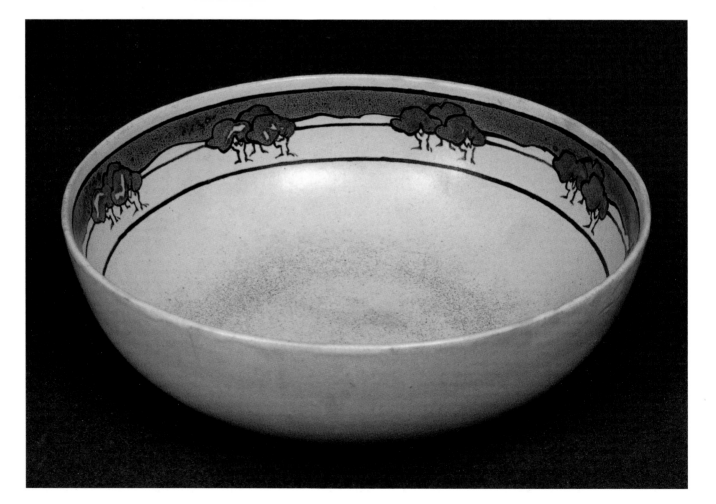

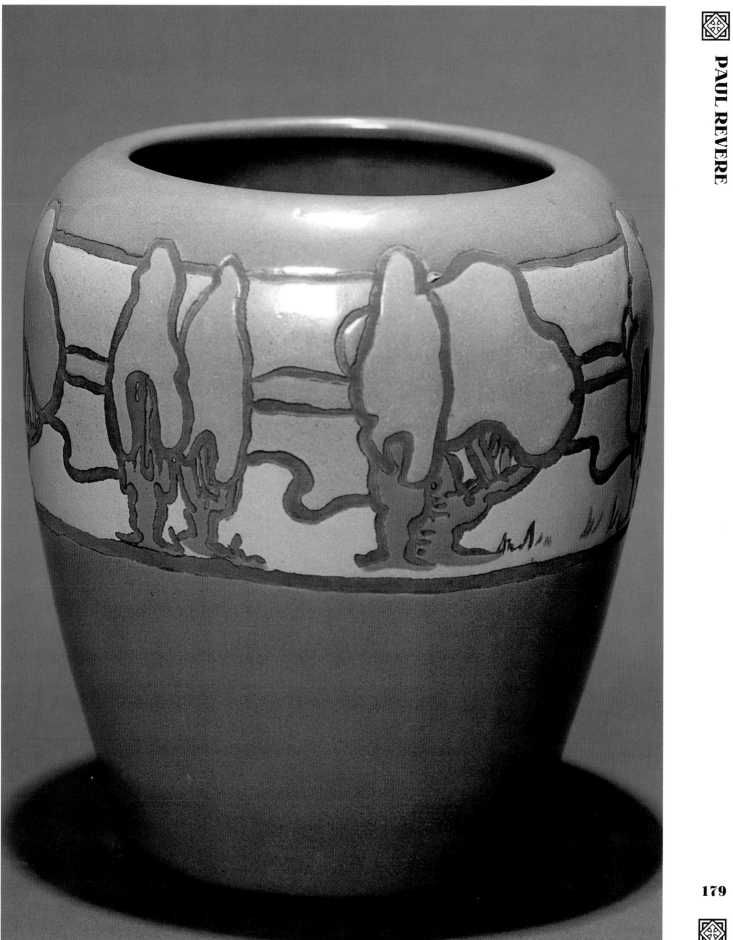

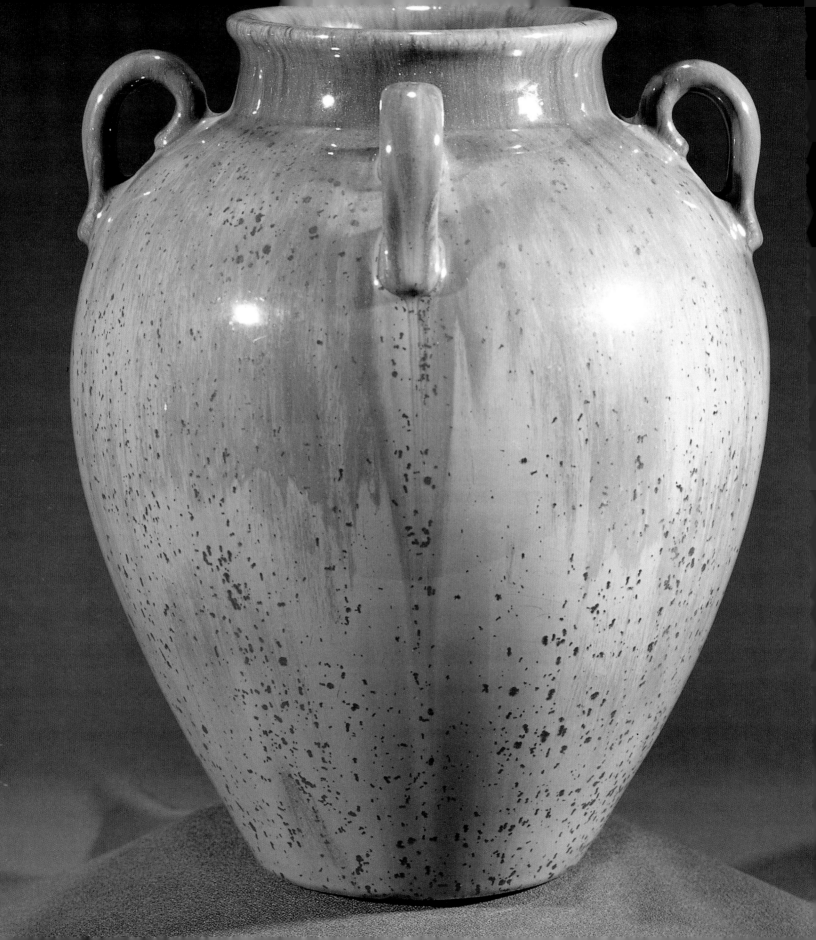

Fulper ✒

ulper Pottery was a company whose public image suffered because of uneven quality standards. More accurately, their production was consistently superior during the early years, just as predictably poor in respect of the later work, and the middle period combined some of each.

The discerning collector, recognizing these signs and buying accordingly, can be rewarded with an intelligent and beautiful assemblage of high-end period ceramics at a relatively low cost. Fulper has defied current market trends and remains modestly priced, despite recent exposure that includes several gallery and museum shows, two monographs, and numerous articles.

This chapter provides a good opportunity to summarize Fulper's distinctive contribution to art pottery and to encourage the interest in collecting that the work deserves. Bluntness will not be spared in disparaging the later, inferior work; I believe this is critical in developing an understanding of why the best ware should be pursued with vigor.

The Fulper Pottery was in business for about a century, producing crude ceramic goods including stoneware and salt-glazed crockery, before the expanding market for decorative artware encouraged the owners to change their emphasis. After John Martin Stangl, a German potter and chemist, was hired to head the staff in 1909, the focus shifted from the utilitarian to the sublime. This early pottery, called "Vasekraft," was probably their best work. It was most important for being the only art pottery to display a Germanic, *Jugendstil* influence. Occasionally heavy and medieval, production from this period is typified by stark, matte, crystalline glazes on angular forms with buttresses and on thin, vertical "arrow-slit" reticulations.

The quality of Fulper's production was consistently high until about 1915. Even on unsuccessful pieces—which were more than occasional—one can't fault the richness and depth of the glazes, the unique forms, or the high overall standard. In the work that didn't quite make it, the faults had more to do with uninteresting glazing and ill-conceived forms than with sub-par production standards. Stangl himself

Opposite: A fine example of a large, bulbous vase with handles, in shades of blue and beige. Each piece of Fulper pottery was painstakingly glazed by hand.

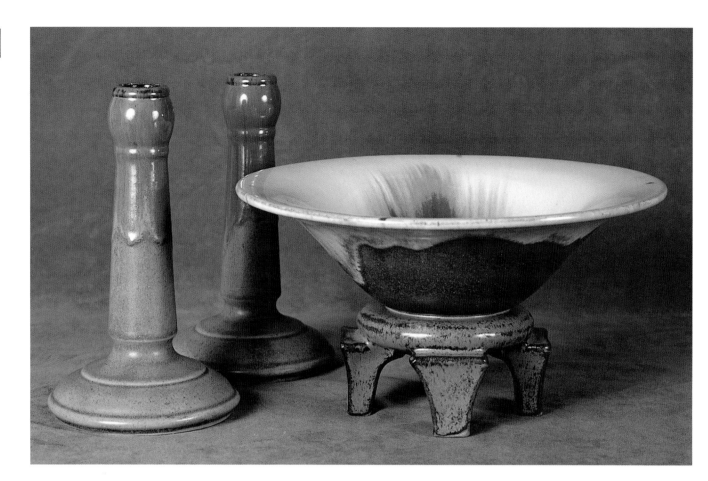

Above: An early example of a console set, including two candlesticks and bowl with four-legged base.

was acutely aware of the failings: certain glazes (such as the insipid raspberry matte) and forms (plates and dull, low bowls) were soon discontinued, judging by their scarcity (for which we can be grateful) and their early markings.

The majority of Fulper's early work, while primarily Germanic in influence, shows the first blush of Oriental and Classical influence to the careful observer. Again, judging by markings and availability, it appears that the production of non-Germanic ware increased from about 1912. One could speculate that Fulper's most aesthetically successful Germanic line was less than successful in terms of popularity, because it had been almost phased out by 1915.

The Oriental and Classical ware, along with a more generic hybrid, typified Fulper's work from the middle period, about 1914 to 1922. This observation is supported by my own experience: the personal interpretation of marks, reading, and the handling of several thousand pieces during the last twenty-five years. The middle-period work was usually of high quality, but the practical demands of a commercially-driven entity began to compromise artistic standards. Small pieces with less interesting glazes became more common at this time, and lower production standards—such as visible mold lines and lighter clay bodies—also mark Fulper's gradual decline.

It must be noted that these unfortunate modifications resulted as much from the effects of World War I as from any other factor. Not

surprisingly, the Great War quickly redefined American priorities, and it was no minor miracle that Fulper managed to remain in business in any capacity. Nevertheless, one can clearly see the impact of the war—along with America's changing tastes—on the production of decorative art in general and the Fulper Pottery in particular.

This decline was still more apparent after 1922, when the Germanic ware on which Fulper had cut its teeth was only a memory, and the high-quality Classical and Oriental ceramic was on its way out. While traces of earlier glory still appeared, the company's 1920s malaise was one of design as well as production standards.

Fulper slipped into an era of producing bland, uninspired work. Their ceramic was probably as good as any commercially produced American ware, but distinctly below the company's former standards. Simple forms adorned with weak interpretations of earlier glazes became the norm. The glaze selection narrowed, and the use of finishes in tandem with secondary and tertiary glazes became less frequent. One gets the sense that the decorators did not have the time—or the management backing—to produce a more distinctive product to high standards.

If the 1920s work was weak, the pottery of the Depression era was worse. A series of new forms was introduced in response to the Art Deco style that was gaining favor in American parlors, but the interpretations were often insipid and the production standards low. Occasionally, Deco-era pieces do show strong design and thoughtful glazing, but these are very much in the minority. More readily available are poorly designed pieces with thin, lifeless glazes on light blanks with manifest mold lines. Pieces from this period are distinctively marked, so that even the uninitiated can identify and avoid such ware easily.

In fairness, the pottery Fulper made during the 1930s is certainly no worse than factory ware typical of that period—and, in most cases, it is noticeably better. Superior work was made only by those in the burgeoning studio industry that served as a bridge between the art pottery period and contemporary ceramists and producers. The Fulper potters, like the few other manufacturers who persisted after the Depression, were and are judged on the merits that first earned them fame, rather than on the dedication and perseverance that kept them going against significant odds. Unfortunately, the standards of their later

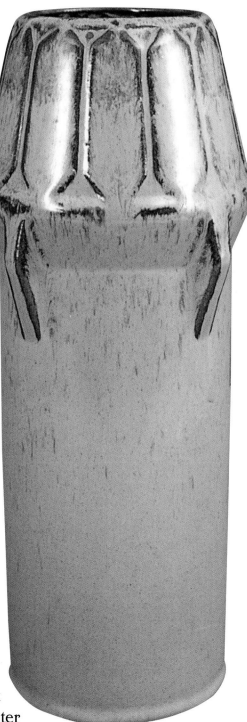

Below: A buttressed vase showing Germanic influence, from the early Vasekraft line.

183

work compromised the reputation of all their work, which is often held in low regard.

Because Fulper is a molded ware, damage will have significant impact on the value of a piece. As always, the rarer and better the example, the less damage affects either price or saleability. A chip on an early Fulper vase will probably reduce the value by about 30 percent; a later, less interesting piece, perhaps 50 percent.

An early Vasekraft vase 8 inches tall, with typical Germanic designs and a fine glaze, would be worth about 400 dollars. A large piece with buttresses and reticulations could bring as much as 2,000 dollars. A middle-period, 8-inch vase of Oriental influence would likely sell for about 300 dollars. A larger, more impressive piece from the same period would bring about 1,250 dollars. A post-1920s piece 8 inches tall would sell for about 200 dollars, a post-1930s example, for about 150 dollars.

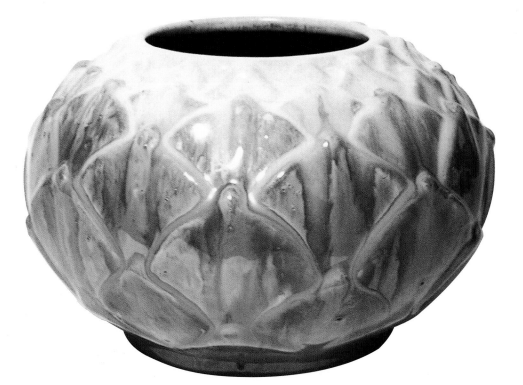

Teardrop Vase *Right*
This early ashes-of-rose teardrop vase on a separate base is a unique example of Fulper ware and was probably a "show" piece.

Artichoke Bowl *Opposite*
A bowl in the form of an artichoke from the middle period, when vegetable and flower shapes were in demand.

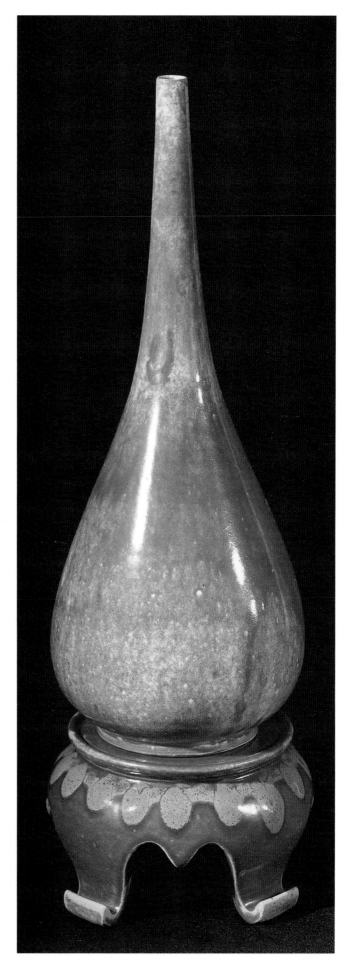

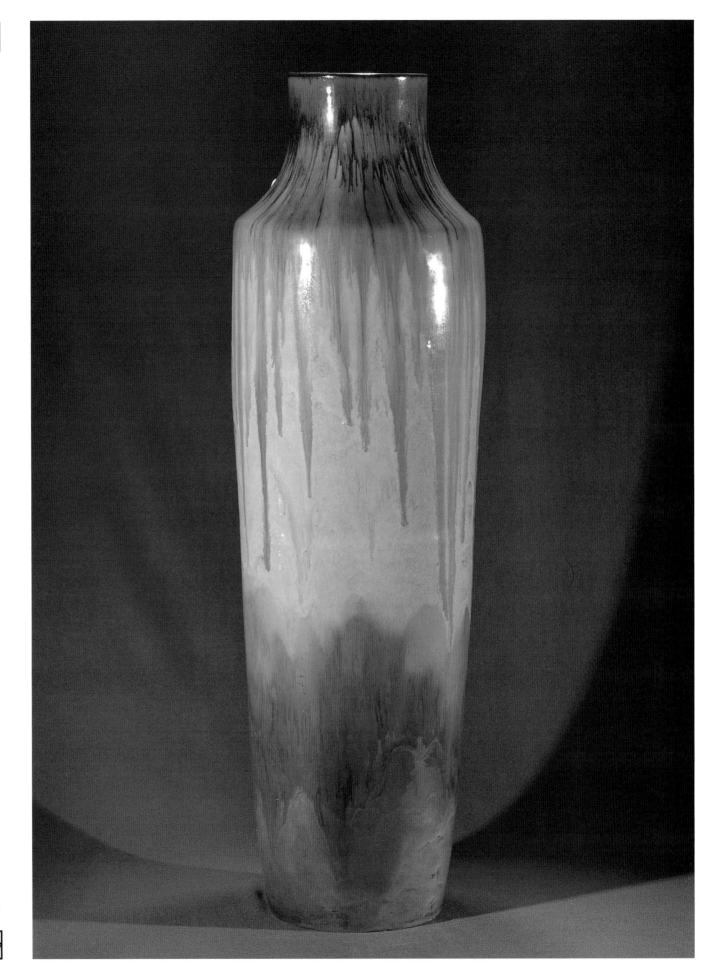

Early Monumental Ware *Opposite and right*
The monumental floor vase on the
opposite page has a tapering rim with
crisp glazing that contrasts with the more
atmospheric glaze patterns on the body
of the piece. The tall classical vase at
right has an attached base, flaring rim,
and brilliant glazing in shades of blue,
purple, and green [Collection of
J. Lubitz].

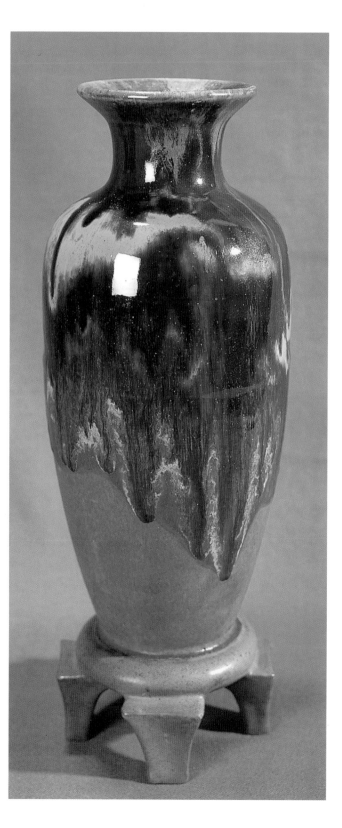

Early Chinese Blue Flambé *Below*
*Two fine examples of Chinese Blue
Flambé glazing. John O.W. Kugler, who
came to work at Fulper in 1909, designed
most of the earliest shapes.*

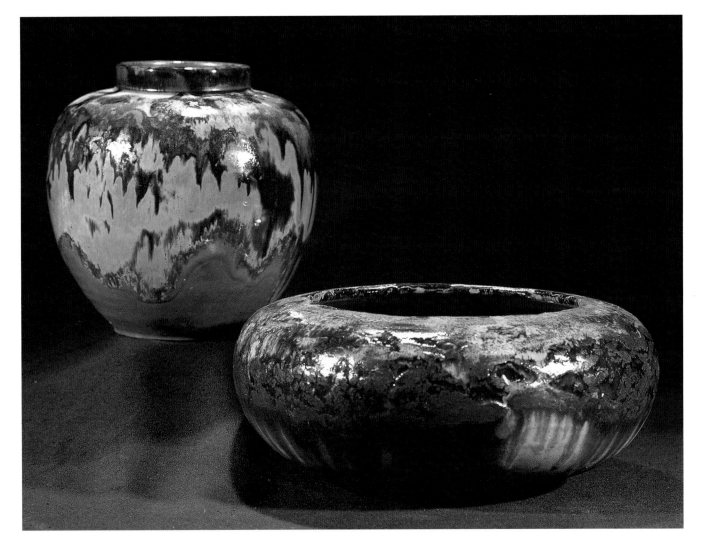

Middle Period Chinese Blue Flambé

Below

Two Chinese Blues from the middle period exemplify the high quality of Fulper glazing during these years.

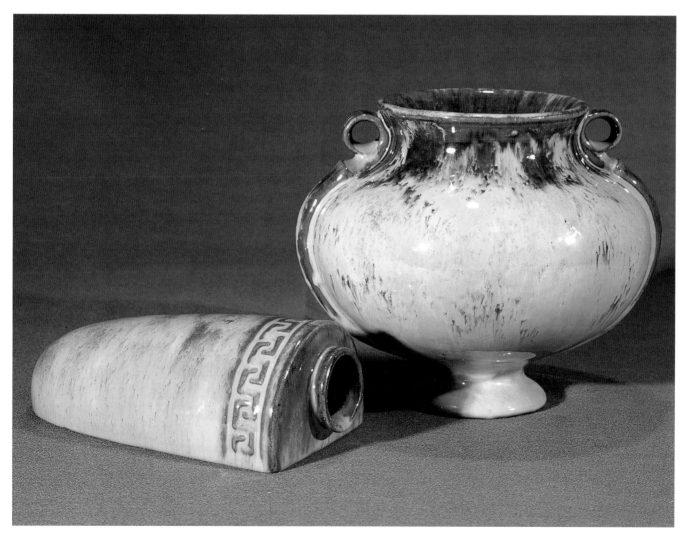

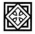

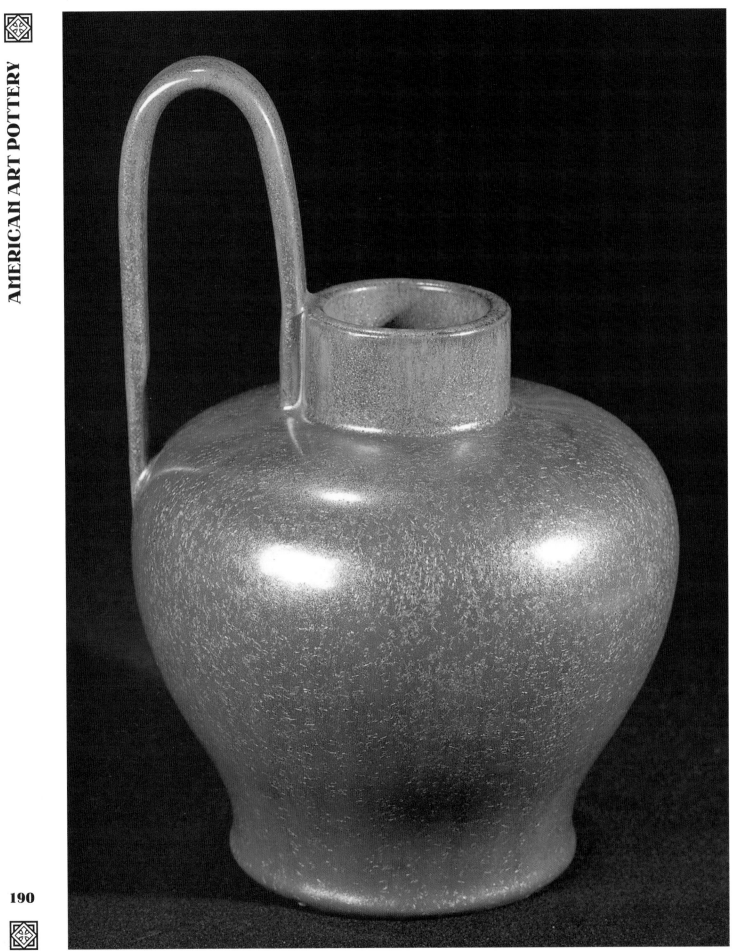

Copper Dust Glazing *Opposite and below*
The bulbous handled jug on the opposite page was created during the early period and is glazed in Copper Dust. The exceptional Norse bowl (below, left) has applied scrolling pieces, Copper Dust glaze, and an intricately designed base. The corseted vase (below, right) demonstrates modeled relief and is glazed with Copper Dust.

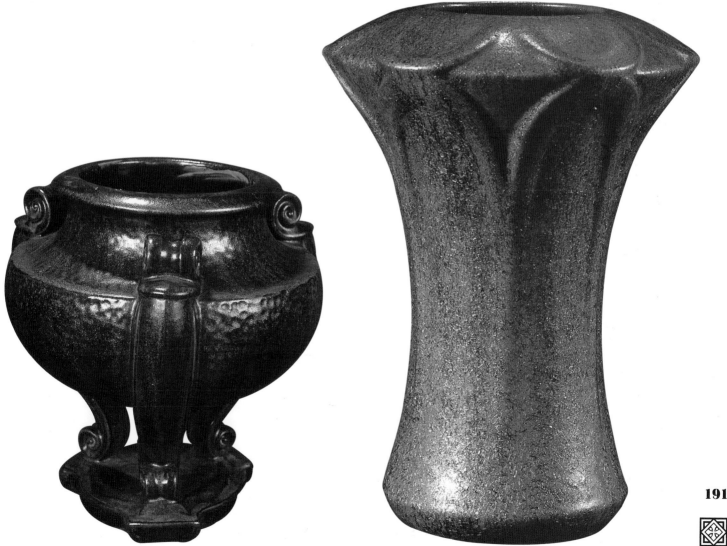

191

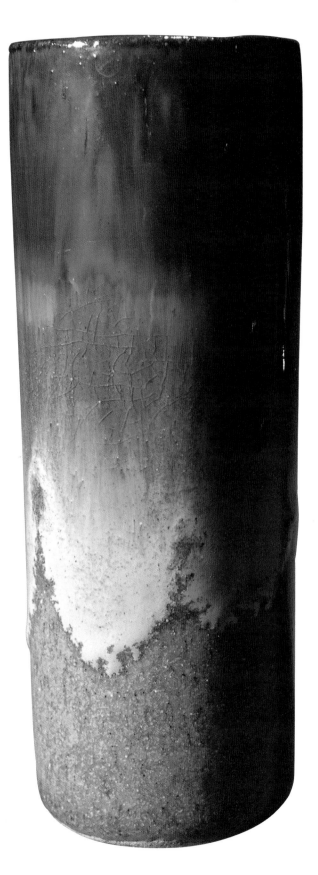

Early Examples of Fulper's Glazes

Left and below

Two types of glazing were used to finish the cylindrical vase at left: Gloss Flambé and Mustard Matte. The reticulated vase below shows Cat's Eye Flambé glazing and is typical of Fulper's Germanic style.

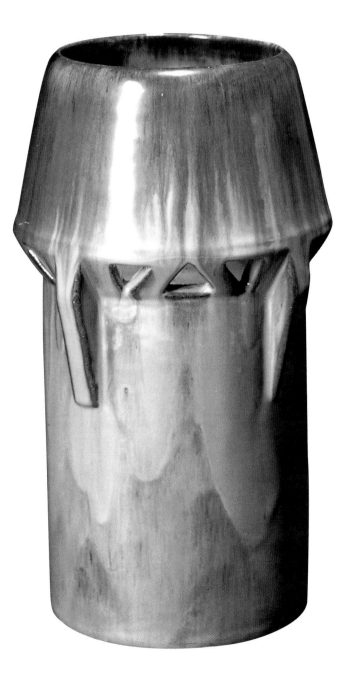

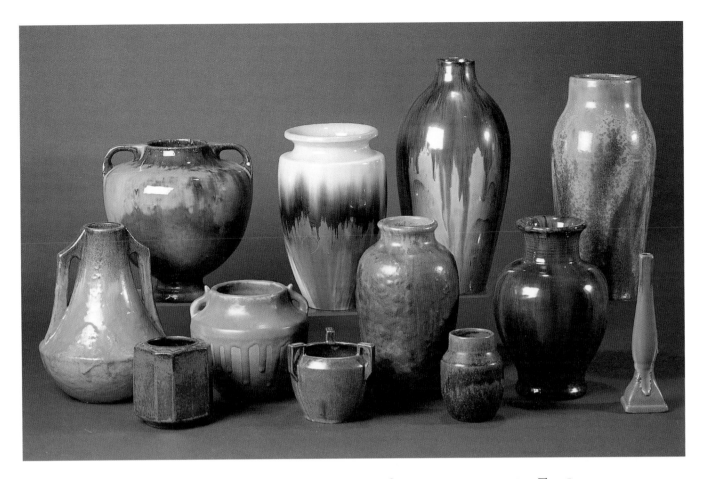

A Selection from the Early and Middle Periods *Above*

This grouping of Fulper vases from the early and middle periods illustrates the variety of glazing techniques used at the pottery. The six general categories were: Mirror, Flambé, Lustre, Matte, Wistaria (pastel colors), and Crystalline.

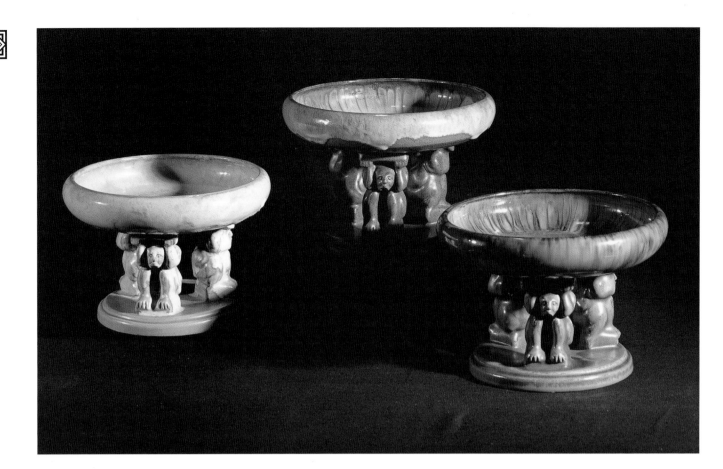

Effigy Bowls *Above*
*Three early effigy bowls with varied
glazes. Each bowl is approximately the
same size and is affixed to three
modeled figures resting on a rounded
base. Identical in subject matter, each
has its own distinctive characteristics.*

Middle Period Vases *Below*
Three vases from the middle period in various sizes. All were glazed with Ivory and Black Flambé.

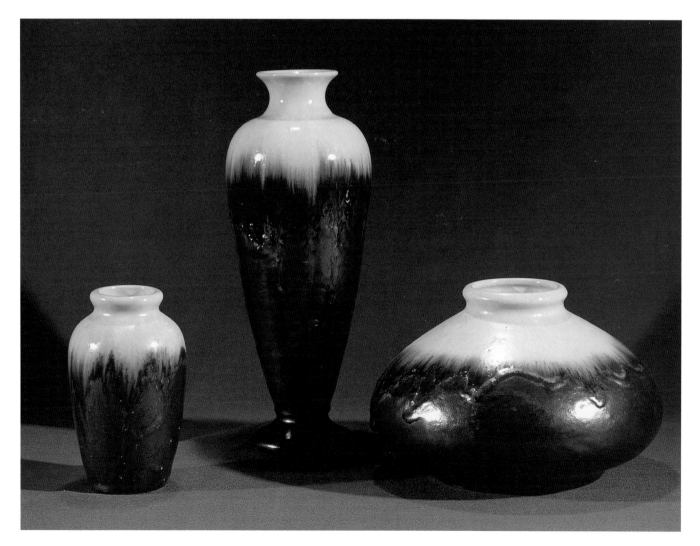

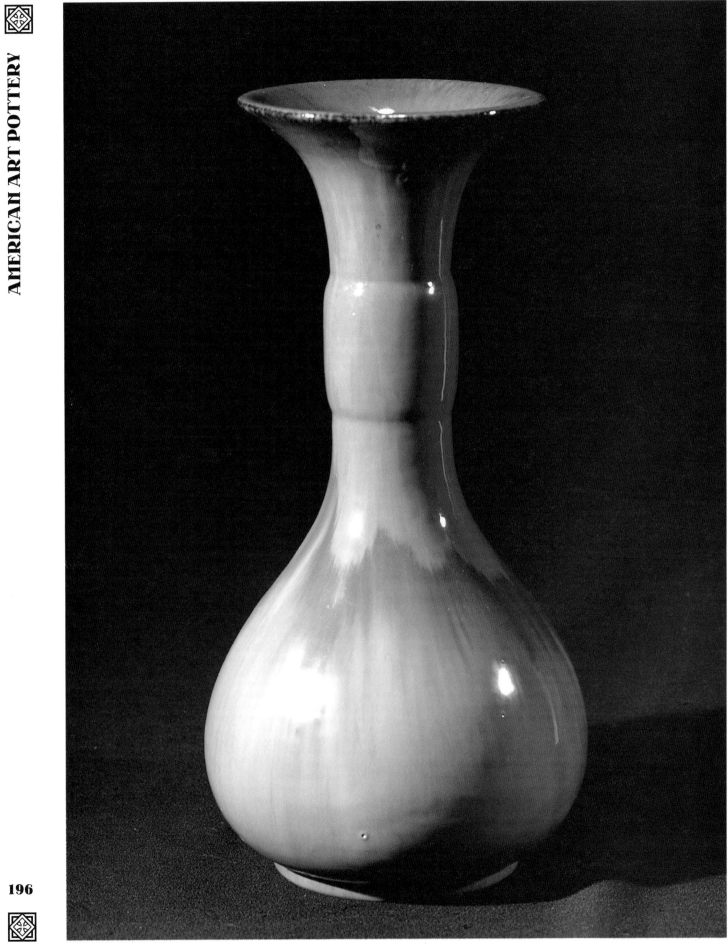

Chinese Polychrome Flambé

Opposite and below

Two middle-period vases with polychrome Chinese Flambé. Color was applied to the various parts of the tall vase on the opposite page to emphasize its sinuous middle section, flaring rim, and bulbous body. The same process was used on the rounded vase below, with the lightest colors applied to the widest section.

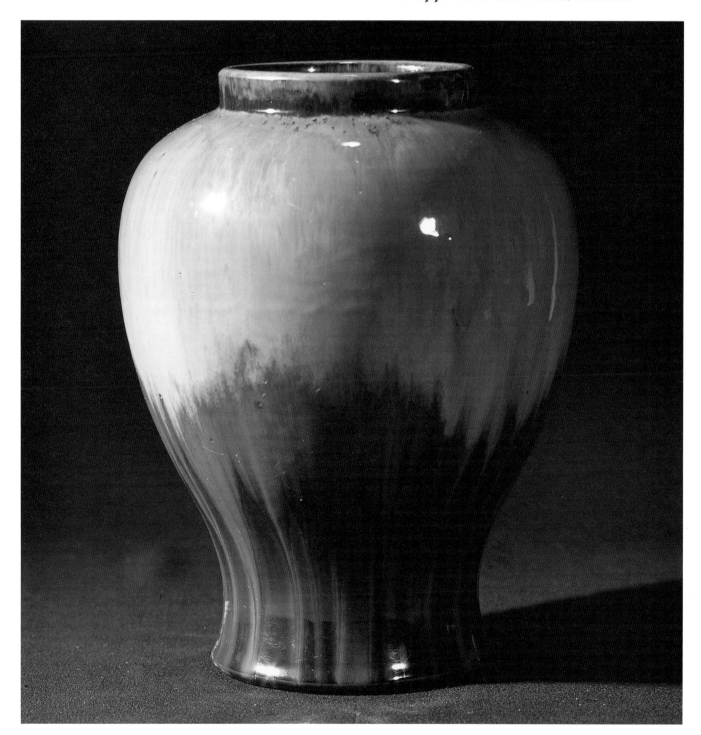

Organic Ware *Below and opposite*
The large, ovoid vase below has two
handles and is glazed with Leopard Skin
Flambé, simulating a tangible, mottled
finish. The cylindrical vases on the
opposite page are decorated with
molded cattails. The greens and browns
of the glazing emphasize the organic
qualities of this nature-inspired subject.

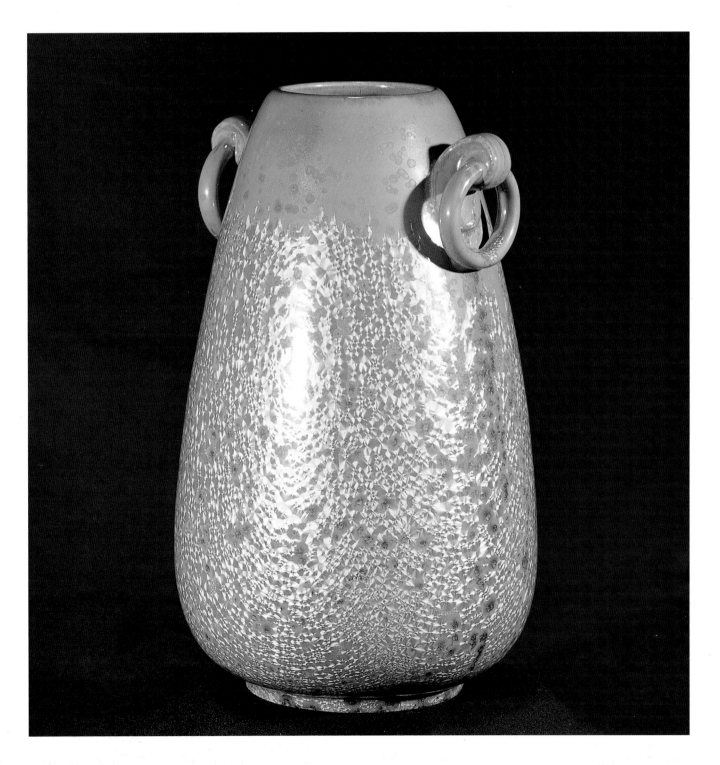

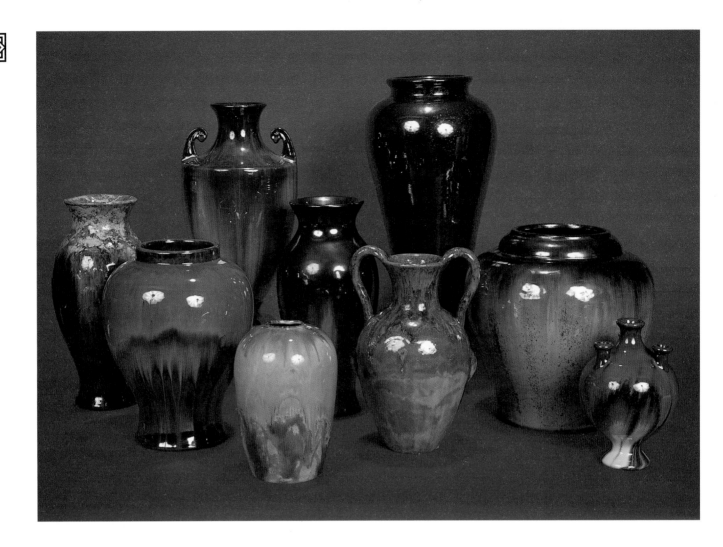

An Assortment of Fulper Ware *Above*
*Early- and middle-period bulbous vases,
showing an extraordinary range of
glazes and textures [Courtesy Gallery
532, New York]. While other potteries
were utilizing a limited number of glazes
to finish their pieces, Fulper both
experimented with and applied a varied
selection of finishes to their ware.
Therefore, the quality of Fulper's gazes is
often the most important element of
their products.*

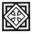

Black Mirror Glaze *Below*
A rare example of a dramatically rounded vase from the middle period. The Black Mirror glazing complements this Chinese-influenced vase.

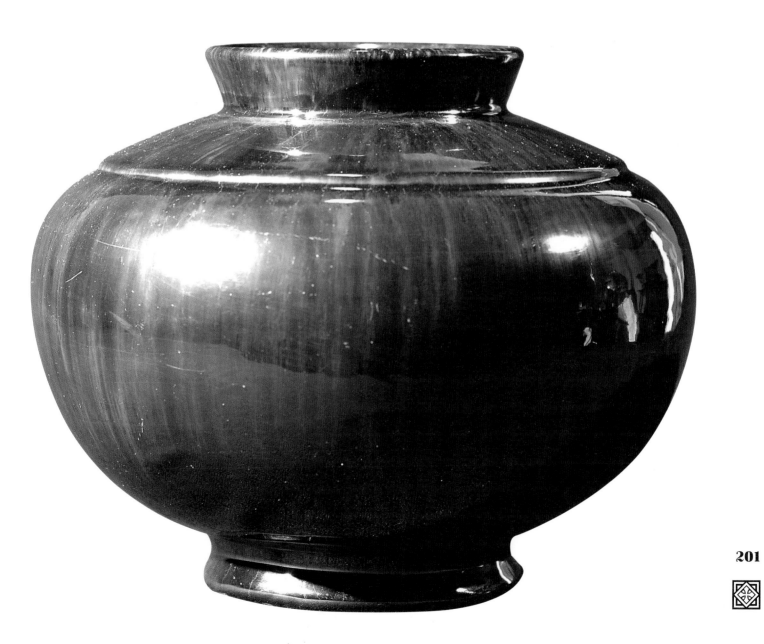

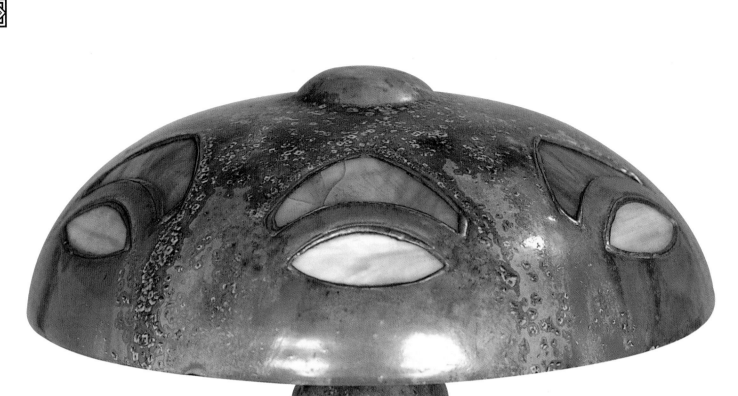

Germanic Table Lamp *Right*
A rare early Germanic table lamp in glass and ceramic media. Combining these two materials was a risky undertaking, as each has a different heating and cooling temperature, with potentially disastrous results [Berberian Collection].

Japanese Table Lamp *Right and below*

The detail at right illustrates the intricate network of glass found in Fulper's table lamps. Each color was applied by hand to the sections, which vary in both size and shape. The shade of the large Japanese table lamp below is mainly glass. Lighted, the lamps created tiny rainbows of color.

Dragonfly and Harlequin Lamps

Following Pages

A ceramic and glass table lamp decorated with a dragonfly pattern (following page). This example has polychrome glazing; different sections of colored glass make up the body of the dragonfly. Fulper first offered lamps in 1910. Facing page, a large Harlequin lamp with patterned "lampshade" rimmed by large triangles of blue-green glass separated by small triangles of rose-colored glass.

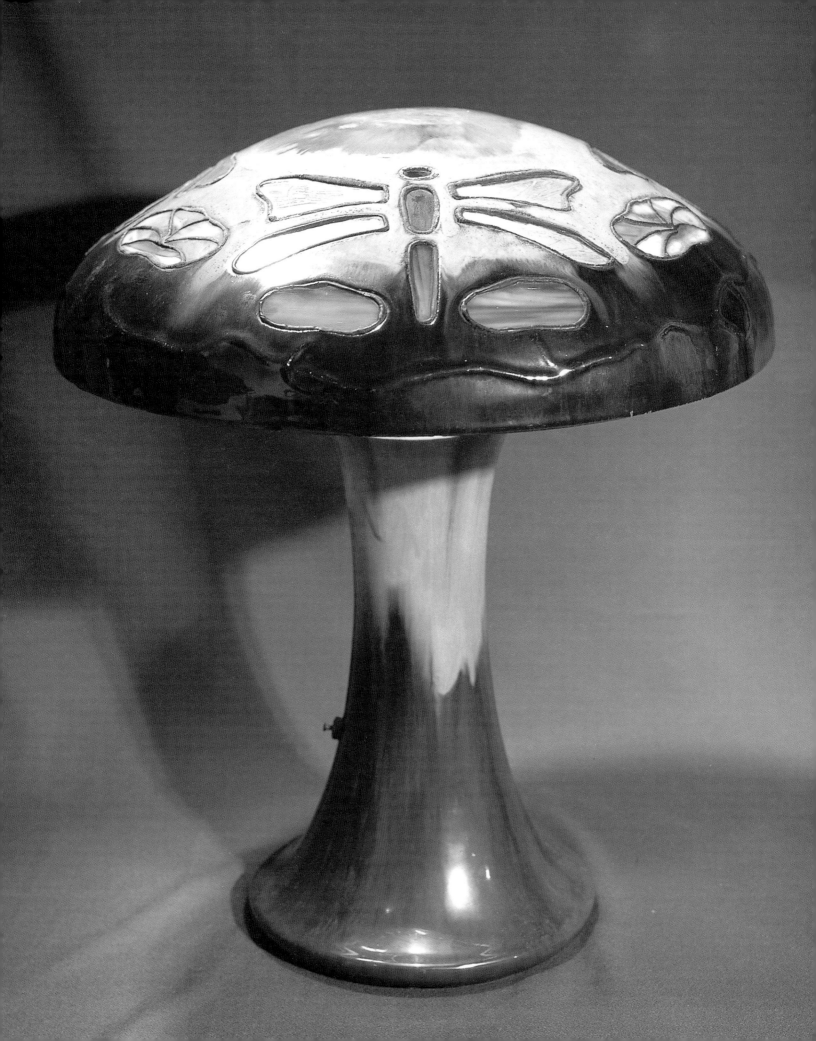

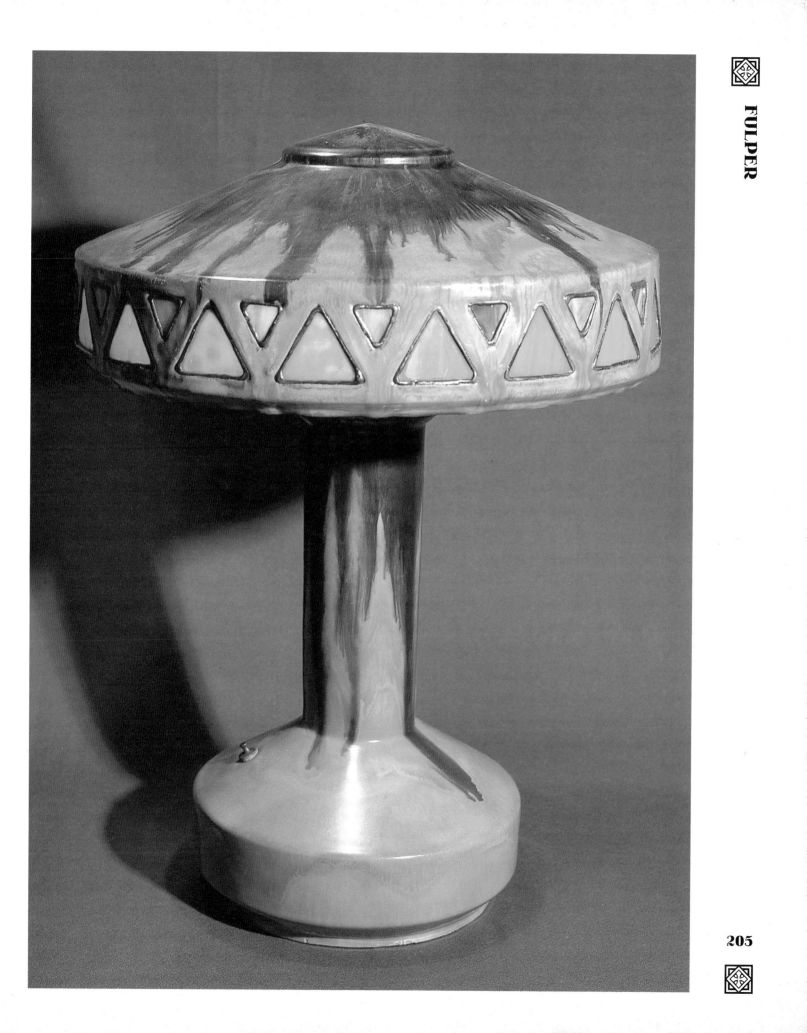

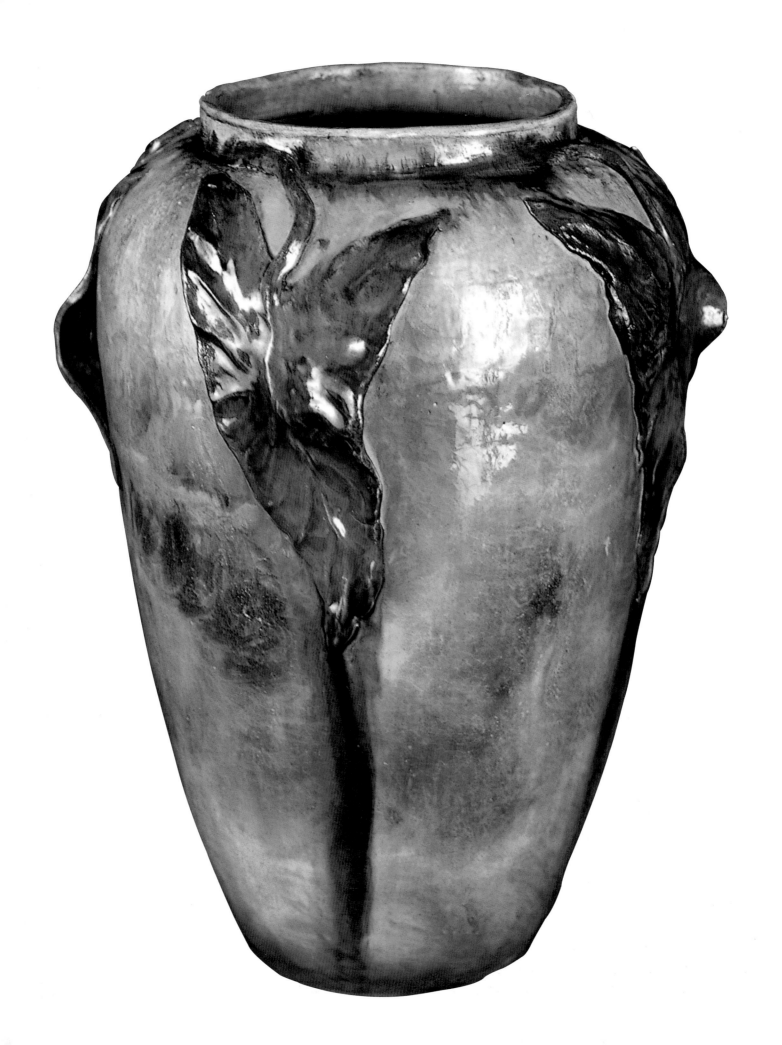

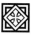

The Best of the Rest

This book is intended as a specific, if brief, overview of the major centers of ceramic production in turn-of-the-century America and the leading exponents in each of those areas. Fourteen companies were chosen to represent the body of work created by nearly 200 manufacturers, and the social and historic ideas that compelled them. One basis of selection was the availability of their work, not necessarily their production of the "premier" decorative ceramic.

For example, Adelaide Robineau was arguably the best potter in the country, with the possible exception of George Ohr. Yet very little of her work is ever on the market, and even her smaller, less interesting pieces bring thousands of dollars. While she must be included in any serious survey of American art pottery, she was not chosen for a chapter of her own because her work will be of little empirical relevance to the average collector. Thus, the editors requested a chapter on "the best of the rest," to include other important potters and companies who created artware and their contributions to the movement. These are grouped within four major areas of American ceramic production:

The Northeast

Arts and Crafts art pottery was first produced in New England, although its manufacture would spread as quickly as the ideas that encouraged the activity. Marblehead, Grueby, and Paul Revere were all involved in this regional interpretation of the aesthetic, with organic naturalism the goal and matte glazes on hand-thrown forms the means. Such work was not, however, restricted to these three companies: other manufacturers responded in their own ways to the same stimuli.

Adelaide Robineau, of Syracuse, New York, was among the premier ceramists of the art pottery period. Working primarily in porcelain, Robineau is best remembered for intricately carved vases with bold, high-fire glazing. Her production was extremely limited, both because hers was a studio-sized operation and because her exacting

Opposite: The vase on the opposite page was produced at Brouwer Pottery in Long Island, New York. Originally founded as Middle Lane Pottery by Theophilus A. Brouwer in 1894, the one-man operation quickly became known by its founder's name.

207

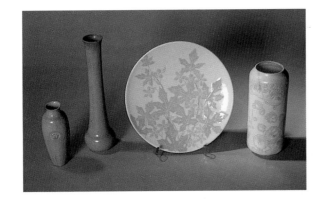

Above: A selection of pottery produced by Taxile Doat at University City Pottery in University City, Missouri. He was an instructor at the pottery from 1909 until 1914.

decorative technique was very time consuming. It is estimated that her total porcelain production was about 600 pieces.

Robineau worked closely with Frederick Rhead during her brief tenure at University City, and afterward, as Rhead was a frequent contributor to her magazine, *Keramic Studio*. In fact, Robineau was at least as influential in her publishing role as she was in her studio. Through the magazine, she worked with many talented artists, including the Overbeck sisters, Katherine Cherry, and Dorothea O'Hara.

Robineau's most famous piece, the Scarab vase, is a masterpiece of design and execution, allegedly the result of more than 1,000 hours of labor. Robineau toiled with the diligence of the beetle she chose as her subject, creating what many believe to be the single most important piece of the period. So rare and valuable is her work that even the least of her pieces—tiny porcelain test vases with relatively simple glazes—bring several thousand dollars. Hand-carved examples are extremely rare, and even the sparest of these will exceed $10,000 in price. It is critical, however, that Robineau pieces bear clear markings. Aside from the faking of pieces and signatures (apparently the work of a Florida potter), Robineau was fastidious about signing her work, and she popularized a look that influenced many admirers. As a rule of thumb, if it's not marked, it's not Robineau.

The Merrimac Pottery, of Newburyport, Massachusetts, operated from 1897 until 1908. It produced a wonderful organic pottery characterized by thick, vegetal matte glazes over hand-tooled, stylized floral designs or, more often, dripping over simple, hand-thrown forms. While this description could easily apply to Grueby's work, Merrimac's production was considerably different in that the shapes were more heavily proportioned, the walls of the vessels thicker, and a greater percentage bore only the glaze as decoration.

Merrimac's best pieces show heavily tooled designs of underwater flora under rich, organic, metallic dark-green matte finishes. A close second are large, squat, bulbous pots with intense dark-green matte finishes which, though lacking in tooled decoration, are visually powerful in a quiet and pregnant way. It should be added that while most pieces appear to be hand-thrown, I have viewed some that appear to be molded. However, the tooled decorations that adorn about 30 percent of their pots always appear to be hand-modeled.

Another New England pottery of considerable merit is the Chelsea Keramic Art Works/Dedham Pottery of Dedham, Massachusetts, founded by Hugh Robertson. This company is the oldest of the American producers. It started operating in 1872, and, after finan-

cial complications, became Chelsea Pottery, from 1891 until 1895. Reorganized as Dedham Pottery, it stayed in business until 1943. Chelsea Keramic work, of English origin, showed the same kind of evolution as did Frederick Rhead's: it began as a traditional European pottery headed and staffed by family members who gradually shed their past in search of a more mature vision. Earliest efforts include hand-thrown and molded redware forms of Classical influence, and "metal shapes," or forms more commonly forged from metal than potted from clay, bearing Oriental themes. During the late 1870s, their production shifted from traditional standards to a more unique and personal product. Although retaining the quality and inspiration of Classical and Oriental ware, the Robertsons introduced a ceramic that broke new ground both in glazing and in decorative elements.

For example, Hugh Robertson, a glazing expert, dedicated himself to the rediscovery of the long lost Oxblood, or *Sang de Boeuf,* finish which, when perfect, attained the color of "fresh arterial blood." While such glazes are easily achieved today because of available knowledge and the kindness of modern kilns, Robertson toiled and failed repeatedly in his initial efforts with experimental glazes fired in crude wood- and gas-stoked kilns. It is said that he even slept by the kilns in order to monitor his progress. One can only wonder how Mrs. Robertson felt about that...

Similarly, Alexander Robertson, Hugh's brother, continued to use the glossy green and brown flambé they had employed earlier but

Below: Merrimac Pottery was founded by T.S. Nickerson in Newburyport, Massachusetts, in 1897. The detail below shows the gentle tooling of the clay and dull finish that often characterize Merrimac ware.

departed from English traditions of form and design to explore new ideas. One example is a small bulbous vase with a tooled spider's web and applied spider, under the same glossy finish. While an interesting pot in its own right, it is also important because it conveys where he was at the time and where he was headed.

While Hugh's work was fascinating aesthetically, it was a commercial disaster, and in 1889 he was forced to cede control of the company to a group of businessmen who had other ideas about how to keep the pottery going. One of Hugh's creations was a rich crackled glaze which he is said to have discovered by accident. Be that as it may, it became the foundation of the famous Dedham dinnerware lines that remain very collectible to today's ceramiphiles. This work is easily recognized by hand-painted, cobalt-blue designs of plants and animals, mostly rabbits, on white crackled grounds. This was a commercially viable product, and it kept

Robertson in the ceramic business for decades. His important red finishes remained the standard of the ceramic industry, but it was his success with crackled ware that afforded him the luxury of additional experiments. Predictably, he will long be remembered most for his dinnerware. And one can only imagine how Mr. Robertson felt about that.

The Southern Potters

We've discussed Newcomb College and George Ohr who, while responding to the nationwide interest in art pottery and the Arts and Crafts movement, pursued very different and personal visions. This is less the case with the North Carolina school, who continued a very traditional line of work.

Pisgah Forest, for example, was a relatively small outlet in Pisgah Forest, North Carolina, which specialized in three main types of ware. The first, a decorated Cameo line, was typified by *pâte-sur-pâte*, or built-up decoration, of pioneering and sylvan scenes in white on contrasting bisque bands against glossy grounds. They also featured a crystalline ware which, at its best, had large snowflake crystal matrix contrasting against lighter, glossy base colors. Their last product was a simply glazed ceramic that can be considered their commercial line. All of the above, however, were hand-thrown and the work of master potters who were very serious about their craft.

Another fine Southern pottery was Jugtown, of Jugtown, North Carolina, operating from 1915 to 1983. Their hand-thrown pottery was seldom tooled but always under one of their distinctive and famous glazes. The best of these is their Chinese Blue Flambé, an intermodulation of a rich red and a shimmering turquoise. Rarer, if somewhat less successful, is a rich, deep black matte and a similarly intense cobalt blue. More common is a frothy Chinese white and a smoother "frogskin" green-brown flambé. Jugtown's work was continued by one of their former potters, Ben Owens, who produced a similar ware with similar glazes. However, his production was limited to what he could pot himself and, as such, is considerably rarer.

The Ohio Valley

As stated in the chapters on Roseville and Rookwood, the Ohio School was a major center of ceramic production with many, many exponents. Their proximity to one another led to a most incestuous coexistence, and it is often difficult to tell one company's work from another.

Above:
Six types of ware were produced at Brouwer Pottery: Gold Leaf Underglaze, Fire Painting, Iridescent Fire Work, Sea-Grass Fire Work, Kid Surface, and Flame—all of which displayed unusual glaze effects.

Below: The decoration on this Redlands vase was inspired by marine life.

The chapter on Roseville could just as easily have been about Weller Pottery, also of Zanesville, Ohio. The former was chosen only because of the wonderful work Frederick Rhead produced there. He was also, however, one of Weller's chief designers and, although he did not scale the same aesthetic heights there, deeply influenced the direction of the company in introducing the squeezebag technique for their Jap Birdimal line.

Weller also enjoyed the creative genius of Jacques Sicard who, when bribed to leave the Massier Pottery in France, invented Sicardo ware in Ohio. This work is recognized mainly for the rich, lustrous, iridescent glazes of purple, burgundy, turquoise, and gold that shimmer on the surface. Closer study reveals that Sicard was equally talented as a painter who incorporated flowing, organic Art Nouveau motifs into his work. His ability to conform decoration and form was sublime, and only Kataro Shirayamadani of the Rookwood Pottery equaled

Above: These two ceramic figures were produced at Weller Pottery in Zanesville, Ohio. Originally a manufacturer of unpainted flowerpots, the company quickly branched out into art pottery and by 1915 was the world's largest producer.

his ability to hand-paint a piece in its totality, rather than in part. Sicard remains one of the most talented artists of the period and his work, though not inexpensive, is relatively modestly priced.

Another Zanesville company, the J.B. Owens Pottery, might have achieved a similar fame had not Owens died in 1907. While shamelessly copying ideas and designs from his local competitors, he also explored new ideas based on similar themes, introducing a myriad of interesting and daring ceramic lines. For example, his Coralene Opalesce line was clearly in response to Sicard's use of lustrous finishes, but Owens modified this by covering much of the surface with a beaded texture of contrasting finish. More important are numerous lines that bear traits of many different design elements, combined and expanded to create wholly new concepts. While a number of these "experiments" are far from successful, they verify a creative exuberance typical of this major pottery center near the turn of the century.

California

We have already discussed Frederick Rhead's work in Santa Barbara and Fairfax, as well as his mature adaptation of earlier decorative techniques. California's extraordinary raw materials, natural vistas, and free spirit similarly influenced other important potters who produced their best work in the Golden State. Albert Valentien, for example, a standout at the Rookwood Pottery, was lured to the West Coast "for a summer" to paint California's wildflowers for the Scripp's

Commission. He fell in love with the state, which is easily understandable, and he and his wife Anna moved to San Diego in 1908 and used their past to redefine their future.

Some of their work is strikingly similar to their efforts at Rookwood; other examples pay homage to the recently deceased Artus Van Briggle, with whom they had both worked in Ohio. While the production at their small pottery was both limited and unpredictable, their best efforts are manifest in some of the period's most enduring masterpieces. One example is a large bulbous vessel with sculpted nude women, under a rich matte finish. Clearly showing the influence of Van Briggle and the French masters, with whom they had studied in Paris under Rookwood's aegis, such ware displays a sensitivity and accomplishment unmatched in American decorative ceramics. Also memorable are Painted Matte pieces, stylistically and technically derived from similar work at Rookwood. Perhaps because they had more control over production at their own studio, or perhaps because they imposed higher standards there, surviving examples display a technical mastery and aesthetic purity that brought their work to new levels.

Another interesting California company was Roblin of San Francisco, headed by Alexander Robertson, formerly of CKAW. While continuing in the English tradition of perfectly thrown and finely tooled ware, Robertson and his associate, Linna Irelan, produced an extremely fine and simple ceramic. Such pieces are seldom glazed and are rarely over five inches tall. This is among the simplest and finest pottery made in America. Had the 1906 earthquake that closed their pottery not ruined their inventory, we might be enjoying more extravagant examples of their genius.

As we have seen, the art pottery movement in America was an era of exuberance and exploration, at once original and traditional, individual and incestuous. As we grow in our enjoyment and understanding of this fascinating time, we'll appreciate more fully the evolution of these artists who defined the work.

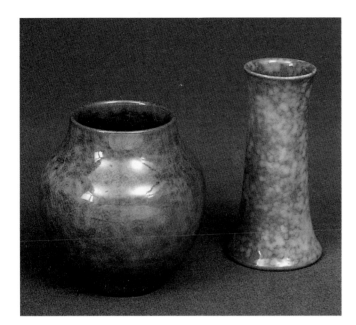

California Ware *Opposite, left, and below*
The corseted vase on the opposite page
was produced by Valentien Pottery,
a short-lived company founded in San
Diego in 1911 by Albert and Anna
Valentien, two former employees of
Rookwood. The pieces at left were made
at Grand Feu Pottery in Los Angeles,
and the vase below is from Arequipa,
originally a sanitarium pottery project,
in Fairfax.

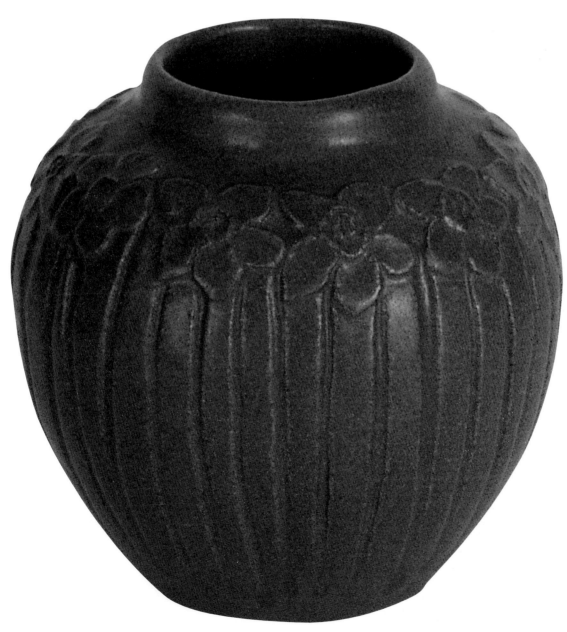

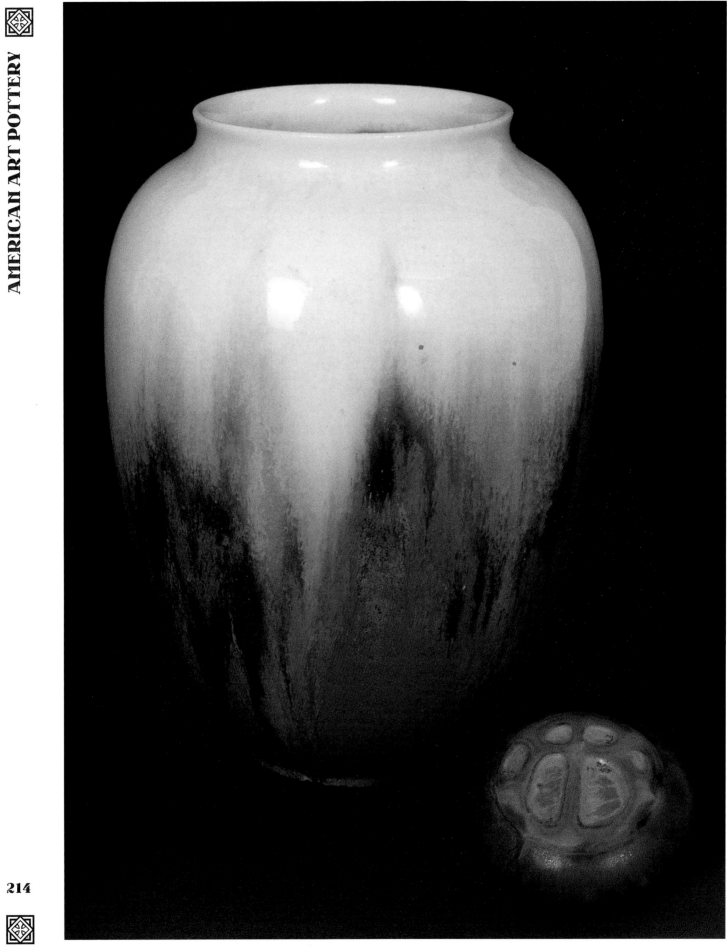

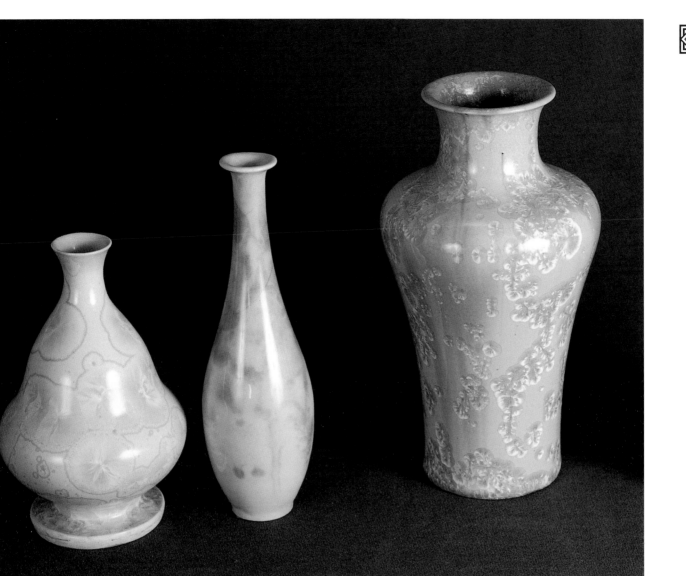

Robineau and University City Pottery

Opposite, above, and right

Despite the fact that Robineau's production probably totaled less than 600 pieces, she is often hailed as the foremost ceramist in the American Art Pottery movement, and her pieces are highly sought after. The vases opposite, right, and above (center) demonstrate her gift for glazing. The pieces at left and right, above, are from University City Pottery, where several distinguished artists, including Robineau, worked between 1910 and 1914.

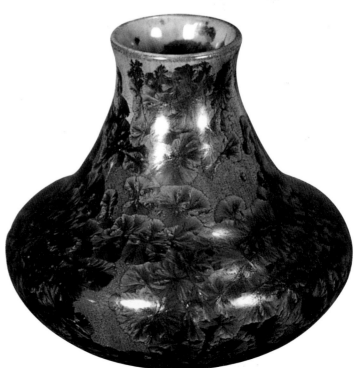

215

Northeast Ware *Opposite and below*
The bulbous vase on the opposite page was produced by Charles Fergus Binns, who worked at New York's Alfred University, the first ceramic school in the United States. He is best known for his glazed stoneware. Many important ceramists trained under Binns, including Arthur Baggs, Elizabeth Overbeck, and Frederick Walrath. The vases below were produced by Binns's former student Frederick Walrath in Rochester, New York. Binns's influence is apparent in the simplicity and clarity of shape and the careful application of design that typifies Walrath pottery.

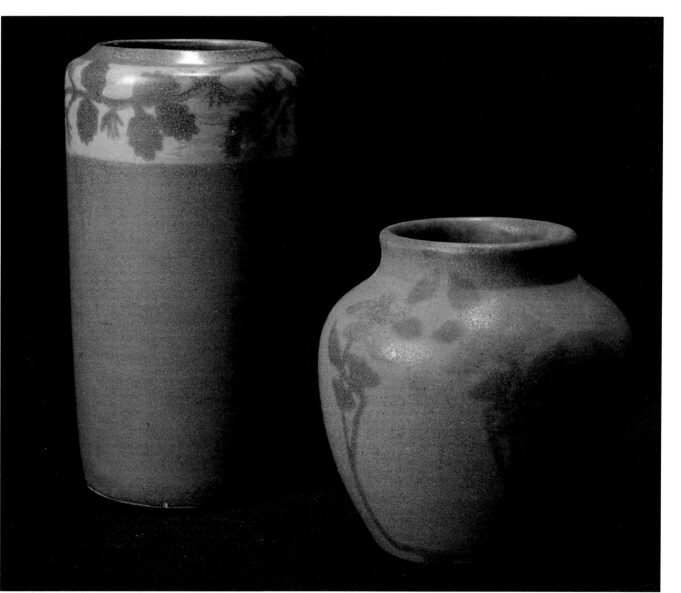

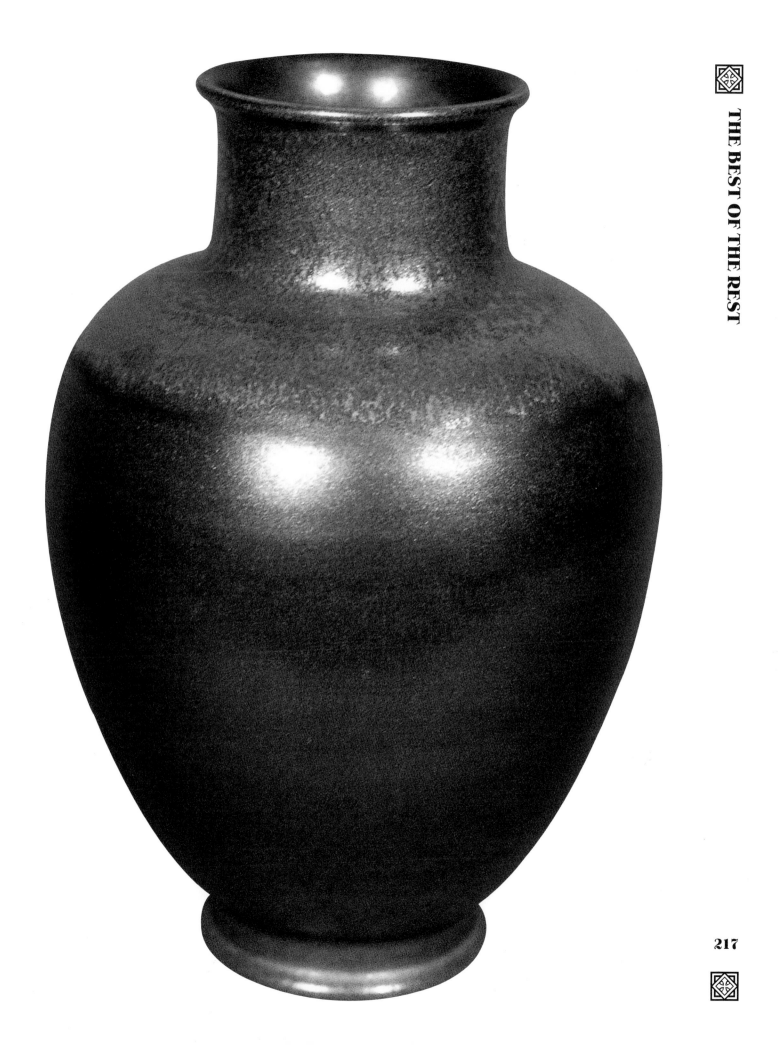

A Selection of Brouwer Pottery

Opposite and below

The unusual glaze effects that Brouwer achieved at his Long Island pottery were the most interesting features of his ware. Bright shades of orange and yellow, achieved by firing an apparently solid-color glaze, finish the two vases on the opposite page. The pieces below were finished with iridescent glazes. The vase at right shows the swirling patterns that Brouwer created, while color was applied over the finish of the piece at left to achieve a dripping effect.

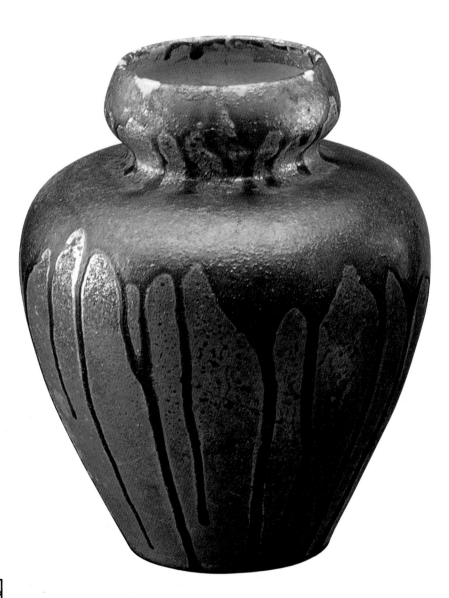

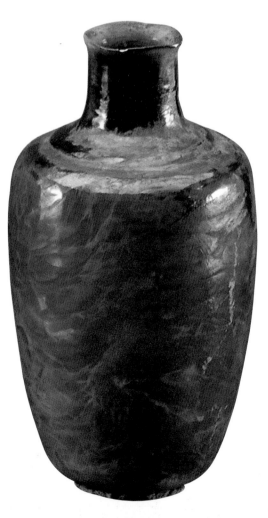

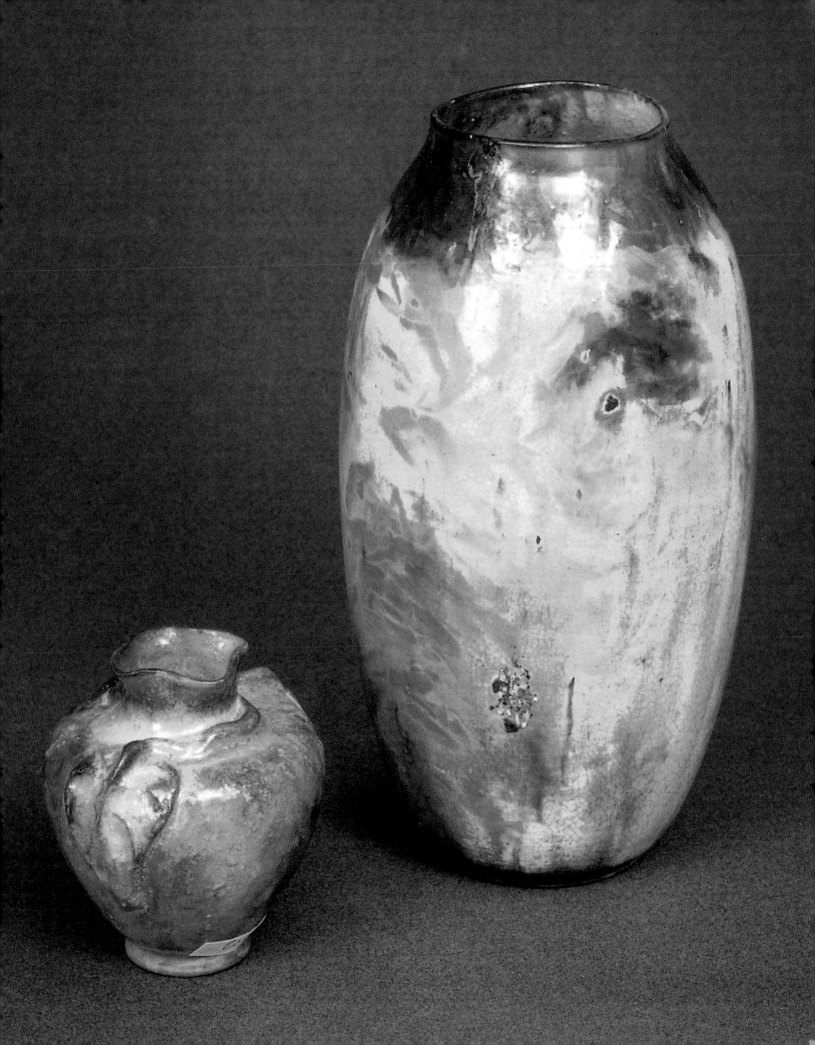

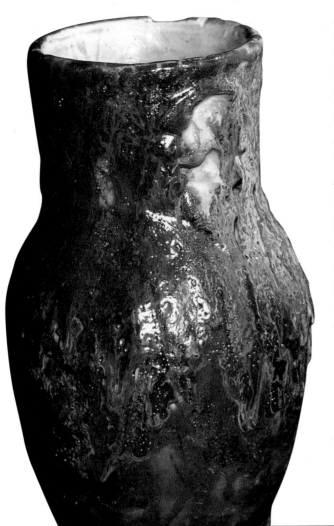

Massachusetts Ware

Opposite, below, and left

The cylindrical vase on the opposite page with applied leaves and green matte glazing was produced at Merrimac Pottery in Newburyport. The company was named Merrimac, the Native American word for sturgeon, for the river that flows through the town. The three pieces below were made by H.C. Robertson at Chelsea Keramic Art Works and its successor, Dedham Pottery. The tactile vase at left, also made by Robertson, is an example of CKAW's volcanic ware.

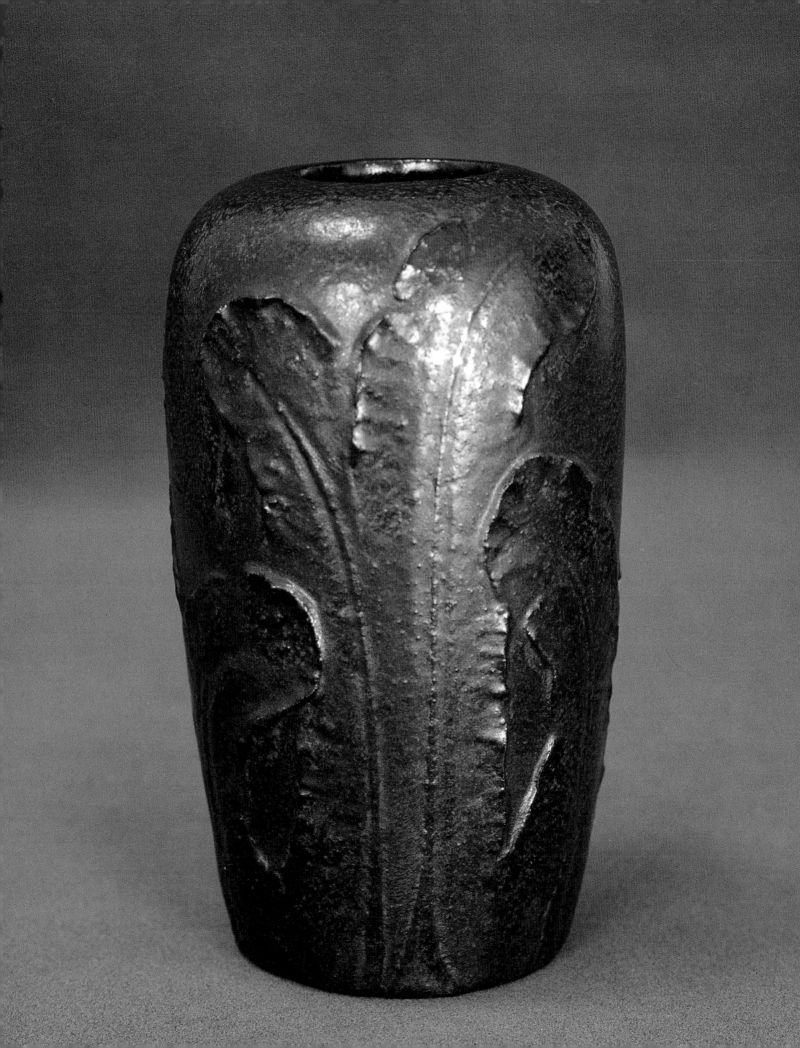

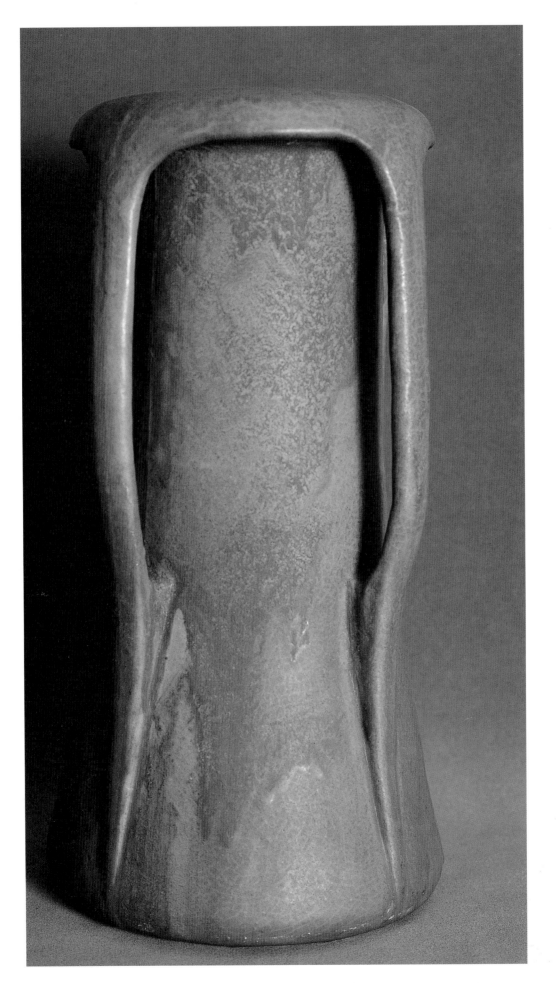

Wheatley's Varied Decorative Techniques *Opposite and below* The simple architectonic vase on the opposite page is typical of Wheatley Pottery's molded ware. The mottled green glaze, buttressed handles, and simplicity of line are all reminiscent of Teco pottery [Collection Terry and Barbara Seger]. However, T.J. Wheatley's one-man studio also produced atypical vases with complex relief decoration, including the marine-inspired lobster vase below [Collection Yale University Museum].

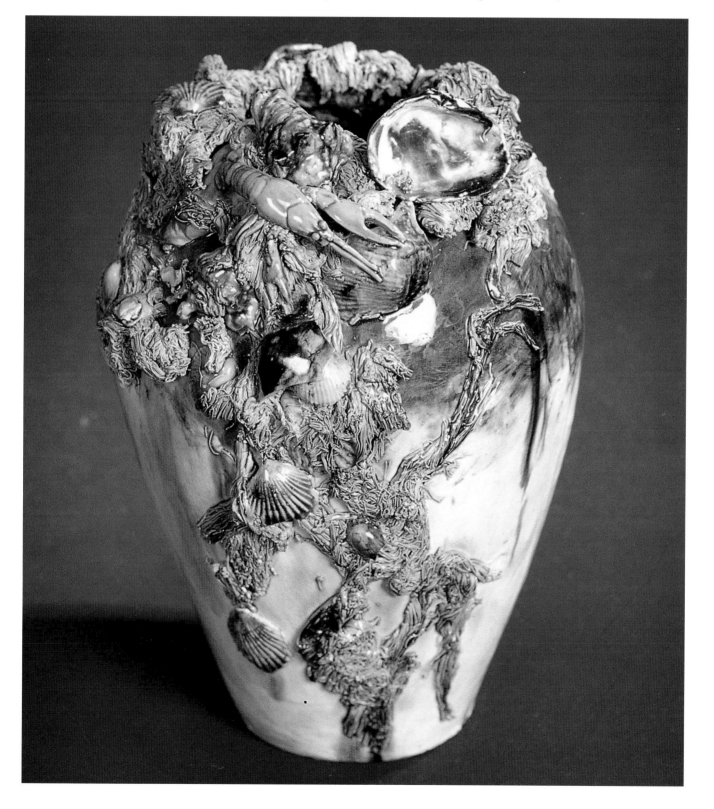

Weller's Diverse Artware

Opposite and below

The ceramic statue on the opposite page is known as "the Coppertone fishing boy fountain"—a humorous addition to their garden pottery line that sprayed water. The glossy Hudson floor vase below is more typical of Weller pottery: Oriental influence is apparent in the painted flowers that decorate it [Collection Ken Kolski]. The piece at bottom right, with iridescent glazing and intricate applied decoration, is from the Weller Sicardo line.

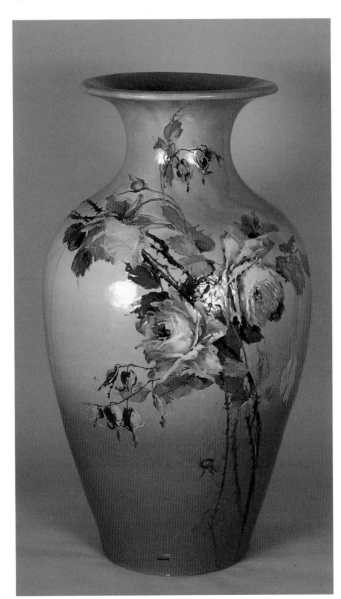

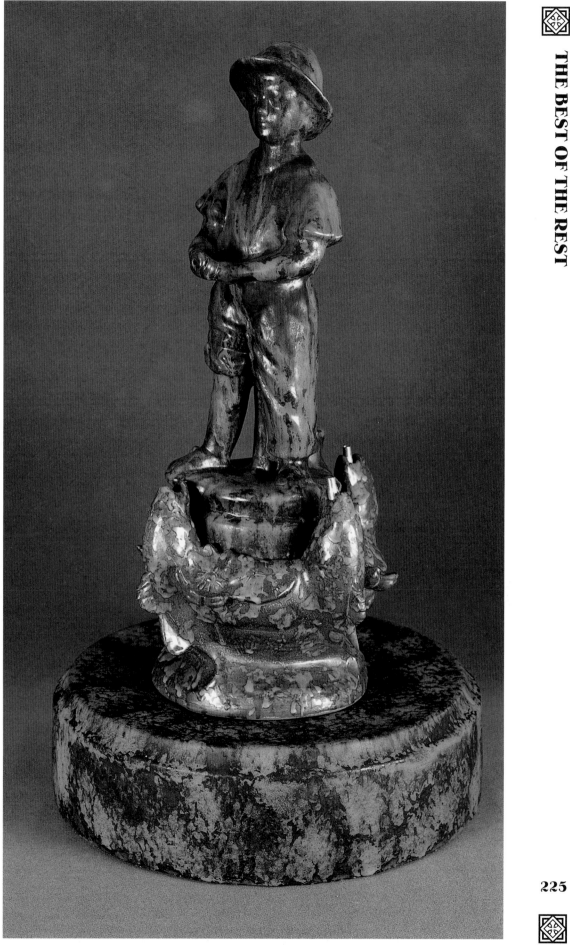

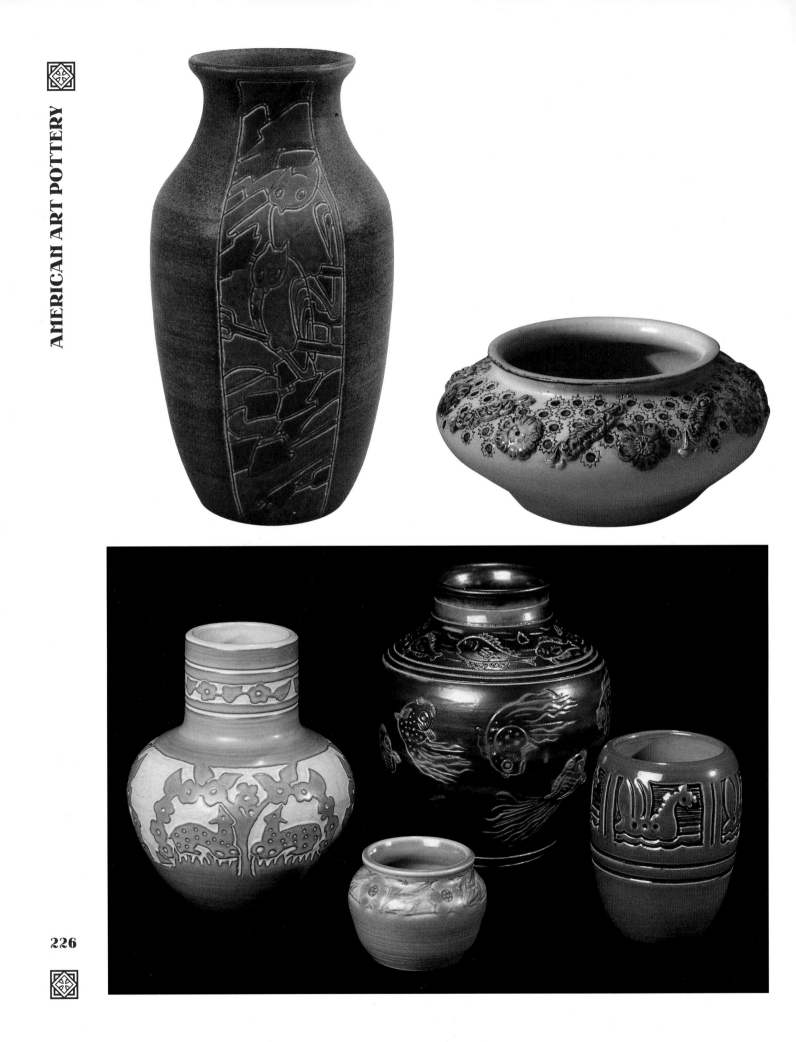

Overbeck, Frackelton, and NDSM

Opposite and below

The group of four vases (opposite, below) was created by students at the North Dakota School of Mines in Grand Forks, North Dakota. Thrown from local clay, each piece has incised decoration. The bowl (opposite, top right) was designed and decorated by Susan Stuart Goodrich Frackelton in Milwaukee, Wisconsin, and is typical of her salt-glazed stoneware. The other three vases (opposite, top left, and below) were designed at Overbeck Pottery in Cambridge City, Iowa. Founded by four sisters in 1910, the studio produced hand-thrown ware from a mixture of clay obtained from Pennsylvania, Delaware, Iowa, and Tennessee.

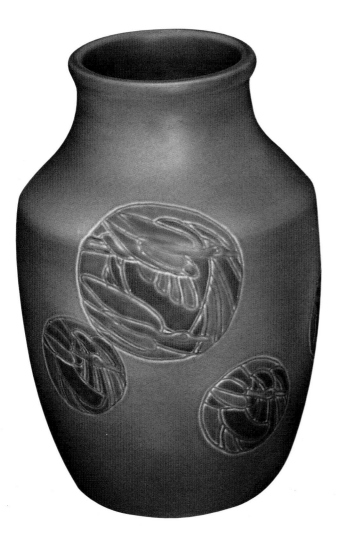

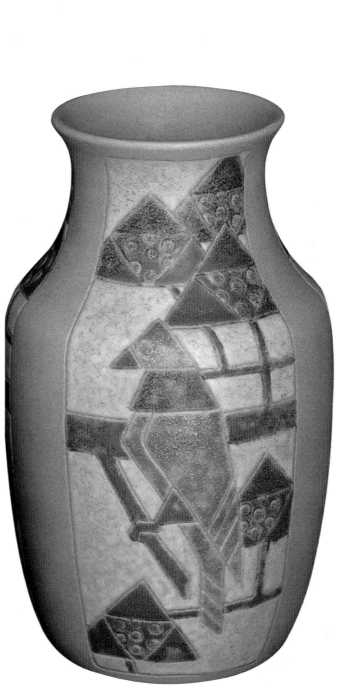

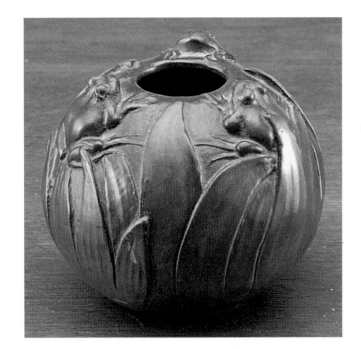

Redlands and Grand Feu Ware

Left and below

The vase at left was produced at California's Redlands Pottery by its founder, Wesley H. Trippet, and is decorated with relief-carved designs. The vase below, also produced in California, at Grand Feu Pottery, has no decoration except the spectacular crystalline glaze.

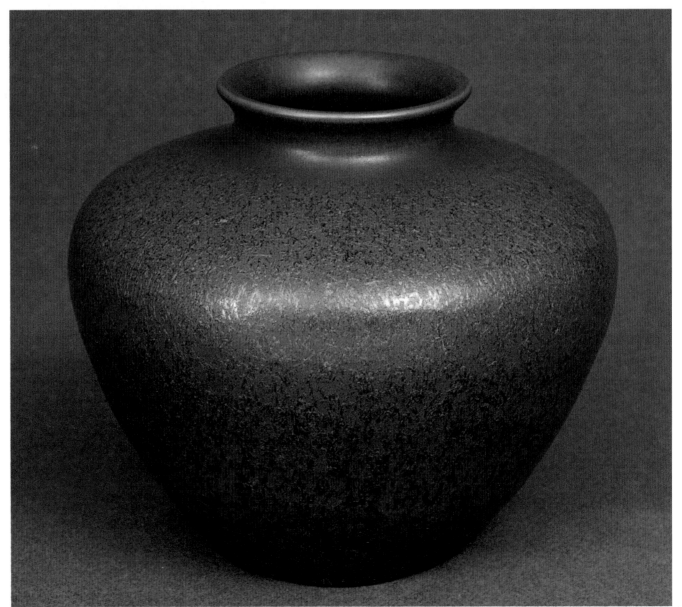

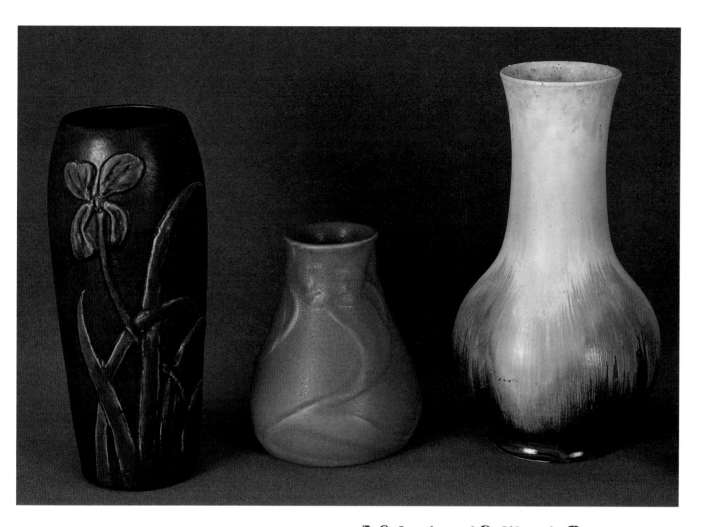

A Selection of California Pottery *Above These three vases were produced at (left to right): Arequipa, Valentien, and Grand Feu, and each has its own defining characteristics. The cylindrical Arequipa vase is embellished by embossed floral decoration, while the smaller Valentien piece bears a sinuous molded design. The Grand Feu vase, with a bulbous body and a long, fluted neck, is finished with striped glaze effects.*

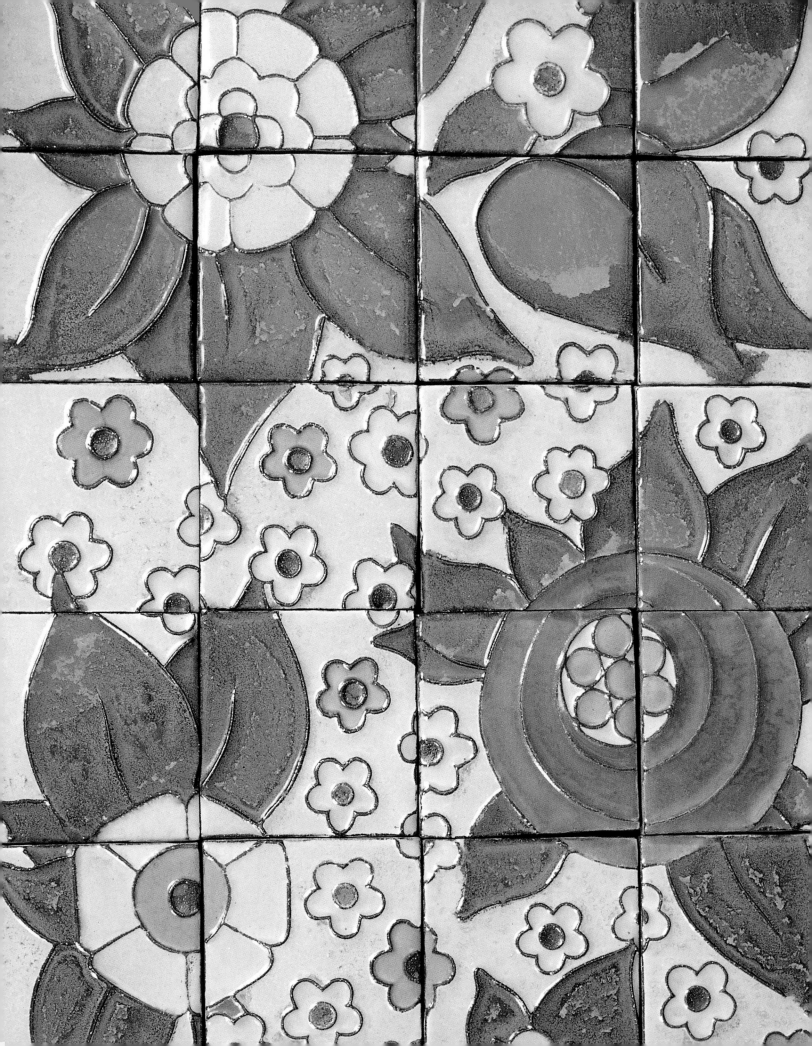

Decorative Tiles
by Suzanne Perrault

Next to paintings, etchings, and engravings, nothing can be more effective for wall decoration than artistically modeled tiles, in which color and shading are replaced by contour. The tile designer combines the arts of the painter and the sculptor, and his ceramic creations, partaking both of the nature of pictures and of delicate carvings, are well deserving of a place among the objects of art which adorn the dwellings of the cultured.

> —Edwin AtLee Barber
> *The Pottery and Porcelain of the United States*, 1893

Opposite: Part of a tile panel, consisting of sixty pieces, produced at Enfield. Tile panels were often used to decorate walls, adding a feeling of warmth to otherwise sparse interiors.

The Victorian Era

Like so many other artistic and cultural elements, the concept of art tiles came here from Europe before the turn of the century. The Centennial Exposition in Philadelphia in 1876 brought many new ideas and fashions to this country, planting seeds in the fertile ground of a nation eager for things foreign, exotic, and new. Exposing the American people to recent inventions, technological advancements, and artistic developments changed this country's course forever.

Contemporary accounts show that many art tiles were displayed at the Exposition, mostly from such English companies as Minton, Maw, and Wedgwood: they created a demand among the American public. The Eastern states were in the throes of a building boom, and fine English tiles found a ready market; they were installed in parlors, kitchens, and fireplace surrounds. The new-found importance of sanitation also encouraged the use of tile in bathrooms, for easier cleaning. Entrepreneurs soon mobilized domestic resources, including clay-rich soil and German or English immigrants with tilemaking backgrounds, to create a superior product.

The First Companies

By and large, the output of the early companies was a direct copy of the English product. Most of them offered the hard-wearing, dust-

Above: Using a plastic sketch, a technique developed by John Low, Arthur Osborne designed Ave Maria *for J & J.G. Low Art Tile Works.*

pressed, encaustic (inlaid) floor tiles with geometric or floral patterns of Gothic inspiration; plain enameled or glazed tiles; fancy tiles decorated in Neo-Classical relief style with mythological subjects, nudes, idealized Renaissance portraits; and realistic flora, fauna, and hunting scenes, many inspired by or copied from Renaissance paintings. Some companies also produced intaglio-carved tiles, a technique whereby the flat, wet ("green") tile is carved with a landscape or portrait, then filled with a single-color glaze which pools in its recesses, giving a darker hue to the deeper grooves. The final effect is one of photographic accuracy.

American tile was of high quality from the start, and, as mentioned above, extremely similar to English imports. Still, because of the deeply ingrained belief that foreign things were better than domestic (some things don't change), the industry had some difficult years before the American market was won over. This process was expedited when domestic tilemakers started winning international competitions on foreign ground. The following manufacturers became some of the most important.

The J. And J.G. Low Art Tile Works
Chelsea, Massachusetts

John Gardner Low, trained in painting in Paris and in ceramics at the Chelsea Keramic Art Works, built the J. and J.G. Low Art Tile Works with his father, the Honorable John Low, in Chelsea, Massachusetts, in 1877. Tile production began in 1878, with modeler Arthur Osborne, and by 1880 the company had been awarded a gold medal at the Exhibition at Crewe, Stoke-on-Trent, England (home of the old and formidable Minton tile factory), making ceramic news here and abroad.

Working mainly with the processes and aesthetics of the time, the Lows also broke new ground with some innovative techniques. One of them, patented as the *natural process*, involved placing a delicate object, such as a leaf, a flower, or a piece of lace, directly on top of a framed, unfired tile, covering it with tissue paper and a second green tile, and pressing the two together, producing two separate tiles with an impressed natural design. Another technique which won them acclaim was the creation of beautifully designed tile panels made of wet or plastic clay, as opposed to damp dust, some of them up to 24 inches long, called *plastic sketches*. Designed by Arthur Osborne, these required much hand-work in undercutting, the designs being embossed in varying depths—ranging from high relief to intaglio within one panel—which gave them a three-dimensional look. The plastic sketches have a Germanic or Barbizon-School flavor in subject matter: cobblestone streets with sheep, landscapes with cows, old monasteries.

Other Low products included the finest stove tiles, brass-mounted clock facings, mantel facings, and soda-fountain panels, one of which was exhibited at the Columbian Exposition in Chicago in 1893. The firm stopped operating in 1902.

The American Encaustic Tiling Company
Zanesville, Ohio

Also known as AETCo, the American Encaustic Tiling Company became the largest and longest-lived art tile manufacturer in the country: it was to the world of tiles what the Rookwood Pottery of Cincinnati, Ohio, was to art pottery. In a mutated form, it has survived to this day.

Beginning in 1875, AETCo was a big business with financial roots and management in New York City. Many considered it a New York company, even though its plant was located in Zanesville, Ohio. When the controlling interests considered moving the plant back East to New Jersey in the early 1890s, the townpeople of Zanesville rallied to keep it in their midst. Money was raised, land was donated, and train tracks were laid: finally, a brand new plant with twenty-eight kilns was built. The citizens of Zanesville declared a holiday and came out en masse to celebrate its opening on April 19, 1892.

The company survived many changes of management, economic condition, popular taste, and modelers. During the first twenty years, it produced the full gamut of flooring and art tiles made of local clays in both wet and damp-dust processes, including imitation mosaics, photographic (intaglio), and damask tiles. German modeler Herman Mueller

Above, left, and below: This selection of tiles produced at American Encaustic Tiling Company shows versatile use of subject, technique, and design.

joined the staff early on and has to his credit the largest and finest Neo-Classical wall panels produced by the company.

One of the most important figures at AETCo was Englishman Leon Solon, who left Minton's for America in 1909 and worked at AETCo from 1912 to 1928. He acted as artistic director and New York representative for the firm and, with others, encouraged a change of direction in production to a more hand-crafted appearance, much in vogue during the building boom of the 1920s.

Englishman Frederick Hürten Rhead, a talented designer and potter committed to the Arts and Craft movement, came to America in 1902. He first joined the Weller Pottery of Zanesville; eventually, he worked with some nine potteries from coast to coast, including Roseville and Arequipa, before his death in 1942. Rhead came to American Encaustic in 1917 as a business manager and designer, creating a research department and a pottery division. He moved on from AETCo to the Homer Laughlin China Company in 1927.

Like other tile companies, the AETCo behemoth ran out of steam during the Depression. It was reorganized with the Franklin Pottery of Lansdale, Pennsylvania. Eventually, the merged companies became known as American Olean.

Below: Three classically-influenced portrait tiles from (top to bottom): United States Encaustic Tiling Company, Hamilton Tile Works, and Providential Tile Works.

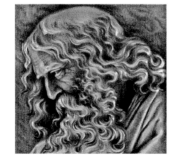

Other Early Tile Producers

Several other early art tile manufacturers must be mentioned, if not because of any major innovations, then certainly because of the talent of their chief modelers. Dates for some of these artists and firms are not certain. They include:

- United States Encaustic Tiling Company, Indianapolis, Indiana, 1877–1939 as U.S. Tile Corporation. Ruth Winterbotham was a principal modeler in the early years.
- Trent Tile Company, Trenton, New Jersey, 1882–1938, started as the Harris Manufacturing Company. Modelers: Isaac Broome, 1883–86, and William W. Gallimore, 1886–93. (Quebec-born Isaac Broome was a talented painter and sculptor who, like Frederick Rhead, spread his knowledge to many different companies, turning what he touched to gold. His sculptures and vases for the Trenton firm of Ott & Brewer were among the finest in the world. His attention to details on the modeling of his tiles makes them immediately recognizable).
- Hamilton Tile Works, Hamilton, Ohio, 1883–95. Adolf Metzner and sons produced dust-pressed decorative and field tiles.
- Providential Tile Works, Trenton, New Jersey, 1885–1913. Isaac Broome and Scott Callowhill, principal modelers.
- Kensington Art Tile Company, Covington, Kentucky, 1885–95. Herman Mueller was the principal modeler before being hired by A.E.T.Co. Kensington eventually merged with Hamilton Tile Works.

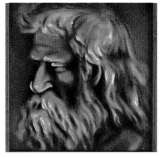

- Beaver Falls Art Tile Company, Beaver Falls, Pennsylvania, 1886–1927. Isaac Broome, modeler, from 1890.
- Cambridge Art Tile Works, Covington, Kentucky, 1887–1929. Ferdinand Mersman, modeler; Clem Barnhorn, designer. Cambridge eventually bought out the Wheatley Pottery of Cincinnati, Ohio, to become the Wheatley Tile & Pottery Company.
- Menlo Park Ceramic Company, Menlo Park, New Jersey. 1888–93. Hand-painted tiles by Charles Volkmar and J.T. Smith.
- Robertson Art Tile Company, Morrisville, New Jersey, 1890–c. 1980. Some modeling done by Hugh Robertson of the Chelsea Keramic Art Works and Dedham Pottery. Later known as Robertson Manufacturing Company.
- C. Pardee Works, Perth Amboy, New Jersey, 189?–192?. William Gallimore was one of the modelers. Pardee bought out the Grueby Pottery in 1921, including its inventory and the knowledge of William Grueby.

The Arts and Crafts Movement

For purposes of decoration it is not always essential nor even desirable that tiles be mechanically perfect, a little irregularity of shape and glaze which will give a variety of color tone is valuable.

> —Addison Le Boutillier,
> "Tiles In Home Decoration," *Good Housekeeping*, 1905

Above: These two six-inch-square tiles with relief profiles were produced at Kensington Art Tile Company (top) and Robertson Art Tile Company.

The turn of the century inspired change and growth. Technological innovations were springing up everywhere: the automobile, flight, electricity. The building market remained strong, due to a constant flow of immigrants to major American cities, and extended into suburbia, as travel became easier.

A herald of this era was the World's Columbian Exposition, held in Chicago in 1893. It showcased works from the English Arts and Crafts movement, a socialist aesthetic rebellion against the Industrial Revolution that had been brewing for decades abroad. Its principal spokesman was William Morris, who, with other members of the Pre-Raphaelite Brotherhood, believed in the welfare and dignity of the worker, whose spirit infused the things he made. Europe and America were ready to hear this message, and the Arts and Crafts movement took the Western world by storm.

For tile manufacturers, "faience" and "enamels" became the rallying cries for a new era. The perfect, dust-pressed tiles of the 1880s and 1890s, with their glossy, monochromatic glazes over precious Neo-Classical images, began to look staid and outdated to artists with an eye to the twentieth century. Art potteries, including Grueby, Rookwood, and Pewabic, began to manufacture tiles. Their design-

ers were aware, through the Columbian Exposition and the magazine *International Studio*, among other things, of the works of European ceramists like Frenchmen Auguste Delaherche and Antoine Dalpayrat and Englishman Christopher Dresser. Much of this new pottery, itself influenced by Oriental masters, had an organic look, with gourdlike shapes and glazes that resembled cucumber skin. While matte or crystalline glazes had been briefly introduced to the American market in the mid-1880s, by Hugh Roberstson at Chelsea Keramic Art Works and by Rookwood Pottery, they had not caught on with the public.

The earthy aesthetic translated well to tiles. The tremendous popularity of the Arts and Crafts movement also changed the way homeowners viewed them. Matte faience tiles, with their irregular hand-made look, began to grace many a hearth, counter-top, or wall. Tiles brought warmth and coziness to the newly popular bungalows and added a touch of fantasy to an otherwise spare interior. True to the Arts and Crafts taste for things Medieval, these tiles might feature images of knights and castles, or monks and apostles. Three-masted ships, landscapes, flower arrangements, and animals were also popular. Adapting European and domestic designs from well-known pattern books, or from competitors' catalogues, was an accepted and widespread practice.

Several traditional Spanish tilemaking techniques came back into favor, including *cuenca* and *cuerda seca*. From the metalwork *cloisonné* technique, *cuenca* implied pressing and firing a tile with raised outlines, or *cloisons*, then filling the sections with glazes that would be contained. The Grueby Pottery did much *cuenca* work, as did many of the California Hispano-Moresque tilemakers. *Cuerda seca*, or dry cord, was practiced by using twine to outline flat color sections: the cord would burn off in the kiln, leaving black outlines. The Saturday Evening Girls Club of Boston, Massachusetts (Paul Revere Pottery) used this technique almost exclusively.

Grueby Pottery
Boston, Massachusetts

Pottery lore has it that thirteen-year-old William H. Grueby started learning the craft of tilemaking during a ten-year stay at the J. and J.G. Low Art Tile Works. After a brief partnership with Eugene Atwood, he opened the Grueby Faience Company in 1894, in Boston, Massachusetts, for the production of enameled architectural faience, tiles, and glazed brick. (Apparently, Grueby insisted on

Below: Addison Le Boutillier designed this six-inch-square, low-relief tile with a stylized mermaid for Grueby Pottery.

differentiating his matte, opaque glazes from the commonly used sheer, glossy glazes of the time by calling them enamels.) Success with art pottery experiments led Grueby to expand and incorporate in 1897, and, by 1907, to subdivide the company into two corporations, first the Grueby Pottery Company, and shortly thereafter, the Grueby Faience Company.

Three men were responsible for most of the tile and architectural terra cotta designs at Grueby. John Lavalle and George P. Kendrick joined the company when it opened. Lavalle "created" the early Moorish *cuenca* tiles and some Della Robbia-inspired works. Kendrick, a founding member of the Society of Arts and Crafts, Boston, and a metalsmith and book illustrator by trade, is credited with the early underglaze-painted peacock tiles, among others. He served as director of design until his departure in 1902, when he was replaced by Addison Le Boutillier.

Le Boutillier, an illustrator and member of the SACB, was responsible for most of the Grueby tiles in the high Arts and Crafts style so popular today, including friezes for Thomas Lawson's mansion "Dreamwold." In typical late-nineteenth-century fashion, he freely borrowed illustrations and vernacular from pattern books and artworks he studied during his travels, as well as from contemporary tilemakers—for example, the knights of Henry Chapman Mercer (which Mercer had himself copied from a church in Nüremberg). He worked mostly in *cuenca*, creating flat, almost naive images of ships, flowers, and animals for fireplaces and walls. He also designed low-relief floor tiles with stylized Medieval or Renaissance cherubs, monks, and apostles divided into components, as if drawn through a stencil.

In spite of tremendous success both here and abroad (including gold medals from the 1900 Paris Exposition, 1901 St. Petersburg Exposition, and 1904 Louisiana Purchase Exposition), financial trials challenged the company. Grueby Faience had to be reorganized in 1909, whereupon the management of both companies was reshuffled. Grueby found himself back in tile and architectural production, heading the new Grueby Faience and Tile Company. A fire crippled the pottery in 1913. The company was eventually sold to the C. Pardee Works of New Jersey, in 1919, but it remained at its First and K Streets address in South Boston for a few years. It appears that Grueby continued to work there under the new management. Operations moved to Perth Amboy, New Jersey, in 1921, and William Grueby died in New York in 1925.

Above: This Grueby tile shows Spanish influence in both subject matter and technique. The depiction of a Spanish galleon was carried out via the cuenca *process.*

Below: Addison Le Boutillier designed this six-inch-square tulip tile for Grueby.

Above and below: A selection of Rookwood tile with scenes from nature and mythology.

Rookwood Pottery
Cincinnati, Ohio

A world-famous pottery established in 1880, Rookwood began to produce architectural terra cotta around 1901 and published its first tile catalogue in 1907. The catalogue boasted that "We supply only Mat Glaze Faience Tile, not bright finished or gloss surface. Rookwood colors and textures are individual and can be obtained only in tile manufactured by the Rookwood Pottery Company." Some 145 decorated tiles were offered in relief or *cuenca*, depicting landscapes, ships, animals, and Dutch scenes. All were made to order in a choice of colors, for up to $15 for a 12-inch by 18-inch scene in *cuenca*. Plain and molding tiles were also produced.

Like other tilemakers of the time, Rookwood's faience department worked closely with architects and designers on custom orders. An impressive list of commissions includes a half-dozen of the original New York City subway stations (at least as many were done by Grueby); hotels (the Norse Room of the Fort Pitt Hotel, Pittsburgh, John D. Wareham, designer); restaurants (Della Robbia Room of the Vanderbilt Hotel, New York City, with Guastavino tiles on the vaulted ceilings); schools (U.S. Military Academy at West Point); railroad stations (Grand Central Station, New York City); department stores (Lord & Taylor); office and government buildings; and banks. The apex of Rookwood's tile production, between 1907 and 1913, prompted the opening of a New York City office to cater to the demand.

Rookwood's pottery department also produced plaques, which, while not technically tiles and much more expensive, rivaled the demand for wall art. Hand-decorated by some of their best artists, including Frederick Rothenbusch, E.T. Hurley, and Carl Schmidt, the plaques were rather like flat vases—slabs of earthenware that were fired, painted, fired again, and covered with a "vellum" overglaze (although a few early plaques were decorated with their popular brown Standard Glaze, most were vellum-glazed and produced between 1904 and 1952). They were sold framed, ready to hang, and were regarded as fine art.

The architectural faience department was closed during the early 1930s. Contrary to what is often believed, it was not profitable enough to "carry" the pottery in hard times, due to the high cost of making pieces to order and by hand. And by this time, apart from the Great Depression, the market for art tile and pottery was in decline.

Pewabic Pottery
Detroit, Michigan

Detroit, even more than most American cities, experienced an intense building boom at the turn of the century. Energized by the car industry, Detroit's population and wealth grew rapidly, as seen in new buildings, hotels, restaurants, and theaters, as well as the development of suburbia.

The Pewabic Pottery played an active role in the city's architectural development. Founded in 1903 by china painter Mary Chase Perry (Stratton) and Horace James Caulkins, a dental technician and the inventor of the "Revelation" kiln, Pewabic (Indian for the "copper color in clay") became an important name in the American Arts and Crafts movement.

The pottery began as a small operation. Initially, all the decoration was done by Mrs. Stratton and production comprised mainly matte green pots, in emulation of William Grueby. After a couple of years, the matte green enamels were abandoned in favor of brilliant, lustred glazes in purple, green, and gold, which would become Pewabic's trademark.

Tile production started around 1907, and one of the first commissions was for New York architect Cass Gilbert. Apparently, upon visiting the pottery, Gilbert crushed a group of tiles and rearranged the tesserae into a mosaic, prompting the company to undertake mosaic production. Pewabic went on to work with some of the nation's most prominent architects, including Albert Kahn and McKim, Mead & White, in styles ranging from Neo-Classical and high-style Art Deco to Gothic and Arts and Crafts. While most of their projects were in Detroit (including the Grand Union Trust Building), their tiles also decorated walls in New York City (roof-garden restaurant, Pennsylvania Hotel), and Washington, D.C., (exceptional panels for the Shrine of the Immaculate Conception).

Mrs. Stratton borrowed freely from historical symbols and patterns, without copying them verbatim. During her travels through Spain, Portugal, and Italy, she filled sketchbooks with tile designs from Alhambra, mosaics from Ravenna, Della Robbia medallions, and Sicilian tesserae. Other important inspirations include the *Handbook of Ornament*, by Franz S. Meyer, 1892, and the 1906 Moravian Pottery catalogue (as seen in tiles for the Church of the Messiah and St. Paul's Cathedral, both in Detroit), as well as the writings of William Shakespeare. Familiar Arts and Crafts themes such as coats-of-arms and other Medieval designs were installed in Tudor and Gothic homes, whereas Christian symbolism brought Pewabic many commissions from religious establishments.

Above: These three Pewabic tiles demonstrate the different degrees of relief that could be achieved by the force of incisions into the wet clay.

Above: "Brocade" musicians and a detail from the fountain spout of "Face and Lilies," both produced at Moravian Pottery and Tile Works.

Below: This four-color, six-inch cuenca *tile was produced at Wheatley Pottery Company.*

The Moravian Pottery and Tile Works
Doylestown, Pennsylvania

Bucks County, Pennsylvania, native Henry Chapman Mercer has a long list of credentials, from cofounder of the Bucks County Historical Society to archaeologist in Mexico's Yucatan Peninsula. While studying old tools in a pottery, he developed an interest in clay. He opened the Moravian Tile Works in 1898. Early production included some crude vessels that he soon discontinued in favor of tile production, which he felt had greater commercial potential. Eventually, he would go back to pottery for a little while, but few serving pieces are seen today.

Between 1908 and 1912, Mercer designed and built two large poured-concrete structures on his estate on Court Street: a fireproof Spanish Colonial Mission-style structure to house his pottery, and his home, Fonthill, a Gothic-style mansion. There he showcased his collection of tiles, ranging from Byzantine to Moravian, as well as old tools, prints, and Moravian stove plates on which he based some of his tile designs.

Faithful to an Arts and Crafts vision, Mercer hand-rolled most of his tiles, which were usually irregular in shape, often small (four inches square), and made of red or white local clay. Many were glazed with a single-color, sheer-satin glaze, in ivory and blue or green, covering all or part of the tile. Others were covered in dead-matte blue and white slip; there were also wonderful "brocades" (1908)—modeled-relief silhouette tiles, in bright glazes or colored clays, sold by the unit or set in panels. One entire room at Fonthill is covered with brocades telling the story of the New World. Mercer also produced mosaic panels depicting scenes of exploration and native American or Colonial life. Wealthy and well traveled, he borrowed freely from a variety of sources, including artworks from Mexico, Spain, Germany, England, and native American designs. Moravian tiles depicted Gothic, Medieval, and Mayan themes, ships, and zodiac signs. Henry Mercer was a seminal force in the American art tile industry, influencing many other successful tilemakers such as Pewabic, Batchelder, and Enfield.

The Moravian Pottery and Tile Works was bequeathed to the Swain family upon Mercer's death in 1930, and purchased by the County of Bucks in 1968. Tile production was revived in 1974 and continues to this day.

Other Arts and Crafts Tilemakers
• Weller Pottery, Zanesville, Ohio, 1872–1948. A variety of hand-painted plaques and tile panels by such highly regarded artists as Frederick Rhead and Mae Timberlake.

- Wheatley Pottery Company, Cincinnati, Ohio, 1880-1936. *Cuenca* tiles with rich curdled matte enamels. Bought out by the Cambridge Tile Manufacturing Company in 1927, reincorporated as the Wheatley Tile and Pottery Company.

- Hartford Faience Company, Hartford, Connecticut, 1894-c.1929. Founded by Grueby's first partner, Eugene Atwood, the company went on to produce deeply molded, high-relief tiles in the Arts and Crafts style, some of which were used in early stations of the New York City subway system.

- Mosaic Tile Company, Zanesville, Ohio, 1894-1967. Langenbeck and Herman Mueller. Gothic and Hispano-Moresque patterns, some animals, Neo-Classical nudes, landscapes, and an elephant balanced on a ball (copied fraudulently).

- Van Briggle Pottery, Colorado Springs, Colorado, 1900-present. Artus Van Briggle's widow, Anne, started the production of tiles c. 1907, making a wide variety of architectural and "tea" tiles, the art tiles decorated in *cuenca* and made in limited quantities.

- Volkmar Kilns, Charles Volkmar & Son, Metuchen, New Jersey, 1903-11. Charles and Leon produced some fine hand-painted tiles in the Impressionist style, as well as some decorated in "squeezebag," a technique in which clay was applied to the pottery using a bag much like the ones used to decorate cakes.

- Marblehead Pottery, Marblehead, Massachusetts, 1904-36. Founded as an adjunct to a sanitarium by Dr. Herbert J. Hall, for the benefit of his patients. The pottery became an independent company in 1908, with Arthur Baggs at the helm. Known mainly for their fine matte pottery vases, Marblehead produced many types of tiles, from a commercial grade depicting a ship to high-end, hand-decorated pieces.

- Enfield Pottery and Tile Works, Enfield, Pennsylvania, c.1906-28.

- Saturday Evening Girls Club/Paul Revere Pottery, Boston, Massachusetts, 1906-42. Philanthropic organization to keep immigrant girls occupied: produced pottery, children's dishes and tiles, and trivets, mostly decorated in *cuerda seca*. Exceptional tile installation at the Forsythe Dental Clinic in Boston.

- J.B. Owens Floor and Wall Tile Company/Empire Floor and Wall Tile Company, Zanesville, Ohio, 1909-?. Second venture by John B. Owens, after the 1907 shutdown of the J.B. Owens Pottery. Fine, large tiles in *cuenca* or high relief covered in matte glazes bear the

Above: Three different techniques were used to design these tiles (top to bottom): A cuerda seca design from Hartford Faience, a cuenca piece from Van Briggle, and an Impressionist landscape tile from Volkmar Kilns.

241

Top and above:
A twelve-inch-square cuenca *with ship motif from J.B. Owens Pottery, and a six-inch-square still life with incised design from Mueller Mosaic Tile Company.*

Owens mark. Few art tiles are found with the Empire stamp—mostly large pieces with landscapes or twelve-inch tiles with nursery rhymes.

- Mueller Mosaic Tile Company, Trenton, New Jersey, 1909–41. Herman Mueller.
- North Dakota School of Mines, University of North Dakota, Grand Forks, North Dakota, 1909–1970. Pottery and trivets by teachers Margaret Cable (at the university 1910–49), trained by Charles Binns (Alfred University) and Frederick Rhead; her sister Flora Huckfield (1924–49); and Julia Mattson (studied and taught at Alfred, worked at USND 1924–63).

California: The Last Frontier

Decorative tiles have been used for centuries to express individuality. Today, modern architecture demands decorative tile for distinction, for color, for the artistic expression of individual ideas."
—Tudor Tile Catalogue, Los Angeles, 1920s

California deserves its own section because of the unique character of its artistic output, and its quality and scope. Migration westward hit its stride in the second half of the nineteenth century, as men prospected for gold and land-hungry settlers sought new frontiers. As in the East, production of fine artifacts did not flourish until living conditions were sufficiently comfortable and secure. The Arts and Crafts philosophy found fertile ground in California in the 1910s and lasted there for more than a decade. It reflected the spirit of a people recently migrated to an earthly paradise, where the desert, snow-capped mountains, and redwood forests met the sea.

Artistic expression had finally reached the Golden State. It benefited from the well-publicized works accomplished by the Stickleys, Grueby, and the Roycrofters of the East Coast, which California made its own. Its shapes and colors are either breezy and full of light, or earthy, grounded, and natural. California sophistication and freedom can be appreciated in the works of the Arequipa, Redlands, and Valentien Potteries, the paintings and furniture of Lucia and Arthur Mathews, the lamps of Dirk Van Erp and Elizabeth Burton, the Plein Air school of painting, the woodblock prints of Bertha Lum, and the tiles of Batchelder, California Faience, and Claycraft.

The California building boom, begun in the mid-nineteenth century and still ongoing, was originally rich in Spanish influence. The local architectural vernacular borrowed freely from the old missions, reminders of the Spanish colonization of California and Mexico from the sixteenth through the eighteenth centuries. Residences with courtyards, low stone walls, fountains, and pools suited the outdoor-indoor living style and created a large demand for tiles, which became part

of the local landscape. The Spanish aesthetic found expression in bright glossy or satin glazes in Hispano-Moresque patterns, featuring flat areas of color in orange, sky or cobalt blue, and yellow, outlined by black curlicues on a white background. These proliferated on stair risers, swimming pools, and fountains. The California Arts and Crafts movement, on the other hand, took the shape of landscapes, animals, and Medieval figures in dead-matte slips on tiles.

Batchelder Tile Company
Pasadena and Los Angeles, California

New Englander Ernest Batchelder started teaching manual arts in Pasadena in 1901, at the Throop Polytechnic Institute. Later he taught intermittently at the Handicraft Guild in Minneapolis, between 1904–09, and spent about a year in England (1905–06), working for some time in Charles Ashbee's guild shop at Chipping Campden. By 1910 he had opened an Arts and Crafts workshop behind his Pasadena residence, where metalwork, tiles, pottery, and leatherwork were produced. The need for tiles in his new home probably encouraged him to start in that direction, and to set his own tiles with others purchased from the Moravian Pottery and Tile Works, to whom he acknowledged an artistic debt. He enlarged in 1912, with new partner Frederick Brown, as Batchelder-Brown. In 1916 the Society of Arts and Crafts, Boston, gallery exhibited some of their tiles. Continued success led the company out of the suburbs and into Los Angeles in 1920, with another partner, Lucien Wilson, under the name Batchelder-Wilson. By 1925 their tiles were distributed in New York City, and the company had grown to 175 employees. It closed in 1932.

Inspired by Mercer's Moravian tiles, Batchelder's tiles were hand-pressed in plaster molds, thick, uneven, and adorned with Gothic, Medieval, floral, or animal designs. Most commonly found are four-inch or six-inch squares of white or red clay with an embossed design of an animal (lion, stag, hare), a hunter with prey, or a stylized floral design. Tile backgrounds were rubbed with sky-blue, green, or dark-blue slip that pooled in the recesses, leaving most of the surface in its unglazed state. Some tiles were entirely unglazed, others were fired, glazed, then refired. Batchelder also made some wonderful panels, usually rubbed with blue slip, depicting nursery rhymes and fairy tales, and worked with architects on special commissions characterized by designs in stylized Arts and Crafts style: Medieval, Mayan, and California.

Above and below: Batchelder made the twelve-inch tile above—a child viewing a castle from a stone wall—and the panel below, composed of six individual tiles that picture St. George slaying the dragon.

Above: California Faience style.

Below: These landscapes of Yosemite National Park (top) and Yellowstone National Park were produced at Claycraft.

California Faience
Berkeley

Founded by artists William V. Bragdon and Chauncey R. Thomas, California Faience was a small, high-quality pottery and tile works. Bragdon had the impressive distinction of being an Alfred graduate who had studied under Charles Binns and taught ceramics at the University of Chicago (1909–12) and at the prestigious University City of St. Louis, Missouri (1912–14), under Frenchman Taxile Doat. Thomas founded the Deerfield Pottery, Deerfield, Massachusetts, (1909–11) before both men moved to Berkeley in 1915; eventually, they taught at the California School of Arts and Crafts.

Their first joint venture, the Tile Shop, was represented at San Francisco's Pan-Pacific Exposition even before it opened. By 1922 the tile and pottery were referred to as California Faience, and the company name followed in 1924. Production standards were always high in this small, studiolike company. Tiles were hand-pressed red clay in plaster molds, decorated with conventionalized designs in *cuenca* with bright matte and glossy glazes. Designs included animals, ships, fruit and flower motifs, sometimes landscapes. Their most important commissions came in the 1920s, for architect Julia Morgan's project for William Randolph Hearst's estate, San Simeon. Decorative ware production was almost over by the early 1930s, and the pottery was sold in the 1950s.

Claycraft Potteries
Los Angeles

In 1921 Gus Larson and Fred Robertson (of the Chelsea, Massachusetts, Robertson family, Chelsea Keramic Art Works, Dedham Pottery, and Roblin Art Pottery), colleagues at Los Angeles Pressed Brick, opened Claycraft Potteries. Their catalogue offered three types of tile: "Faience," "Claycraft," and "Handmade," all basically machine-made with built-in irregularities, but finished and colored by hand, sometimes with an added "distress" process to give them that extra-worn, handmade "faience" look. The decorated tiles are very colorful, often rectangular in shape. Most look like book illustrations in the Arts and Crafts aesthetic, with bungalows or farm houses tucked cozily under trees by a river, or a bend in the road; mission courtyards; pioneer scenes; forest vistas; plus Mayan designs, peacocks, knights, and floral bouquets, in the style of Batchelder, but finished with polychrome slips. While they produced a great variety of glazes and textures, the tiles that usually surface have a slip coating (engobe), giving a natural, dead-matte finish. From time to time, a tile comes up with a sheer, frothy overglaze (a lovely effect), much like some Rookwood Faience tiles.

Also offered were fountains, columns, garden pieces, and very large panels: some comprised as many as 150 tiles in the form of a mural.

Fred's son George joined the pottery in 1925, and the two of them opened Robertson Pottery in Los Angeles in 1934. The closing of Claycraft came some time before that date.

Other California Tile Producers

- Los Angeles Pressed Brick Company, Los Angeles, 1887–?. Large-scale production of faience tiles began when Fred Robertson, of the Roblin Art Pottery, was hired in 1906. The firm eventually gave up art tile to concentrate on architectural components.
- California Clay Products (Calco), South Gate, 1917–2?. Formerly Southern California Clay Products, founded by the multi-talented Rufus Keeler, who left to set up Malibu Potteries.
- Malibu Potteries, Malibu, 1926–32. Owned by Marblehead Land Company, directed by May Knight Ringe, and designed and managed by architect-ceramist Rufus Keeler. Among the most important commissions were large tile panels for the Los Angeles City Hall and Mrs. Knight Ringe's residence.
- Solon and Schlemmel (S&S), San Jose, 1920, which became Solon and Larkin in 1936. Albert Solon from Stoke-on-Trent, England, managed the Arequipa Pottery after Frederick Rhead joined forces with Frank Schlemmel.
- California Art Tile Company (Cal Art), Richmond, 1922–?. Formerly the Clay Glow Tile Company, founded by James W. Hislop and sons for the manufacture of machine-pressed, hand-glazed "faience" tile.
- Gladding, McBean, Los Angeles. Started producing tiles after purchasing the Tropico Potteries in Glendale, 1923. Took over Los Angeles Pressed Brick, Los Angeles, 1926, and had another facility in Santa Monica. Bought the two American Encaustic Tiling Co. facilities in the Los Angeles area, 1933, making it the largest producer of tiles in the West (perhaps the country).
- Walrich Pottery, Berkeley, 192?. Founded by Gertrude Walrich, an Ohio potter, and her husband James Walrich, formerly of Royal Doulton. This small, studio-style company hand-produced pottery and tiles that were covered mostly in sheer, glossy glazes, usually representing native landscapes in six-inch pieces.
- Tudor Potteries, Los Angeles, 1927–31. Initially produced press-molded tiles in the style of Batchelder, then resist-line geometric patterns in bright colors.
- Taylor Tilery, subsidiary of the Santa Monica Brick Company, Santa Monica, 1931–39. Probably organized after a fire devastated the Malibu Potteries (November 1931), as many former Malibu employees worked there.

Above: This Cal Art tile was machine pressed and finished by hand.

Following page: Tiles made during the postwar years at (top to bottom right) Franklin, Flint Faience, and Harris G. Strong.

Below: McBean incorporated the slogan and symbol of the National Recovery Administration, created by Franklin D. Roosevelt in 1933 to counter the effects of the Great Depression, into this propagandistic design.

The Best of the Later Tilemakers

- Franklin Pottery, Lansdale, Pennsylvania, 1923. Founded by the brothers Malcolm and Roy Schweiker, the company produced machine-made, hand-decorated faience tiles by 1925. In 1935 Malcolm Schweiker was encouraged by the government to dismantle an ailing American Encaustic Tiling Company, and after the war Franklin took on the name American Encaustic. AE later merged with National Gypsum (1958), and acquired the Olean Tile Company, when it changed its name to American Olean Tile Company (1964). The company is owned today by Dal-Tile International.

- Flint Faience Company, Flint, Michigan, 1921–33. Founded as a division of A.C. Spark Plug Company by Albert Champion, the company produced pressed faience tiles that were widely used in the Detroit area. Flint was purchased by General Motors in 1929 and closed due to the Depression in 1933.

- Harris G. Strong, Bronx, New York, 1952–69. Harris Strong started by making lamps, ashtrays, and tiles in his Bronx workshop, but soon concentrated on the commercially successful tile panels. The panels consisted of groups of commercial six-inch tiles, hand-decorated in different styles by an ever-expanding group of artists, then matted and framed, and sold through decorator showrooms (eventually their own). To this day, Harris Strong runs a successful business producing wall art in Ellsworth, Maine.

—Suzanne Perrault

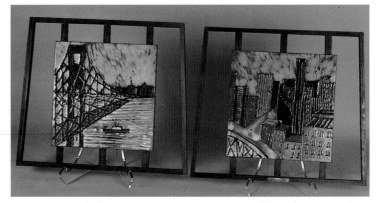

Glossary

applied design: decoration attached to the surface of a piece of pottery.

baluster: art pottery having a bulbous middle and a flared top and base.

bisque: art pottery left unfinished after firing.

brocade: a rich cloth or tile panel with a raised design that often tells or alludes to a story.

charcoaling: copper crystal blackening.

cloisons: raised outlines on tiles made by the *cuenca* process (see below).

crazing: gentle crackling of the glaze that occurs when the body and the glaze expand at different rates in the kiln.

crystalline glaze: glaze with a surface lustre sheen resulting from recrystallization of particles during the cooling period.

cuenca: Spanish tilemaking process whereby wet tiles are impressed with raised outlines before firing and the resulting inner sections glazed.

cuerda seca: Spanish tilemaking process whereby dry cord is used to outline flat color sections; these outlines become black during the firing stage, when the cord burns away.

earthenware: a lightly fired pottery whose porous body is often sealed with a glaze.

embossed design: raised surface decoration.

enamel: a glossy, opaque, hard protective coating.

encaustic: a process by which a design is inlaid using heat.

faience: earthenware decorated with colorful, opaque glazes, from the French for "handmade."

glaze: the coating applied to seal the porous body of earthenware.

granite ware: stoneware that has a speckled appearance.

green tile: flat, wet tile as yet undecorated.

ground: the basic body of a piece of pottery on which the decoration is applied.

incised design: engraved or carved decoration.

intaglio: a design that is carved, incised, or engraved, rendering it below the surface.

Jugendstil: displaying a Germanic influence on early twentieth-century decorative artware.

natural process: a technique developed at J. and J.G. Low Art Tile Works whereby a delicate object, such as a leaf or a piece of lace, was placed between two unfired tiles, covered with tissue paper, and pressed to produce two separate tiles with an impressed natural design.

olla: from the Spanish for "jar"; a bulbous pot with a wide mouth.

overlay: application of surface or overglaze decoration to a piece of pottery.

plastic sketches: technique developed by John Low at J. and J.G. Low Art Tile Works whereby tile panels were made from wet or plastic clay, as opposed to damp dust.

porcelain: a high-fired ceramic ware with varying degrees of thickness and translucency.

porcellaneous: exhibiting porcelain-like qualities.

pottery: generic term that includes earthenware, clay, and stoneware products.

relief design: decoration raised from the body of a piece of pottery or porcelain.

scroddle: the process whereby clays of various colors are mixed together to produce a swirled effect.

sgraffito: technique in which decoration is scratched through the surface glaze to reveal the underlying color of the clay body.

shaped rim: decorative technique whereby the rim of a vase is given a regular or irregular pattern instead of a smooth outline.

slip decoration: technique in which liquid clay is applied to the body of a piece to produce a raised design, usually decorated with colored glazes.

sponging: application of color or glaze to the body with a sponge to produce a mottled effect.

squeezebag: decorative technique whereby liquid clay, or slip, is applied in a manner similar to that used in cake decorating.

stoneware: refined pottery having a strong, nonporous body.

stylized design: non-naturalistic decoration, sometimes abstracted from a natural motif.

terra cotta: unglazed, lightly fired earthenware that is reddish in color.

tesserae: the small pieces used in mosaic work.

tyg: a three-handled cup.

Who Was Who

Asbury, Lenore An artist at Rookwood (1894–1931) who returned to work there occasionally in later years. Asbury's pieces were marked with her initials.

Atwood, Eugene R. Founded Atwood & Grueby in Boston, Massachusetts, with William Henry Grueby in 1891. The company was in business for only a few years; during that time they produced art tile, which was installed in several major Boston buildings.

Baggs, Arthur Trained under Charles Fergus Binns in Alfred, New York, before becoming director (later, owner) of Marblehead Pottery in Marblehead, Massachusetts, in 1908. Baggs remained at Marblehead until 1936. A crystalline expert, he was head of the Ceramic Department at Ohio University between 1928 and 1935.

Bailey, Henrietta A student at Newcomb College from 1901 until 1905, she worked as a designer at the pottery until 1909. She then served as an arts craftsman (to 1926), after which she became a teacher at the college, where she taught until 1938.

Barber, Edwin AtLee The author of *Marks of American Potters* (1904) and *The Pottery and Porcelain of the United States* (1909), two books that markedly influenced the Arts and Crafts movement in America.

Barnhorn, Clem The designer of art tile at Cambridge Art Tile Works.

Batchelder, Ernest Opened an Arts and Crafts workshop at his Pasadena, California, residence in 1910, after teaching manual arts at the Throop Polytechnic Institute (1901) and at Handcraft Guild in Minneapolis (1904–09). Originally his company produced pottery, metalwork, and leatherwork, then expanded into tiles. In 1912 Batchelder formed a partnership with Frederick Brown to become Batchelder-Brown. Their tiles were exhibited at the Society of Arts and Crafts of Boston, where their success enabled Batchelder to move his company to Los Angeles, in 1920, with a new partner, Lucien Wilson. By 1925 Batchelder tiles were available in New York City. The company closed in 1932.

Binns, Charles F. Born in Worcester, England, Charles F. Binns (1857–1934) was the son of the director of the Royal Worcester Porcelain works, where he apprenticed. He moved to the United States in 1897 and opened the first ceramic school here. From 1900 until 1931, he served as director of the New York State School in Alfred, where such artists as Arthur Baggs, Paul Cox, William V. Bragdon, Elizabeth Overbeck, and Frederick Walrath trained.

Bragdon, William V. One of the founders of California Faience, a small pottery and tile works in Berkeley, California. Bragdon had studied under Charles Binns at Alfred University in New York, before teaching at the University of Chicago (1909–12) and University City of St. Louis,

Missouri, (1912–14). Originally called the Tile Shop, California Faience produced hand-pressed tiles decorated in *cuenca* (see Glossary) and finished with bright matte or glossy glazes. Production of tiles had all but ceased by the early 1930s.

Broome, Isaac A talented painter and sculptor, Broome was employed as a modeler at Trent Tile Company (1883-6), Providential Tile Works, Ott & Brewer, and Beaver Falls Art Tile Company. His attention to details makes his work easily recognizable.

Brouwer, Theophilus A., Jr. In 1894 Theophilus Brouwer (1865–1932) founded Middle Lane Pottery, which soon became known as Brouwer Pottery. He ran the company singlehandedly, manufacturing six types of ware: Gold Leaf Underglaze, Fire Painting, Iridescent Fire Work, Sea-Grass Fire Work, Kid Surface, and Flame. Middle Lane Pottery closed in 1946, fourteen years after Brouwer died.

Brown, Edith One of the women who suggested in 1906 that the members of Boston's Saturday Evening Girls Club make pottery. Their company became known as Paul Revere Pottery, and by 1912, SEG ware was selling well. More than two hundred women worked at the pottery over the years. Paul Revere Pottery closed down in 1942, ten years after Edith Brown died.

Brown, Frederick Became Ernest Batchelder's partner in 1912, forming Batchelder-Brown, a tile company in Pasadena (later, Los Angeles) California.

Burt, Stanley Hired as a chemist at Rookwood in 1892, Stanley Burt became superintendent in 1898. He developed Rookwood's line of Vellum ware.

Cable, Margaret A teacher at the North Dakota School of Mines from 1910 until 1949, Cable produced trivets and art pottery.

Callowhill, Scott One of the principal modelers at Providential Tile Works.

Carpenter, Jim A New Jersey barber and antique dealer who bought George Ohr's collection of pottery from his sons. He is credited with bringing Ohr's genius to the attention of the American public.

Caulkins, Horace J. The founder of a dental-supply business, Caulkins worked closely with Mary Chase Perry to develop the Revelation China Kiln, which transformed the Art Pottery movement in America. The kiln was fueled by kerosene and could reach unprecedented temperatures. Caulkins and Perry established Revelation Pottery, which later became known as Pewabic Pottery, around their invention.

Chaplet, Ernest (1835–1909) A French studio potter whose ware influenced the American Art Pottery movement.

Chase, William Merritt Chase (1849–1916) was a successful American artist whose subjects

include portraits, landscapes, and still lifes. He also taught painting for thirty-six years. Adelaide Alsop Robineau, one of the most influential figures in the Art Pottery movement in America, left her teaching position in Minnesota to study under Chase in 1899.

China Decorator, The A magazine purchased in 1899 by Adelaide and Samuel Robineau. In 1900 it was renamed *Keramic Studio*, a monthly journal that became the leading forum for serious ceramists.

Conant, Arthur (1889–1966) An artist at Rookwood from 1915 until 1959.

Cox, Paul Ernest Cox was responsible for modernizing Newcomb College Pottery's technical operations in 1910, and for producing the transparent matte glaze that replaced their standard clear, glossy finish. His innovations were partly responsible for the shift from stylized design and decoration to a more naturalistic rendering of subject.

Cram, Ralph Adams The architect of St. Paul's Cathedral in Detroit, Michigan, Cram incorporated tiles produced at Pewabic Pottery into the interior pavement of the church in 1908.

Dalpayrat, Antoine An influential French ceramist.

Daly, Matthew Daly (1860–1937) was an artist at Matt Morgan Pottery in Cincinnati before he joined Rookwood in 1882. He remained there until 1903 and in 1928 married Olga Reed Pinney, a fellow artist at Rookwood.

Deleherche, Auguste A French ceramist who had a decided influence on the American Art Pottery movement.

Diers, Ed An artist who worked at Rookwood from 1896 until 1937.

Dresser, Christopher An influential British ceramist and designer.

Eppley, L. An artist who worked at Rookwood from 1904 until 1948.

Freer, Charles L. An avid collector of art pottery in the first half of the twentieth century.

Fry, Laura Anne An honorary member of the Pottery Club of Cincinnati, founded in 1879 by Mary Louise McLaughlin. Laura Anne Fry (1857–1943) joined the decorating department at Rookwood in 1881 and remained there until 1887. In 1883 she developed Rookwood's Standard Glaze. She also worked at Lonhuda Pottery in Steubenville, Ohio (1892-4).

Fujiyama, Gazo (Fudji) Hired by Roseville Pottery in 1900 to bring the sought-after Oriental influence to the company, Gazo Fujiyama developed the Woodland, or Fujiyama, and Rozane Fudji lines. He also worked at Weller Pottery in Zanesville, Ohio.

Fulper, Abraham The father of William Hill Fulper, II, Abraham Fulper was Samuel Hill's partner in Samuel Hill Pottery of Flemington, New Jersey. When Abraham acquired the com-

pany in 1860, he renamed it Fulper Pottery Company.

Fulper, William Hill, II, William Hill Fulper, II, born in 1872, was responsible for transforming the ware produced at his father's Fulper Pottery Company. Originally a producer of drain tiles and utilitarian earthenware and stoneware, Fulper was reorganized when William undertook the production of high-quality pottery. His Vasekraft line is distinguished by its simple shapes and glazes. Each piece of Fulper ware was glazed by hand and was both aesthetically pleasing and affordable. Two years after he died in 1928, J. Martin Stangl, superintendent of Fulper's technical division, acquired the company, and in 1955 it was officially registered as the Stangl Pottery Company.

Gallimore, William W. Gallimore modeled art tile at Trent Tile Company (1886-93) and C. Pardee Works.

Gates, Major The youngest son of William D. Gates, Major Gates worked at Teco, his father's pottery (see below), where he invented several pieces of innovative equipment: a machine that threw three different streams of color onto the pottery, producing a mottled effect; a tunnel kiln; and an improved pressing machine.

Gates, William D. Born in Ashland, Ohio, in 1852, William D. Gates (1852-1935) founded Spring Valley Tile Works in 1881. He renamed the company Terra Cotta Tile Works in 1885 and enlarged the production line to include terra-cotta bricks and pottery. After a fire in 1887, he rebuilt and renamed the company American Terra Cotta and Ceramic Company, but it was often referred to as Gates Pottery. In 1902 "Teco" became the acronym used to identify the company. Until the pottery closed in 1929, at least one-half of the ware produced at Teco was designed by Gates. Reopened as American Terra Cotta Corporation in 1930, the company is in production today on the site of Gates's original pottery.

Gilbert, Cass Influential New York architect who is credited with inspiring Pewabic to produce mosaic tile; he gave the pottery one of its first art tile commissions.

Gregory, Anne see Van Briggle, Anne Gregory

Griffin, Walter Burley A member of the Prairie School of Architecture, which flourished in the early twentieth century, Walter Burley Griffin (1876-1937) worked with Frank Lloyd Wright from 1901 until 1906. Teco ware is considered the "pottery of the Prairie School."

Grueby, William Henry The founder of Grueby Faience Company, William Henry Grueby (1867-1925) embarked on his long career in art pottery when he was hired by the Low Art Tile Works in Chelsea, Massachusetts, at the age of thirteen. In 1890 he moved to Revere, Massachusetts, where he worked for a manufacturer of architectural faience. A year later, Grueby joined forces with Eugene R. Atwood and opened Atwood & Grueby, a tile manufacturing company, but the partnership was dissolved three years later, and Grueby went on to open his own pottery, Grueby Faience Company. During his years there, Grueby developed innovative glazes that earned him medals at various expositions. At the Paris Exposition

in 1900, he received two gold medals and one silver. Grueby's designs were quickly copied by other potteries, who sold their reproductions at cheaper prices. Competition caused the company to close in 1920, five years before William Grueby died.

Hall, Herbert J. Dr. Herbert J. Hall established Marblehead (Massachusetts) Pottery at Devereux Mansion, a sanitarium that he ran, in 1904. Originally created to provide occupational therapy for patients at the sanitarium, Marblehead separated from the institution in 1908.

Hearst, William Randolph California Faience received one of its most important commissions when Hearst incorporated its art tiles into designs for his estate, San Simeon.

Herold, John Hired by Roseville in 1900, artist and designer John Herold (1871-1923) created the company's Rozane Mongol line. He left Roseville to start his own company, Herold China Company, which later became Coors China Company. Herold also worked at Owens and Weller. The pieces that he produced throughout his career are identified by his initials.

Hill, Samuel The founder of Samuel Hill Pottery, one of the nation's oldest potteries, in Flemington, New Jersey, in 1814. Initially, the company was a successful producer of drain tiles and utilitarian earthenware and stoneware. When Hill's partner, Abraham Fulper, acquired the pottery in 1860, the company was renamed Fulper Pottery Company.

Hislop, James W. Hislop and his sons founded Clay Glow Tile Company, which later became California Art Tile Company, in 1922, for the production of machine-pressed, hand-glazed faience tile.

Huckfield, Flora An artist at North Dakota School of Mines from 1924 until 1949.

Hurley, E.T. Worked as an artist at Rookwood from 1896 until 1948. In 1907 he married fellow designer Irene Bishop.

Irvine, Sadie A prolific artist at Newcomb College. She attended the college between 1902 and 1906, served as an art craftsman from 1908 until 1929, then became a director and teacher. Irvine's career at Newcomb ended in 1952.

Johns, Jasper A modern artist, b. 1930, whose work influenced the realm of Abstract Expressionism, Johns brought attention to George Ohr's pottery by purchasing his work and including it in his paintings.

Keeler, Rufus An architect and ceramist, Keeler founded California Clay Products (Calco) in South Gate, California, in 1917. After leaving Calco, Keeler became manager of California's Malibu Potteries in 1926.

Kendrick, George P. A founding member of the Boston Society of Arts and Crafts, Kendrick (1850-1919) worked as a designer at Grueby Faience from 1898 until 1901. During this period, he designed most of the shapes that were decorated by female artists. He is credited with the early underglaze-painted Peacock tiles. Although new designs were added after he left the pottery, Kendrick ware continued to be produced until the company closed in 1920.

Keramic Studio Originally called *The China Decorator*, this magazine was purchased by Adelaide and Samuel Robineau in 1899.

Renamed *Keramic Studio,* it was published monthly from 1900 and quickly became the major forum for ceramists.

Kugler, John O.W. Kugler began working at Fulper Pottery Company in 1909 and designed most of the pottery's shapes.

Kunsman, John One of the chief potters at Fulper Pottery Company.

Larson, Gus One of the founders of Claycraft Potteries, opened in Los Angeles in 1921 with Fred Robertson, with whom he had worked at Los Angeles Pressed Brick. Claycraft produced three types of tile: Faience, Claycraft, and Handmade, all of which were made by machine and finished by hand.

Lavalle, John One of the chief designers of Grueby's tile and architectural terra cotta, Lavalle created the early Moorish *cuenca* tiles (see Glossary) and some Della Robbia-inspired art tile.

Le Boutillier, Addison An author and illustrator, Le Boutillier designed most of the Grueby tiles done in the high Arts and Crafts style. He became director of design in 1902, when he replaced George Kendrick.

LeBlanc, Marie de Hoa A student at Newcomb College from 1897 until 1902, Marie de Hoa LeBlanc remained at the pottery until 1914. She worked as a potter (1901-08) and as an art craftsman (1908-14). Her ware was marked with her initials.

Lessell, John Lessell was the art director at Weller Pottery in the early 1920s and is responsible for creating Lamar and LaSa ware, both of which were decorated with simple landscapes and trees.

Lingley, Annie An artist at Grueby Faience from 1899 until 1910.

Long, William A. A native of Ohio, William Long (1844-1918) founded Lonhuda Pottery in Steubenville, Ohio, in 1892. Originally a druggist, he became interested in art pottery after visiting the Philadelphia Exposition of 1876. Long experimented with glazes and is believed to have developed the brown underglaze that was used on Rookwood pottery. In 1895 Long joined forces with Samuel Weller to create Lonhuda Faience Company in Zanesville, Ohio. A year later Long left Lonhuda to work at Zanesville's J.B. Owens Company.

In 1900 Long founded Denver China and Pottery Company in Denver, Colorado; it stayed in business until 1905. After leaving Colorado that year, he moved to Clifton, New Jersey, and founded Clifton Pottery, where he developed a type of ware called Crystal Patina. Long returned to work with Weller in 1909 and remained at Lonhuda until 1912, after which he worked at Roseville Pottery and then at American Encaustic Tiling Company.

Low, John Gardner A former employee of Chelsea Keramic Art Works, Low organized J. and J.G. Low Art Tile Works in Chelsea, Massachusetts, with his father, the Honorable John Low, in 1877. Tile production began in 1878, and several innovative techniques were introduced, including the *natural process* and *plastic sketches* (see Glossary). Under John Gardner Low's direction, Low Art Tile Works produced brass-mounted clock facings, mantel-facings, and stove tiles. It closed in 1902.

Luther, Jessie One of the early instructors of the patients at Marblehead (Massachusetts) Pottery, which began as an occupational therapy project at Devereux Mansion Sanitarium.

Mattson, Julia Mattson studied and taught at New York's Alfred University before joining the faculty at North Dakota School of Mines (NDSM) in 1924. She remained there until 1963

McLaughlin, M. Louise A member of the Cincinnati School of Design's china class, Mary Louise McLaughlin (1847-1935) wrote a book about china painting on porcelain in 1874. Interested in French pottery, McLaughlin continued to experiment with glazes and probably produced the first American underglaze art pottery. She received an honorable mention at the Paris Exposition of 1878. A year later she founded the Pottery Club of Cincinnati, Ohio, with Maria Longworth Nichols, who left to found Rookwood Pottery. In 1900 McLaughlin's experiments led to Losanti—a true porcelain ware made entirely from local clay, which was discontinued in 1906. Before her death in 1939, she worked in art jewelry, lacemaking, and portrait painting.

Mercer, Henry Chapman A native of Bucks County, Pennsylvania, Mercer opened Moravian Tile Works in 1898. He showcased his tiles, most of which were hand-rolled, in a fireproof California Mission-type structure and at his mansion, Fonthill. Moravian tiles, made from red or white clay, are usually small and irregular. When Mercer died in 1930, Moravian Pottery and Tile Works was bequeathed to the Swain Family. It was purchased by Bucks County in 1968.

Mersman, Ferdinand A modeler of art tile at Cambridge Art Tile Works.

Morgan, Julia The architect who commissioned California Faience to supply art tile for the William Randolph Hearst estate, San Simeon, during the 1920s.

Mueller, Herman A designer at AETCo who produced their finest Neo-Classical panels, Mueller founded Mueller Mosaic Tile Company in Trenton, New Jersey, in 1909. The company produced tile until 1941.

Myers, Joseph An artist and potter, Joseph Myers was responsible for George Ohr's decision to throw pottery to be decorated by the women of Newcomb College.

Nichols, Maria Longworth After leaving the Pottery Club of Cincinnati, Ohio, Nichols (1849-1932) founded Rookwood Pottery in 1880, seven years after she became interested in decorating china. She worked at Dallas Pottery and experimented with glazes until her father purchased an abandoned schoolhouse as her studio: she named it Rookwood for her childhood home in Cincinnati. Nichols worked full time at Rookwood until 1889 and continued to carry out commissions for the company until 1906.

Ohr, George E. Regarded as one of the most eccentric—and brilliant—potters of the movement, Ohr (1857-1918) began producing his ware in Biloxi, Mississippi, from local clay, in 1883. A one-man operation, he threw all of his own pots, claiming that no two were alike. After a fire destroyed his Biloxi Art Pottery in 1894, Ohr rebuilt it to continue producing his highly manipulated ware with innovative glazes. Unsuccessful in his own time, he was driven by the belief that he was the "greatest potter on earth." After closing his pottery in 1909, he stored thousands of pieces in a shed for his children. During the 1970s, his pottery was rediscovered and finally received the acclaim that was denied Ohr in his lifetime.

Osborne, Arthur The chief modeler at J. and J.G Low Art Tile Works from 1878. Osborne designed the company's *plastic sketches* (see Glossary).

Owens, John B. Owens founded J.B. Owens Floor and Wall Tile Company in 1909, two years after his first venture, J.B. Owens Pottery, closed. His company produced large examples of art tile using the *cuenca* technique before closing in 1919.

Perry, Mary Chase Perry, born in 1868, first became known through her essays on china painting and watercolor designs, which appeared in leading periodicals, including Robineau's monthly journal *Keramic Studio*. She was involved in the field of china painting and conducted her own experiments with clays and glazes. In 1903 Perry withdrew from membership in the National League of Mineral Painters and, with Horace J. Caulkins, founder of a dental-supply business, formed Revelation Pottery. Its name derived from their newly developed Revelation China Kiln, an innovative kerosene-fueled kiln that could fire pottery at unprecedented temperatures. The Revelation Kiln revolutionized the production of art pottery in America.

Revelation Pottery soon became known as Pewabic Pottery, for the region in upper Michigan where Perry had been born and raised. Pewabic produced tiles, tile mosaics, and interior fittings in addition to art pottery. Their architectural tiles were used to decorate many buildings, including St. Paul's Cathedral in Detroit, Michigan.

Perry introduced Persian or Egyptian Blue, her most famous glaze, in 1909, and perfected many crystalline and volcanic glazes used to finish Pewabic ware. Pewabic continued to operate as a private pottery until 1965, four years after Perry died, when it was incorporated into Michigan State University. It still operates there as a pottery studio and a museum.

Pinney, Olga Reed An artist at Rookwood from 1890 until 1909. She married Matthew Daly, also a designer at Rookwood, in 1928.

Purdy, Ross Purdy (1875-1949) created the original Rozane line at Roseville Pottery in Zanesville, Ohio. The name combined "Roseville" and "Zanesville," and the ware was similar to the brown pottery with slip decoration that was popular in the early 1900s.

Rhead, Frederick Hürten Born in England, Rhead (1880-1942) moved to the United States in 1902 and began working at the Vance/Avon Faience Pottery in Wheeling, West Virginia. He left to work at Weller Pottery during 1904, after which he spent four years at Roseville Pottery. Before beginning his own company in Santa Barbara, California, in 1914, he worked at Jervis, University City, and Arequipa Potteries. A talented artist, he developed Fiesta dinnerware and the Della Robbia and Olympic lines at Roseville; he was proficient in the squeezebag technique. In 1917 Rhead became a designer and business manager at AETCo and was responsible for the company's animal designs and crystalline glazes. He left AETCo in 1927 to work at Homer Laughlin China Company.

Robertson, Fred Before founding Claycraft Potteries in Los Angeles, California, in 1921, Robertson had worked at Dedham Pottery and Roblin Art Pottery. His son George joined him at Claycraft in 1925, and together they opened Robertson Pottery in Los Angeles in 1934.

Robertson, George The son of Fred Robertson, George joined his father at Claycraft Potteries in 1925. Together, he and his father left Claycraft to open Robertson Pottery in Los Angeles, California, in 1934.

Robertson, Hugh A cofounder of CKAW, Robertson modeled tile at Robertson Art Tile Company and art pottery at Chelsea Keramic Art Works and Dedham Pottery.

Robineau, Adelaide Alsop One of the most influential figures in the Art Pottery movement. Robineau (1865-1929) began as a china painter and taught the craft until 1899, when she studied painting under William Merritt Chase in New York City. She married Samuel Edouard Robineau, a fellow ceramic enthusiast, and they purchased the magazine *The China Decorator* in 1899 and began publishing it as *Keramic Studio*, a monthly journal that became the major forum for serious ceramists, in 1900.

Adelaide wanted to create a uniquely American porcelain, and she exhibited her one-of-a-kind ceramics at various exhibitions. By 1905 New York's Tiffany & Company was offering a full range of her work. She was considered an expert in the art of high-fire porcelain.

From 1909 until 1911, Adelaide worked at the University City Pottery; in 1912 she established an arts and crafts school at her home in Syracuse called The Four Winds Summer School. It provided instruction in pottery-making and china painting until 1914. Syracuse University awarded Adelaide an honorary doctorate of ceramic sciences in 1917, and three years later she joined their staff as an instructor of pottery and ceramic design (to 1928). She was honored with a memorial retrospective at the Metropolitan Museum of Art after her death.

Robineau, Samuel Edouard Married Adelaide Alsop Robineau in the late 1890s, and together they published *Keramic Studio*, a monthly journal on the latest developments in the art of ceramics.

Rothenbusch, Fred An influential artist and decorator at Rookwood Pottery.

Sax, Sarah (1870-1949) An artist at Rookwood from 1896 until 1931.

Schmidt, Carl An artist at Rookwood Pottery.

Sicard, Jacques In 1901 Jacques Sicard left his native France to work at Weller Pottery, where he introduced a popular line called Sicardo, characterized by metallic lustres on an iridescent background.

Simpson, Anna Frances Simpson attended Newcomb College from 1902 until 1908. She worked at the pottery as an arts craftsman between 1908 and 1929.

Sheerer, Mary Given Hired by Newcomb College to teach classes in pottery decoration in 1894, Sheerer remained at the company until 1931 and was one of the major influences on

the pottery's style.

Shirayamadani, Kataro (1865-1948) A gifted Japanese artist who worked at Rookwood for two long periods: 1887-1911 and 1921-48.

Smith, J.T. Smith was employed by Menlo Park Ceramic Company, where he hand-painted many of the company's tiles.

Smith, Kenneth Smith worked at Newcomb College Pottery as a ceramic engineer, teacher, and potter from 1929 until 1945. He became manager of Newcomb in 1931.

Solon, Leon A native of England who worked as artistic director and New York representative at AETCo from 1912 until 1928. He advocated a more hand-crafted appearance for art tile. Before moving to the United States in 1909, he had been employed at England's Minton pottery and porcelain factory.

Stangl, J. Martin A German potter and chemist, J. Martin Stangl was the superintendent of Fulper Pottery's technical division, where he developed the company's unusual glazes. After William Hill Fulper, II, died, Stangl acquired Fulper, in 1930. In 1955 he registered the firm as Stangl Pottery Company.

Stickley, Gustav Stickley (1857-1942) was an American furniture designer, craftsman, and theorist, and a leading exponent of the American Arts and Crafts movement. His publication, *The Craftsman*, had a wide audience and influenced American design for many years. He used art pottery in his furniture catalogues, thereby increasing the demand for it.

Storrow, Mrs. James Financed Boston's Library Club House, which later became known as Paul Revere Pottery, to provide employment opportunities for underprivileged women. Regarded as the firm's "financial angel," she died in 1944.

Stratton, Mary Perry see Perry, Mary Chase

Sullivan, Louis One of the founders of the Chicago School of Architecture, Sullivan (1856-1924) was an important influence on American design and on Frank Lloyd Wright, his most famous disciple.

Taylor, William Watts Became an administrator and partner at Rookwood Pottery in 1883 and revamped the company's marketing methods. Watts determined which lines of ware should be discontinued based on how well they were selling. He remained at Rookwood until his death in 1913.

Thomas, Chauncey R. Thomas founded Deerfield (Massachusetts) Pottery in 1909. He closed it two years later and moved to Berkeley, California, in 1915 to teach at the California School of Arts and Crafts. Thomas and William V. Bragdon opened the Tile Shop, which soon became known as California Faience, in 1925. Before closing in the early 1930s, the company produced high-quality tile and pottery.

Tiffany, Louis C. A renowned designer, Tiffany (1848-1933) began producing pottery at the Tiffany metal furnaces in Corona, New York, in 1898. It wasn't until the St. Louis Exposition of 1904 that he displayed his pieces. Most of the ware produced at Tiffany Pottery was marked with the initials "L.C.T."

Timberlake, Mae An artist at Weller Pottery.

Todd, C.S. An artist who worked at Rookwood from 1910 until 1922.

Valentien, Anna Marie An artist at Rookwood from 1884 until 1905, Valentien (1862-1947) (also known as Valentine) met and married Albert Valentien there in 1887. She studied with the French sculptor Auguste Rodin before opening Valentien Pottery with her husband in San Diego, California, in 1911. The pottery closed in 1914.

Valentien, Albert R. Also known as Valentine, Valentien (1862-1925) worked at Rookwood from 1881 until 1907. He married Anna Marie Valentien in 1887. In 1911 they founded Valentien Pottery in San Diego, California, and operated it until 1914.

Valentine see Valentien

Van Briggle, Artus Born in Felicity, Ohio, in 1869, Artus Van Briggle studied at Cincinnati's Academy of Art before joining Rookwood Pottery in 1887. In 1893 he traveled to France, where he studied with the sculptor Auguste Rodin. During his years in France he became engaged to his future wife, Anne Gregory. After returning to Cincinnati in 1896, he continued to work at Rookwood until 1899, when he moved to Colorado Springs, Colorado, for his health. Two years later, the first pieces were fired at Van Briggle Pottery. He married Anne Van Briggle in 1902, and she continued to manage the company after her husband's death in 1904.

Van Briggle, Anne Gregory Born in Plattsburgh, New York, in 1868, Anne Gregory, the wife of Artus Van Briggle, was a talented artist in her own right and took over the management of Van Briggle Pottery after her husband's death in 1904. She erected a memorial building, the Van Briggle Art Pottery, in Colorado Springs, in 1908. After the pottery went bankrupt in 1913, Anne Gregory retired from the company. She died in 1929.

Volkmar, Charles One of the artists at Menlo Park Ceramic Pottery, Volkmar decorated many of the company's tiles before opening Volkmar Kilns with his son in 1903. The company produced tile until it closed in 1911.

Walley, William J. Born in Ohio in 1852, William J. Walley worked at the Minton factory in England. He returned to the United States in 1873 to work in Portland, Maine, and Worcester, Massachusetts. He began producing his pottery at the old Wachusett Pottery in West Sterling, Massachusetts, in 1898. The pottery was a one-man operation, and Walley continued to produce all of the ware until his death in 1919. Most of his pieces are incised with his initials.

Wall, Gertrude An art teacher from the Midwest, Gertrude Wall moved to California, where she began to work with ceramics, in 1912. With her husband James, she founded Walrich Pottery in Berkeley, California, in 1922. The small company produced both tile and pottery that was sold in California department stores and gift shops. After the pottery closed in 1930, Gertrude Wall taught classes in pottery at the University of California Extension Division. She died in 1971.

Wall, James Before moving to the United States, James Wall was employed at Doulton works in England. After he married Gertrude Wall, they founded Walrich Pottery in Berkeley, California (1922). Before closing in 1930, the company produced both art tile and pottery.

James Wall remained in the ceramics industry until his death in 1952.

Wareham, John D. The designer of the Norse Room of the Fort Pitt Hotel in Pittsburgh, Pennsylvania, Wareham incorporated Rookwood tile into the room.

Warhol, Andy An artist and filmmaker, Warhol (1928-1987) founded the American Pop Art movement and changed the course of American art. He purchased some of George Ohr's pottery, helping to bring attention to his work.

Weller, Samuel A. Weller (1851-1925) founded Weller Pottery in 1872 in Fultonham, Ohio. It became one of the largest companies in America, producing inexpensive art pottery including flowerpots and crocks that were thrown using local red clay. When Weller bought the American Encaustic Tiling Company in 1891, the company expanded to include an assortment of ornamental pottery. Before his death in 1925, Weller created many innovative lines of pottery, including Aurelian, Eocean, Tourada, and Samantha.

Wilcox, Harriet E. Worked at Rookwood from 1886 until 1907 and returned later to remain until 1930.

Wilson, Lucien In 1920 Lucien Wilson joined forces with Ernest Batchelder of Batchelder-Brown Tile Company to form Batchelder-Wilson, which moved from Pasadena to Los Angeles, California.

Winterbotham, Ruth The principal modeler during the early years at United States Encaustic Tiling Company.

Woodward, Ellsworth Born in 1861, Woodward was a visionary man who believed that women should be educated and trained for careers. To further this idea, he established the New Orleans Art Pottery Company in 1886, but it closed only a year later. He became supervisor of the fine arts program at Sophie Newcomb College, and in 1895 began training young women in the field of art pottery. This successful venture became Newcomb College Pottery.

Wright, Frank Lloyd Wright (1867-1959) worked as a young draftsman for Louis Sullivan and became one of the most influential figures in the development of modern architecture. He inspired the Prairie School of architecture, centered in the Midwest, and used Arts and Crafts ware like Teco pottery to furnish his interiors.

Wyckoff, Edward One of the chief potters at Fulper Pottery Company.

Young, George When Roseville Pottery was incorporated in 1892, George Young became secretary and general manager. After the company moved to Zanesville, Ohio, in 1910, Young decided that it should also produce art pottery, and the Rozane mark was created. In 1918 Young turned his job over to his son, Russell T. Young.

Young, Russell T. Became general manager of Roseville Pottery in 1918.

Leading Studios

American Encaustic Tiling Company (AETCo) AETCo was founded in 1875 in Zanesville, Ohio, and has the distinction of being the largest and longest-lived art tile manufacturer in the United States. During the first twenty years of operation, the company produced both flooring and art tiles made from local clays in various processes, including mosaics, intaglio, and damask. After the Great Depression, AETCo was reorganized with the Franklin Tile Company of Lansdale, Pennsylvania. Eventually, the two companies became known as American Olean. Many important figures worked at AETCo, including Leon Solon, Frederick Rhead, and Herman Mueller.

American Terra Cotta & Ceramic Co./Gates Potteries See Teco Pottery.

Arequipa Approximately twenty-five patients at Arequipa, a tuberculosis sanitarium directed by Dr. Philip King Brown in Fairfax, California, began decorating pottery that was thrown by a workman in 1911. Frederick Hürten Rhead and his wife Agnes were the first instructors (1911–13). The patients were young women who received payment for their work and proceeds from sales. In 1913 Arequipa Potteries was incorporated as a separate commercial venture; although the corporation dissolved two years later, production at the pottery continued. Albert L. Solon, a ceramic engineer, replaced Rhead in 1913 and reorganized the pottery. Production of tiles, new shapes, clay bodies, and glazes were introduced. When Frederick H. Wilde, an English potter, replaced Solon in 1916, a line of handmade tiles with Spanish influence was introduced. Arequipa closed down in 1917, the year that the United States entered World War I. The sanitarium remained open until 1957. Arequipa ware is characterized by its thick, durable look and was made using local clays. The ware was both thrown and cast, and designs were often incised onto the pottery.

Atwood & Grueby See Grueby Pottery.

Batchelder Tile Company Ernest Batchelder organized Batchelder Tile Company in Pasadena, California, in 1910 for the production of tiles, pottery, metal, and leatherwork. Two years later he enlarged the company with Frederick Brown (Batchelder-Brown) and increased the production of art tile. Batchelder ware was so successful that the company moved out of the suburbs and into Los Angeles, California, in 1920. By this time, Batchelder had formed a new partnership with Lucien Wilson (Batchelder-Wilson). The company closed in 1932. Batchelder tile was usually small and irregular in shape. Hand-pressed in plaster molds, the tiles were rarely glazed all over. Light blue is the most common color.

Binns, Charles Fergus A native of England, Professor Charles Fergus Binns (1857–1934) moved to the United States in 1897, where he became head of a school in New Jersey. Three years later he became the director of the first American ceramic school: the New York State School of Clay Working and Ceramics in Alfred, New York. Both a potter and a teacher, Binns made glazed stoneware, usually marked with his initials and the date. He is responsible for training such formative figures as Arthur Baggs, Paul Cox, Elizabeth Overbeck, and Frederick Walrath.

Brouwer Pottery Founded by Theophilus A. Brouwer, Jr., as Middle Lane Pottery in 1894, the company quickly became known as Brouwer Pottery for its versatile owner, who ran it singlehandedly. Potting in Long Island, New York, Brouwer experimented with metallic and lustre glazes in unusual colors and produced six types of ware: Fire Painting, Flame, Gold-leaf Underglaze, Kid Surface, Iridescent Fire Work, and Sea-Grass Fire Work. All of these lines were characterized by their unusual glaze effects. In 1903 Brouwer moved his pottery from East Hampton to West Hampton. He used the jawbone of a whale as the gate to the pottery and marked his ware with either an "M" enclosed by a symbol of this memorable structure, or with his name. In 1925 he incorporated Ceramic Flame Company to produce his ware. Before his death in 1932, Brouwer experimented with building boats from concrete, among other things. The pottery remained open until 1946.

California Faience William V. Bragdon and Chauncey R. Thomas founded California Faience in Berkeley, California, in 1924. The small company produced high-quality tile and pottery. Tile was made from local red clay that was hand-pressed into plaster molds and decorated with conventionalized designs in *cuenca*. Architect Julia Morgan used California Faience art tile in designing the William Randolph Hearst estate, San Simeon. Production all but ceased during the 1930s, and in the 1950s the company was sold.

Chelsea Keramic Art Works (CKAW) Established by Hugh, George, and Alexander Robertson and their father, James, in Chelsea, Massachusetts, in 1872, Chelsea Keramic Art Works produced a red bisque ware. Most pieces were shaped like urns and decorated with red figures on a black ground. Due to the unpopularity of this line, the company developed a new type of ware in 1877 in which decoration was incised or applied when the clay was damp. Called Chelsea Faience Floral, it was popular, but proved too expensive for the American public. In 1880 Hugh Robertson gained control of the company and began experimenting to formulate an American version of the Chinese *Sang de Boeuf* glaze, a blood-red finish. He finally developed the glaze and named it Robertson's Blood. He also created large wall plaques that resembled carved wood and plaques with figures in high relief. Despite technological advances and important discoveries, CKAW's product remained too expensive, and the company was forced to close in 1889. Determined to succeed, Robertson went to Dedham, Massachusetts, in 1895 and opened Dedham Pottery.

Claycraft Potteries Gus Larson and Fred Robertson, who were colleagues at Los Angeles Pressed Brick, opened Claycraft Potteries in Los Angeles, California, in 1921. They offered three types of machine-made tile processed to look handcrafted: Faience, Claycraft, and Handmade. All of their ware was finished by hand, and decorations are usually colorful. In 1925 George Robertson, Fred's son, joined the company. After Claycraft Potteries closed, Fred and George Robertson opened Robertson Pottery in Los Angeles.

Dedham Pottery After Chelsea Keramic Art Works closed in 1889, Hugh Robertson continued to produce pottery: in 1895 he moved to Dedham, Massachusetts, where he opened Dedham Pottery. Lack of local materials forced him to import clay from New Jersey and Maryland, among other places. A small company, Dedham had only two kilns, which were used in different ways. The first kiln fired their best-known ware—dishes with Crackle Glaze—while the second was used to produce Volcanic Glazes. These "accidental" glazes were achieved by firing a piece up to twelve times, causing the thick glaze to run down the pottery. Most of the ware produced after Robertson's death in 1908 was made from his earlier designs. Dedham Pottery continued operating until 1943.

Four Winds Summer School See Robineau, Adelaide Alsop, "Who Was Who in American Art Pottery."

Frackelton Pottery Susan Stuart Goodrich Frackelton (1848–1932) founded Frackelton Pottery in Milwaukee, Wisconsin, in 1882. A successful potter and decorator, she also invented a gas-fired kiln that enabled the average woman to produce pottery from her home, developed odorless paint for china, and wrote a guide for china painters. Made from local clay or salt-glazed stoneware, Frackelton pottery is extremely rare and highly sought-after due to the short life of the company (the pottery closed in 1902). Frackelton ware is usually marked with the founder's initials.

Fulper Pottery Company Originally founded in 1814 as Samuel Hill Pottery in Flemington, New Jersey, Fulper Pottery Company is one of the oldest in America. It was acquired by Abraham Fulper, Hill's partner, in 1860. Originally successful as a producer of drain tiles and utilitarian earthenware and stoneware, the firm broke new ground under William Hill Fulper, II. He produced high-quality pottery that is easily distinguished by its simplicity of shape

and glazing under the trademark name Vasekraft. Six general categories of Fulper glazes have been identified: Mirror, Flambé, Lustre, Matt, Wistaria (pastels), and Crystalline. Each piece of Fulper ware was individually glazed by hand and differed in color and texture. Fulper Pottery Company was acquired by J. Martin Stangl in 1930 and officially registered as Stangl Pottery Company in 1955.

Grand Feu Pottery Grand feu is used to describe pottery that is fired at a high temperature, including porcelain and *grès*, a white stoneware. Grand Feu Pottery was opened in Los Angeles, California, in 1913, by Cornelius Brauckman (1863-1951) to produce the latter type of ware. The high-fired stoneware was glazed with green, blue, yellow, and red in both matte and glossy finishes. Mottled effects were also produced. The early pieces (1913-16) are marked with "Grand Feu Pottery L.A., Cal." and those from 1916-18 with "Brauckman Art Pottery." The company stopped producing pottery in 1918.

Grueby Faience Company William Henry Grueby and Eugene Atwood founded Atwood & Grueby in Boston, Massachusetts, in 1891. The company made and installed tile in various locations in Boston before it closed in 1894. That same year, Grueby opened Grueby Faience Company, using the same facilities. For the next few years, Grueby conducted experiments in glazing and developed the famous Grueby Green—an opaque, matte enamel finish. Grueby Faience was incorporated in 1897, and George P. Kendrick, a prolific designer, joined the staff. Addison Le Boutillier became the chief designer after 1902.

Production was of two types: architectural tiles and art pottery. Grueby Pottery Company was organized for the production of art pottery and incorporated in 1907. When Grueby Faience went bankrupt in 1909, William Grueby organized a new company for the production of tiles, the Grueby Faience and Tile Company. Inexpensive reproductions of Grueby pottery plagued the company, and in 1910 Grueby Pottery Company closed. Grueby Faience and Tile Company stayed in business until 1920, when it was purchased by C. Pardee Works of Perth Amboy, New Jersey.

Most Grueby ware was thrown by hand and was characterized by its simple design and matte finish. Artists employed by the company included many graduates of nearby Boston schools, among them the Normal Art School and the Boston Museum of Fine Arts School. Immediately popular with both the public and the critics, Grueby's pottery received two gold medals and one silver at the Paris Exposition of 1900.

J. and J.G. Low Art Tile Works Founded by John Gardener Low, an artist and ceramist, and his father, the Honorable John Low, in Chelsea, Massachusetts, in 1877, J. and J.G. Low Art Tile Works manufactured art tile, stove tiles, mantel facings, and brass-mounted clock facings. Arthur Osborne was the chief modeler: discoveries led to advances in the tilemaking process. He developed the *natural process*, which involved using actual elements from nature, like leaves, in the design, and *plastic sketches*, which were tile panels made from wet or plastic clay instead of

damp dust. In 1880 the company received a gold medal at the Exhibition at Crewe in Stoke-on-Trent, England. The company closed in 1902.

Jugtown Pottery In 1915 Jacques and Juliana Busbee created Jugtown Pottery as a training and sales organization for potters in Jugtown, North Carolina. They soon opened a shop in Greenwich Village, New York City, to sell their ware, and by 1919 were so successful that Juliana stayed in New York to manage the shop, while Jacques supervised the potters in Jugtown, where he opened a shop in 1921. Ben Owens came to work as a potter in 1923; he fired the pieces that Jacques designed and glazed. As Jugtown pottery caught on, more and more people began producing art pottery, and soon an industry had developed in North Carolina. In 1926 the Village Store in New York City was sold, and Juliana returned to Jugtown.

Unlike other potteries, Jugtown continued to prosper during the Great Depression. After Jacques died in 1947, Juliana and Owens continued to run the business. Juliana died in 1962, and Owens left to start his own company. From 1968 until 1983, Nancy Sweezy operated the pottery as Jugtown Pottery for Country Roads, Inc. Vernon Owens, a cousin of Ben Owens, became the owner in 1983. Most of their ware was marked with an impressed circular stamp with the words "Jugtown Ware" and an image of a jug.

Marblehead Pottery Founded in 1904 at Devereux Mansion, a tuberculosis sanitarium in Marblehead, Massachusetts, by Dr. Herbert J. Hall, Marblehead Pottery was organized for the benefit of the patients. Under the direction of Jessie Luther and Arthur E. Baggs, they learned how to decorate the pottery. They were paid for their time and received proceeds from sales, producing an average of 200 pieces per week. In 1908 Marblehead was separated from the sanitarium, and Baggs became the director and later owner of the pottery (1915).

Early Marblehead ware is characterized by its simple shape and abstract, conventionalized design. Designs were usually painted directly onto the body of the piece, although occasional examples can be found with incised decoration. Made from a mixture of New Jersey and Massachusetts clay, the pieces were finished in matte glazes that included blue, green, yellow, and brown. Marblehead produced vases, candlesticks, bookends, tile, and tableware before it closed in 1936. Most ware is marked with a shop design and the letters "MP."

Merrimac Pottery Company Merrimac Ceramic Company was organized by T.S. Nickerson in 1897 in Newburyport, Massachusetts, for the production of drainpipes and tiles. Reorganized in 1902, it became Merrimac Pottery Company to produce art pottery. Nickerson chose the name for the Merrimac River, an Indian word that means sturgeon. Initially, the company produced small vases for interiors, then garden pottery. Merrimac ware is characterized by its superior glazes, developed chiefly by Nickerson, who had studied in London. His line of crackleware is the most widely acclaimed of his products. The company closed in 1908, shortly after a fire destroyed the building and most of the inventory.

Middle Lane Pottery See Brouwer Pottery.

Moravian Pottery and Tile Works Henry Chapman Mercer founded Moravian Pottery and Tile Works in Doylestown, Pennsylvania, in 1898. Initially the company produced rather crude art pottery, which Mercer soon abandoned in favor of art tile. (Later, he returned to art pottery.) He showcased his ware at his castlelike mansion, Fonthill. Moravian art tile, usually hand-rolled, was made from local clay and is usually small and irregular in shape. When he died in 1930, Mercer bequeathed his company to the Swain family. It was later purchased by Mercer's native Bucks County (1968).

Newcomb College Pottery Established at Newcomb College in New Orleans in 1894, the pottery was organized to "furnish the students of the art school with a means to continue their work after completing their studies there." It also provided financial support to advanced students, who derived income from the sale of their own pieces. The first year was dedicated to testing clays and glazes, but by 1895 the company was fully operational.

Tasks at the pottery were divided by gender: women designed and decorated the pots, while men were responsible for potting, firing, and glazing the pieces. All of them were individually decorated: after Rookwood, Newcomb was the largest American producer of this kind of ware. Their distinctive style was characterized by relatively simple shapes decorated with flat, conventionalized designs of Southern vegetation. Most pieces were finished in a cool palette of blues, grays, and greens.

Paul Ernest Cox modernized Newcomb's technical operations in 1910 and perfected a transparent matte glaze that replaced the standard clear, glossy finish. Softer textures, subtler underglazes, and a more naturalistic rendering of subject also occurred at this point. After forty-seven years as a pottery, Newcomb became solely an educational program in 1940.

New York State School of Clay Working and Ceramics See Binns, Charles Fergus.

North Dakota School of Mines (NDSM) The North Dakota School of Mines was established at the University of North Dakota in 1898, and in 1909 the university began offering a ceramics course. Margaret Kelly Cable came as an instructer in 1910. She used local clay to teach students the techniques of throwing, glazing, and firing pottery. Cable remained at the university for almost forty years. Her sister, Flora Cable Huckfield, worked there from 1924 until 1949, and the university's ceramics course still operates. NDSM ware is varied in style: it includes Art Nouveau, Art Deco, and utilitarian. North Dakota foliage and wildlife are common motifs. Ware produced before 1963 is marked with the university name. Pieces made after that date display only the students' names. Matte glazes were usually used to finish the pieces.

Ohr, George E. The brilliant and eccentric potter George Ohr, working at the turn of the century, went largely unrecognized until the 1970s, when Jim Carpenter bought his entire inventory from Ohr's sons. Ohr started his one-man Biloxi Art Pottery in Biloxi, Mississippi, in 1883, and sold his own ware, claiming that each piece was one of a kind. He threw and glazed

all of his pots, which were extravagantly manipulated, with multilayered ruffles, pinched bodies, and other bizarre forms. After a fire burned his second pottery shop and most of his inventory in 1894, Ohr rebuilt it from scratch to produce even more complex ware. Despite the fact that his work never received acclaim during his lifetime, Ohr died in 1918 convinced that he was "the greatest potter who ever lived." Today, many share that belief.

Overbeck Pottery Four sisters, Margaret, Elizabeth, Mary, and Hannah Overbeck, founded Overbeck Pottery in their family's home in 1920. After Margaret, the eldest, died, the other three women divided the work among themselves, although each could perform each step in the process of producing pottery. Hannah created most of the designs, Elizabeth was the technician, and Mary designed and glazed the pieces. Each sister remained at the studio all her life. Mary was the last to die, in 1955.

Overbeck ware was made from both local clay and a clay that contained Pennsylvania feldspar, Delaware kaolin, and Tennessee ball clay. Most of the pieces were thrown on a wheel and were one of a kind. Glazes were both matte and glossy, and designs were incised and carved. Early ware is marked with the incised name of the artist, while later pieces bear both the potter's and the designer's initials. All of the pieces made after 1911 have the Overbeck monogram.

Paul Revere Pottery Edith Guerrier and Edith Brown organized Paul Revere Pottery in Boston, Massachusetts, in 1906, as an occupation for members of the Saturday Evening Girls Club, a group of young immigrant girls. With the financial backing of Mrs. James Storrow, the pottery moved to Hull Street, where it became known as Paul Revere. SEG ware was extremely popular and sold well: by 1915 the pottery had its own building in Brighton, Massachusetts. Paul Revere continued to operate until 1942. Its products included children's dishes and tiles with matte and glossy glazes, usually one-color. Decoration was outlined in black and filled in by hand. Different marks were used on the ware, including "Bowl Shop, S.E.G.," an encircled man on horseback, and incised initials of individual decorators.

Pewabic Pottery Founded in 1903 as the Revelation Pottery by Mary Chase Perry, who, with Horace J. Caulkins, founder of a dental supply business, helped to develop the Revelation China Kiln. Fueled by kerosene, the kiln could be fired at much higher temperatures than existing units. Perry renamed the company Pewabic Pottery for the upper Michigan region where she was born and raised.

Pewabic Pottery also produced tiles, tile mosaics, and interior fittings incorporated into many important buildings. In 1908 Ralph Adams Cram, the architect of Detroit's St. Paul's Cathedral, used Pewabic tiles for the interior pavement of the church. A year later, Perry introduced her best-known glaze, Persian or Egyptian Blue, which was iridescent. She also perfected a fine selection of crystalline and volcanic glazes.

Pewabic continued to operate as a private pottery until 1965 when it was incorporated into Michigan State University. Reopened in 1968, Pewabic Pottery now serves as a pottery studio and museum.

Pisgah Forest Pottery Walter Benjamin Stephen founded Pisgah Forest Pottery in Pisgah Forest, North Carolina, in 1926, for the production of a fire-vitrified ware. Pisgah Forest ware is characterized by dark glazed pots with cameolike decorations and included vases, teapots, jugs, candlesticks, tea sets, mugs, and bowls. Pre-1926 ware is marked with "Stephen" or "W.B. Stephen"; after 1926 the "Pisgah Forest" mark was used. After Stephen died in 1961, it continued under the direction of J. Thomas Case and Grady G. Ledbetter. The pottery is open during the summer and continues to operate today.

Redlands Pottery Wesley H. Trippett produced Redlands pottery in Redlands, California, from 1902 until 1908. It is marked with a circle enclosing a tadpole-like figure ringed by the words "Redlands Pottery." Trippett produced vases, dishes, and tiles that were naturally colored from cream to red. Thrown from local clay, they were decorated with relief-carved designs of animals or left plain.

Revelation Pottery See Pewabic Pottery

Rhead, Frederick H. A native of England, Frederick Hürten Rhead was born in 1880 and moved to the United States in 1902, where he embarked on an important career in art pottery. Before his death in 1942, Rhead had worked at Jervis (1902-03; 1908-09), Weller (1904), Roseville (1904-08), University City Pottery (1909-11), and Arequipa (1911-13). He also founded Rhead Pottery in Santa Barbara, California (1913-17). Rhead's accomplishments include bringing the squeezebag technique from England to America, Rhead Faience, and Della Robbia ware. Rhead Pottery products included vases, tiles, and bowls, thrown by an Italian potter and decorated by young women. It was marked with an impressed depiction of a potter at a wheel and the words "Rhead Pottery, Santa Barbara."

Robineau, Adelaide Alsop In addition to publishing *Keramic Studio*, the leading forum for art pottery, Robineau was perhaps the country's greatest potter. She began experimenting with porcelain in the early 1900s and developed a wide variety of matte and crystalline glazes. Her ware was thrown and decorated by hand, often with intricate decorations. From 1909 until 1911, Robineau worked at University City Pottery with such other important art potters as Frederick Rhead. In 1920 she joined the staff at Syracuse University, where she remained until 1928. Robineau pottery is extremely rare.

Rookwood Pottery Founded in Cincinnati, Ohio, by Maria Longworth Nichols in 1880, Rookwood Pottery quickly became the most important studio in the emergent American Art Pottery movement. It was certainly the most influential. Laura Fry developed the famous Standard Glaze in 1883, and in 1887 Kataro Shirayamadani joined the staff. In 1889 Rookwood gained international acclaim when it received a gold medal at the *Exposition Universelle* in Paris. The Sea Green, Aerial Blue, and Iris lines were developed in 1894; three years later, portrait vases were manufactured. The production of architectural tiles began in 1901, and they were so successful that Rookwood tiles were used in New York City's subway system in 1903. During 80 years of production, more than

40,000 glaze formulae were developed, 500 of which were in daily use in the 1930s. Rookwood closed in 1960.

Roseville Pottery Incorporated in Zanesville, Ohio, in 1892, Roseville Pottery produced artware from 1900 until 1908, although the company remained in business until 1954. Stoneware and flowerpots were produced until 1900, when the first Rozane line was developed by Ross C. Purdy. It was named Rozane by combining the words "Roseville" and "Zanesville," and Rozane was soon used to designate all of the company's lines. John Herold developed Rozane Mongol, while Gazo "Fudji" Fujiyama developed Woodland (also known as Fujiyama). Frederick Rhead worked at Roseville from 1904 until 1908; he is responsible for the Della Robbia and Olympic lines. Roseville ware was highly successful, and the interaction with other Zanesville potteries, such as Weller, kept standards high.

S.A. Weller Company See Weller Pottery.

Samuel Hill Pottery See Fulper Pottery Company.

Saturday Evening Girls Club See Paul Revere Pottery.

Stangl Pottery Company See Fulper Pottery Company.

Teco Pottery Teco, an acronym of American Terra Cotta and Ceramic Company, produced three types of art pottery: architectural, organic, and faience. Described as the "pottery of the Prairie School," Teco ware was largely molded and mass-produced. Over 10,000 different shapes were produced before the company closed in 1929. Teco's pottery is primarily glazed with a green matte enamel, although copper crystal blackening and glossy glazes do occur.

Tiffany & Company/Tiffany Studios Louis Comfort Tiffany began producing art pottery in Corona, New York, in 1898, but did not display his ware to the public until the St. Louis Exposition of 1904. By 1905 the studio was manufacturing both vases and lamp bases for its glass shades. Most Tiffany ware was marked with "LCT" and was cast in molds, although some pieces were thrown on the wheel. Decoration was inspired by nature, as were the shapes used. Bronze pottery was developed in 1910. Glazed ware was sold at Tiffany and Company, while unglazed ware was sold at Tiffany Studios. Production of art pottery ceased some time before 1920.

T.J. Wheatley & Company See Wheatley Pottery Company

University City Pottery Edward Gardner Lewis founded the American Woman's League in University City, Missouri, in 1907. The League offered classes in a variety of fields including pottery. Taxile Doat, a French potter, began teaching there in 1909, the same year that Adelaide Robineau joined the staff. Before UC closed, in 1914, such influential potters as Frederick Rhead and Edward Dahlaquist also taught at the pottery. Marked with the initials "UC," Universtiy City ware was glazed with crystalline glazes. Doat's shapes and *pâte-sur-pâte* technique were used. Doat returned to France a year after the pottery closed.

Valentien Pottery Founded by Albert and Anna Valentien in 1911 in San Diego, California, Valentien Pottery produced cast pottery that was

finished in both matte and vellum glazes. Occasional pieces with slip decoration can be found. Both the Valentiens were skilled artists, and before their pottery closed in 1914, they were producing forty-three different plain shapes and forty-eight shapes with designs or relief decoration. Each piece of Valentien ware was marked with a poppy and the letters "VP."

Van Briggle Pottery Company Artus Van Briggle and his wife Anne founded the Van Briggle Pottery Company in Colorado Springs, Colorado, in 1902. Their ware was characterized by its exceptional glazes, elegant forms, and simple decoration. After Artus died in 1904, Van Briggle Pottery expanded into a variety of tiles, faience, fountains, and garden pottery for interior and exterior decoration. In 1910 it was renamed Van Briggle Pottery and Tile Company. Although the studio was plagued by financial problems and changed ownership repeatedly before 1969, it is still producing new designs as well as reproductions of earlier designs.

W.J. Walley William J. Walley (1852-1919) began potting at the old Wachusett Pottery in West Sterling, Massachusetts, in 1898, and worked until his death in 1919. He used local red clay to make flowerpots and more decorative artware. Most of his pieces were finished with a green matte glaze, but he also used shades of blue, red, and brown. Walley incised his initials on the bottom of most of his pieces.

Walrath Pottery Artist Frederick Walrath (1871-1921) had trained as a potter under Charles Binns at Alfred University and taught at the Arts and Crafts School of the Chautauqua Institution in 1903. He worked at Grueby and at the Mechanics Institute Department of Decorative and Fine Arts in Rochester, before becoming head ceramist at Newcomb College in 1918. He began selling his pottery in 1904. Walrath's early ware was decorated with one-color matte glazes or crystalline glazes. Two-color glazes were used after 1908. Walrath decorated his pottery with conventional, stylized designs.

Weller Pottery Samuel A. Weller opened Weller Pottery around 1872 in Fultonham, Ohio. He made plain and decorated flowerpots and crocks from the local red clay. After he bought the American Encaustic Tiling Company in 1891, he increased his line to include an assortment of ornamental pottery. Three years later, in 1894, Weller and William A. Long of Lonhuda Pottery joined forces to create the Lonhuda Faience Company, which survived for only one year.

Weller was responsible for creating Aurelian, Tourada, and Samantha wares and introduced Eocean ware in imitation of Rookwood's Iris line. In 1901 Weller hired Jacques Sicard to produce a line called Sicardo that was decorated with metallic lustres on an iridescent back-ground. Frederick H. Rhead, who worked at Weller from 1902-04, created the Jap Birdimal and L'Art Nouveau lines, and John Lessell, art director in the early 1920s, introduced several new lines, including Lamar and LaSa.

In 1925, the year that Samuel Weller died, Weller Pottery became S.A. Weller Company. Foreign competition was responsible for the company's closing down in 1948; a year later it was formally dissolved.

Wheatley Pottery Company Thomas Jerome Wheatley established T.J. Wheatley and Company in Cincinnati, Ohio, in 1880, producing molded, glazed, and fired pottery in a homemade kiln. The company closed between 1882 and 1884. The ware that Wheatley produced included art pottery, tile, and garden pottery, including some of the largest pieces to come out of the Art Pottery movement in America. Wheatley moved to Zanesville, Ohio, and began working at Weller Pottery in 1897. He returned to Cincinnati in 1900 and opened Wheatley Pottery Company in 1903. Ware produced at the pottery was decorated in both green and other matte glazes. Occasionally, examples appear with relief decorations. The company continued to produce art and garden pottery after Wheatley died in 1917. Incorporated in 1921, it was bought by Cambridge Tile Manufacturing Co. in 1927 and reorganized as Wheatley Tile and Pottery.

Index

(Picture and caption references appear in **boldface** *type.)*

Abstract Expressionism 249
Aerial Blue 10, 11, 254
Aesthetic movement 9
Alfred University 155, 216, 242, 244, 248, 250, 252, 255
Alligator Matte finish **61**
American Art Pottery, 7
American Encaustic Tiling Company (AETCO) 165, 233-34, **233**, 246, 249, 250, 251, 252, 255
American Olean 234, 246, 252
American Terra-Cotta and Ceramic Company (Terra Cotta, Illinois) *see* Teco
applied decoration 53, 58, **62**, **63**, **70**, 71, **72**, **73**, 77
Architectonic ware **118**, **119**
Arequipa 71, 165, **166**, **167**, 171, **213**, **229**, 234, 242, 250, 252, 254
Art Deco 9, 145, 183, 239, 253
Art Moderne 9
Art Nouveau 9, 10, 11, 12, 19, 101, 164, 211, 253
Asbury, Lenore 248
Ashbee, Charles 243
Atwood, Eugene 49, 53, 236, 241, 248, 249, 253
Atwood & Grueby *see* Grueby Faience
Aurelian ware 251, 255
Aventurine glaze **121**
Avon Faience **168**, **169**
Avon Pottery Works 163, 164

Aztec ware 149
Baggs, Arthur 71, 155, 216, 241, 248, 252, 253
Bailey, Henrietta 41, 248
Barber, Edwin AtLee 6, 31, 231, 248
Barbizon School 232
Barnhorn, Clem 235, 248
Batchelder, Ernest 243, 248, 251, 252
Batchelder Pottery 240, 242, 243, **243**, 244, 245, 251, 252
Beaver Falls Art Tile Company 235, 248
Biloxi Pottery *see* Ohr, George
Binns, Charles Fergus 155, 216, **217**, 242, 244, 248, 252, 255
bisque ware **9**, **80**, **82**, **83**, 101, 123, 210
Black Flambé **195**
Black Iris **20**, 21
Black Mirror glaze **201**
Book of Rookwood Pottery, 7
School of the Museum of the Fine Arts (Boston) 49, 253
"Bowl Shop" 173, 254
Bragdon, William V. 244, 248, 251, 252
Braukman, Cornelius 253 *see also* Grand Feu Pottery
"brocade" ware 240, **240**
Broome, Isaac 234, 235, 248
Brouwer, Theophilus A. 207, 248, 252
Brouwer Pottery **206**, 207, **210**, **218**, **219**, 248, 252
Brown, Edith 171, 173, 248, 254
Brown, Frederick 243, 248,

252
Burton, Elizabeth 242
C. Pardee Works 235, 237, 249, 253
Cable, Margaret 242, 248, 253
California Art Tile Company (Cal Art) 245, **245**, 249
California Faience 242, 244, **244**, 248, 249, 250, 251, 252
California Clay Products (Calco) 245, 249
Callowhill, Scott 234, 248
Cambridge Art Tile Works 235, 248, 250
Cambridge Tile Manufacturing Company 241
Cameo line 210
Carnelian lines 146
Carpenter, Jim 77, 248, 253
Cat's Eye Flambé **192**
Caulkins, Horace J. 239, 248, 250, 254
Centennial Exhibition (1876) 10, 231, 249
Chaplet, Ernest 101, 248
Chase, William Merritt 248, 250
Chelsea Faience Floral ware 252
Chelsea Keramic Art Works (CKAW) 208-10, 212, **220**, 232, 235, 236, 244, 249, 250, 252
China Decorator, The see *Keramic Studio*
Chinese Blue Flambé **188**, **189**, 210
Chinese Polychrome Flambé **197**
Clark, Garth 78, 255

Classical influence 111, 164, 182, 183, 209, **234**, **235**
Clay Glow Tile Company *see* California Art Tile Company
Claycraft Potteries 242, **244**, 244-45, 249, 250, 252
Clifton Pottery 249
cloisonné 236
Collector's Guide to American Art Pottery, A 6
Columbian Exposition (Chicago 1893) 233, 235-36
Conant, Arthur 248
Cooper-Hewitt Museum (New York, NY) 101, 102, 104, **105**
Copperdust Crystalline glaze 190, **191**
Coralene Opalesce line 211
Cowles Art School 49
Cox, Paul 34, 248, 252, 253
Craftsman, The 251 *see also* Stickley, Gustav
Cram, Ralph Adams 248, 254
crystalline ware **190**, **191**, 193
Conant, Arthur **30**
Contemporary Craft Museum (New York, NY) 78
Crystal Patina ware 249
Cucumber Green finish 56, **57**, **60**, 61, **62**, **64**, **67**
cuenca decoration 236, 237, **237**, 238, **240**, **241**, **242**, 241-42, 248, 249, 250
cuerda seca decoration 172, **173**, 174, 236, 241, **241**
Dallas Pottery 250
Dalpayrat, Antoine 236, 248
Daly, Matthew **9**, 248, 250

Dedham Pottery 208-10, **220**, 235, 244, 250, 252
Deerfield Pottery 251
Delaherche, Auguste 49, 101, 236, 248
Della Robbia ware **142**, 143, 144, **145**, **146**, **147**, **148**, **149**, **150**, **151**, 164, 166, 237, 239, 249, 250, 254
Despondency 124
Devereux Mansion 249, 250, 253 *see also* Marblehead Pottery
Diffloth, Emile 164
Doat, Taxile 164, **208**, 244, 254
Dresser, Christopher 236, 248
Eidelberg, Martin 7
embossed design **17**, 101, 102, 104, **105**, 116, 125, **126**, **128**, **129**, **130**, **131**, **132**, 145, **229**
enameled design 22, **23**, 144, **146**, 164
encaustic tilemaking 231-32
Encyclopedia of American Art Pottery 6
Enfield art tile **230**, 231, 240, 241
Eocean ware 251, 255
Eppley, Linda **22**, 248
Erickson, Ruth **58**
Evans, Paul 6
excised design **46**, **47**, 104, **105**, 144, 164, 165
Exhibition at Crewe, Stoke-on-Trent (England) 232, 253
Favrile Pottery 106, **107**
Fire Painting ware 210, 248, 252
flambé 102, **103**, 193

Flame ware 210, 252
Flint Faience 24, 246, **246**
Fonthill 240, 250, 253
Four Winds Summer School 250, 252 *see also* Robineau, Adelaide
Frackelton, Susan Stuart Goodrich **226**, 227, 252
Franklin Pottery 23, 245, 246, **246**, 252
Fry, Laura 9, 29, 248, 254
Fudji ware 143, 146, 254
Fudzi ware 143
Fujiyama, Gazo (Fudji) 143, 149, 248, 254
Fujiyama ware **148**, **149**, 248, 254
Fulper, Abraham 248-49, 252
Fulper, William Hill, II 248, 249, 251, 252-53
Fulper Pottery Company 7, 145, 180-205, 248-49, 251, 252
Gallimore, William W. 234, 235, 249
Gates, William D. 249
Gates Pottery *see* Teco Pottery
Germanic influence 181, 182, **183**, 184, **192**, **202**, 232
Gilbert, Cass 239, 249
Gloss Flambé **192**
Gold Leaf Underglaze 210, 248, 252
Gothic influence 231-32, 239, 243
Grand Feu Pottery **213**, **228**, **229**, 253
Great Depression 9, 126, 145, 183, 234, **245**, 246, 252, 253
Gregory, Anne *see* Van Briggle, Anne
Griffin, Walter Burley 111, 249
Grueby, William 49, **50**, 53, 235, 236-37, 239, 241, 248, 249, 253
Grueby Faience 48-69, 72, 109, 111, 124, 135, 171, 207, 208, 235-36, **236**, 236-37, **237**, 242, 248, 249, 252, 253, 255
Guastavino tile 238
Guerrier, Edith 171, 254
Hall, Herbert J. 249, 253
Hamilton Tile Works 234, **234**
Handbook of Ornament 239
Handcraft Guild 243, 248
Hartford Faience Company 241, **241**
Hearst, William Randolph 244, 249, 250, 252
Hill, Samuel 248-49
Hislop, James W. 245, 249
Homer Laughlin China Company 165, 234, 250
Huckfield, Flora 242, 249, 253
Hurley, E.T. **10**, **29**, **30**, 238, 249
Impressionism 241, **241**
incised design 12, **22**, **27**, **38**, **39**, **40**, **42**, **44**, **47**, 72, 104, **105**, 126, 144, **153**, 156, 164, 165, 168, **169**, 174, **226**
intaglio tile 233
International Studio magazine 236
Iridescent Fire Work 210, 248, 252
Iris ware 9, 10, 11, **13**, **19**, **20**, **21**, 254, 255
Irvine, Sadie 41, 249
Ivory Flambé **195**
J. & J.G. Low Art Tile Works 232-33, **232**, 236, 249, 250, 253
J.B. Owens Pottery 143, 241-42, **242**, 249, 250

Jap Birdimal line 163, 166, 211, 255
Jervis, William 164
Jervis Pottery 155, **162**, 163, 164, **165**, 254
Jewel Porcelain ware 12, 13, **22**, **23**, **26**, **27**, **29**, **30**,
Johns, Jasper 77, 249
Jugtown Pottery 210, 253
Keeler, Rufus 245, 249
Kendrick, George P. 48, 49, **64**, **65**, **66**, **67**, 237, 249, 253
Kensington Art Tile Company 234, **235**
Keramic Studio magazine 208, 249, 250, 254
Kid Surface 210, 248, 252
Kovel, Ralph and Terry 6
Kugler, John O.W. 188, 249
Lamar ware 249, 255
Larson, Gus 244, 249, 252
LaSa ware 249, 255
Lavalle, John 237, 249
Le Boutillier, Addison 66, 235, **236**, 237, **237**, 249, 253
Lessel, John 249, 255
Lewis, Edward G. 164, 254
Lingley, Annie **58**, 249
Long, William 249, 255 *see also* Lonhuda Pottery
Lonhuda Pottery 10, 248, 249, 255
Lorelei ware **122**, 123, 124, 125, **127**
Los Angeles Pressed Brick 244, 245, 249, 252
Losanti ware 250
Low, the Hon. John 232-33, 249, 253
Low, John Gardner 232-33, 249, 253
Luther, Jessie 250, 253
Mad Potter of Biloxi, The see Clark, Garth
Malibu Potteries 245, 249
Marblehead Pottery 71, 154-61, 171, 207, 241, 248, 249, 250, 253
Massachusetts Normal Art School 49, 253
Massier Pottery 211
Matt Morgan Pottery 248
matte ware 10, 11, 12, 13, **17**, **22**, **23**, **27**, 34, 35, **41**, **42**, **43**, 49, 50, 55, **122**, 123, 124, **125**, 126, 130, **131**, 156, 158, **159**, 165, 193, 208
Mattson, Julia 242, 250
McBean, Gladding 245, **245**
McLaughlin, Mary Louise 248, 250
Menlo Park Ceramic Company 251
Mercer, Henry Chapman 237, 240, 250, 253
Merrimac Pottery 208, **209**, 220, **221**, 253
Mersman, Frederick 235, 250
Metropolitan Museum of Art, NYC 250
Michigan State University 250, 254
Middle Lane Pottery *see* Brouwer Pottery
Minton porcelain works 231, 232, 234, 251
Mock Orange ware 146
modeled design 12, 34, 56, **57**, 123, 124, 144, 165, 208
molded design 102, 124, 126, 144, 145, **152**, **176**, **177**, 184, 208, 209, **229**
Moravian Pottery and Tile Works 239, 240, **240**, 243, 250, 253
Morgan, Julia 244, 250, 252
Morris, William 235

Mosaic Tile Company 241
Mueller, Herman 233-34, 241, 242, 250, 252
Mueller Mosaic Tile Company 242, **242**, 250
Myers, Joseph 78, 250
native American influence 50, 51, 220
natural process 232-33, 249, 253
Neo-Classical influence 232, 233-34, 235, 239, 241, 250
New Orleans Art Pottery Co. 251
Newcomb College 32-47, 54-5, 78, 155, 171, 172, 210, 248, 249, 250, 251, 253, 255
Nichols, Maria Longworth 7, 10, 31, 250, 254 *see also* Rookwood Pottery
Nickerson, T.S. **209**, 253
North Dakota School of Mines **226**, **227**, 242, 248, 249, 250, 253
Ohr, George 6, 6-7, 13, 49, 71, 76-79, 111, 136, 207, 210, 248, 249, 250, 251, 253-54
Olympic ware 149, 250, 254
Oriental influence 9, 10, 163, 164, 182, 183, 184, 209, **224**, 236
Osborne, Arthur 232, **232**, 250, 253
Ott & Brewer 234, 248
Overbeck sisters 216, 251, 254
Overbeck Pottery 208, **226**, **227**, 248, 254
Owens, Ben 210, 253
Owens, J.B. 143, 211, 241-42, 249, 250
Owens, Vernon 253
Oxblood finish *see Sang de Boeuf* finish
Painted Matte ware 13, **17**, 212
Pan-Pacific Exposition (San Francisco) 244
Paris Exposition of 1878 250
Paris International Exposition (1900) 10, 41, 237, 249, 253
Paul Revere Pottery/SEG 170-79, 207, 236, 241, 248, 251, 254
Peck, Herbert 7
Perry, Mary Chase 135, 138, 238, 248, 250, 251, 254
Pewabic Pottery 134-41, 235-36, 239, **239**, 240, 248, 249, 250, 254
Pinecone ware 145, 146
Pinney, Olga Reed 248, 250
Pisgah Forest Pottery 210, 254
plastic sketches 232-33, **232**, 249, 250, 253
Plein Air school 242
Poppy ware 145, 146
Pottery and Porcelain of the United States, The see Barber, Edwin A.
Pottery Club of Cincinnati 248, 250
Prairie School 109, 110, 111, 249, 251, 254
Pre-Raphaelite Brotherhood 235
Providential Tile Works 234, **234**, 248
Purdy, Ross 250, 254
Redlands Pottery **210**, **228**, 242, 254
Renaissance influence 232, 237
reticulated design 34, 146, **147**
Revelation China Kiln 248, 250, 254
Revelation Pottery *see* Pewabic Pottery
Rhead, Agnes 164, 252

Rhead, Frederick Hürten 71, 143, 144, 149, 155, 162-69, 208, 209, 211, 212, 234, 240, 242, 245, 250, 252, 254, 255
Rhead, Harry 146
Rhead Faience 164, 254
Rhead Pottery 165, 254
Robertson, Alexander 209, 212, 252
Robertson, Fred 244-45, 249, 250, 252
Robertson, George 245, 250, 252
Robertson, Hugh 208, 109-10, 235, 236, 250, 252
Robertson, James 252
Robertson Art Tile Company 235, **235**, 250, 252
Robineau, Adelaide 77, 164, 207-08, **214**, **215**, 248, 249, 250, 254
Robineau, Samuel 249, 250, 254
Roblin Art Pottery 212, 244, 245, 250
Rodin, Auguste 123, 251
Rookwood Pottery 6-7, 8-31, 49, 50-1, 53, 54-5, 123, 124-25, 143, 210-12, 213, 233, 235-36, 238, **238**, 244, 248, 249, 250, 251, 253, 254, 255
Roseville Pottery 7, 49, 50, 142-53, 164, 210-11, 234, 248, 249, 250, 251, 254
Rothenbusch, Fred **12**, 13, 15, 20, **21**, 238, 250
Rozane ware 10, **145**, 146, **153**, 248, 249, 250, 251, 254
Saint Louis Exposition (1904) 99, 106, 237, 251, 254
Saint Petersburg Exposition 237
Samantha ware 251, 255
Samuel Hill Pottery 248-49, 252
Sang de Boeuf finish 209, 252
Saturday Evening Girls Club *see* Paul Revere Pottery
Sax, Sarah 12, 19, **20**, **23**, **26**, **27**, 250
Schmidt, Carl 238, 250
Schneider, Norris 7
Sea-Grass Fire Work 210, 248, 252
Sea Green ware 10, 11, 13, **18**, **19**, 254
sgraffito ware **146**, **151**, 163
Sheerer, Mary Given 250-51
Shirayamadani, Kataro 12, **17**, **28**, 29, **30**, 211, 251, 254
Sicard, Jacques 211, 250, 255
Sicardo ware 143, **211**, **224**, 250, 255
Simpson, Anna Francis 41, 250
slip decoration 50, 123, 255
slip-trail technique *see* squeezebag decoration
Smith, J.T. 235, 251
Smithsonian Institution 79 *see also* Cooper-Hewitt Museum
Society of Arts and Crafts (Boston) 237, 243, 249
Solon, Albert 245, 252
Solon, Leon 234, 251, 252
Solon & Schlemmel 245
Spring Valley Tile Works *see* Teco Pottery
squeezebag decoration **145**, 163, 164, **164**, 165, **166**, **167**, **168**, **169**, 241, 250, 254
Standard glaze (Rookwood) 10, 13, **22**, **24**, **25**, **28**, 29, 123, 238, 248

Stangl, John Martin 181-82, 249, 251, 253
Stickley, Gustav 12, 51-3, 59, 80, 109, 242, 251
Storrow, Mrs. James 251, 254
Strong, Harris G. 245, **246**, 246
Sullivan, Louis 109, 110, 251
Sunflower ware 145, 146
Taylor Tilery 245
Teco Pottery 108-21, 223, 249, 251, 252, 254
Thomas, Chauncey R. 244, 251, 252
Throop Polytechnic Institute 243, 248
Tiffany, Louis Comfort 101, 251, 254
Tiffany Studios 100-107, 250, 251, 254
tile, decorative 53, 230-46
Tile Shop 244, 248, 251 *see also* California Faience
Timberlake, Mae 240, 251
Todd, C.S. **27**, 251
Tourada ware 251, 255
Trent Tile Company 234, 248, 249
Trippet, Wesley H. **228**, 254
United States Encaustic Tiling Company 234, **234**, 251
University City Pottery 164-65, 166, 208, **208**, **215**, 244, 248, 250, 254
Valentien, Albert 211, 213, 251, 254-55
Valentien, Anna 212, 213, 251, 254-55
Valentien Pottery **212**, 213, **229**, 241, 251, 254-55
Valentine *see* Valentien
Van Briggle, Anne 123, 124, 125, 126, 128, 132, 241, 251, 255
Van Briggle, Artus **25**, 123, 124, 125, 126, 128, 212, 241, 251, 255
Van Briggle Pottery 122-33, 241, **241**, 251, 255
Vance/Avon Faience Pottery 250
Vasekraft ware 181, **183**, 184, 249, 252-53
Vellum ware **10**, **11**, **13**, **14**, **15**, **17**, 238, 248
Victorian influence 9, 10, 33, 50-51, 171
Volkmar, Charles and Leon 235, 241, 251
Volkmar Kilns 241, **241**, 251
Wall, Gertrude and James 245, 251
Walley, William 70-75, 251, 255
Walrath, Frederick 34, **216**, 248, 252, 255
Walrich Pottery 245, 251
Wareham, John D. 238, 251
Weller, Samuel 249, 251, 255
Weller Pottery 10, 143, 163, **164**, 166, 210, **211**, **224**, **225**, 240, 243, 248, 249, 250, 251, 254, 255
Wheatley Pottery **222**, **223**, 235, **240**, 241, 255
Wilson, Lucien 243, 248, 251, 252
Winterbotham, Ruth 234, 251
Woodward, Ellsworth and William 33, 251
Wright, Frank Lloyd 109, 110, 111, 249, 251

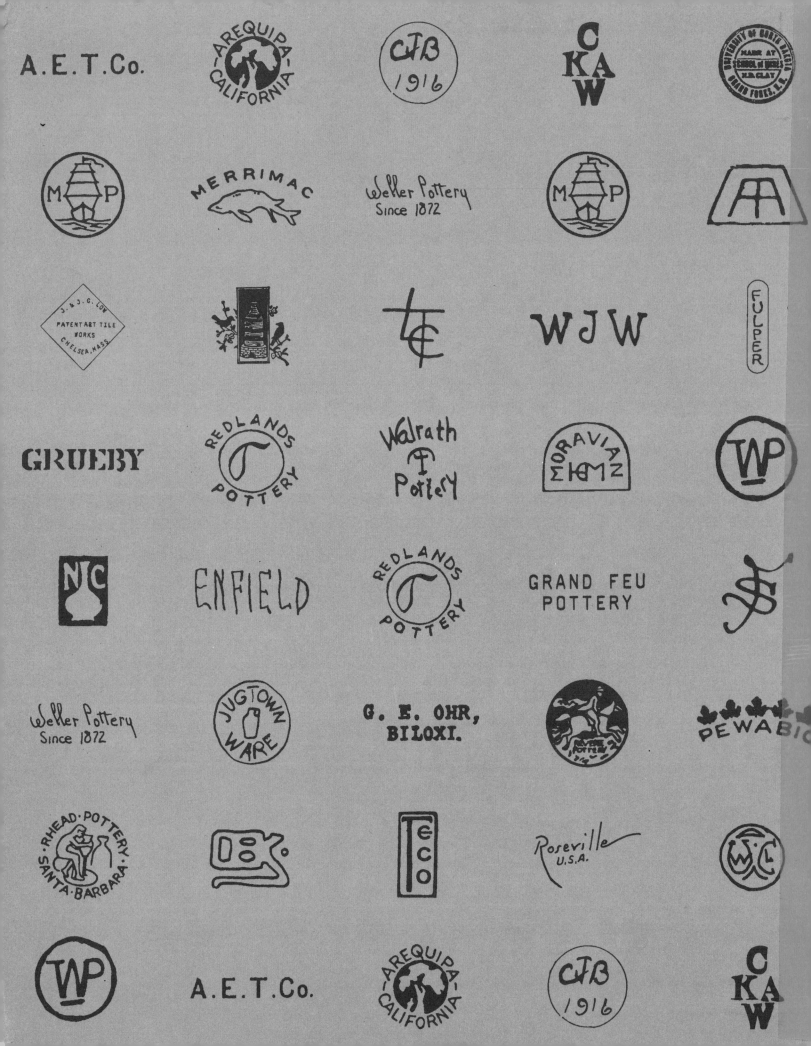